DATE DUE	
MAY 3 0 1991	
SEP 0 6 1996	
BRODART, INC.	Cat. No. 23-221

LONE STARS
VOLUME II

A Legacy of Texas Quilts,
1936–1986

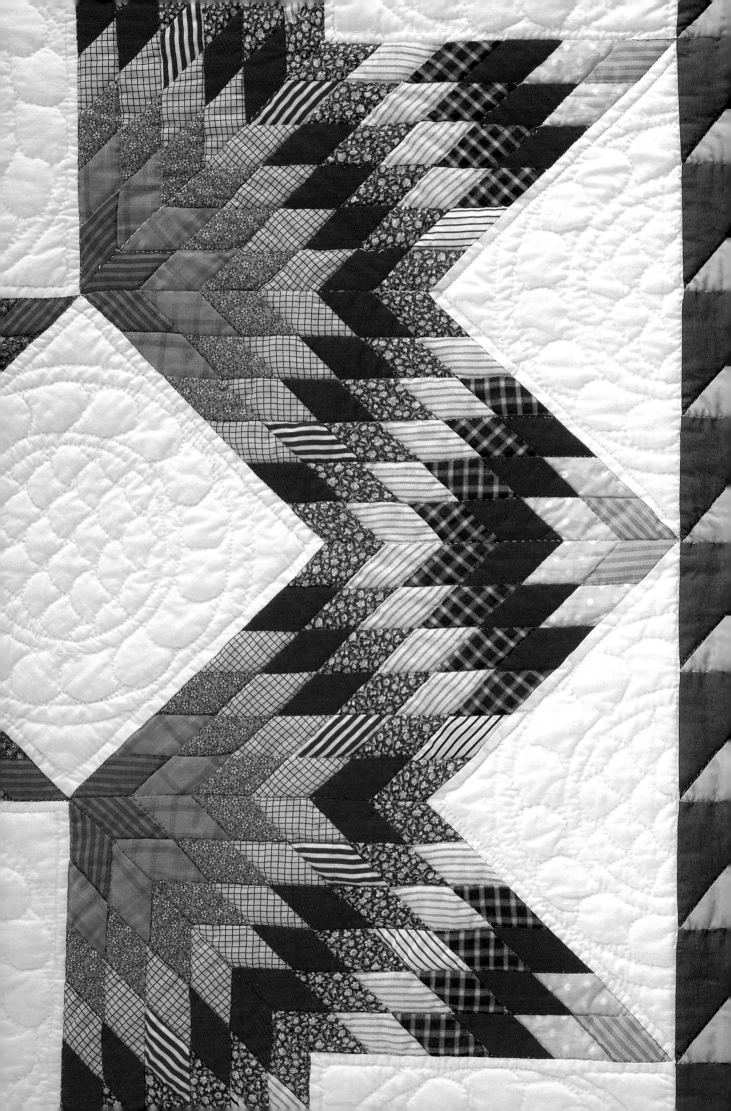

LONE STARS

VOLUME II

A Legacy of Texas Quilts, 1936–1986

by Karoline Patterson Bresenhan
and Nancy O'Bryant Puentes

UNIVERSITY OF TEXAS PRESS, AUSTIN

First Edition, 1990

Requests for permission to reproduce material from this work
should be sent to Permissions, University of Texas Press,
Box 7819, Austin, Texas 78713-7819.

∞ The paper used in this publication meets the minimum
requirements of American National Standard for Information
Sciences—Permanence of Paper for Printed Library Materi-
als, ANSI Z39.48-1984.

LIBRARY OF CONGRESS
CATALOGING-IN-PUBLICATION DATA
(Revised for vol. 2)

Bresenhan, Karoline Patterson.
 Lone stars.

 Exhibition catalog.
 Includes bibliographical references.
 1. Quilts—Texas—History—19th century—
Exhibitions. 2. Quilts—Texas—History—20th century—
Exhibitions. I. Puentes, Nancy O'Bryant. II. Title.
NK9112.B68 1986 746.9′7′09764074764 85-31589
ISBN 0-292-74641-5 (v. 1)
ISBN 0-292-74649-0 (pbk : v. 1)
ISBN 0-292-74659-8 (v. 2 : alk. paper)
ISBN 0-292-74671-7 (pbk. : v. 2 : alk. paper)

Frontispiece: detail from
Folk Life Festival Poster Quilt, *page 120*

To the next generation,

BRANDY BENET BRESENHAN
AND JULIE CATHERINE PUENTES,
our niece and stepdaughter,
and to young Texans everywhere.

May they appreciate the beauty of quilts,
value the inspiration, commitment,
and hard work it takes to produce them,
and feel a sense of kinship with all
the creative women who have ensured
that quilting does not become
a lost art.

ACKNOWLEDGMENTS

WE WOULD like to thank Linda Joiner, for her help in coordinating this large and sometimes unwieldy project and for her assistance with research; Vi McCorkle, for her ongoing aid in manuscript preparation and recordkeeping; Richard Cleveland, for his assistance during the photography session; and Neill Hart, for his aid in transporting quilts.

And, again, we thank Texans near and far for sharing their quilts and family histories with us and with everyone who values woman's work.

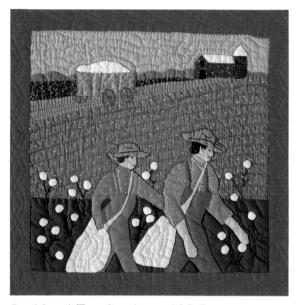

Detail from A Texas Sesquicentennial Quilt, *page 140*

All photographs of quilts and quilt details are by Sharon Risedorph of San Francisco, assisted by Roderick Kiracofe.

CONTENTS

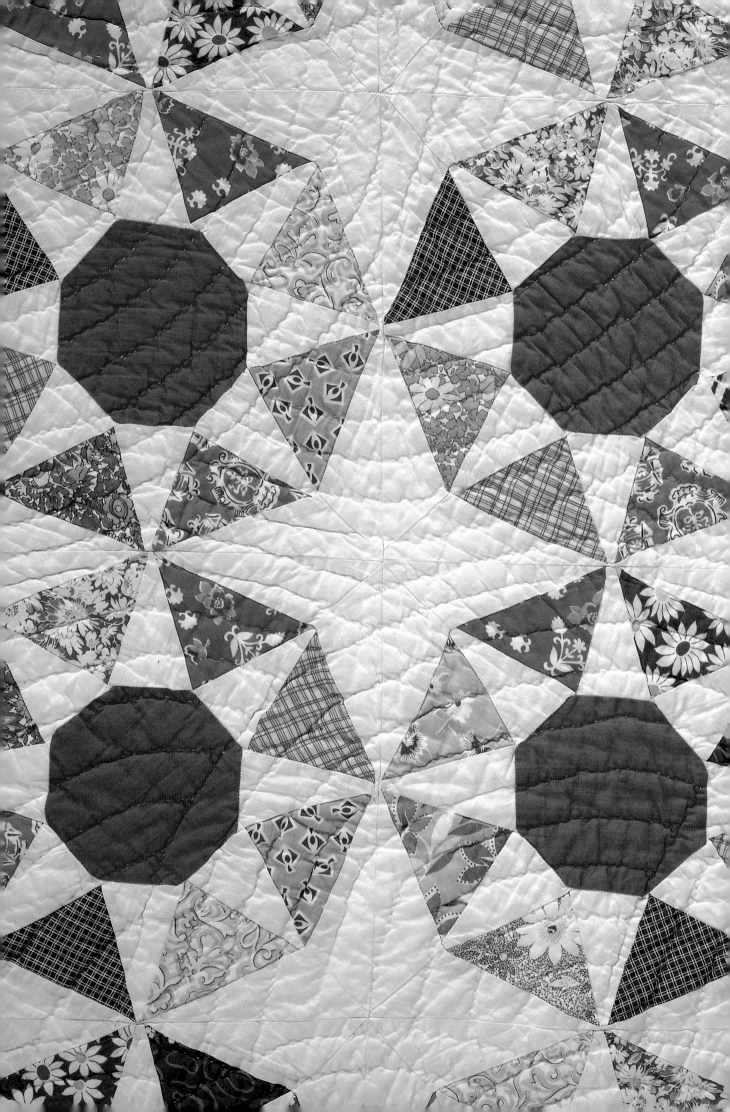

THE SEARCH
FOR TEXAS QUILTS

THIS BOOK is a continuation of the Texas Quilt Search, an ongoing statewide quilt documentation project initiated in 1980 by the authors and the nonprofit Texas Sesquicentennial Quilt Association.

The immediate aim of the project was to see that the artistic and cultural contributions of Texas women, through the predominantly female art of quiltmaking, were recognized during the Texas Sesquicentennial, the state's 150th birthday, in 1986. The long-range goal is to trace an ongoing record of quiltmaking in Texas.

An exhaustive statewide quilt search that occupied a total of three years and involved the participation of hundreds of volunteers, nonprofit quilt guilds, and local art and historical museums and organizations initiated the first phase of the project. Twenty-seven regional quilt days and a statewide call to action produced 3,500 documented quilts. An intensive selection process and a historic quilt conservation seminar provided a stunning exhibition of antique quilts in the State Capitol on San Jacinto Weekend, 1986, and a smaller traveling exhibit that toured the state.

In addition, the Great Texas Quilt RoundUp, which was a year-long contest for contemporary Texas quilters to produce quilts on various Texas themes, was conducted. Top quilts were selected to tour the state in 1986 and 1987 as a contemporary counterpoint to the traveling exhibition of antique quilts.

Information gathered on all of these quilts and quiltmakers became the basis for the establishment of the nonprofit Texas Quilt Archives, a resource center for persons wishing to learn more about Texas quilts. The Honor Roll of Texas Quilters was also established as a means by which family members and friends could single out individual quiltmakers for a special place in the ongoing history of quilting in Texas. A grant from the Texas Commission on the Arts and the National Endowment for the Arts, as well as a number of corporate and individual donations, helped to make the first phase of the Texas Quilt Search a great success.

The second phase is less spectacular but no less vital. The ongoing documentation of Texas quilts and quiltmakers is providing us with a picture of the changing role of Texas women in a state that has seen an enormous transformation in the last fifty years and of the way in which that transformation is reflected in their quilts. The Texas Quilt Archives is still the repository for all information gathered through the Texas Quilt Search, and the Honor Roll of Texas Quilters is still available to all families wishing to salute the achievements of relatives and friends who quilt.

All of the work that goes into such programs is voluntary. The Texas Sesquicentennial Quilt Association, its board of directors, which includes Karoline Bresenhan, Kathleen McCrady, Nancy O'Bryant Puentes, and Suzanne Yabsley, and all individuals who are involved in any way with the Texas Quilt Search and Project, the Texas Quilt Archives, and the Honor Roll of Texas Quilters give their time and raise funds to see that these efforts continue. Grants and donations are currently being sought to computerize the documentation records for easy retrieval and to house and manage the archives.

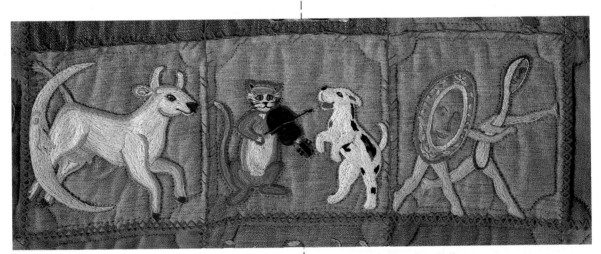

Detail from My Blue Jean Quilt, *page 110*

posite: detail from
ening Star Quilt, page 40

9

I was born in Texas,
grew up in Texas,
was educated in Texas.
I believe everyone who goes to heaven
must come through Texas.

—*Linda Moore-Lanning,* BREAKING THE MYTH:
THE TRUTH ABOUT TEXAS WOMEN

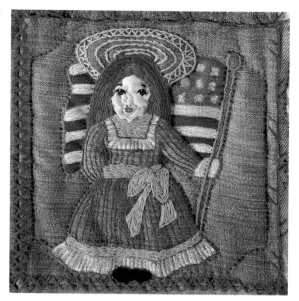

Detail from My Blue Jean Quilt, *page 110*

10

THE CHANGING
FABRIC OF SOCIETY

LIKE THEIR pioneer foremothers, Texas women of the past half century have lived with both heartbreak and history, boom and bust. They have survived the Dust Bowl, the Depression, and droughts that drove them from the land. They have seen man walk on the moon and women walk into the halls of government. They have lived through the years of the great movements: for civil rights, women's rights, world peace, the environment. This half century began only eighteen years after women won the right to vote and ended shortly after the Equal Rights Amendment died aborning. Although quilting has been quiescent during certain decades, it has never ceased completely in Texas. Quilts have always been made in the Lone Star State, and here quilts have always been treasured. These quilts reflect both the lives of their makers and the times in which they were made. They provide us with a cultural and historical documentation of an era, a people, and a state.

Quilts have been made in Texas since 1731, long before Texas was a Republic and forty-five years before the American Revolution. That year Maria Betancour, a twenty-eight-year-old widow and mother of five children, arrived in what was to become Texas to found the first permanent settlement in San Antonio; she led a group of thirty-one Canary Islanders into the Texas frontier to settle the community. In 1779 Maria Betancour died, and in her will, filed in the Royal Presidio of San Antonio de Béxar and detailed in Ruthe Winegarten's *Texas Women: A Pictorial History,* is found the first recorded mention of quilts in Texas history: "Now that I am afflicted with all the infirmities and aches inevitable to old age . . . I hereby publish the last will and testament of all my property . . . one day of irrigation water . . . the stone house in which I live . . . all the cattle . . . a ranch . . . one chest which I brought from the Canary Islands . . . To my granddaughter . . . I have left the mattress and *quilt* which I am using" (p. 13; emphasis added).

Maria Betancour was only the first of a long line of Texas quiltmakers; the descendants of those talented textile artists have continued and expanded upon this stitching tradition to such an extent that today Texas is known as a hotbed of quilting throughout the world. Texas is where quilting trends start, where artistry develops, where equal tribute is paid to the finest quilts of the past and to the exciting quilts of the future.

The last half century—from the Texas Centennial in 1936 to the state's Sesquicentennial in 1986—has witnessed changes that have forever altered the lives of every Texas citizen, that have brought new freedoms, choices, and options to Texas women. During our mothers' lifetimes, the world of the Texas woman evolved from the 1930s extreme of the homebound, rural, isolated, and impoverished wife and mother who was dependent upon her butter and egg money for everything but the barest necessities of life, who held her family together in the face of dire circumstance by sheer faith and sheer grit, and who made her many scrap quilts to keep her children warm. Texas women have seen the rise of the 1980s extreme—Superwoman—the executive wonder who manages multi-million-dollar international projects without missing a single PTA meeting or serving a single frozen dinner, who jogs with her husband every night before her law-school classes, and who creates one-of-a-kind textile art pieces to hang on her wall. Both images are stereotypes that play a role in developing the folk myth of the Texas woman, yet both have some basis in fact. The similarity between the two is the emphasis on family and the love for quilts. The difference between the two lies primarily in options and opportunities, and those are behind the enormous changes of the past fifty years.

The Texas quilter in 1936, the year marked by the statewide celebration of the Centennial of Texas independence, had just survived the worst of the Great Depression. If she lived in the Panhandle or the Plains, she watched the Dust Bowl blow away the hopes and dreams that lay in the topsoil the wind swept into black clouds as high as mountains. If she lived in East Texas, she saw the birth of the oil boom that changed Texas from a rural state whose economic future could never hope to match her physical size into a wealthy, urban state. If she lived near the border or in West Texas, she saw the tremendous surge of migration from Mexico that began at the turn of the century. If she lived on a farm, she watched with forboding while cotton prices plummeted, the land dried up under its worst drought in history, and her friends and family lost their farms. If she lived in one of the state's cities, she experienced the grinding despair of bankruptcy and unemployment in a state where the work ethic was held to be holy.

The Texas work ethic was inculcated into Texas women by generations of ancestors who had

survived hard times. As Linda Moore-Lanning claimed in *Breaking the Myth: The Truth about Texas Women,* the early Texas woman "looked down on anyone who did not labor from dawn to dusk . . . [she] preferred a belief in the comforts of the next life over an acceptance that her hardships were 'all there is' . . . [she] was adept at doing without, and she believed in the value of hard work . . . [she] was vigorous and usually too practical to spend time analyzing whether she liked the place or not. Chores awaited her; families depended on her" (pp. 27–35). During the Depression, hard work was considered a virtue. "People wanted to work, needed to work, and took pride in their achievements. The result was maximum human productivity," according to Kenneth Ragsdale, writing in *The Year America Discovered Texas: Centennial '36* (pp. 96–97). The oil boom itself added to the work ethic, for the early oil field workers came directly from the farm, where they tolerated hard, dirty, and dangerous work; they learned to accept the fact that fortune comes and goes, that grit counts, and that being a good loser is just as important as being a good winner. The Texas woman absorbed all those lessons and adapted them to her own life.

After 1918, when she could vote and hold office, the Texas woman saw her first woman governor, Miriam "Ma" Ferguson, ride her disgraced husband's coattails into office and the first woman ever elected to the Texas Senate, Margie Neal, almost singlehandedly push the Texas Centennial through a reluctant legislature. She may have gone to Dallas to celebrate the 1936 Centennial, in the year that "the rest of America discovered Texas" as Stanley Marcus once said. And if she did, she came back home full of patriotism, with a new understanding of her state and its settlers, a new pride in the achievements of one hundred years of independence, and a new knowledge about the world beyond her home. That year she watched the newspapers report how women made a success of the Centennial—Janice Jarratt, the Texas Sweetheart, waving her white cowboy hat on front pages around the world; the Texas Centennial Rangerettes, a traveling team of good-will ambassadors, capturing the imagination of the country with their western regalia of ten-gallon hats, cowboy chaps, and riding breeches (women's jeans were an unknown in 1936); Jan Isbelle, creating the Cavalcade of Texas, the overwhelming hit of the Dallas exposition; and Sally Rand,

shocking people (and selling tickets) with her famous fan dance.

She may have left her family's farm and followed her husband into the decade's phenomenal oil boom that changed Texas and Texans' lives. "Between 1901 and the most recent oil boom, generations of Texans came to the oil fields. They left the hardscrabble farms and drought-parched ranches in search of opportunity and excitement. The oil fields promised both. In Texas, as in other states, the main lure of the oil field was economic opportunity . . . The Texans faced the hazards and challenges of a new life because they saw the promise of a better one, for themselves and for their children. The oil fields offered a chance to get ahead—or, at the very least, an escape from the soul-numbing drudgery of being dirt poor" (*Life in the Oil Fields,* p. 1). Once she arrived in the oil fields, she must have been appalled at the living conditions, for "ragtowns," tent cities, shacks, lack of indoor plumbing, lack of running water, bathing in a galvanized washtub, and eating with one's head under a sheet to keep the sand out of the food were the common denominators of oil-field life. According to Diana and Roger Olien, authors of *Life in the Oil Fields:* "Ragtown living was harder on wives and mothers than it was on husbands and children . . . for the wives and mothers, there was no escape from the constant problem of trying to transform a tent or a shack into an acceptable home. Housekeeping conditions were primitive, quarters were cramped, and small children were always underfoot" (p. 87). The Oliens interviewed many women who had tried their best to create homes among the chaos of the oil fields. Said one: "We had to buy water for everything . . . We'd pay one dollar a barrel for it. If the train didn't come in with the water, it was just terrible. You took your bath in it, but you didn't throw it out. You kept it for your clothes, 'cause your clothes was full of sand. You'd put them on the line, and you'd hope the sand wouldn't start blowing and get them full of sand until you'd get them off the line" (pp. 89–90). Another woman remembered: "We didn't have refrigeration. Most people would buy ice from the iceman every day . . . we'd get ten cents' worth. That would make tea for our dinner and supper; and we would wrap it in a quilt, and keep it in a tub. If you had butter and milk, you would put that real close to the ice" (p. 92). The primitive conditions were particularly difficult in the Gulf Coast area

where open tents provided no protection from the insects or from two-legged varmints, yet the women were seldom afraid even when they were alone all night: "We had mosquito netting. We couldn't have slept a night if we hadn't had it . . . Our bedposts was set in oil to keep ants from getting on the bed. There was flying ants . . . and centipedes was bad . . . We had many, many meals with our heads under a sheet . . . You would fix your meal and cook everything covered to keep the sand out. Then you would eat with your head in under a sheet. We put the table legs in kerosene to keep the ants from coming up . . . Them days your husband went to work in the evening . . . You'd go to bed with that open tent. You never thought a thing in the world about it. You was never molested in any way whatsoever" (pp. 89–90).

Even in the ragtowns, Texas women made their quilts. The Texas quilter made quilts featuring maps of Texas, with each of the 254 counties delineated, usually by embroidery. She made patriotic red, white, and blue quilts in myriad designs and Lone Stars of every description, never quibbling that the quilt pattern had eight points and Texas' lone star had only five. Like other United States quilters, she was enchanted with the cheerful, pastel flowered fabrics of the 1930s and produced a profusion of Dutch Dolls and Sunbonnet Sues, Dresden Plates, Double Wedding Rings, and Grandmother's Flower Gardens, the latter three patterns being the most popular of all of the 1930s quilts. Even Governor Ferguson fell victim to quilt fever and made a Double Wedding Ring during this prolific period. One unusual quilt from the end of the 1930s is the XIT Ranch Autograph Quilt made by Mrs. J. Luther Ramsey between 1938 and 1941. The quilt was pieced out of satin, and Mrs. Ramsey collected autographs and comments on the pieces from many of the famous ranch's former cowboys.

Although the 1930s quilter had access to excellent quiltmaking fabrics, in many cases she lacked the funds to purchase special fabrics for her quilts, and thrifty as her ancestors, she made good use of the colorful printed sacks in which livestock feed and grain were packaged. She also bleached sugar sacks and flour sacks and seamed them together to produce fabrics for backings; she saved the small sacks that held tobacco until she had enough to make a quilt, then dyed them to produce the colors she wanted. She even saved the strong red and

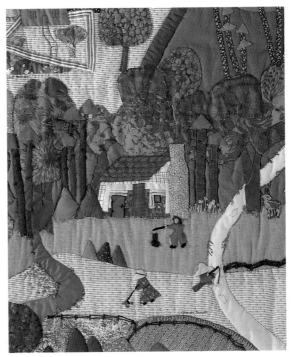

Detail from Huntsville's Birthday Quilt, *page 166*

orange cords that stitched the feed sacks closed; those she used to tie heavy woolen comforters. She made skirttail quilts, shirttail quilts, britches quilts, and "stomach" quilts with pieces cut from the part of worn-out housedresses that had always been protected by her apron. She often made her quilts narrow, just wide enough to cover the bed and give the sleeper some protection from drafts but not wide enough to require a fancy border. She sewed special muslin coverings—beard protectors—on the top edges of her quilts to save her work from soil and the unsightly wear that pulling up a quilt under an unshaven chin could cause. Yet the Texas quilter never contented herself with the strictly utilitarian, as Diane Corbin explains in "The Textile Artist," a chapter in *Folk Art in Texas*: "After a hard day of canning or cooking or washing or hoeing, she deserved a rest, but felt less guilty if her hands were occupied with 'fancy work'" (p. 124).

She quilted with her church group, worked with neighborhood quilting bees, and often hung her quilting frame from the ceiling on pulleys so that it could be raised at night to get it out of the family's way. She enjoyed the quilting renaissance of the 1930s, with its how-to magazine articles,

13

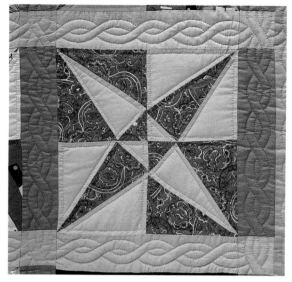

Detail from Crossed Canoes Quilt, *page 82*

books, newspaper columns featuring patterns, kits, mail order packets of fabric scraps, extensive pattern catalogs, give-away patterns in batting wrappers, county and state fairs with quilting divisions, and contests. Perhaps, like Texan Lois Hobgood, who kept her two prize ribbons pinned to her applique entry, she even entered one of the many huge contests like the Sears, Roebuck Century of Progress competition of 1933, when 25,000 entries were received for a grand prize of $1000 (which must have seemed a fortune during the Depression) and the honor of having the winning quilt given to the First Lady, Eleanor Roosevelt. According to Patricia Mainardi, writing in *Quilts: The Great American Art*: "Women exhibit their quilts, and still do, at state and county fairs, churches, and grange halls, much as our contemporary 'fine' art is exhibited in museums and with much the same results. Good quilt makers were known and envied throughout their area; the exhibition of exceptionally fine craftswomanship and design influenced other women who returned home stimulated to even finer work" (p. 3).

Following Mrs. Roosevelt's lead in emphasizing American arts and crafts, the 1930s quilter may have participated in one of the WPA quilt-related projects, such as the Index of American Design, described in *Twentieth Century Quilts* as "the most massive government-sponsored project ever attempted to record such early American decorative arts as . . . textiles, including quilts" (p. 5). She may have stitched her own response to her world in a continuation of the nineteenth-century tradition of creating quilts as political statements; according to Carter Houck, writing in *All Flags Flying,* "women were again using fabric as an art medium to create what amounted to huge posters declaring their feelings about the Depression, the administration, and finally World War II." One of those poster quilts, a patriotic tour de force, was Historic U.S.A., made in Texas by Charles and Fanny Norman. This splendid quilt is also known as the Presidents Quilt because it contains the portraits of thirty-one United States presidents; the center panel features a detailed rendition in fabric of the signing of the Declaration of Independence, and Liberty Bells and American eagles are used in the corners.

The Texas quilter, like her compatriots in other states, turned to her quilts for comfort and solace at a time when her world was uncertain. As recounted in *Twentieth Century Quilts,* "Particularly during the Depression, quilting gave women a profound sense of accomplishment, of being able to *do* something at a time when the labor force was idle and to *piece* something together when many people's lives were falling apart" (p. 35). Women were standing uncertainly on the brink of major change.

And that change came on December 7, 1941: Pearl Harbor Day and the entry of the United States into World War II. The most obvious change, of course, came when the soldiers marched off to war, leaving the women behind to deal with wartime shortages and wartime opportunities. Shortages became a way of life, and, like their pioneer foremothers, the woman of the 1940s relied on her ingenuity to deal with hardships. She baked sugarless cakes, planned meatless dinners, kneaded dye into margarine to make it look like butter, planted a Victory garden, recycled tin cans, rode public transportation to save gasoline, and made do without stockings by carefully painting fake seams on her bare legs. Fabric, too, was scarce and hard to come by; the Texas quilter with a traditional scrap bag felt lucky to have it and used every piece in her stash.

But the shortages were only temporary inconveniences, whereas the opportunities brought with them permanent changes in women's lives, in Texas as in the nation as a whole. Within a time span of only four years, more than six million

women entered the paid labor force for the first time. Before the war, most of the white working women were either single or widowed, and it was not considered "socially acceptable" for married women to work outside the home. Suddenly, those rules no longer applied, and the government mounted an unprecedented media effort to convince married women that for them to go to work was now just as acceptable—for the duration, of course—as it had been unheard of only the year before. As Sara Evans pointed out in *Born for Liberty: A History of Women in America,* "As in previous wars, activities once viewed as inappropriate for women suddenly became patriotic duties for which women were perfectly suited" (p. 229).

Texas women responded in force to the government's call for help. A woman might have taken pilot training at Hughes Airport in Houston, where women were taught to ferry planes and fly noncombat missions, thereby freeing the men to pilot combat planes. Or perhaps she was one of the lucky 1,074 women (out of 25,000 applicants) who successfully applied for jobs with the Women's Airforce Service Pilots (WASPS) at Avenger Field in Sweetwater, the only all-woman air base in history. She might even have been one of the thirty-eight WASPS who lost their lives serving their country. She could have signed up to work the "swing shift" at any one of the state's many munitions and armaments factories. One of her number, Oveta Culp Hobby, led more than 100,000 women in the war effort, including 8,000 from Texas. And if the Texas woman of the 1940s chose not to go to work in a paid job, she freely offered her help in more traditional volunteer positions, such as with the Red Cross or Civil Defense. Whether she worked outside the home or not, she bought war bonds and put off buying anything new, from shoes to cars.

This was also an era of fund-raising quilts, another example of a woman using her needle to support her beliefs. As in the First World War, the "war to end all wars," signature quilts to benefit the Red Cross were made across the state, with hometown citizens and business leaders paying a small amount for the privilege of having their names or signatures embroidered on the quilt. And at least one bomber was bought "for our boys" by the fund-raising efforts of quilters in one community. Patriotic quilts attracted media attention, and magazines urged quilters to use red, white, and blue in adapting old patterns. "Such a

quilt, made in this period, would certainly be treasured by your descendants," stated the February, 1941, issue of *Farm Journal and Farmer's Wife.* Special Victory quilts, such as the Navy Wives quilt, commemorating a husband's or son's service in a particular branch of the armed forces, were designed and encouraged; some creative quilters, like Felma Headrick whose work is shown in this book on page 74, were not content to replicate a published pattern—instead they created totally original quilts with patriotic messages. And quilters everywhere were forced to give up one of their favorite old patterns—an ancient Indian symbol of friendship that had many names like Heart's Seal, the Battle Ax of Thor, Catch-Me-if-You-Can, Windpower of the Osages—but that was best known in the 1940s as the dreaded Swastika, the symbol of Hitler's crimes against humanity. Many of the Swastika quilts were made throughout the nineteenth century and well into the twentieth, but with the advent of World War II, these pieced quilts disappeared entirely from the quilters' repertoire.

Women were in great demand in nontraditional roles during the wartime fervor. But once the men had marched home, the rules changed again. As Evans points out in *Born for Liberty:*

As the men were mustered out of the army, women were mustered out of the factories; both were sent home to resume increasingly privatized lives. What the war had accomplished, with a reinvigorated economy and pent-up consumer demand, was a new expectation that most Americans could enjoy the material standard of living promised by the consumer economy in peace. The purpose of work outside the home was to procure the resources to sustain this standard of living . . . the female task was to oversee the quality of this private life, to purchase wisely, and to serve as an emotional center of the family and home. The principal obstacle to this vision, however, was the possibility that women might not choose to play their publicly condoned role . . . pressure will be brought to bear on the married women to stay at home and mind the children. In war she heard promises; peacetime will be full of prohibitions. (Pp. 229–230)

Yet at the end of the war women knew with certainty that they, too, had helped win the victory, and they were not all inclined to give up the independence they had found in work outside the home. They saw government plans educate servicemen under the GI bill, while college remained out of reach for most women. They saw the gov-

ernment help servicemen purchase property, yet a woman could not buy a home unless a man would cosign her loan. Women were at a crossroads— their working for pay had been a constant source of controversy for twenty years; now it seemed only just that this option should remain open to them after their wartime service. However, the traditionalists still defined the woman as house-wife—"child-centered, consumer conscious, and fully responsible for all housework," according to Evans (p. 230)—and despite minor victories by individual women determined to have the right to work for a paycheck, these traditional attitudes dominated the postwar period. To Evans, this dominance "reflected the pessimism that perme-ated the atmosphere in the late 1940s. People had lived through 15 years of war and depression. Celebrations at the end of the war were haunted by images of the Nazi death camps and the shadow of the atomic bomb. The magnitude of human evil and the potential for global destruction were hard to comprehend even after a war in which millions died. VE and VJ days had barely been celebrated when a new threat loomed, the onset of the cold war" (p. 234).

With the war behind them, women had little time to spare for traditional needlework. As au-thor Betty Friedan put it in *The Feminine Mys-tique*: "We were all vulnerable, homesick, lonely, frightened. A pent-up hunger for marriage, home, and children was felt simultaneously by several different generations; a hunger which, in the pros-perity of postwar America, everyone could sud-denly satisfy" (p. 174). Interest in quiltmaking began to decline, and the traditional way quilting was taught—handed down from mother to daugh-ter—began to lose the continuity that had kept quilting a thriving force. Quilting seems to have skipped a generation in Texas between the end of the 1940s and the middle of the 1960s. The un-broken chain that linked generations by their love of quilts is missing the postwar brides and those of the 1950s; not until their daughters came of age would quilting become popular once more.

Although the women had tasted independence in the wartime jobs, now they went back home to have their families. But perhaps that brief inde-pendence had a long-range effect that could not be anticipated in the postwar years. As explained in *Born to Liberty,* "The mothers of the baby boom generation experienced a moment of indepen-dence and cultural validation (whether personally

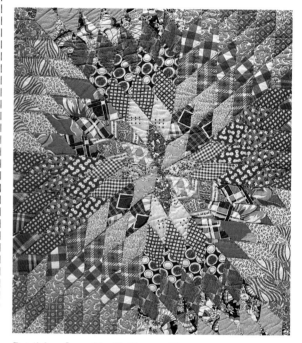

Detail from Lone Star Quilt, *page 86*

or vicariously) during the war years; this may well have shaped the mixed messages they gave their daughters who loudly proclaimed the rebirth of feminism two decades later and politicized daily life once again with the slogan 'the personal is po-litical'" (p. 241).

After the war, with factories converting rapidly to production of consumer goods to fuel the econ-omy and with the women's magazines promot-ing new babies, new homes, new furniture, new styles, and the "new look," quilts fell out of favor and yielded their position as buffers against the cold to inexpensive new blankets. Instead of how-to quilting articles, magazines featured coordi-nated bedrooms with matching bedspreads and curtains; the patchwork or appliqué quilt was simply left out of this equation. According to Suzanne Yabsley in *Texas Quilts, Texas Women*: "To many, the quilt was associated with lean times and 'making do.' For the first time in Texas, quilt-making had become dated and old-fashioned." However, national and regional contests con-tinued to draw significant entries. For example, *Woman's Day* offered a $1000 grand award in its 1942 quilt contest, and in 1943 the Chicago Art Institute's Decorative Arts Department mounted

a special exhibition of thirteen Bertha Stenge quilts that turned out to be one of the most popular shows in the department's history. In 1949, prize-winning quilts from state fairs were shown at the Central States Quilt Exhibition, sponsored by Stearns and Foster. As Tom Woodard and Blanche Greenstein explain in *Twentieth Century Quilts*: "When America came back from the war, it was a very different era. The modern age had become the atomic age. The women who had quilted the 'Navy Wives' design . . . became brides themselves, and their interests turned to babies, mortgages, fin-tailed cars, television, and all the diversions that postwar prosperity had to offer" (p. 34).

The Texas quilter of the 1950s continued to make her quilts, but now she worked in solitude instead of being part of a national quilt fever. She began to have less and less time to quilt as her life became more complicated. For the first time since the end of the Civil War, she had to examine her feelings about race relations. The 1950s brought the first school integration case—*Heman Sweatt vs. the University of Texas Law School*—before the Supreme Court, and when Rosa Parks sat down in the first available bus seat in Montgomery, Alabama, instead of moving to the "colored section" at the rear of the bus, the civil rights movement was born. The 1950s brought more war, this time in Korea, and again, Texas men marched off to fight, leaving women behind to cope. This time, when she went back to work in the war effort, she continued working even after the war.

By this point, the whole structure of Texas had changed. From a rural state with the bulk of its population living on farms and ranches, Texas had inexorably evolved into an urban state. The terrible droughts of the 1950s and the repeated bollworm infestations helped to make that change final, as more and more of the hardscrabble farmers and the small family ranchers had to bow to the dual defeat of no rain and no crops. They left the land that had been in their families for generations to support their own families by taking city jobs. When the women left the farms, they left their quilting behind with the other trappings of a more innocent age. This was the era of the "Red scare," the cold-war communist witch hunt led by Senator McCarthy in Washington, and Texas was caught up in the same fear, disguised as patriotism, that swept the country and ruined many in-

nocent people's lives. In Texas, all communists were required to register with the Texas State Police, and the death penalty was authorized for sabotage. Schoolchildren were taught how to protect themselves against atomic attack, Civil Defense shelters were created and stocked, and building a bomb shelter in the backyard was considered a good idea if you could afford it.

Not only did the Texas woman of the 1950s have to deal with integration and race relations, war, the heartbreaking move off the land to the cities, and the pressures of the cold war, but now a new and insidious influence was brought into her home: the television set. No longer could she isolate herself in Texas; the world was being forced on her in her own living room, and television quickly became a major influence on her children, an influence that she sometimes felt powerless to counter. Politics was brought into the home with televised school-board meetings and political-party conventions; television ads blared forth the qualifications of every office-seeker. After living in a "yellow dog democrat" state for generations, the Texas woman now actually had to evaluate her political beliefs, and in the 1950s, for only the second time in the state's history, Texas voted in a Republican president. In the 1950s, women occupied less than 5 percent of public offices, even local offices, and during this decade, both political parties abolished their women's divisions, thus effectively disassociating women from politics less than half a century after they were first given the right to vote.

June Cleaver of "Leave It to Beaver" and Harriet Nelson of "Ozzie and Harriet" may have been the ideal mothers of the decade, doing their housework in high heels and pearls, but other women of the 1950s spent their time organizing schools, libraries, churches, and park systems, making their communities better places to raise families. Yet once those new entities were established, only rarely was a woman placed in control. The basic problem—how could housework be classified as real work when it could not be measured in dollar bills?—was blown out of proportion to eliminate women without work experience outside the home from consideration for any official position, under the theory that a housewife could not know anything about complicated concepts like budgets.

The 1960s were a turbulent time for Texas women and for women everywhere—a time of political unrest, of social upheaval, of worldwide

confrontation, of breakdowns in traditional family structure, of drastic change on almost every front. Change was in the wind, and many Texas women, especially the younger generations, had had enough of the "protection" of being relegated to hearth and home. For the first time, young women graduating from college expected to go to work as a matter of course rather than marrying right out of school and staying home to raise families. For the first time, too, birth control and family planning became simple with the advent of the "Pill," while at the same time, divorce became a socially acceptable alternative to staying in a bad marriage "for the children." The Texas woman faced a multitude of challenges—mothers' issues, women's strikes for peace, the Equal Pay Act of 1963, the Civil Rights Act of 1964, the birth of the National Organization for Women and the women's liberation movement, assassinations, Vietnam and the antiwar movement, hippies and the newly threatening drug culture, the Berlin Wall. The calm prosperity of the 1950s must have seemed like paradise as the 1960s woman tried to balance on the shifting sands of the next decade.

Quilting was quiescent in Texas, as in the rest of America, during the early 1960s. Still largely a rural art, quilting had not yet made the transition from country to city, young women were now going off to college rather than learning to make quilts for their hopechests, and even some of the old-time quilters were lured by the false promises of the first polyester knits. As they had for generations, quilters worked with the scraps of clothing made at home, but with the advent of polyester knits, these scraps were no longer the tried-and-true cotton prints that could last for a hundred years. Instead, they were heavily textured man-made fibers that picked, pulled, ran, and generally proved themselves to be unsatisfactory as quilting fabrics. This is the time period that most people refer to when they insist that "quilting almost died out." Quilting was indeed at an all-time low point, but it never died out in Texas. According to Penny McMorris and Michael Kile, authors of *The Art Quilt*: "The crafts revival of the 1960s, which had begun as a reaction against standardization and the dehumanizing factors of technology, gained popularity as the decade of unrest wore on. 'Moving to the country' came to stand for making a new start in life, leaving behind a complicated, overheated civilization that nurtured pollution, crime and civil unrest . . . skirts and

hair grew longer, young women and men resembling their great-grandparents more than their own mothers and fathers. The Age of Aquarius was born" (p. 40). By the end of the decade, Bonnie Leman had started *Quilter's Newsletter* on her kitchen table, and with the creation of that bible of quiltmaking, a network was established that linked quilters throughout the nation, with many of the original five thousand subscribers in Texas. Quilt cooperatives were started in other parts of the United States, primarily in Appalachia, to provide additional income for the women in those poverty-stricken areas. Kile and McMorris pointed out that, "as the sixties drew to a close, one craft emerged as the overwhelming favorite: quiltmaking. Millions of people have been touched by the quilting revival" (p. 43).

And by the mid-1970s, with the celebration of the American Bicentennial looming just ahead and the pressures of the previous decade's crafts revival still encouraging a return to handwork, more and more women turned to the old, traditional arts such as quilting to form a tangible link to past generations. "It was during the 1970s that the women's movement, in discovering and publicizing the previously ignored achievements of women throughout history, recognized the quilt's importance as an art form," Yabsley recounts on page 40 of *Texas Quilts, Texas Women*. "The back-to-the-land movement, prompted by the antimaterialism of the late 1960s, generated a desire among the young people to learn hand skills that had been neglected in the postwar rush toward an automated society. Enthusiasm for old crafts and art forms made the quilt a fashionable collector's item and sparked a renewed interest in its manufacture . . . as women began to examine their artistic legacy, the quilt emerged as a powerful link between early and contemporary artists." Carter Houck, editor of *Lady's Circle Patchwork Quilts,* presented another perspective on the re-emergence of quilting in the 1970s in her book, *All Flags Flying*: "Perhaps it was a desire to do something more artistic with needle and thread that brought about a new interest in quilts as a way of celebrating the Bicentennial, or perhaps it was nostalgia for the time of the Centennial, years that certainly seemed simpler to the women of 1976" (p. 8).

And perhaps it was a reaction to change and to choice, for the woman of the 1970s had to face more of both than her foremothers had ever

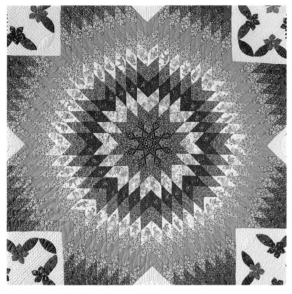

Detail from My Two Loves Quilt, *page 156*

dreamed. In 1972, Congress approved the Equal Rights Amendment, and by the end of the year, twenty-two of the needed thirty-five states had ratified it, including Texas, which also passed an ERA amendment to the state constitution that resulted in a complete rewriting of the state's laws to eliminate all sexist language and discrimination based on sex. "'Woman's lib' was on everyone's lips . . . People were fascinated, intrigued, and often angered by the flamboyant tactics of feminist radicals," Evans writes in *Born for Liberty* (p. 287). But those tactics were having effect: in 1972, the Equal Opportunity Act broadened the jurisdiction of the Equal Employment Opportunity Commission and strengthened its enforcement capability; in 1971, the National Women's Political Caucus (NWPC) was formed; in 1974, the Equal Credit Opportunity Act was passed that made it possible for women to obtain credit in their own name. Houston was the site of the first NWPC convention, and women from across the country were startled to find that the headquarters hotel for the convention refused to page women in the lobby and restaurants on the grounds that only prostitutes would want to be paged in a hotel. The women also had to face a ridiculous but troubling problem with hotel accommodations when a previous convention of men refused to give up its sleeping rooms and check out on time, believing that if the women could not get a place to stay,

they would go home and things would rock on as before. Instead, the women camped out in the lobby of the hotel and redoubled their determination to change the status quo. The result of the first women's political convention since Seneca Falls in the nineteenth century was that throughout the United States more and more women became involved in the political process, not only as envelope stuffers and telephone-bank operators but also as candidates and elected public officials. In 1972, when Frances "Sissy" Farenthold took on the establishment, Texas saw its first serious female contender for governor since "Ma" Ferguson held office in the 1930s. By 1974, women were running against one another in legislative races, and one candidate even financed a large part of her five-figure campaign by selling quilts and antiques in friends' homes.

The 1970s saw the emergence of more women-owned businesses now that women could get credit in their own name, and throughout Texas and the United States, quilt specialty stores began to open their doors to serve the growing numbers of American quilters. Quilts and quilting came out of the closet, and fewer quilters had to work in isolation with the development of national and regional quilting conferences. In 1971, the prestigious Whitney Museum of American Art in New York mounted an exhibition, Abstract Design in American Quilts, that changed the nation's viewpoint on these textile treasures. In 1979, Quilt National was created in Ohio as a showcase for art quilts, original designs rather than traditional. *Good Housekeeping,* to celebrate the Bicentennial, sponsored a national quilt contest that drew nearly ten thousand entrants and focused entirely on creative quiltmaking by disallowing kit quilts. National magazines carried glowing articles about the use of quilts in decorating, and as McMorris and Kile pointed out in *The Art Quilt,* "Like a self-fulfilling prophecy, the quilt revival forged ahead, powered now by its own momentum" (p. 50). Around this same time, two of Texas' best-known collectors—Ima Hogg and Faith Bybee—started collecting quilts to complement their superb collections of American furniture, now the prize possessions of museums in Houston and Dallas. Miss Hogg's quilts were used primarily in the Winedale Historical Center, a part of the University of Texas, while Mrs. Bybee's quilts were stored and displayed in the restored collection of early Texas buildings she

moved to Henkel Square in Round Top. One of the most significant quilts created for America's 200th birthday was made in Houston by Grace Simpson—the Bicentennial Quilt, later featured on the cover of *Quilter's Newsletter Magazine* and in the book written by Mrs. Simpson, *Quilts Beautiful: Their Stories and How to Make Them.* This spectacular quilt traces American history from the landing of the Mayflower to the landing of a man on the moon, all depicted in elaborate, detailed appliqué blocks. (Another quilt by Grace Simpson Caudill is shown on page 112.)

The new quilters of the 1970s were often the daughters of the women who married in the late 1940s and 1950s, the lost generation of quilters, those who married into a consumer's paradise where everything had to be new and store-bought, not made with loving hands at home. Those women themselves, as their first grandchildren were born, marched into the stores to learn what they had spurned a quarter century earlier. Their own grandmothers still quilted, just as they always had, but now sometimes they were bewildered by the attention their quilts created as the art world began to discover folk artists and quilts as art. The book world was also beginning to recognize the value of publications documenting quilts, and in 1977, *The Quilters: Women and Domestic Art* was a selection of the Notable Books Council.

For Texans, the 1980s were highlighted by the celebration of 150 years of independence, the Sesquicentennial of the Texas Revolution, and the oil bust that stopped the boom of the 1970s cold. As T. R. Fehrenbach explains in his introduction to *Seven Keys to Texas*: "The oil bust of 1981–82, followed by the severe local downturn of 1982–83, the slowing of the real estate boom and flattening of immigration, only repeat old Texas cycles on a grander scale." Just as the state pulled itself out of the mire of the Great Depression to celebrate the Centennial in 1936, so Texans had to climb out of the trough of the oil crunch to celebrate in 1986. The state's economic doldrums lasted almost as long as the 1930s Depression, with much the same effect on quilting. Women turned to quilting in the 1980s as a relatively inexpensive source of creative expression, a way to make valued gifts that could be produced by one's own labor rather than purchased, a means of decorating their homes that would fit within a sharply reduced budget, a type of enter-

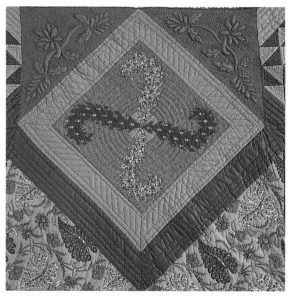

Detail from An American Sampler Quilt, *page 150*

tainment that could be enjoyed while surrounded by family activities, even a way of reducing tension from high-pressure jobs. Carter Houck in *All Flags Flying* points out: "There are even those who believe that the quilt revival of the 1970s and 1980s is closely linked with the women's movement. Certainly, when politically conscious women use needle and thread to express their sentiments about government and leaders and war and peace, they are taking a stand on subjects of world importance in a time-honored feminine way. Perhaps the quilters have finally made their mark as artists in this last decade—at least more men have joined their ranks as admirers, collectors, dealers, and even quilters." Among the most important museum exhibits of the decade were 1981's American Quilts: A Handmade Legacy at the Oakland Museum in California; Homage to Amanda, The Art Quilt, Kentucky Quilts, and The Artist and the Quilt, four of the 1980s traveling museum exhibitions; and Lone Stars: A Legacy of Texas Quilts, 1836–1936, which opened in 1986 in the rotunda of the Texas Capitol and traveled through Texas art and history museums for the next two years. The Kentucky and the Texas exhibits were two of the first of the decade's statewide quilt searches, which have resulted in documenting many states' quilts and quiltmakers, in books, and in other exhibitions across the United States. In 1981, a color film entitled

Quilts in Women's Lives was the highest-ranked entry at the American Film Festival. In 1982, the Sam Houston Memorial Museum in Huntsville featured an exhibit, Patterns in Patchwork, that included work by Martha Mitchell, a well-known folk artist from the East Texas region. Speaking to the Texas Folklore Society in College Station in 1983, Ms. Mitchell commented, "My brother once told me a person had to be crazy to take large pieces of cloth, cut them up into small pieces, and sew them back together to form an area that is no larger than the cloth was to start with, but the finished work of art is worth all the effort that is put into it."

Why, then, do women continue to make quilts when machine-made bedding is so inexpensive and so readily available? Their reasons are as varied as the women themselves. Some, like Laura Powell of Uvalde, continue the age-old tradition of making quilts as gifts for loved ones and for special occasions, like the Hawaiian Fruit Tree quilt she made as a wedding present for her granddaughter. The bride spotted a design she liked in a magazine; the picture was no bigger than a postage stamp. From that tiny start, the grandmother cut her own patterns and created the quilt of her granddaughter's dreams, a quilt that will be cherished for generations to come. As Woodard and Greenstein note in *Twentieth Century Quilts*: "A quilt was something in which a woman gave of herself—to mark marriages, graduations, and generations as it was handed down from children to grandchildren. In addition, it served as a reminder of her thoughts . . . It was a fabric diary" (p. 8).

Some quiltmakers create their work with the vision of textile artists, painting with their needle and thread just as surely as other artists paint with brush on canvas. However, the majority of the quilters in Texas today would probably stop short of describing themselves as artists, even though they quilt as an outlet for their creative spirit, a means of expressing themselves and their values. These people prefer to work with the traditional patterns of the past, adapting them as they choose, selecting contemporary colors and unusual stitching, but not creating a vision from whole cloth. A hardy contingent of Texans, mostly senior citizens today, quilt because they have always quilted and see no reason to stop; still others take in quilting as a source of dependable, though minimal, supplemental income. Some people quilt in a con-

scious effort to keep the past alive, to maintain the links with generations long gone. As Melvin Mason explains in "Quiltmaking: A Creative Tradition," a chapter in *Folk Art in Texas*: "For many, the making of new [quilts] is a means of strengthening connections with the past, with family and cultural heritage. And there are those who are simply continuing what they have done for years, stitching their time, their skill, their patience and love, into something of themselves they can pass along to others" (p. 137). Others make but one quilt in a lifetime, a special design for a special purpose, even if it is only to prove that, like her ancestors, she can call on the appropriate skills. According to Woodard and Greenstein in *Twentieth Century Quilts*: "People seemed to believe that quiltmaking would at last be buried with many of the great folk arts of the nineteenth century. When they consider the quilting scene today, they are astonished by its broad popularity and consider it to be still another revival. It seems far more accurate, however, to think of quilt history as being one continuous unbroken thread, with interest surging in certain decades only to diminish in others . . . [Women] will keep on quilting because the basic needs that quilting satisfies are a rare mix of the artistic, the spiritual, and the practical" (pp. 35–36).

Society has changed to a drastic extent and life is no longer what it was fifty years ago. Today, more women work outside the home than stay at home; although unsuccessful, a woman was the official nominee of a major political party for vice-president of the United States. Instead of worries over rickets and pellagra, today's Texas women watch the spread of AIDS with concern and fear; instead of the Women's Christian Temperance Union (WCTU), women today mastermind Mothers Against Drunk Driving (MADD) and wars against drugs; instead of having the large families needed to work the farms and ranches of a half century ago, today's women limit their families to one or two children; instead of needing to marry a man who would provide her with a life, the 1980s woman is creating her own life—and she is still creating her quilts.

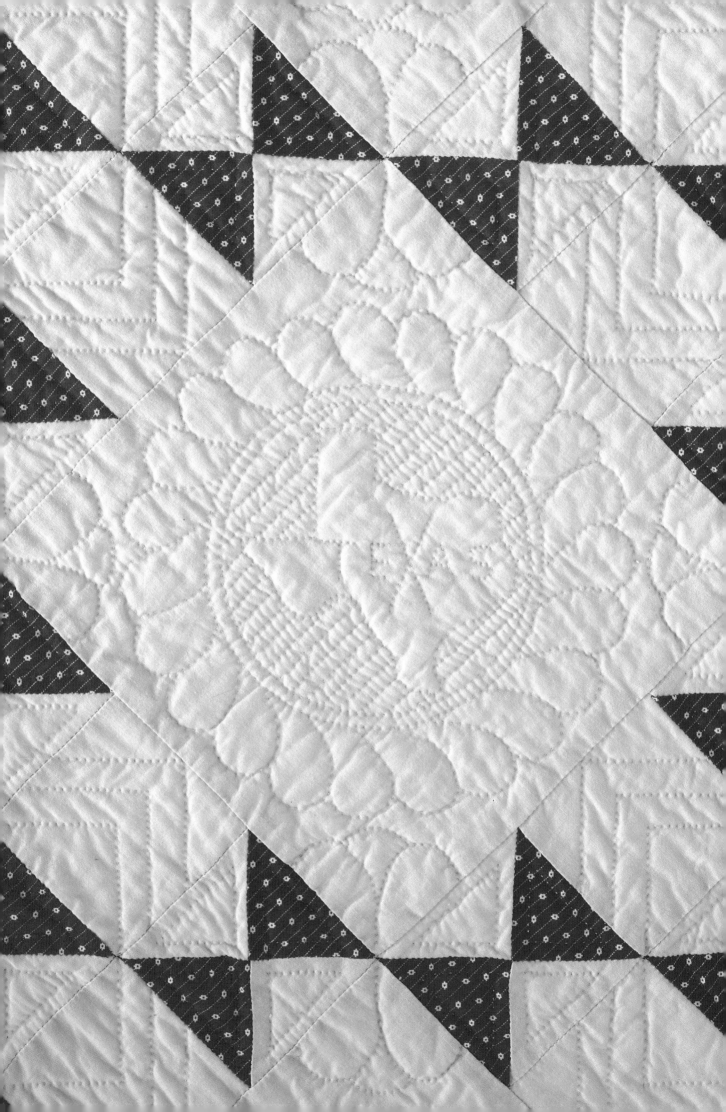

A NEW PERCEPTION
OF QUILTS

QUILTS have long been perceived as utilitarian objects. Only within memory have they slowly come to be recognized as having both artistic merit and cultural and historical worth.

To the everlasting surprise of many old-time quiltmakers, quilts recently have been accorded the status of an art form—just as Navajo weavings and basketry, jazz, modern dance, African tribal art, and many folk arts have been—and have reached that status through the same slow, evolutionary pattern of acceptance. At first quilting was something done by individuals outside the mainstream of art, then it was discovered and extolled by a very few truly enlightened individuals who were able to see it without the blinders of artistic preconceptions, then it was seized upon as avant-garde, and only since then has it begun slowly drifting toward the mainstream.

The terms "folk" or "decorative" art have until recently been appended to any discussion of quilts as art. Beatrix R. Rumford describes the folk art tradition in *The Abby Aldrich Rockefeller Folk Art Collection*:

In the United States folk art has become a widely accepted term for describing various creative efforts of amateurs and craftsmen working outside the mainstream of formal art. The typical folk artist has little understanding of the rules for rendering correct linear perspective, anatomy, color balance, or the proper use of light and shadow. Unfamiliar with the academic solutions for such problems, a successful folk artist somehow solves the technical difficulties he encounters in his work and intuitively produces a satisfying picture, carving, or household furnishing. (P. 11)

Perhaps the most famous of American folk artists was Anna Mary Robertson Moses, who originally began her artistic endeavors as a decorative painter, embellishing household furnishings such as tables, and then moved on to become a fiber and needle artist in the 1930s when she made "yarn pictures." Only later was she encouraged to try paints and canvas. In *Grandma Moses,* Otto Kallir says that "in contrast to Europe, no art schools had existed in America until well into the nineteenth century. People who painted had to find their own technical and artistic means of expression."

In other words, American folk artists were disconnected from the accepted body of art and outside the mainstream of art history. Because they did not know of the existence of rules, they frequently made up their own to solve the design problems they encountered. Discussing a landmark exhibition of American folk art paintings that traveled to Europe in 1954 under the auspices of the Smithsonian Institution as American Painting: Peintres Naifs from 1700 to the Present, Kallir points out that "each of these untaught artists had found his individual way of expressing ideas of his time and experiences of his daily life" (pp. 116–117).

Early quilt artists, and some working today, broke rules they never knew existed, just as Grandma Moses did. Their innovative, sometimes radical, often powerful designs were not conceived to make a statement or to flout tradition. Instead, they were worked out to solve a particular design problem or to achieve an especially desired effect. Like Grandma Moses, too, quilters expressed themselves in their work; they did not talk about art, they made it. With no access to a body of art history or a philosophical underpinning to their work, they simply produced the designs they saw about them in nature or imagined in dreams or recalled from memory. With no knowledge of the avant-garde, they have been seen to have been in the vanguard of many of the movements in modern art—"such phenomena as 'op' effects, serial images, use of 'color fields,' a deep understanding of negative space, mannerism of formal abstractions and the like," according to Jonathan Holstein in *The Pieced Quilt* (p. 13).

Cecilia Steinfeldt in *Texas Folk Art* notes that, "although naive artists and craftsmen have always existed, their work was largely ignored until the beginning of the twentieth century. Actually, it was the artists who espoused the new vernacular of 'modern' art who were among the first to recognize the merit in the work of the naive, or untrained, artist who had been expressing himself freely for centuries" (pp. 158–159).

Those old-time quiltmakers "in most cases . . . would not have dreamed of presenting themselves as 'artists,' or their . . . needlework as 'art,'" as Mirra Bank put it in *Anonymous Was a Woman* (p. 9). They would have been surprised to hear that quilts are art, whether folk, decorative, or otherwise. Such surprise perhaps should be attributed to semantics, however. For while art was a term seldom if ever used by these women to describe their work, rigorous and virtually universal standards were applied in evaluating a quilt, fine quilts were highly valued and carefully treated by women, women often signed and dated their

quilts, and, from the time of Maria Betancour through Martha Washington and on, quilts were frequently enumerated as special bequests in women's wills. Women quilted because they were taught to quilt and because quilts were needed, but beyond that they found time to quilt for their own pleasure and that of others and for an expression of artistic sensibility that they would have been hard-pressed to articulate but that was no less valid for being undefined.

Says Lilian Baker Carlisle in *Pieced Work & Appliqué Quilts at Shelburne Museum*:

Women of every earthly rank and nationality, however gifted with intellect and genius or endowed with beauty, have in common the peculiarity of needlework. From time immemorial they have always had . . . handiwork ready to fill up the gap of every vacant moment . . . The slender threads of wool, silk and cotton keep all women united with the small and familiar interests of life and the shared human sympathy which runs along this thin line also keeps all women in a kind of communion with their kindred beings. Much of the needlework done by the women of the past century and a half was of necessity the 'meat and potatoes' kind of handiwork—the spinning and the weaving, the sewing of clothes for every member of the family. But after the necessities had been coped with, then a housewife was free to create an object of great beauty in her eyes—and many of them turned to quiltmaking to fulfill this ambition. (P. iii)

So both the needle art tradition and the folk art tradition were reservoirs from which quilters could draw. And sometimes an exquisitely crafted quilt by an experienced needlewoman or a quilt created with a unique folk sensibility emerged that was undeniably something other than utilitarian: it was art, with no qualifiers.

For a brief but enlightened and impassioned discussion of the ways in which women artists, especially quilt artists, have been dismissed and excluded from their rightful place in art history, even that concerned with decorative and folk art, until very recently, we highly recommend Patricia Mainardi's *Quilts: The Great American Art*, first written as an essay for *The Feminist Art Journal* in 1972.

Women have always made art. But for most women, the arts highest valued by male society have been closed to them for just that reason. They have put their creativity instead into the needlework arts, which exist in fantastic variety wherever there are women, and which in fact are a universal female art, transcending race, class and national borders. Needlework is the one art in which women controlled the education of their daughters, the production of the art, and were also the audience and critics, and it is so important to women's culture that a study of the various textile and needlework arts should occupy the same position in Women's Studies that African art occupies in Black Studies—it is our cultural heritage. (Pp. 1–2)

The experience of quilting provides women today with a means of connection with the only needle art that has been, albeit slowly, universally recognized as a unique and valid means of transmitting artistic truisms.

But along with the movement to view quilts as art is another equally important one: to view quilts as a sociological, cultural, and historical record. Two important museum exhibitions, one, Optical Quilts, in 1965 in the Newark Museum and another, Abstract Design in American Quilts, in 1971 in the Whitney Museum, laid the groundwork for the perception of quilts as art. An event, the American Bicentennial in 1976, and another exhibition, American Quilts: A Handmade Legacy, in 1981 at the Oakland Museum, were the cornerstones for the identification of quilts as cultural and historical artifacts.

Thomas Frye, chief curator of history at the Oakland Museum, notes that at the Whitney exhibition, where quilts were displayed as paintings, "we saw quilts as art, as aesthetic expressions, separated from their specific social and cultural context. Most subsequent exhibitions have examined quilts from this perspective. As visually stimulating as these exhibitions have been, they have left sizeable gaps in our knowledge."

The Oakland exhibition sought to show quilts as they might have been used in everyday life, in relation to other aspects of a woman's existence and interests. In differentiating the exhibition from others, he said: "For too long quilting has been neglected as a serious part of the study of women's history. While quiltmaking was traditionally utilitarian and focused on family and community, it has been developed by women into a recognized art form exploiting pattern, texture and color in ever-varying forms. But quilts have a significance beyond the aesthetic which this exhibition, the catalogue, and accompanying film, 'Quilts in Women's Lives,' seek to explore. By examining the role of quilts in women's lives, patterns of our culture come to light in ways unseen by most academic historians."

Many quiltmakers have stated that they first perceived quilts as something other than bed-coverings when they attended quilt shows and saw quilts hung vertically. All their work on quilts and all their experience in appreciating quilts had been in looking down on them, at an angle, with portions of the overall design distorted or hidden by being rolled on quilting frames, clasped in an embroidery hoop, tucked around pillows, or draped down the sides of a bed.

When they saw quilts displayed vertically and fully extended at quilt shows and, within the last twenty-five years, in museums, their perceptions and those of the general public began to change. They began, both literally and figuratively, to look up to quilts. This progression of quilts from the bed to the wall has been both a cause and an effect of the great change in perception of quilts as artistic achievements and cultural and historical markers.

For some contemporary quiltmakers, there is little or no intention of ever making a quilt that will cover a bed. All their quilts are "wall quilts," generally a smaller size than bed quilts, and are designed and made to be displayed on a wall, as art. Other quilters working today have gone one step further, taking quilts from the bed to the wall to the back, as they have applied their medium to embellish garments that make a statement not only about the quilt as art but also about its relation to the lives and activities of the women for whom the wearable art is designed.

John Perrault, in his introduction to McMorris and Kile's *The Art Quilt,* has theorized that photography has also served to change the perception of quilts and to validate the concept of quilts as art. In that we concur wholeheartedly. We have been startled occasionally at the crystallization of a quilt's design components that takes place when a fine photograph of it is viewed. While the dimension and tactility of a quilt can only be suggested by even the best photograph, a compensating distillation and distancing is achieved that makes it easier to evaluate a quilt's visual appeal quite apart from its physical or emotional appeal.

It is through the third eye of the camera, whether still or moving, that the beauty and graphic impact of quilts will truly achieve a mass audience, for even the largest quilt show or museum exhibition can reach only thousands, while quilt books, videos, and television programs can theoretically touch millions. And it is the combination of photography and narrative that will acquaint or remind those millions of the unique place that quilts have occupied in the minds and hearts of women and in the heritage of our country and our state.

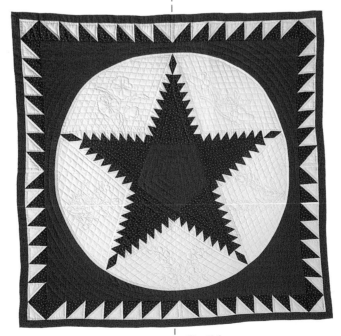

Detail from
Founders' Star Quilt, *page 172*

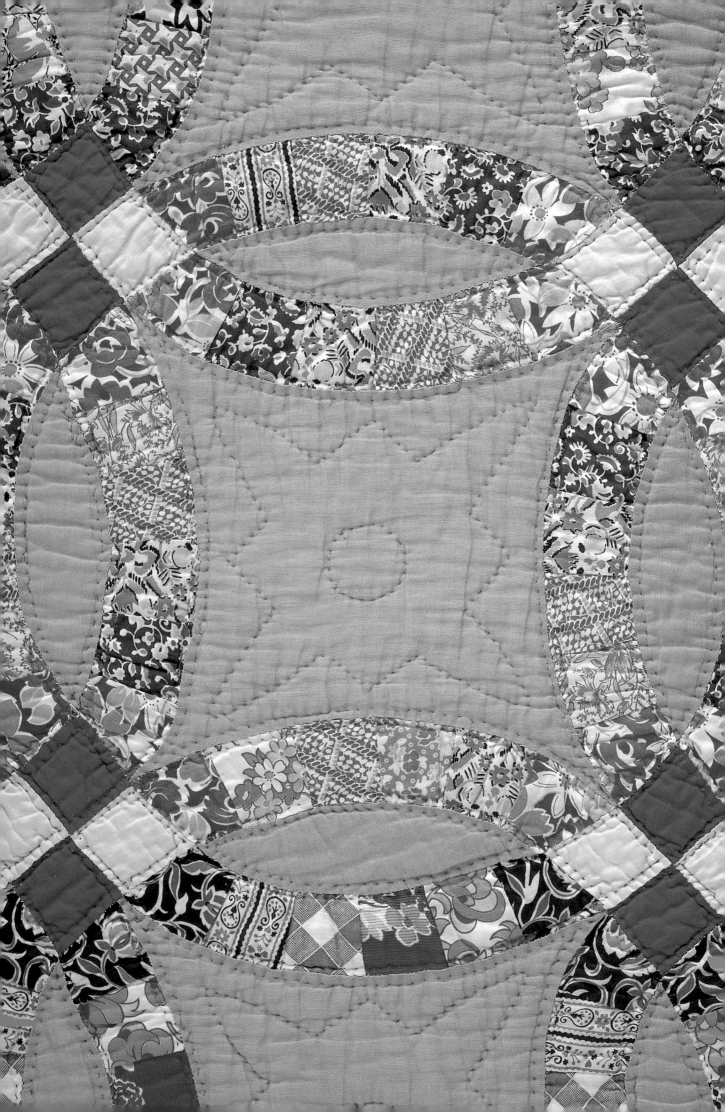

LONE STARS
VOLUME II

A Legacy of Texas Quilts,
1936–1986

Opposite: detail from
Double Wedding Ring Quilt, page 76

SPRING BOUQUET
QUILT

76″ × 88″
Cotton

1936

Appliquéd by Bessie Evans Carruthers in Crystal
City, Zavala County
Quilted by Mrs. J. E. Peal in Crystal City
Owned by Emalee Carruthers

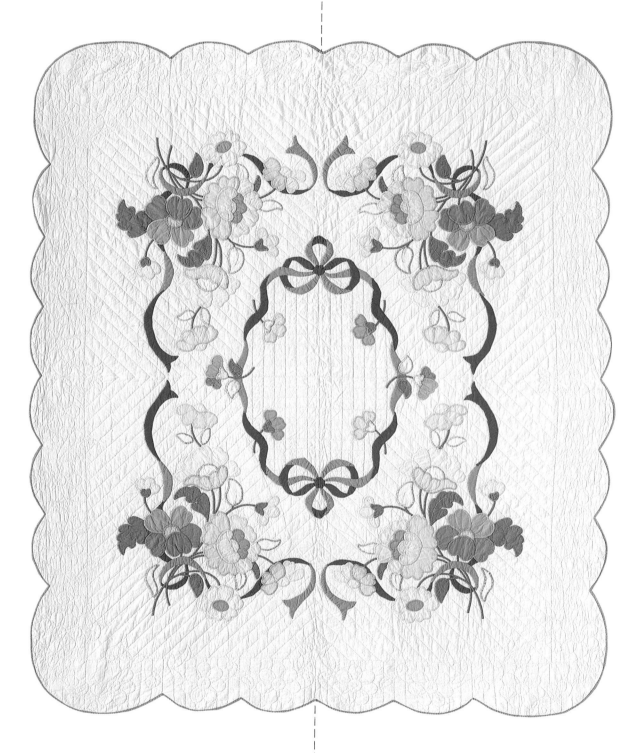

THE DEPRESSION ERA is best remembered as hard times, as any survivor will recount. Little money existed for anything but the barest necessities; beauty and frivolity and the comforts of life became only fond memories for many Texans. During the Texas Quilt Search for the Sesquicentennial, at the Quilt Day in Lufkin, one older gentleman explained succinctly why, then, so many beautiful quilts emerged out of the 1930s: "Lady, we didn't have no money. Nobody had no money. All we had was time. People made them quilts because there wasn't nothing else to do!" Whole families became involved in the making of quilts—the children were taught to card cotton and make the quilt batts, the husbands helped with the cutting and sometimes even the stitching, and the wives worked on the quilts themselves, often with the help of a mother or mother-in-law who lived with them. Making quilts was a family endeavor and a way to keep the family together and productive.

By 1936, Texas was starting to emerge from the Depression; the Centennial brought new excitement to the state, and the economy had begun its slow recovery. There was a little more money to be had—though only a little—and a little more time, which allowed the women to turn their energies and abilities to producing the exquisite floral appliqué quilts of this prewar period. Those quilts, a special genre all their own, are elegant testimonials to the fact that the women never stopped hungering for beauty even while their flying fingers were stitching together cut-off trouser legs to make "suggans" to ward off the cold.

Suggans were heavy utility quilts usually made of pieces of worn-out wool suits and pants, often backed with flannel and tied with red yarn, frequently filled with layers of worn out blankets, sometimes even filled with layers of burlap feed sacks—they were not pretty but they were warm and almost indestructible.

Much more attention to workmanship was required for the beautiful appliqué quilts. The appliqués demanded fine stitching and, most importantly, planned colors and fabrics to be their best. They were never seen as scrap quilts or ways to use up sewing scraps. They required purchased fabrics, and sometimes the quiltmaker, uncertain about her own ability to select or locate the carefully blended colors needed for these quilts, would resort to a purchased kit. The quilter had to have access to a large expanse of white or cream fabric for the background of the quilt onto which the floral design was applied. All of these requirements meant that few of these quilts were produced during the depths of the Depression but more began to be seen as times became a little easier.

This splendid example features all of the elements so popular in the prewar period: bows, ribbons, bouquets, graceful flowers, and elaborate quilting. Whether the quilt was a kit or a purchased pattern is not known by the family; however, the quilting design was stamped onto the background because faint marks still remain even after forty years of washing. The delicate pastel colors of the flowers with their carefully shaded petals, entwined with the blue ribbons, form a complex curvilinear frame for the simple central oval medallion. All of the appliqué is executed in a tiny buttonhole stitch rather than using blind-stitch appliqué.

Quilting designs decorate the surface of the quilt, flattening the background slightly to emphasize the appliquéd flowers. The border is quilted in a floral pattern, and rays of straight-line quilting are also used to tie the floral designs together. Each piece of the appliqué designs has been quilted around the edge on one side. The quilting stitches measure seven to nine per inch. A separate bias binding in a contrasting color has been used to enclose the raw scalloped edges of the quilt; the binding shows some wear.

"This quilt was in my husband's 'trousseau' when we married in 1942," recalled the daughter-in-law of the quiltmaker. "At that time, there were few pretty things to be had, so it brought joy and color to our home, even though the first three years were spent with Uncle Sam." Mrs. Carruthers was born in 1886 in Marble Falls, Burnet County, and died in 1964; she married but was widowed while she still had young children at home. According to her daughter-in-law: "Bessie spent many hours doing handwork of all kinds. I'm sure it was her therapy as she was alone, raising two children, and there were no 'freebies' from Uncle Sam in those days." She learned to quilt early and made her first patchwork quilt as a child living near Mertzon, Texas. The daughter-in-law also commented that it was difficult to answer the questions about Mrs. Carruthers, because "Bessie has been dead for twenty-five years, and sons do not pay much attention to such things."

Bessie Evans Carruthers

TEXAS UNDER SIX FLAGS QUILT

72″ × 84″
Silk

1936

Made by Leila Wilkins Cheney in Hallettsville,
Lavaca County
Owned by Raymond and Sharon Cheney

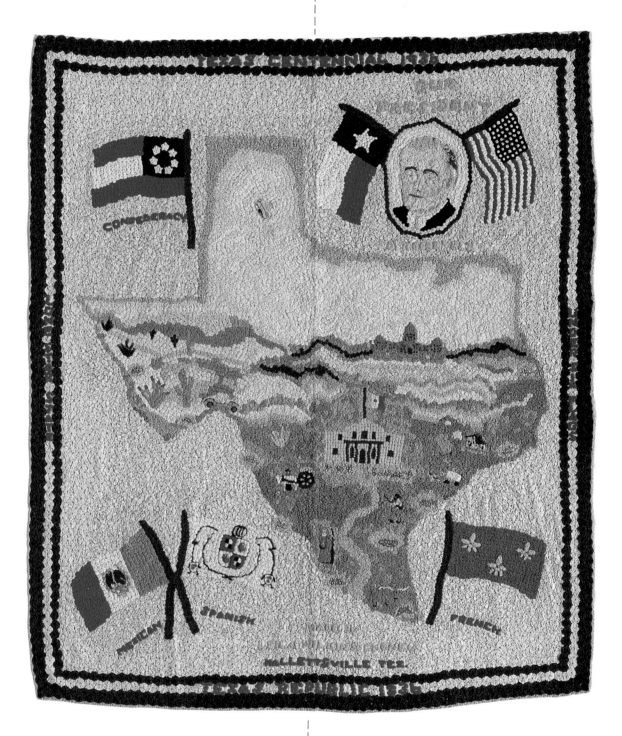

MORE THAN ten thousand yo-yos have been used in the creation of this unusual pictorial quilt, which was made to commemorate the Centennial of the Republic of Texas in 1936. First described in Suzanne Yabsley's book, *Texas Quilts, Texas Women,* Texas under Six Flags has since been featured in a special quilt exhibit at the Goethe Institute in Houston that focused on cultural influences of ethnic groups on Texas quiltmakers.

The quilt represents an astonishing feat of both patience and vision. "It is made entirely of yo-yos, small circles of fabric gathered around the edges to form puffed rounds," according to Yabsley. The yo-yos, which vary from the size of a quarter to smaller than a dime, are so closely compacted to form the quilt that the surface has a ruffled or rippled appearance.

The six flags that have flown over Texas—representing Spain, France, Mexico, the Republic of Texas, the United States, and the Confederate States of America—are depicted on this quilt, along with a splendidly conceived and executed topographical map of Texas, showing the deserts and mountains of the West, the fertile greenbelt that parallels the Gulf Coast, and the rolling hills of Central Texas. Placed near their actual geographic location are the Alamo, known as the Shrine of Texas Liberty, and the Texas Capitol. Charming figures of people and animals, a detailed homestead, a covered wagon, realistic cactus, an airplane flying overhead, and a classic roadster all combine to make this a quilt that must be studied to be appreciated. In the upper right quadrant of the quilt is a portrait of the United States president at the time, Franklin D. Roosevelt, flanked by the Texas and the United States flags. A pioneer woman, with her musket in hand and her powder horn slung over her long dress, stands on the alert, ready to defend her family and her home from marauders; it is a mark of the quiltmaker's artistry that she was able to convey such detail while working only with tiny yo-yos. She has proudly signed her work at the center bottom of the quilt.

Born in 1891 in Paris, Texas, Leila Wilkins Cheney married and had one son, the present owner of the quilt who shares ownership with his wife. According to her son, the movie *True Grit* could have been written about Mrs. Cheney, who died in 1971 in San Antonio. "She and her father owned a plantation in Mexico, almost in Central America. Together they fought off outlaws time and time again." Mrs. Cheney told her son that one time the situation in Mexico got so bad that the American ambassador had to call in a gunboat to evacuate him to the first U.S. port of call—despite the danger, the father and daughter stayed behind to defend their property.

"She was a wonderful person and very talented. She loved Texas history and knew more about it than I knew, even though I taught Texas history in high school for a time," recalled the quiltmaker's son. "She made this quilt by kerosene lamplight. She wanted to make something for me to have and to keep, something she had made with her own hands. Proud of her? You bet I am."

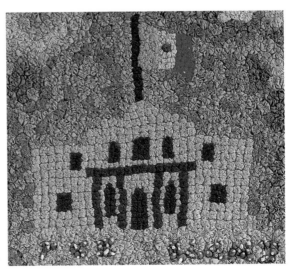

POMEGRANATE QUILT

79" × 79"
Cotton

ca. 1937

Pieced, appliquéd, and quilted by
Mary Louise Hammonds Bollman in Lockney,
Floyd County
Owned by the quiltmaker

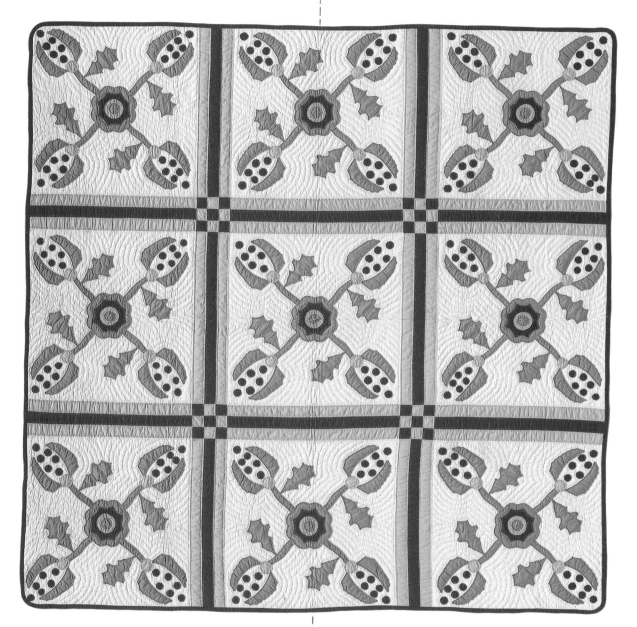

Mary Louise Hammonds Bollman

WHEN CHANCE brought the original of this splendid quilt, made generations earlier, to her home county, this quiltmaker seized the opportunity to create a duplicate of the quilt complete in every detail. The original quilt belonged to Sallie Jeffe Lokey who died childless after losing three children as infants. After her death, her widowed husband left Texas for a new life in Oregon. Two trunks containing his wife's beautiful handwork, this quilt, and her wedding dress, were left behind with his sister in Collin County, along with the instructions that they were to belong to her if something happened to him. When he died in Oregon in 1914, she fell heir to the trunks and their contents. The trunks were later brought to Floyd County, where the quilt was first seen by this quiltmaker. "When I saw this beautiful quilt, I decided to make one exactly like it, using the same colors as the original quilt. I treasure this quilt, and to this day, I've never seen another quilt of the same pattern," recalled the quiltmaker.

The quilt pattern is unusual and not easily identified. Some elements of the design resemble Cockscomb and Currants; others evoke the Pineapple variation quilts. However, the design most closely resembles the Pomegranate pattern, sometimes known as the Love Apple. There are two important differences to note. First is that here the quiltmaker has chosen to depict her pomegranate split in half, filled with the myriad of juicy seeds known to generations of Texas youngsters, instead of showing the fruit whole, with the seeds left to the imagination. Second is the fact that this design is entirely appliquéd, whereas the old Love Apple patterns were usually pieced. The quilt consists of nine twenty-four-inch blocks; in the quiltmaker's opinion, twelve blocks would have been more pleasing, but since she had set out to copy the original quilt exactly, she made no changes, even those that she felt would have improved the design.

Machine piecing is used to form the set of the quilt and to piece the small Nine Patch blocks used at the intersections of the sashing. The appliqué is all executed by hand. Special attention has been paid to attaining the perfect circles that represent the seeds of the pomegranate; these are not easy to accomplish and require skillful manipulation to turn under the edges so smoothly that the circles are perfectly round with no jagged edges.

This quilt derives much of its charm from its extensive quilting. Outline quilting, flowers, leaves, and circles are used to enhance the design of the blocks, and echo quilting has been used most effectively. Each piece is double-quilted, or quilted around both sides of the edge. The quilting stitches measure approximately seven to nine per inch. A separate bias binding has been used to finish the edge of the quilt; the narrow red binding forms a colorful frame for the riotous colors.

Mary Lou Bollman was born in 1909 eight miles south of Lockney, where she still lives. She married Henry Bollman and had four children. In 1934, she earned a bachelor's degree in home economics from Texas Woman's College (later Texas Wesleyan College), where quilting played a role in her college education. "In 1933, I was a member of Miss Anna Lois Burdette's design class, and part of the class requirement was designing your own quilt block," she remembered. This training supplemented her early introduction to patchwork when a neighbor taught her to piece by working on a Four Patch when she was only seven. In the 1930s, she made her first quilt, an eight-pointed star set together with blue fabric, and quilts and quilting have remained a lifelong interest. She has won recognition at local exhibits and quilt shows with her work and is an active member of three Texas quilt guilds: Lubbock, Lockney, and Plainview.

In 1985, when she was seventy-six, Mrs. Bollman thought nothing of driving across hundreds of miles of West Texas roads to attend a Quilt Day during the Texas Quilt Search; in one month, she attended three different Quilt Days, all widely separated geographically. A year later, during the Sesquicentennial celebrations, she followed the trail of one of the huge wagon trains assembled for this historic year. Between May 8 and July 4 she visited the wagon train more than fifteen times, sometimes sleeping in her car to get an early start on the next day. She was present to cheer on the weary riders when the wagon train came through downtown Fort Worth in the rain, heading to the Fort Worth Stockyards. Mrs. Bollman was named Lockney's Woman of the Year in 1986, and in 1989 she was named Floyd County Pioneer Woman at the annual Pioneer Reunion Day. Later that year the Floyd County Historical Museum created the Mary Lou Bollman History and Genealogy Center in honor of Mrs. Bollman, her knowledge of genealogy, and her dedicated efforts to locate and mark all unmarked graves in Lockney and the South Plains area.

PANSY QUILT

77″ × 87″
Cotton

ca. 1937

Appliquéd and quilted by Thelma Jetton Patterson in Hillsboro, Hill County
Owned by La Trelle Dunaway Sommers

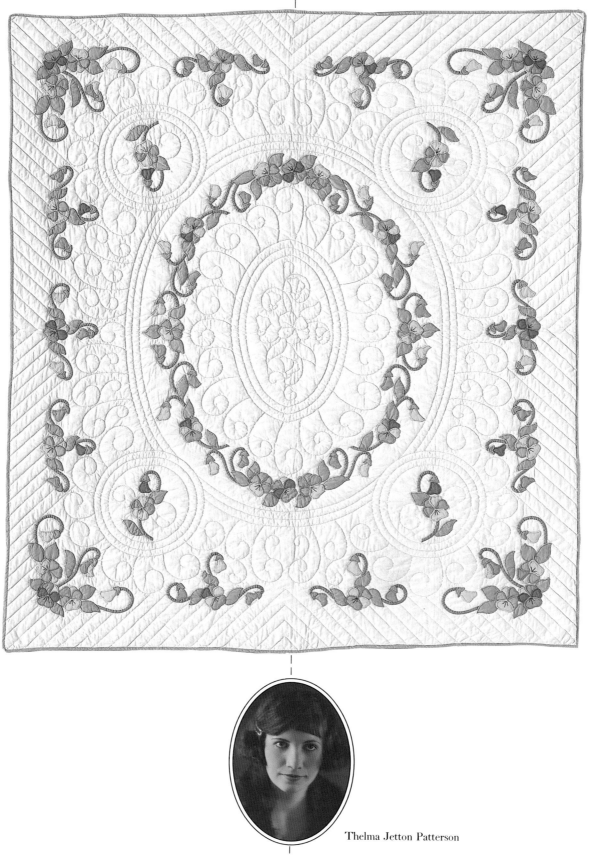

Thelma Jetton Patterson

PANSIES provide the one dependable spot of winter color in many Texas flower gardens—in some parts of the state, it is not unusual for them to bloom from November till May, when the heat finally wilts them permanently. Because of their endurance and cheerful faces, they have often been an inspiration for quiltmakers who love to depict floral designs; there are both pieced and appliquéd patterns for pansy quilts. In Judy Rehmel's book *Key to 1000 Appliqué Quilt Patterns* (now part of *The Quilt I.D. Book*), nine different pansy patterns are identified.

This particular Pansy quilt was one of the many beautiful quilts made from purchased kits. From the time kit quilts first became available, many women chose to use them in making their quilts. The popularity of kit quilts may have stemmed from the women's uncertainty about their own abilities to select suitable colors and fabrics, their preference for the convenience of precut pieces, or their hesitation to expend all that time and energy on the actual piecing, appliqué, or quilting without knowing for a fact that the finished outcome would be lovely. Kit quilts solved all those problems.

Discussing kit quilts, Tom Woodard and Blanche Greenstein in their book *Twentieth Century Quilts, 1900–1950,* stated: "The earliest ones [kit quilts] were not significant timesavers. Although they did spare the quilter the necessity of buying and choosing her fabric, their designs had to be stamped by hand, a process that involved perforating a paper pattern with a tracing wheel and rubbing stamping powder, which usually came in yellow or blue, through its holes. With the advent of iron-on transfers and pre-stamped fabrics, kits became more lucrative" (p. 21).

In evaluating quilts from this period, many people mistake those made from patterns for those made from kits. They base their assumption that the quilt was made from a kit on the blue dots that are frequently still visible on the line of quilting stitches, yet patterns from the twenties, thirties, and even forties often recommended that the quiltmaker stamp her own quilting designs, using the method described above, which produced the same effect as the premarked kit quilts. There were far more quilts made from patterns than were ever made from kits, even at the height of popularity for quilt kits.

The wreath of pansies seen in this quilt is beautifully executed, with careful, meticulous appliqué work and perfectly curved stems and tendrils, one of the marks of a master quiltmaker. A tiny buttonhole stitch has been used around the edge of each piece rather than the blind-stitch appliqué more often seen in such floral quilts. Five petals are used in each pansy, embellished with embroidery to form the faces of the flowers; the delicately furled buds that rise above the blossoms add a graceful note to the quilt.

Elaborate quilting has been used to set off the floral design. Not only is each piece quilted in outline on both sides of the piece, but also fancy scrolling designs have been used in the center of the wreath and surrounding the wreath. Simple straight-line quilting is used in the border. The quilting stitches, through cotton batting, measure seven to nine per inch. A separate bias binding in a contrasting color has been used to finish the edges of the quilt.

A lifelong Texan, Thelma Jetton Patterson was born in 1905 in Mertens, Texas. She attended Baylor Belton College and taught at a business college in Dallas before she married R. D. Patterson. As manager of a grocery store, her husband worked very long hours; "she made this quilt while he was working," recalled the niece who now owns the quilt. "It was an enjoyable way to pass the time."

Mrs. Patterson learned how to quilt from her mother and made her first quilt, a Rose appliqué, in 1935, when she was thirty years old. "She enjoyed the creative rewards of quilting and the sense of heritage that came with it," according to the niece. The quiltmaker never entered her work in any competition; however, after she gave the Pansy quilt to her niece, the niece entered it in a quilt show in Dallas where it won second place for antique quilts made prior to 1939.

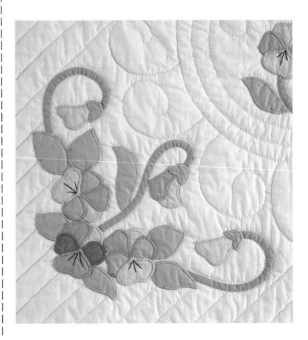

PINE TREE QUILT

73″ × 85″
Cotton

1938

Pieced and quilted by Mary Louise Sansom Jetton in Mertens, Hill County
Owned by La Trelle Dunaway Sommers

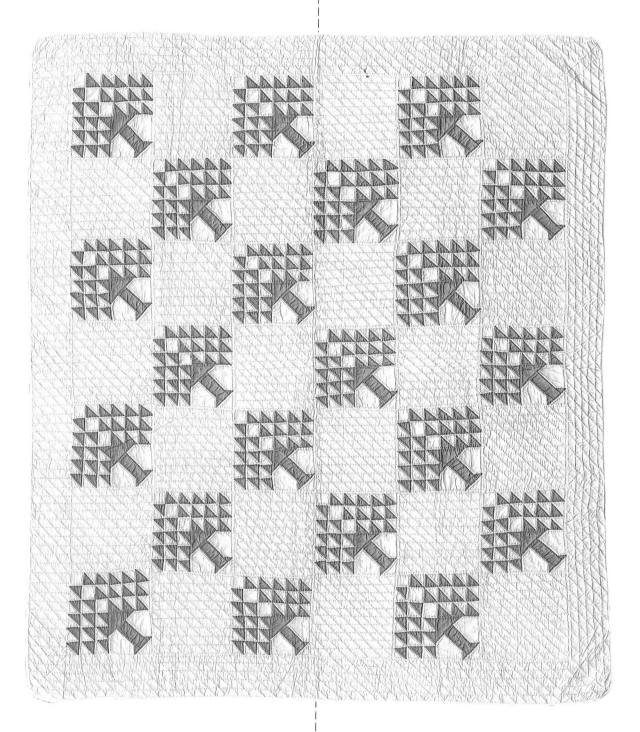

TRADITION and necessity were the reasons Mary Louise (Lula) Sansom Jetton quilted. Her granddaughter, who has inherited this Pine Tree quilt from Mrs. Jetton, said that after her grandparents married "they had to have cover so she made quilts out of necessity." Later, after her four children's needs were taken care of, Mrs. Jetton made quilts as gifts.

Born in 1873 in Granbury, Hood County, Mrs. Jetton lived most of her life in Mertens, Hill County. She died in 1952 in Italy, Ellis County. Her first quilt, a Nine Patch, was made in 1894 when she was twenty-one years old and living south of Irene, Hill County. Very simple patterns such as the Four Patch or the Nine Patch were usually the first quilt patterns young girls attempted.

According to Carrie A. Hall and Rose G. Kretsinger's *The Romance of the Patchwork Quilt in America*: "The three basic designs earliest used were the square, the rectangle, and the diamond. In the four-patch we see the very simplest form of the square, the design being created by the use of light and dark patches. Secondary designs are the hexagon and the circle. These five designs and the various parts into which they may be divided form the entire range of lines in quilt-pattern cutting . . . The 'Nine-patch' in its simplest form was the next step in the use of the square patch and the one oftenest used for the child's first lesson in quilt-making" (pp. 49–50).

Weather, nature, and religious themes were often the subjects of quilt patterns, and many Texas quiltmakers drew their inspiration from these and from the flora and fauna they observed in daily life. For this quilt, Mrs. Jetton chose a Pine Tree, one of the oldest patterns first used in the Thirteen Colonies and one which had ties to both nature and religion. A poem by Minnie M. Robertson, quoted in *The Romance of the Patchwork Quilt in America*, underscores the Pine Tree quilt's biblical connection:

Who fashioned first a patchwork tree
An emblem wrought, unconsciously:
God fashioned trees for mankind's good—
Man straightway hewed a Cross of wood. (P. 103)

Mary Louise Sansom Jetton

Variations on the Pine Tree pattern, such as Tree of Paradise, Tree of Temptation, Tree of Life, Forbidden Fruit Tree, and Christmas Tree, reflect a number of religious themes. Related themes are suggested by such versions as Temperance Tree and Steps to the Altar.

This classic Pine Tree has a pieced cotton top, cotton batting, and cotton backing. It features a simple color scheme of green and white, with the green closely resembling the Nile green predominant in quilts of the 1930s. It would have been in keeping with the times if Mrs. Jetton had used fabrics from the scrap basket that she might have collected in the thirties or had cut up old dresses to obtain the fabric. She quilted on both sides of each piece and used one-half to one inch crosshatch quilting in the alternating counterpane blocks between the Pine Tree blocks, with seven to nine stitches per inch. A separate white bias binding finishes the quilt.

NOSEGAY QUILT

76″ × 88″
Cotton

ca. 1938

Pieced by Agness Elizabeth Wynne Kemper in Fort Worth, Tarrant County
Quilted by Rosa Nichols, Viola Brummett, and Cynthia A. Boatman in White Settlement, Tarrant County
Owned by Cynthia A. Boatman

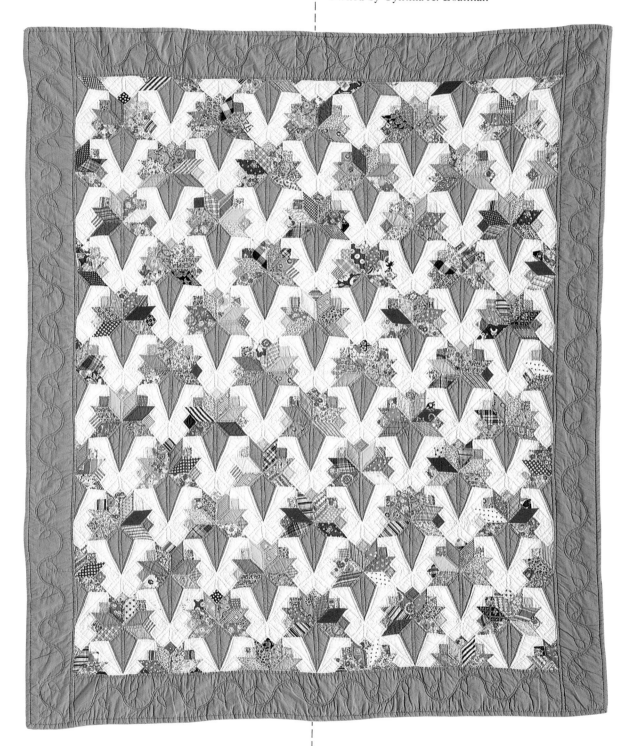

DESTINY sometimes plays a part in the lives of quilts and quiltmakers, as it did in the case of this pieced Nosegay quilt.

In October 1982, a widower residing in a nursing home donated a quilt top to the Wesley United Methodist Church in White Settlement for the church's fall festival sale. His wife, Agness Elizabeth Wynne Kemper, had pieced the top in the 1930s but had never quilted it, and their only son and daughter-in-law were uninterested in quilts.

Church member Cynthia Boatman, who *was* interested in quilts, decided the Nosegay top would be worth more if it were quilted and asked one of the older quilters in the church to help her with the task. Rosa Nichols, in her eighties, already had a quilt in her frame but promised to finish it in a hurry, since the sale was scheduled for mid-November.

While Mrs. Nichols was busy with her task, Mrs. Boatman shopped for border material to match the green in the top, for muslin to back the quilt, and for batting. She was fortunate, because the color she had to match was "that green," as it is known to every quiltmaker. The particular shade, Nile green, was used in so many quilts in the 1930s that there is a considerable market for it today among quilters repairing 1930s quilts or replicating them. The demand for it became so great, in fact, that one fabric company began manufacturing it again and named their color simply "That Green," which was self-explanatory to quiltmakers.

By the time Mrs. Boatman had added the green borders to the Nosegay top, Mrs. Nichols' frames were empty, and the two recruited Viola Brummett, another church member, to help with the project. Mrs. Nichols determined that the quilt would look best if it were quilted by the piece. "So much quilting in such a short time, but the three of us did it!" recalls Mrs. Boatman.

When the church auction at Wesley United Methodist Church took place, Mrs. Boatman's husband, who knew how much the quilt meant to her, kept bidding until he purchased it, making his wife extremely happy.

Two years later, in 1984, the same widower donated a quilt completed by his late wife to a Sunday school class at the same church for fund-raising purposes. Again the pattern was the Nosegay, but the quiltmaker had put a pink border and yellow back on this quilt. When the Boatmans' bid won the second Nosegay, they decided "the Lord thought those two quilts should stay together" and they intend to adhere to that plan.

This hand-pieced, hand-quilted Nosegay is heavily quilted with rows of stitches one-half to one inch apart on both sides of the pieces. It has seven to nine stitches per inch. A leaf and vine quilting design, which complements the floral bouquets, was selected for the border. This quilt pattern is also known as Cornucopia or French Bouquet.

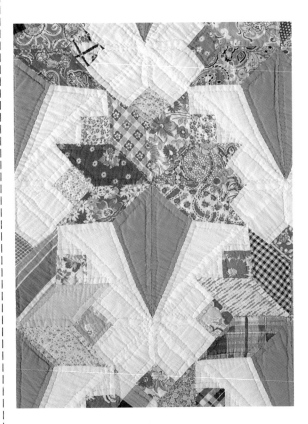

EVENING STAR QUILT

71″ × 88″
Cotton

ca. 1938

Pieced and quilted by Fannie Tennessee Watts
Lightfoot in Pride Community, Lynn County
Owned by Deborah Lightfoot Sizemore

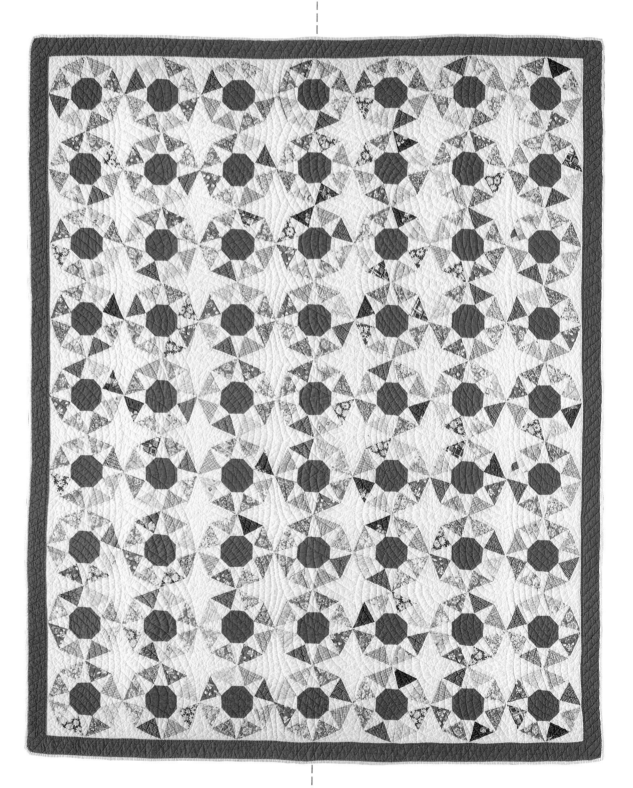

THE WOMAN who made this quilt was married at fourteen, lived in a dugout, helped her husband run a 320-acre cotton farm on the South Plains, raised twelve children for whom she provided virtually all the food and clothing, was a devout churchgoer, and still found time to make quilts for her own home and for her children upon their marriages.

One of her daughters-in-law recalled that Fannie Tennessee Watts Lightfoot was a beautiful woman, with a tiny waist and thick auburn hair. She was born on April 10, 1884, completed grade school, and married in Liberty Hill, Williamson County, on October 5, 1898. Her first child was born in December of the following year, and her twelfth and last child was born twenty-six years later. She died in 1970 in Lubbock.

The Lightfoots were charter members of the Pride Community Church, and she was a dedicated Baptist. "She used to ask the migrant farmworkers, 'Are you saved?' If they weren't, she got right to work," a daughter-in-law recalled.

The quiltmaker's ninth child, Glenn Billy Lightfoot, was born in 1916 and died in 1984. This quilt was one of four he received when he married, rather late for his day, at age thirty-one. His daughter, Deborah Lightfoot Sizemore, who inherited his quilt, remembers many of the stories he used to tell about the days when he was growing up on the farm.

One family tale was especially frightening. When her father was a youngster and the family was living in a dugout on the South Plains before their house was built, the dirt walls of the one-room dugout were covered in cheesecloth, which was commonly used in dugouts to keep the dirt in place and the dust down. At one point during the winter, the family observed those walls bulging and moving. In the ensuing investigation, it was discovered that a large nest of rattlesnakes was enjoying the warmth of the household, "denned up" during their hibernation behind the thin, gauze-like fabric.

The quiltmaker's daughter-in-law, Francis Lightfoot, recalled: "When the Lightfoots worked their farm, the South Plains was beautiful—it was a level sea of grass with good water. Now it's all dust. The doodlebuggers [geologists] and the drillers [for oil] broke through into the salt water, and it spread into the good, sweet water. By the time we were raising our children, I had to buy bottled water."

The Lightfoots took their cotton to be ginned at New Moore, and most of it was then stored in a warehouse at O'Donnell, where Francis Lightfoot said the family also took bales of cotton to be made into mattresses. Mrs. Lightfoot plucked chickens to get feathers for pillows. She also made all the clothes for her girls. Her daughters remember her "always at the sewing machine." The older girls

Fannie Tennessee Watts Lightfoot

helped by taking care of the younger children. At night, their mother did her piecing or quilting, spending most winters at her quilting. "She always had those old frames in the living room up on the ceiling. A quilt was up there the first time I met her," said Francis Lightfoot.

That quilt served as an icebreaker between the two Mrs. Lightfoots because the quiltmaker got to know her new daughter-in-law over the quilting frames. Her son was just out of the air force after World War II, when he met twenty-four-year-old Francis Cable. Two weeks later, the two got around Texas' three-day waiting period for a marriage license by going to Lovington, New Mexico, to wed. "One of the first things I did after we got back was to sit down at the quilting frames with my mother-in-law. She was asking me all about myself, because we didn't know each other," Francis Lightfoot recalled. "Later on, she gave us four quilts. Two were the kind that's pieced on paper; the other was a utility quilt. This one was the prettiest, and I don't remember ever using it. I used the other three."

Deborah Lightfoot Sizemore asked for the quilt when she went to Texas A&M University. "It was a little touch of home in my apartment. But later I began to feel guilty about using it and put it away," she said.

But her grandmother's quilt, while pretty, was made to be used. As most mothers of her day with many children to raise, she did her quilting for cover, and her quilts were generally scrap quilts, as this one is. It was quilted four to six stitches per inch and finished with an inner border and separate bias binding. Its scrap fabrics are arranged in eight equilateral triangles alternating with eight muslin isoceles triangles, which form an eight-pointed star around red octagonal centers.

The quilt pattern closely resembles the Evening Star and can be considered a variation. No doubt the big expanse of sky on the South Plains provided many clear nights when the Evening Star, or Venus, could have served as inspiration to a quiltmaker planning a new quilt.

COBWEB QUILT

64″ × 72″
Cotton

ca. 1938

Pieced and quilted by Prunella Bowmer Towler in
San Angelo, Tom Green County
Owned by Vicki Walz

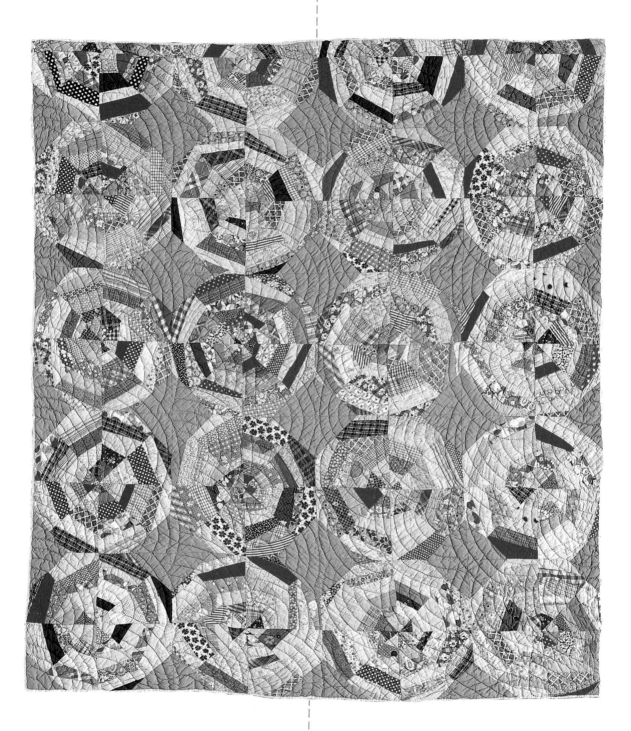

COBWEB or Spiderweb quilts were classic scrap-bag designs that were almost always pieced onto a newspaper backing. This allowed the frugal quiltmaker to make use of tiny scraps too small for other types of sewing. This style quilt was often pieced over a long period of time, as the scraps accumulated, and the finished pieces were stored until enough were completed to make a quilt. The Cobweb effect is formed by stitching together eight pie-shaped wedges. Other quilt-makers chose the same basic technique but pieced string diamonds instead of wedges; when sewn together, the diamonds formed stars instead of spiderwebs. Although this quilt was pieced by hand, it is equally common to find such designs pieced by machine.

The Cobweb design is particularly striking because of the effect of motion produced by the use of so many different colors and patterns. It is an extremely graphic quilt, making good use of the negative space that exists between the spiderwebs. Typical of this kind of quilt, fabrics from several decades have been used in its construction. However, the spiderweb designs themselves are set together with the Nile green so prevalent in quilts made during and just after the Great Depression. String or scrap quilts were very popular during the Depression period, when goods and money were both so scarce that women saved everything, even scraps that apparently had no further use.

The quilt has been quilted in an overall shell pattern, which is typical of both the period and the type of quilt, with quilting stitches that measure four to six to the inch. The arcs in the quilting pattern reflect the length of the quilter's reach, for they were marked with chalk tied to the end of a string. As Suzanne Yabsley explains in *Texas Quilts, Texas Women*: "Because the design was marked and quilted from the quilt's edges inward, it was difficult to make the design meet in the middle. Most quilts with the shell design have a thin strip down the center marking this discontinuity. Old-time Texas quilters called this strip, 'the hog's back,' a name that probably derives from the razorback, a type of pig once common throughout the South, which has a hairy ridge down its spine" (p. 37). Fine quilting, incorporating feathers, cables, or floral designs, was usually saved for appliqué quilts or for wide borders that are not commonly seen in Depression-era scrap quilts.

Quilts from this period are often narrow like this one, made only wide enough to cover the bed and hang over a few scant inches. They were made to provide cover for the bed and warmth for its inhabitants, not primarily as decorative spreads. However, working within the limitations of the scraps she had handy or those she could trade for, the quiltmaker made every effort to improve upon

Prunella Bowmer Towler

the utility of the piece, particularly when it was made for a special purpose, such as this one.

This quilt carries on another old Texas tradition, that of making a quilt for a future family wedding, even though the prospective bride or groom may yet be a child. This quilt was made specifically to be a wedding gift for Mrs. Towler's grandson, who was only six years old at the time; it was given to him on the occasion of his marriage years later. Continuing the tradition, the quilt was later given to the grandson's daughter, the great-granddaughter of the quiltmaker, during her first year of marriage.

Prunella Bowmer Towler was born in 1877 in Maxdale in Bell County, Texas, attended Baylor Belton College where she studied art and piano, married in 1905 at the age of twenty-seven, and had four children. She died in San Angelo in 1969. Her husband owned a cotton gin where Mrs. Towler kept the books. She also taught piano in the community. She learned to quilt as a young girl, taught by her mother, and made her first quilt as a child in Maxdale.

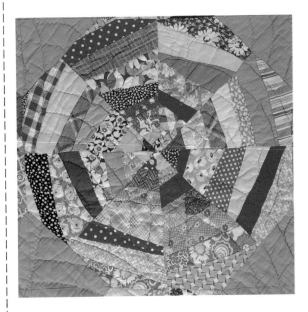

AIRPLANE QUILT

70″ × 82″
Cotton

1939

Pieced and quilted by Ophelia Parker Bloys in Fort
Davis, Jeff Davis County
Owned by Vivian Bloys Grubb

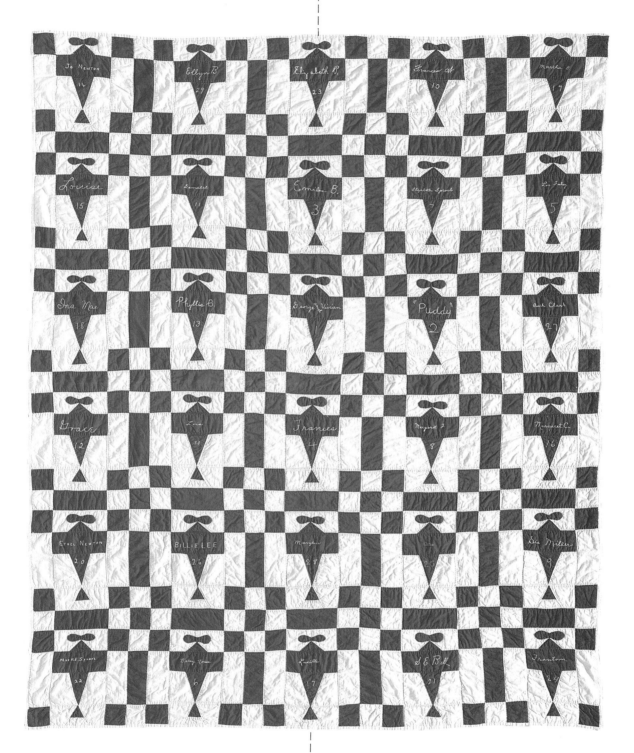

A PATTERN from the *Kansas City Star* was the inspiration for this charming quilt, but the quiltmaker was not content to follow the pattern exactly: she added the propeller to make the design more personal. The quilt was made as a wedding present for the quiltmaker's fourth child, the present owner, and was presented to her at her bridal shower in December 1939. Continuing the tradition of friendship quilts given to mark special times in a person's life, the quiltmaker distributed small blocks of fabric to all her daughter's friends and asked them to embroider signatures on the blocks. These autograph blocks became the wings of each airplane. Each block is also numbered, with the "1" block on the quilt (seen in the middle) representing the bride and groom.

The quilt is hand-pieced and appliquéd by hand. The signatures and numbers are also embroidered by hand. Each individual piece is outline-quilted on one side of the piece only, and rows of quilting stitches less than one-half inch apart are used as accents. The quilting stitches measure approximately four to six per inch. A separate bias binding finishes the quilt, which is in good condition despite being used for half a century. The quilt has been washed many times, which has resulted in the cotton batting separating into clumps. Cotton batting requires close quilting to hold it in place during washing; otherwise the cotton lumps together between the rows of stitching, as has happened in this quilt.

In the 1930s, when this quilt was made, the world could still be excited by the romance of air travel. Only twelve years earlier, in 1927, Charles Lindbergh had held the world in thrall with his heroic solo crossing of the Atlantic. In 1931, Texan Wiley Post and Australian Harold Gatty had made the first round-the-world flight in less than ten days, flying a plane called the *Winnie Mae*; two years later, Wiley Post broke his own record by flying around the world alone in seven days. Just the year before the quilt was made, in 1938, Howard Hughes, another Texan, had cut the record to a little under four days, flying with several assistants. Although it would be years before travel by air would be as easy as getting on a train was in the 1930s, these exciting trips were the precursor of things to come and fired the imagination of the nation's quiltmakers. The excitement of flight inspired many quilt patterns: Lone Eagle, Lindy's Plane, several variations of

Ophelia Parker Bloys

one called simply Airplane, Spirit of St. Louis, Propeller, Aircraft Quilt, Lindbergh's Night Flight, Air Ship Propeller, Airplanes, and Altaplane.

Born in Barksdale, Texas, in 1885, Mrs. Bloys was governess and teacher on several West Texas ranches: the Shakelford Ranch near Marathon, the Henderson Ranch near Alpine, and the Knight Ranch near Valentine. She then assumed the position of postmistress in Valentine. She married Roy Bloys in 1911 in the Valentine Community Church that had been organized and built by her husband's father; the Bloys reared five children and were married for sixty-nine years. A skilled seamstress, she even made her own white satin wedding dress adorned with seed pearls and tatting. She learned to quilt by helping her mother but had no formal instruction in quiltmaking. Late in life, when she was almost ninety, the quiltmaker started painting in oils, without lessons or training. She died in 1981 in Fort Davis, one of Texas' best-preserved frontier forts, where the 10th Cavalry's black Buffalo Soldiers had been stationed to battle Indians in the area during the nineteenth century.

As the family history recalls: "She often said that she had lived in the most interesting times in all history. From horses to walking on the moon . . . from guns on the hip, to under the pillow, to vanished from sight . . . from hauling water and washing on a rub board to washing machines and dryers . . . she had seen it all in her lifetime."

A NURSERY RHYME QUILT

45″ × 63″
Cotton

1939

Pieced, appliquéd, and quilted by Margaret
Thurmond Cockerell in Abilene, Taylor County
Owned by Kay Cockerell

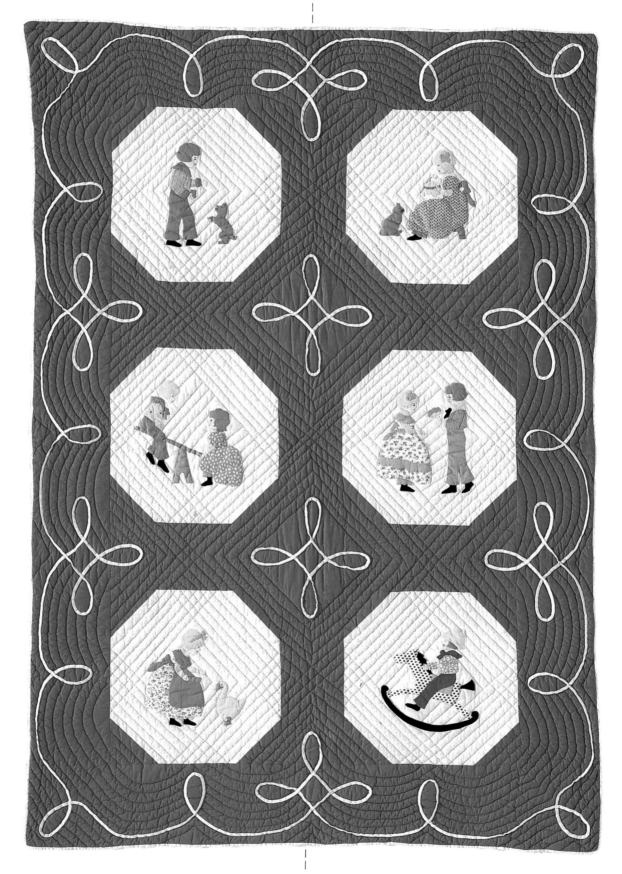

POSTMISTRESS of Weinert, Haskell County, from 1915 to 1920, Margaret Thurmond Cockerell was married to a country doctor who rode a motorcycle on his rural house calls.

She was born in Gallatin, Cherokee County, in 1878, and married there in 1903. In 1921, she and her husband moved to Abilene, Taylor County, where she lived until her death in 1968. She enjoyed such needle arts as quilting and embroidery. Kay Cockerell, the wife of one of Mrs. Cockerell's grandsons, owns several pieces of the quiltmaker's embroidery, including a large map of the United States with flowers, and several birth announcements, in addition to this quilt, given to her by her mother-in-law. "Mimi always did beautiful handwork," she recalled.

The quiltmaker's husband and his brother took turns attending Baylor Medical School; one would work a year while the other was in school. Mr. Cockerell graduated in 1900, and he and Margaret Thurmond were married three years later. Soon after, they moved to Weinert, where "Doc" frequently made his rounds on a motorcycle.

This charming Nursery Rhyme quilt, which was made for the birth of grandchild Edward E. Cockerell III, husband of the quilt's present owner, is based on a design by Anne Orr, a talented, well-known quilt and needle-art designer who was on the staff of *Good Housekeeping* magazine from 1919 to 1940. It depicts six popular nursery rhymes in blocks, with a seventh block becoming a coordinated pillow.

Margaret Thurmond Cockerell
with her husband and their grandchildren

It is unusual for a baby's quilt because the maker selected a deep shade of marine blue rather than a pastel. The deep hue forms a marked contrast with the white background of the pieced-in blocks, the appliquéd calligraphic scrollwork, and the separate bias binding. Mrs. Cockerell's quilt has seven to nine stitches per inch. She quilted it in outline quilting around the appliquéd figures in the blocks, with a close crosshatch of one inch or less filling in the background. Embroidery embellishment is used in some of the blocks.

The design is typical of an Anne Orr quilt in that it has a restrained, rather formal air, with the figures in the blocks relatively small and delicate in scale. Anne Orr was famous for quilt designs that featured a petit-point look, achieved by the piecing of very small squares of fabric. This design also has a distinctively 1930s look.

It is obvious from the fine condition of the quilt that it was always highly valued and probably was never used by a baby on a day-to-day basis. Most likely, it was kept for ceremonial occasions.

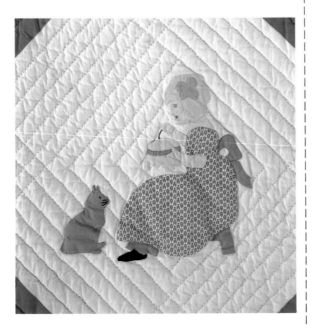

THE ROOSEVELT ROSE QUILT

86″ × 88″
Cotton

1939

Appliquéd by Annie McGlasson Pennington in Abilene, Taylor County
Quilted by Kay Cockerell and the Thursday Quilters in Abilene
Owned by Edward and Kay Cockerell

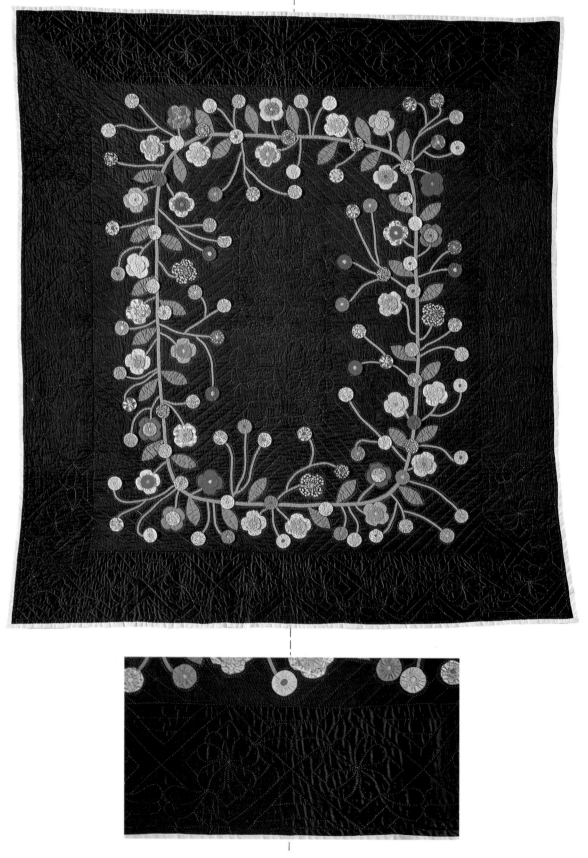

DESIGNED BY Ruth E. Finley, best known to-day as the author of *Old Patchwork Quilts and the Women Who Made Them,* the Roosevelt Rose was named in honor of President Franklin Delano Roosevelt and his wife, Eleanor. In the January 1934 issue of *Good Housekeeping,* the pattern could be purchased for twenty-five cents from the magazine's Needlework Department.

According to Mrs. Finley: "The Roosevelt Rose quilt is very gay, its flowers being as varied as the contents of a scrap bag: purple flowers with lavender centers, light blue with dark blue centers, yellow with brown centers, red with pink centers—all harmonious, but as festive as a bed of mixed zinnias." The pattern gave general instructions for making the appliquéd flowers and the unusual flowers created from tiny yo-yos or puffs; however, the arrangement of the flowers and leaves was left, "just as it was in the old days, to the artistic taste and industry of the individual maker."

The quilt was usually executed in black cotton sateen, the same fabric used in this elegant example. The subtle gleam of the sateen, more like a patina than a shine, proved the perfect setting for the multi-colored flowers with their charming floral prints. The sateen in this quilt has been heavily quilted with an elaborate design including feathers and stars, which perfectly complements the lush floral wreath in the center. In addition, each small piece of the wreath has been outlined with quilting stitches.

Almost forty years separated the making of the top and the quilting of the finished quilt. The top

Annie McGlasson Pennington

was appliquéd around 1939, during Roosevelt's second term as president; in 1976 it was quilted by the wife of the quiltmaker's grandson and five of her quilting friends, the Thursday Quilters, who met every week for a quilting bee. According to the family, the quiltmaker's husband was a lifelong Democrat—the family term is a "brass collar Democrat"—and a strong supporter of President Roosevelt. This particular quilt reflected the family's political persuasion and the enormous popularity of the president. Quiltmakers have expressed their political beliefs in their quilts for almost as long as quilts have been made; even when women were not encouraged to be politically active, they quietly stitched their political leanings into their handwork, as witness such quilt patterns as the NRA Blue Eagle, Clay's Choice, Democrat Donkey, Fifty-Four-Forty-or-Fight, Free Trade Patch, Kansas Troubles, Lincoln's Platform, Order No. Eleven, Radical Rose, Sherman's March, Slave Chain, Underground Railroad, Union Star, and Whig's Defeat.

Annie McGlasson Pennington was born in Troy, Texas, in 1889 and died in Abilene in 1964. She married Clarence R. Pennington, a fellow classmate at Baylor University, in 1909 and had two children, one of whom died of appendicitis as a small child. Her husband was in the insurance business in Abilene originally, and Mrs. Pennington assisted him in the company's offices for several years. According to the family's recollection: "Annie was a wonderful cook and did lots of canning. A lifelong Baptist, she joined the church in Waco when she was thirteen and later taught the junior high boys' and girls' Sunday School class at the First Baptist Church in Abilene for more than forty years. Her husband helped to finance an elevator for the church when the steps began to bother her." The quilt is now owned by her grandson and his wife.

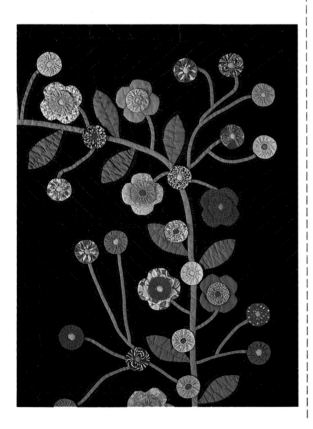

ROB PETER TO PAY
PAUL QUILT

68″ × 78″
Cotton

1940

Pieced and quilted by Winnie Jetton Dunaway in
Italy, Ellis County
Owned by La Trelle Dunaway Sommers

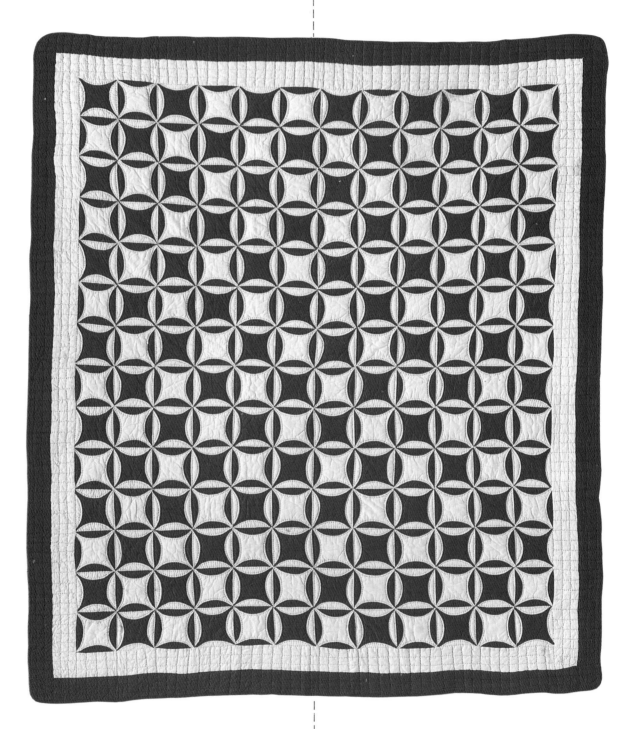

THIS QUILTMAKER traded her quilts for oil paintings done by her best friend so each could have the other's art in her own home.

Born on a farm south of Irene, Hill County, in 1896, Winnie Jetton Dunaway was the daughter and granddaughter of quilters. She attended Texas Christian University in Fort Worth for a time, then married and moved to Italy, Ellis County, in 1920. She lived there for sixty-two years, dying in 1982 in Waxahachie.

Mrs. Dunaway was a housewife and piano teacher, married to a farmer. On the farm, she liked to turn the radio on in the afternoon and quilt in one room that was large enough to serve as a sitting room and bedroom as well as to house her quilting. While she often quilted alone, she also worked with her mother and grandmother. Later in her life, she quilted with a church group. These friends quilted for the public, turning the money they earned over to the church as their donation.

A sister recalled that Mrs. Dunaway's first quilt was a Grandmother's Flower Garden. By the time she made Rob Peter to Pay Paul, she was quite an accomplished quilter, for piecing curved seams is not for the beginner. The solid red and white color scheme she chose nicely shows off this design, which has a "very old Quaker name," according to Hall and Kretsinger's *The Romance of the Patchwork Quilt in America.*

Variations of Rob Peter to Pay Paul could become Nonesuch, Love Ring, Drunkard's Path, Rocky Road to Dublin, Rocky Road to California, Country Husband, Vine of Friendship, Fool's Puzzle, Falling Timber, Wonder-of-the-World, or Around the World. All of these quilt patterns, notes *Romance,* are obtained by different arrangements of color and pieces within the quilt block. Differences are also achieved by different settings of the completed blocks.

This version was hand-pieced and quilted with six stitches per inch by Mrs. Dunaway on both sides of each individual piece. The two borders, the inner one white, the outer one red, are quilted in a one-inch crosshatch, and a separate red bias binding finishes the quilt. A crisp and graphic quilt, Rob Peter to Pay Paul was obviously one Mrs. Dunaway prized, for she gave it to her only daughter when she married.

Winnie Jetton Dunaway
(Moreland Herring photo)

LOVER'S KNOT QUILT

78″ × 88″
Cotton

ca. 1940
Pieced and quilted by Myrtle Augusta Loomis
Patterson in Gilmer, Upshur County
Owned by Jewel Pearce Patterson

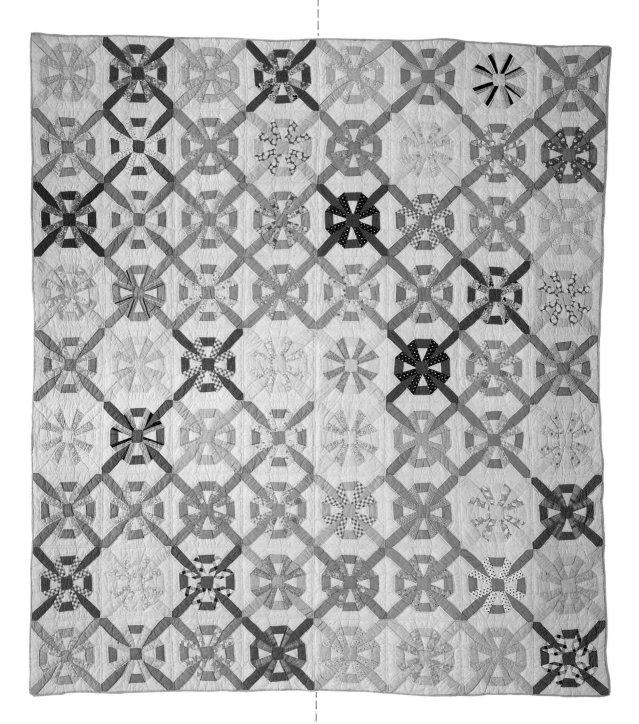

THE LOVER'S KNOT is an old-fashioned scrap design that is most effective when many different, contrasting fabrics are used. Each block is pieced of two fabrics—one print and one solid—and a muslin background; the many fabrics enhance the casual charm of the quilt.

The design is hand-pieced and hand-quilted. Each piece is quilted around both sides of the design through cotton batting. The quiltmaker loved to piece, and one of the sorrows of her life was losing both quilts and quilt tops that were stored in a washhouse when it burned down. Despite her enjoyment of the piecing process, the quilting itself was not Mrs. Patterson's favorite task, and she often made use of the quilting services sponsored by the Works Progress Administration in Upshur County during the Depression. The WPA group would quilt a top for around $1 a spool—the more quilting, the more spools of thread, the more the quilters earned.

History dealt sternly with Upshur County, a hilly, heavily forested region in Northeast Texas. First settled by Anglos in 1835, the territory was part of the Cherokee and Caddo lands until the Indians were driven away in 1839 after an abortive Mexican-Indian uprising. During the next twenty years, plantation farming and fertile soil attracted settlers from the South, but with the intervention of the Civil War, the county's rural economy suffered a double blow. The first blow was obvious: the county lost manpower to the Confederate forces. However, the second—the drastic increase in the slave population that resulted from plantation owners in other Southern states sending their slaves to East Texas for safekeeping—had a more subtle but longer-lasting effect. When the war ended, there were 400,000 slaves in Texas, more than double the number counted in the 1860 census. After the war, most of the freed slaves, uneducated and now unemployed, stayed where they were—in East Texas—to form a majority of the population and a subculture of poverty that was to haunt this region well into the next century. During the Great Depression, the economy in Upshur County was also hit severely, and the population began to decline as families left for possible jobs in the cities.

If the drastic increase in the slave population was the single biggest economic influence on East Texas in the nineteenth century, certainly there can be no question that the discovery of oil in the twentieth century proved another enormous influence on both the economy and the way of life in the region. From the time Spindletop blew in near Beaumont in 1901 to the discovery of Kilgore's giant field in 1930, oil has affected East Texas.

Oil meant jobs, and when the oil fields near Henderson and Kilgore were discovered, rural Texans, discouraged by hardscrabble farming,

Myrtle Augusta Loomis Patterson
(Rembrandt Studio photo)

rushed to this new source of work. Housing was scarce, and oil workers often had to drive for many miles to find a room. Diana and Roger Olien's book, *Life in the Oil Fields,* contains a vivid description of housing conditions in the oil patch as remembered by an East Texas oil worker's wife: "There were people living in tents with children. There were a lot of them that had these great big old cardboard boxes draped around trees, living under the trees. And any- and everywhere in the world they could live, they lived. Some were just living in their cars, and a truck if they had a truck. And I can tell you, that was bad. Just no place to stay whatsoever" (p. 31). To find a place to live, some of the oil-field workers were willing to drive as far as Gilmer, where Mrs. Patterson ran a popular boarding house during the boom.

Myrtle Loomis Patterson, a native Texan, was born in 1882 in Mims Chapel, located between Hughes Spring and Woodlawn. She married Henry Marvin Patterson about 1902, reared two sons, and died in Gilmer in 1959 at the age of seventy-seven. She belonged to the generation that believed that a girl should marry with a hope chest full of quilts, and since she did not have any daughters, she made each of her sons his own hope chest of quilts.

A mainstay of the First Methodist Church in Gilmer, Mrs. Patterson quilted for years with the ladies of the church. According to the family, one of her favorite stories to tell involved how the quilting ladies would, out of politeness, let an inexperienced quilter work on one of their projects, but when the beginner had gone home, the older quilters would stay behind, carefully pick out her inexpert stitches, and requilt that area so that "all the stitches would look the same." When she died, her only bequest was to leave her cut glass to her granddaughter. Unfortunately, she did not bequeathe her quilts, and her surviving son, believing that his niece "would want all new things when she got married," took all of Mrs. Patterson's quilts to the poor section of town and gave them away.

TULIP BOUQUET QUILT

78½″ × 86½″
Cotton

1940

Appliquéd and quilted by Eunice Ward in Slaton,
Lubbock County
Owned by Esther Morris

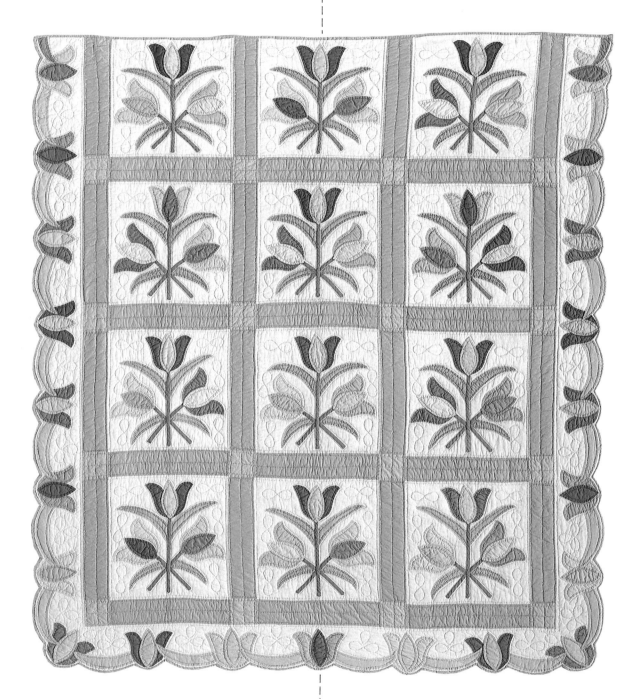

TULIP QUILTS have been popular since the early nineteenth century, and there are many variations: Crossed Tulips, Windblown Tulips, Spring Tulips, Tennessee Tulips, Grandma's Tulips, Tulip Basket, Cottage Tulips, and even Egyptian Tulips. This particular variation shows Art Deco influences from the late 1930s: the stylized tulips, the carefully arranged border elements, the starkly arranged stems and precisely placed leaves. The soft pastel colors are also typical of the period when this quilt was hand-appliquéd.

Although the quilt was appliquéd in the late 1930s, it was not quilted until 1940. Each of the appliqué designs is outline-quilted on both sides of the pieces, with figure 8s quilted into the background. The rows of quilting are often less than a half-inch apart, and there are seven to nine stitches per inch. The scalloped edge of the quilt was finished with a separate bias binding. Although the quilt has been used and washed, the binding does not show wear. This is unusual since the binding is frequently the first part of a quilt to wear out because it takes the most handling as the quilt is used on the bed. Many old-time quiltmakers chose to finish their quilts with a doubled bias binding—this provided four layers of fabric on the edge that absorbed the most wear.

Floral appliqué quilts have always been beloved of quiltmakers with the patience and dexterity for fine appliqué; in the 1930s and 1940s, United States quilters produced a plethora of floral quilts, which became almost synonymous with the period. Many elaborate floral appliqué kits were produced and sold across the nation through large mail-order houses that specialized in needlework. Family recollection indicates that this Tulip Bouquet quilt was made from a pattern, not a kit; however, it has the perfect design and lovely colors that are the common denominators of the best kit quilts.

Eunice Ward

Eunice Ward, born in 1894 in Jonesboro, Texas, started making quilts before her marriage in 1912 when "quilts were still a necessity," according to her daughter who now owns the Tulip Bouquet quilt. Mrs. Ward's first quilt was a Nine Patch, made when she was sixteen. By the time she made the Tulip Bouquet, she had reared six children and had begun to make special quilts as gifts for her family. A graduate of a country school who later had two years of private tutoring, she considered herself to be an artist who worked in fabrics, and she quilted as a form of artistic expression.

BASKET OF FLOWERS
QUILT

72″ × 87″
Cotton

1942

Appliquéd by Emmaline Nannine Fischer Gee in
Houston, Harris County
Quilted by Pauline Galloway in Galveston, Harris
County
Owned by Helen Cecile Louisa Fischer Labuzan

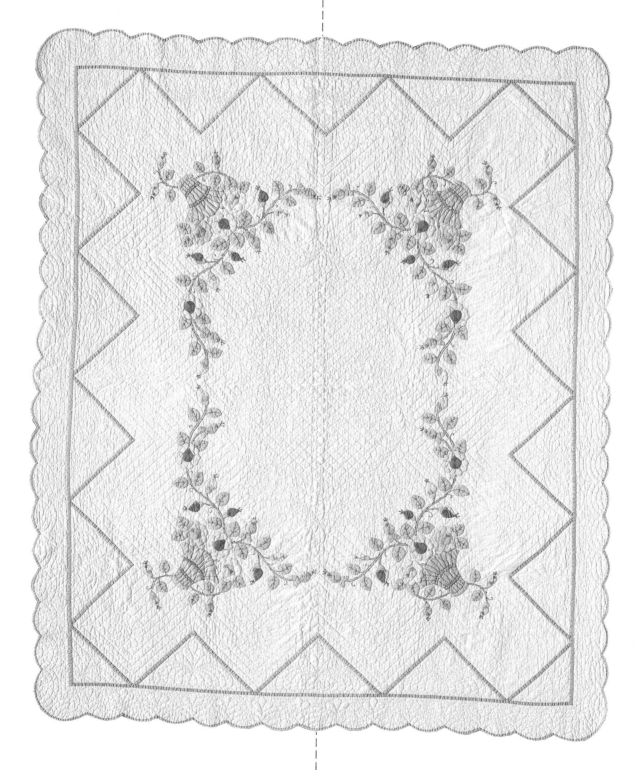

WHILING away the time during her first pregnancy in the early 1940s when her husband was traveling a lot, Emmaline Fischer Gee went to Foley's in Houston and bought a kit quilt. Though she had made tops for her hope chest when growing up, she had never tackled a design as intricate as this Basket of Flowers appliqué quilt. And she had never quilted her tops.

Not only did she make a Basket of Flowers for her sister, Helen Fischer Labuzan, she also made one for their mother, Henriette Junker Fischer. By the time she had finished the appliquéing of this classic pattern with yellow, pink, and rose flowers spilling from four corner baskets onto a white background, she was ready to have someone else handle the quilting.

A friend of her mother's, Pauline Galloway of Galveston, was pleased to have the opportunity to earn extra income by quilting the two tops. She was a seamstress who also quilted for the public, and her quilting is exceptionally nice in this quilt. It is quite elaborate, with a vining effect that adds to the floral motif. Each piece of the appliquéd design is quilted around the edge, and she has quilted seven stitches per inch. The quilt has a zigzag inner border in blue and a narrow outer blue border, both of which frame the floral baskets and central counterpane quilting.

Born August 6, 1913, Mrs. Gee, in recalling her quilting activities after this appliqué top, said that her husband's mother lived in the sawmill town of Call Junction, Jasper County, and she remembered quilting when they visited. "When she put a quilt in the frame, everyone pitched in and helped quilt it, whether you were a good quilter or not."

Mrs. Gee, while basically a self-taught quiltmaker, has received lots of encouragement, assistance, suggestions, and support in her work from a Methodist church women's group. She made her first complete quilt in about 1987 when she was seventy-three years old. She has finished three complete quilts for her daughter and two grandsons and now is working on a Lone Star for her son. She likes to work in the early evening in front of the television.

When she lost her husband four and a half years ago, Mrs. Gee's resulting loneliness caused her to turn to quilting more than she had at earlier stages in her life. Like many others before her, she learned that quilts, and quilting, can be a comfort.

TOUCHING STARS QUILT

79″ × 79″
Cotton

1942

Pieced by Karoline Esmunde Uttech Glaeser in Sabinal, Uvalde County
Quilted by Glaeser family members in San Antonio, Bexar county
Owned by Karoline Helen Patterson Bresenhan

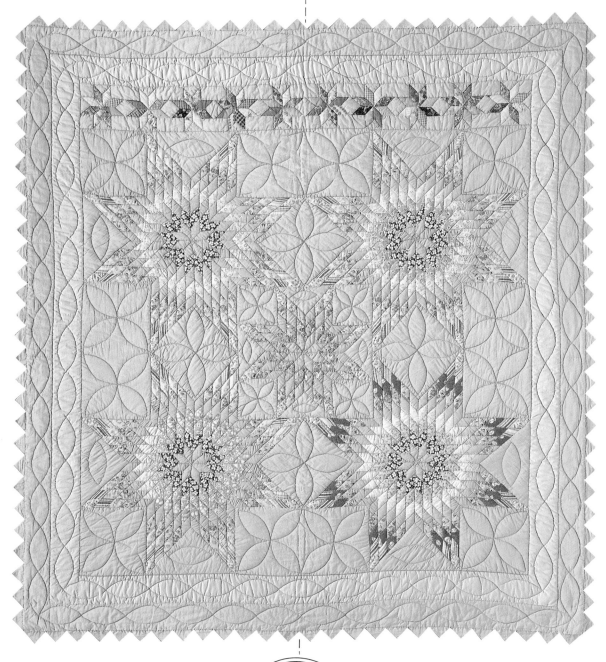

Karoline Esmunde Uttech Glaeser

PIECED for the birth of a first great-grand-daughter and quilted twenty-one years later for her wedding, this quilt contains the work of four generations of one family. The Touching Stars design is a variation of the classic Lone Star pattern and was a favorite of the quiltmaker, who made a Star quilt for every new Methodist preacher who came to town.

Born in Germany in 1862, the quiltmaker emigrated as a young girl, sailing from Germany with her widowed mother and two older brothers to join family members settled in Texas. The family landed in Indianola, a nineteenth-century port where thousands of immigrants, including large colonies of Germans, first entered Texas. Between 1854 and 1886, Indianola was ravaged by repeated bouts of yellow fever and devastated by hurricanes, the last of which effectively obliterated the town; today the ghost town of Indianola is remembered chiefly as the port of entry for Europeans who were drawn to Texas by the promise of cheap land.

The flood of German immigrants came in response to the paeans of praise about Texas that were sent back to German newspapers by early colonists, yet those laudatory accounts were often misleading, according to Linda Moore-Lanning in *Breaking the Myth: The Truth about Texas Women.* "Arriving in what she had been told was the land of milk and honey, the German woman found disease and danger instead of delivered promises. When the German woman of Texas landed . . . she was forced into several weeks' delay on the coastal swamps. There her babies and friends died of disease. She then faced a 200-mile walk in spring storms and floods" to reach her destination in the Hill Country (p. 41).

This quiltmaker's family moved from Indianola by oxcart to a farm near Hallettsville, not quite as long a walk as that faced by the pioneers who set out for Hill Country land. In 1882, the quiltmaker married Wilhelm Friedrich Glaeser in Seguin (she wore thirteen petticoats on her wedding day) and moved to a farm near Gonzales, then to a farm in Cost. Over a period of twenty-six years, she bore thirteen children, eleven of whom lived to adulthood, and she died in Sabinal in 1950 at the age of eighty-eight. As matriarch of a large family, her stoicism in the face of hardship and unflinching acceptance of hard work left their mark on her descendants. She was typical of the German immigrant women who populated large segments of Texas—as Moore-Lanning explains in *Breaking the Myth,* they "left behind family and friends they would never see again. What they brought to Texas were their hopes, their customs, and their values. Weathered headstones may now mark their graves, but their perseverance still fuels the Texas spirit" (p. 44).

Karoline Uttech Glaeser and her mother, Wil-helmina Schlack Uttech, learned to quilt after emigrating to Texas, working by lamplight in a tent on the Texas prairie. Once the family was able to afford a sewing machine, Karoline quickly adopted this new way of piecing and made many quilts by machine-stitching scraps onto a paper foundation, a thrifty method that allowed her to use old newspapers and catalogs and otherwise useless pieces of fabric.

Like others of her generation, this quiltmaker worked out of an extensive scrap bag; therefore, some of the fabrics in the Touching Stars are more typical of the Depression era than of the 1940s. The turquoise fabric used in the set of the quilt and for the backing was purchased in 1963, when the quilt was finished. The row of eight-pointed stars at the top of the quilt was added in 1963 to lengthen the quilt in response to the great-granddaughter's wish to make the quilt "long enough to tuck over the pillows." Ella Wilhelmina Glaeser Pearce, the quiltmaker's daughter and grandmother of the bride, was a dressmaker who pieced the extra stars from scraps left over from "her ladies' dresses." By 1980, the points of the large stars had become threadbare; they were replaced with new fabric by Jewel Pearce Patterson, the quiltmaker's granddaughter and mother of the quilt owner.

Because quiltmaking is so time-consuming, quilters have always been eager to try new methods and new products that are supposed to make the job of creating a quilt easier; therefore, un-bonded synthetic batting, which was new to the market at that time, was selected for this Touching Stars quilt. Unfortunately, fibers from the synthetic batting have subsequently migrated through the threads of the fabrics, producing a slightly fuzzy effect called "bearding." The quilting designs were marked by tracing around plates and cups, and each piece of the stars is outline-quilted. Quilting stitches measure approximately eight to the inch. The edge of the quilt is finished with Prairie Points using alternating prints and solids.

This quilt, which served as the authors' first introduction to the art of quilting, was quilted in one August weekend in 1963 in San Antonio. There were eight family members around the quilting frame, including four of the quiltmaker's daughters—Ella, Minnie Glaeser, Edith Glaeser Goodrich, and Henrietta (Hattie) Glaeser Saat-hoff—two of her granddaughters—Jewel and Helen Pearce O'Bryant—and two of her great-granddaughters, the authors of this book. The younger Karoline, for whose wedding the quilt was finished, remembered her grandmother sitting the two cousins down at the quilting frame to teach them how to quilt and saying, "Now girls, learn to take real pretty little stitches . . . because you're going to wake up every morning of your life and look at them."

MEADOW DAISY QUILT

81″ × 92½″
Cotton

ca. 1943
Appliquéd by Jennie Marie Wilson Cooper in
McKinney, Collin County
Quilted by others in Wichita Falls, Wichita, Archer,
and Clay counties
Owned by Rebecca Wilson Huston, Rebecca Cooper
Gay, Heather and Erin Gay

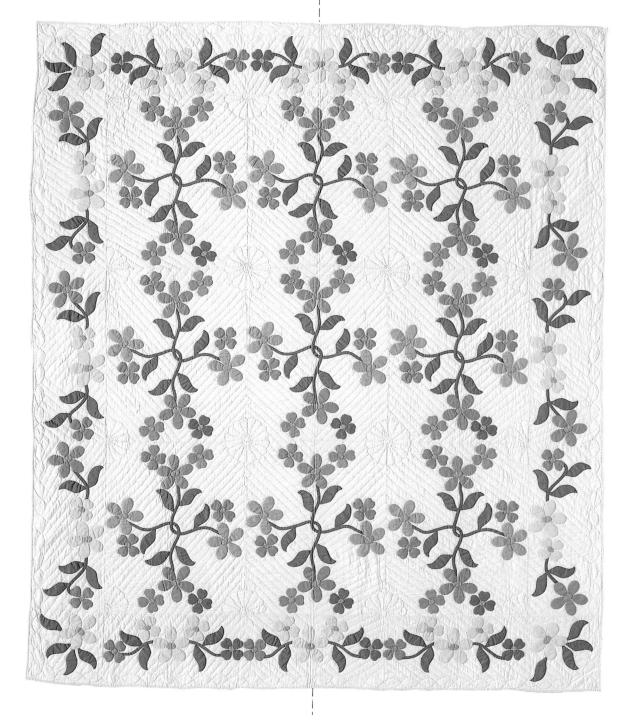

THIS GRACEFUL, delicate quilt was created by an ambitious quiltmaker who liked the design so well that she made two identical quilts. The appliqué shows an artist's touch in the twining stems and realistically arranged petals; the many curves employed in the creation of the flowers reflect the meticulous care taken by the quiltmaker with her work. All of the appliqué has been executed entirely by hand with the petals and leaves carefully turned under to avoid the jagged edges often seen in less-skilled appliqué efforts. The pastel colors evoke the idea of a garden in full bloom.

The quiltmaker learned her needlework skills by observing her mother, Rachel Dugger Wilson, "who made many beautiful quilts, both pieced and appliquéd," as remembered by the quiltmaker's sister, one of the owners of Meadow Daisy. The quilt was made during World War II, when the quiltmaker had moved back to the family home in McKinney to await the birth of her first child. A love of beautiful things was passed down in the family, along with the strong sense of heritage that doubtless was part of the motivation to complete two of these time-consuming designs.

In the early 1940s, when this quilt was made, many Texans considered Collin County still to be a part of the South, where family heritage and respect for the old ways of doing things were integral elements of regional culture. In Graham's *Texas: A Literary Portrait,* a writer recalls:

In economy, mores, and manners, Collin County prior to the late 1950's was decidedly Southern in its make-up, and it's this distinctly Southern feel to the place that makes me want to align it with the region further east. Certainly Collin County was not far from where a different country altogether began; west of Fort Worth, the West began, and Fort Worth was only about 40 miles away. But it seemed much farther, because . . . we lived in Dixie . . .

The Southern world I lived in until I was twelve years old is completely gone now, and there are reasons not to mourn its passing . . . but there are also reasons to feel acutely a sense of loss, and chief among those is a kind of civility that prevailed . . . at all levels of that society. These country people, for the most part, had beautiful if not polished manners; they had an easy sense of dignity that the world always needs and always has too little of; above all they were such decent, modest, and generous people; they were citizens of a republic. (Pp. 44–47)

Obviously, the family of Jennie Wilson Cooper has retained many of those traditions.

Although Meadow Daisy was quilted by another person, the quilting patterns were selected by the quiltmaker to enhance the beauty of the design. Small fans are quilted in the corners of the blocks with half fans used in the borders. Interlocking chains have been used as the outer frame of the quilt, and the background is quilted in a grid. In addition, each petal and leaf has been

Jennie Marie Wilson Cooper

quilted in outline. The quilting designs are fancy, and the quiltmaker selected a thin cotton batting, yet the quilting stitches themselves are not as well executed as the rest of the quilt, measuring only four to six per inch. In addition, some knots are visible on the top of the quilt; had the quiltmaker done her own quilting, she would doubtless have hidden her knots, a technique that is more in keeping with her beautiful appliqué work.

Jennie Wilson Cooper was born in 1912 in McKinney, Texas, married and had two children, and died in 1988 in Fort Worth. She received her bachelor's degree, *cum laude,* in 1935 from what is now Texas Woman's University in Denton and later, while living in Palacios, drove many miles to study with a well-known artist who was living in the region. A former elementary-school teacher, the quiltmaker "was an artist in many areas—petit point, painting, dollmaking, knitting—and was an expert in all of them," her sister remembered. She gave this quilt to her sister and gave the other Meadow Daisy to her son. Later in life, when the quiltmaker was quite ill, her sister graciously offered to share ownership of her Meadow Daisy with the quiltmaker's daughter, "so that Jennie could observe Ann's excitement over it." Continuing the family tradition, the quiltmaker's daughter has included her own two daughters, Heather and Erin, in joint ownership of the Meadow Daisy because "she feels strongly that quilts belong to families, rather than to individuals."

In an interesting coincidence, the quiltmaker and her sister saw the Carpenter's Square quilt made by their grandmother, Martha Kincaid Wilson, honored in the landmark 1986 quilt exhibit in the rotunda of the Texas Capitol during Texas Quilt Appreciation Week held as part of the state's Sesquicentennial celebrations. The Carpenter's Square was pictured and described in *Lone Stars, Volume I: A Legacy of Texas Quilts, 1836–1936* (pp. 92–93).

STRING QUILT

86″ × 96″
Cotton

1944

Pieced by Maude Ada Franks Combs in Wellington,
Collingsworth County
Quilted by Carrie Dennis in Memphis, Hall County
Owned by Etoile Combs Holley

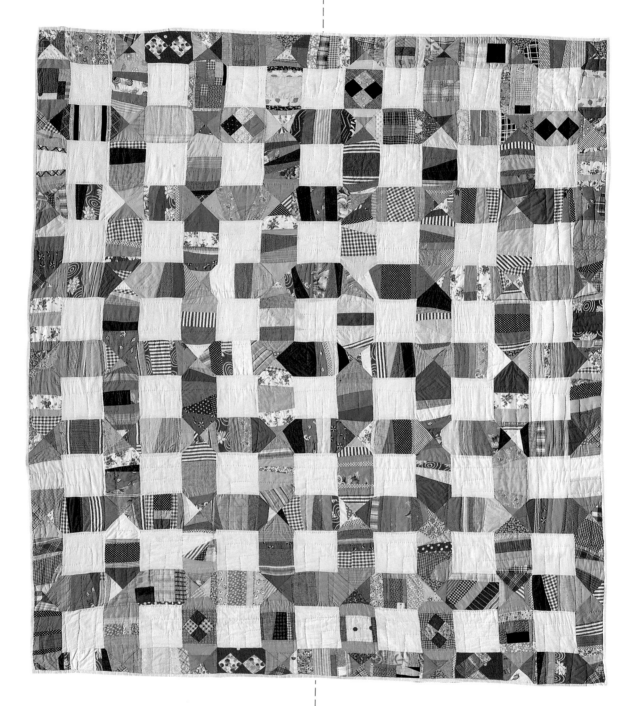

PIECED by machine onto a paper or fabric foundation, string quilts allowed the thrifty quilter to make use of even the tiniest scraps of fabric. These reminders of previous sewing projects were sometimes handed down by earlier generations, so string quilts often contain fabrics from several different decades. This particular geometric design was pieced using a pattern cut from a section of comic strips that ran in a Sunday newspaper. One of the comic strips is dated 1944, and two of the "funnies" refer to wartime conditions such as rationing and secret government projects.

"My mother did not take pleasure in pastels; her quilts are not pale, English garden types," recalled the quiltmaker's daughter, the present owner of this piece. It is the use of these vivid colors that makes this quilt so striking, and the repetition of the bright golden yellow is particularly effective in distracting attention from the random nature of the string piecing method. Framing the quilt is an unusual combination of string-pieced blocks and traditional patterns, such as the Four Patch. "For the outside edge, my mother must have used the bits and pieces left over from what she had when she married in 1908," the daughter explained, "then she changed to the vivid 'washfast' prints and solids of the late thirties and early forties." The pieced strips were set together with "ten pound sugar sacks bleached with lye soap," she recalled, and the quilt's batting is hand-carded cotton that had been "picked up in tow sacks from the scraps of excess cotton left over at the gins."

The quilting is simple straight-line quilting that forms right angles, with the lines of quilting stitches approximately two inches apart. There are between four and six quilting stitches per inch. The edge of the quilt has been finished by bringing the back of the quilt to the front. "Although my mother usually quilted her own work, this quilt was quilted by my husband's aunt who was in her late sixties at the time," the quilt owner explained. She also recalled that her mother quilted on "quilting frames made by my father that were suspended from hooks in the wood ceiling; the frame was lowered to work on during the day and rolled up overhead at night. She marked her quilts with a plate for circular designs and a string on a pencil for fans."

Maude Franks Combs was born in 1889 in Arkansas, the daughter of an early Methodist preacher; the family moved to Texas when she was only nine years old. She married and reared four children; she died in 1965 in Claude, Texas at the age of seventy-six. According to her daughter:

Her mother and a number of aunts taught her the (then) necessary homemaking "arts," including sewing and needlework. Quilts were made because they were needed, and she constantly had quilts in all stages of construction. She taught her creative pattern designing to others and taught them that a quilt must evolve and not be a task, that what makes a quilt unique is honestly using, creating imaginatively with what is at hand. I do not recall at what age she taught me to carefully mark, cut, and string tiny pieces for intricate blocks, but when I was enrolled in kindergarten, I had scissor marks on my right hand and my thimble finger was already bent . . . and I was not even five years old.

Mrs. Combs' work has won ribbons at the Tri-State Fair in Amarillo.

LONE STAR QUILT

72″ × 76″
Cotton

1945

Pieced by Wanda Fae Hanson Gallagher in Jayton,
Kent County
Quilted by Alice Byrd Hanson in Jayton
Owned by the quiltmaker

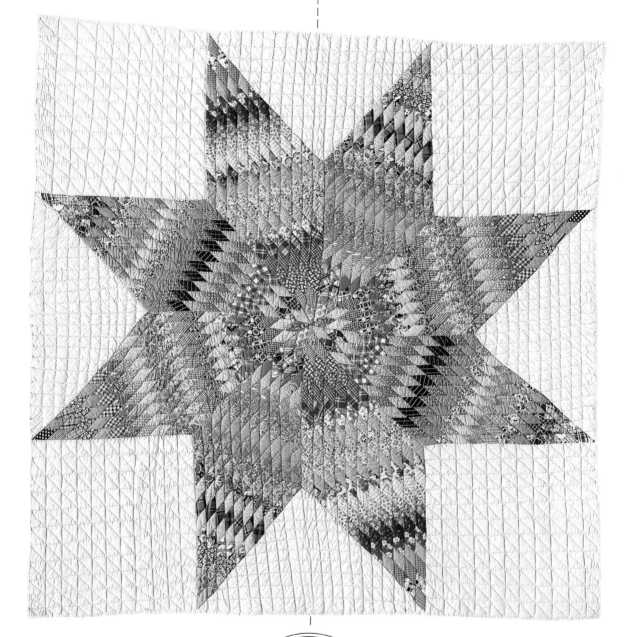

Wanda Fae Hanson Gallagher

DURING WORLD WAR II, shortages became a way of life. Not only were foodstuffs and gasoline rationed, but also fabrics were scarce and hard to come by; quilters with traditional scrap bags felt lucky to have them and used every piece in their precious stash. This scrap Lone Star is a perfect example of such a quilt—the points do not match, not because the quiltmaker did not know better but because she ran out of fabric.

Made in 1945, while the quiltmaker's new husband was serving in the Pacific, this Lone Star was pieced entirely out of scraps from her mother's scrap bag. "The quilt was made as a utility quilt to be used in my own home when my husband returned from service," recalled the quiltmaker, who was nineteen at the time she made the quilt. Her mother, who quilted the Lone Star for her, was so impressed with the effect of the scrap piecing that she decided to make a similar one for herself. The quilting stitches measure approximately seven to nine per inch; each piece in the star is outline-quilted on one side of the piece only. The background is quilted in a simple cross-hatch design.

Largely because of, rather than in spite of, the mismatched, hit-or-miss fabrics used in its construction, this Lone Star reflects an energetic, vibrant quality that can often be missing from quilts that are so carefully planned that they become static. This quilt represents the real substance of patchwork—the art of creating a unified whole from bits and pieces of what the quilter has at hand. The ultimate effect of a scrap quilt depends on the eye of the quiltmaker; how she places and combines her scraps determines whether her quilt will convey a visual statement or simply imply that she did the best she could with what was available to her.

The quiltmaker was born in 1926 in Dunn, in Scurry County; she married in Jayton in 1944 and reared three daughters. Although she was salutatorian of her class, her father did not feel it was important for a girl to be educated so she did not go on to college but went to business school instead. She worked in the offices of the *Abilene Reporter-News* until taking early retirement. When she was only nine years old, she made her first quilt—a Nine Patch, the classic beginner's pattern—and after that, she started a new quilt every year until she married at age eighteen. One of her favorite quilts, pieced when she was sixteen, depicted a full-size map of the United States; her daughters remember sleeping under it and learning their geography from the quilt.

She had five finished quilts and three tops completed for her hope chest at the time of her wedding; she pieced all the quilts, and her mother quilted them for her. After emptying her mother's scrap bag to make the scrap Lone Star, she began piecing "on the halves" so that she would have

fabric for her quilts. ("On the halves" refers to a common quilting custom whereby the quilter would piece a quilt for someone in return for being given enough fabric to piece a second one for herself.) When her husband returned home from the war, she stopped making quilts while they built a life together in what were hard times for farm families: they rented their first house for fifteen dollars a month and could lie in bed and watch the snow come through the holes in the ceiling, they picked cotton for a living until better work came along, and they paid the hospital bill when their oldest daughter was born with proceeds from the sale of pigs.

West Texas in the 1950s was not kind to farmers or ranchers: two record-breaking drought years—one of which produced a total cash income of less than a hundred dollars for the Gallagher family—defeated many and forced them to move to the cities for employment. Killing droughts like these were best described in *The Time It Never Rained* by Elmer Kelton:

Time was when an inch of rain would have brought fresh life, a greening to the land. But there had been grass then, a spongy turf to soak up and hold the moisture, and live roots to draw sustenance from it. Now the bare ground had nothing to soften the impact of rain, to catch and drink up the water. The first burst of precipitation would pack and seal the topsoil. The falling raindrops would strike hard and splash upward, brown with mud. Instead of soaking in, the water would swirl and run away, following the contours of the land, seeking out the draws and swales. Burdened by a heavy load of stolen soil, the rivulets swelled quickly into streams, the dry draws turned to rivers, and the muddy rivers bled away the vitality of a once-generous land. . . . For a few days, a thin cast of green would buoy the ranchman's hopes, give him a fresh surge of enthusiasm and encourage him to take a deeper hold. Then, slowly, the hope would die away under the hot west wind and the merciless pressure of a hostile sun. (P. 181)

The quiltmaker's family left the farm in 1959 and moved to Abilene; in 1976, the quiltmaker was widowed and turned again to making quilts. Her oldest daughter, who works on the staff of Houston's International Quilt Festival, stated: "I worried about Mother after my father died, but quilting has filled the void for her and become a very strong bond that the two of us share."

"I quilt mostly for my own pleasure," stated the quiltmaker, "and to carry on a family tradition. I remember as a child seeing my mother, grandmother, and aunts quilt, and I want to make a quilt especially for each of my three daughters and my six grandchildren. I quilt to relax and because I enjoy creating something out of nothing. I just have a love for quilts that I'm sure my mother passed on to me." Her work has received recognition by being accepted for exhibition at the Abilene Fine Arts Museum.

BLAZING STAR QUILT

70″ × 90″
Cotton

1945

Pieced and quilted by Armenda (Minnie) Elizabeth
Eeds Mercer in Gonzales, Gonzales County
Owned by Kathleen H. McCrady

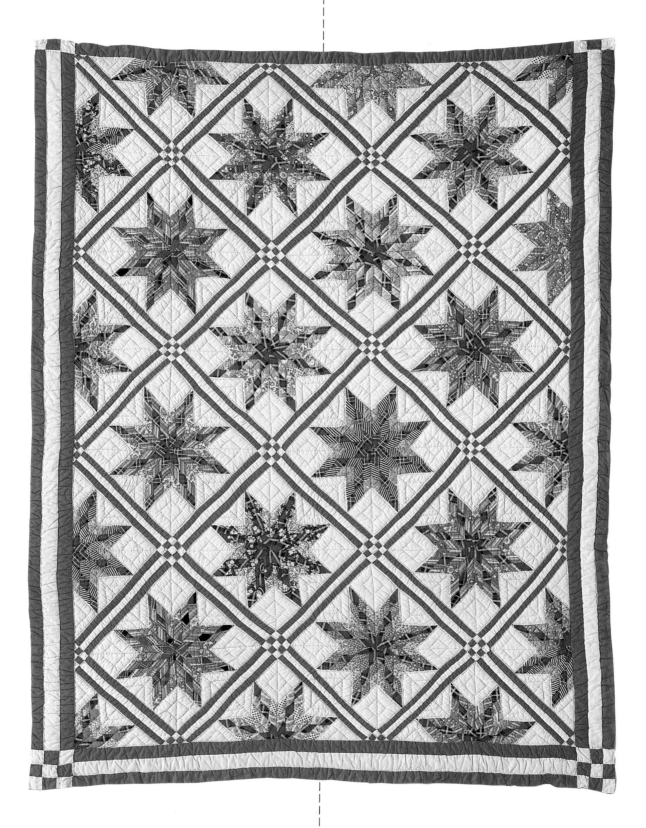

AN IRISH TEXAN whose father emigrated to Texas from Alabama in the late 1800s, Minnie Eeds Mercer was born in Prairie Lea, Caldwell County, in 1892.

Her quilt, made in 1945, is a very crisp and colorful example of a Blazing Star scrap quilt. The top uses prints with red plaids in each of the stars, which are in blocks of muslin set on their points. The setting features two bands of brilliant solid red separated by a band of muslin, with tiny red-and-white Nine Patches at the junctures. The border repeats this same three-banded design on a larger scale, with larger Nine Patches at the corners of the quilt.

The backing of this quilt is pieced of muslin that has a very thin, red pin stripe, such as that often found in tea towels of the era. This quilt is quilted in outline quilting on one side of the piece only, and on one side of the red strips and border. The quilting is relatively simple, and the quilt-maker took four to six stitches per inch. The front of the binding is taken to the back.

This quilt was part of the Goethe Institute's exhibition, A Patchwork Melting Pot: Ethnic Quilts in Texas, which was curated by Suzanne Yabsley. This exhibition, which hung at the institute's headquarters in Houston during October and November 1987, focused on quilts made by members of various ethnic groups that helped to settle Texas.

According to Ms. Yabsley, Minnie Eeds Mercer's father "bought land in the South Coastal area of Texas, where Irish settlement was particularly concentrated, married, and began his family . . . The Irish were among the earliest pioneers in Texas, having established themselves as a group in Mexico for some years prior to Texas's bid for independence. Although the Irish eventually settled throughout Texas, two of the earliest Mexican land grants were given to Irish empresarios. The communities of Refugio and San Patricio along the South Texas Coast were originally Irish colonies."

Mrs. Mercer, whose mother died when she was young, was taught to quilt by an older sister and other relatives. She had three children herself and died in Gonzales, Gonzales County, in 1976.

Armenda (Minnie) Elizabeth Eeds Mercer
(Studer photo)

RAILROAD CROSSING QUILT

68″ × 84″
Cotton

ca. 1945
Pieced and quilted by Ruby Bates Smither in
Mabank, Kaufman County
Owned by Isabell "Mopsy" Andrews

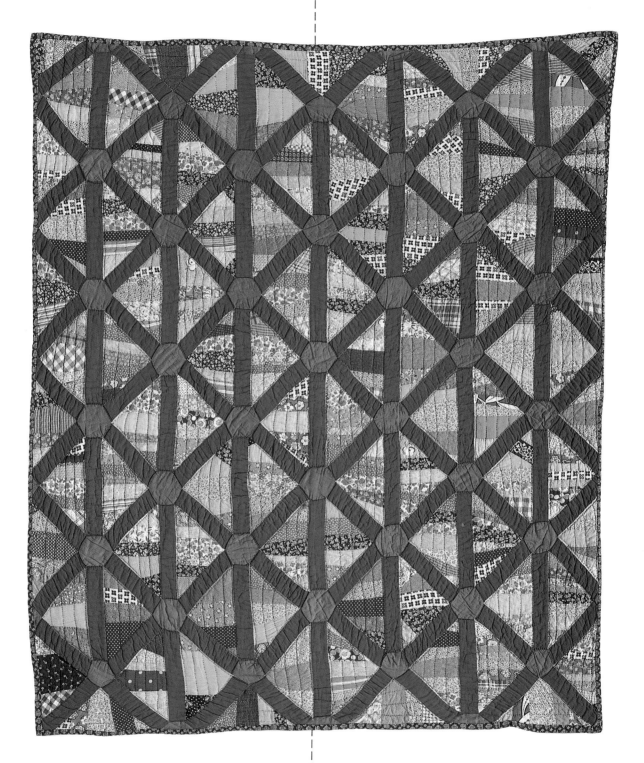

RUBY SMITHER was born in 1904 in Mabank, "a straight shot from Gun Barrel City," where her father's family owned land, according to her niece, who inherited the Railroad Crossing when her aunt by marriage entered a nursing home in 1982.

The quiltmaker graduated from high school and enrolled at Methodist Hospital in Dallas in 1928 to study nursing. She became a registered nurse in 1931 and devoted her life to that profession, later becoming administrator of hospitals in Carrollton and Athens.

"Aunt Ruby always loved to sew and her wardrobe was all handmade, including her coats and suits. She and her mother made several beautiful quilts in the 1920s and early 1930s before Ruby married," said "Mopsy" Andrews.

Mrs. Smither had been taught to quilt by her mother, Gertie V. Thompson Bates, and had made her first quilt in 1920, when she was sixteen years old. She used to quilt in the parlor of her parents' house, and most of her quilting was done before she left home. She married on June 23, 1934, in Bryan County, Oklahoma, when she was thirty. She and her husband had no children.

Her Railroad Crossing quilt has great graphic appeal and uses a number of 1940s plaids and some patriotic fabrics. The backing is an unusual print of red, white, and pink on navy, with some small designs that are similar to quilt blocks, a girl, and a star.

It is hand-pieced from scraps pieced onto a foundation, the method known as string piecing. Simple outline quilting is used and quilting rows are from one and a half to two inches apart. There are four to six stitches per inch, and the quilt is finished by the back being brought to the front of the quilt.

The Railroad Crossing pattern selected by the quiltmaker is especially appropriate because Mabank, settled about 1846 on the southeastern edge of Kaufman County, was on the Texas and New Orleans Railroad, now the corporate name for Southern Pacific's operations in Texas. Prior to the Civil War, Mabank had been west of its current site but was moved to the present location in 1873 to be on the railroad, which provided a vital transportation link for the farm products of that area of the county.

Ruby Bates Smither

SEVEN SISTERS QUILT

73″ × 87″
Cotton

1947

Pieced by Tomasita Ferro Bastardo in San Angelo,
Tom Green County
Quilted by the Miles Senior Citizens in Miles, Tom
Green County
Owned by Josephine Juarez Carrillo

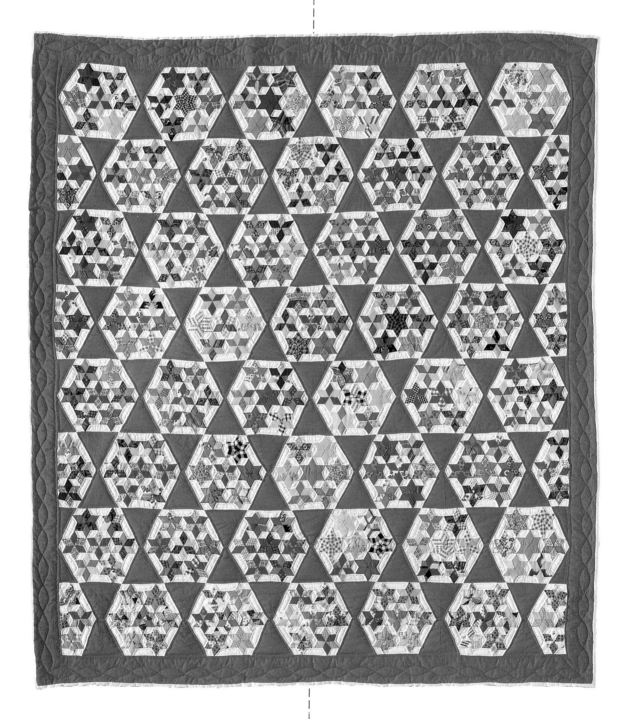

BORN in San Antonio in 1880 and transplanted to San Angelo as a young child after the death of her mother, Tomasita Ferro Bastardo and her relatives were among the early Mexican Americans in that city, which had been organized in 1875.

When her mother, who was born in Presidio and married a man from northern Mexico, died, Mrs. Bastardo was sent to live with an aunt in San Angelo. Her aunt, Alvina Morales, passed on her knowledge of quilting to the little girl, who made her first quilt top when she was nine years old.

Tomasita Ferro Bastardo lived the rest of her life either in the small town of Knickerbocker or in San Angelo. After she married in 1899, Mrs. Bastardo carried on the family quilting tradition herself, and other family members often joined in to help her quilt as well. Widowed when she was very young and with eight children to raise, Mrs. Bastardo helped support her family by selling her quilts and by occasionally catering for weddings. A self-reliant woman, she also taught herself to read English and to do math. She also made many quilts for gifts, such as this Seven Sisters top, which she gave to her granddaughter Josephine Juarez Carrillo upon her marriage.

Mrs. Carrillo said that in 1947, when her grandmother pieced the quilt, "It was hard times and she did not have enough material, so I had to piece the border later. She used every little scrap she could find because there was no money to go buy new materials."

Her grandmother followed the old tradition of piecing tops and saving them, not spending the money to buy batting or backing fabric or expending the labor involved in quilting them until there was a particular reason. That could sometimes be a wedding, a significant birthday, the birth of a baby, or even, in the case of quilters who "quilted for the public" (the old-fashioned phrase used when women made quilts for sale), when someone liked a top and wanted to purchase it as a finished quilt. Many times, quilt tops were handed down in the family, with the recipient either quilting a top or paying someone to quilt it. The Seven Sisters top, for example, was quilted for Mrs. Carrillo by the Miles Senior Citizens. They quilted it on one side of each piece only with seven to nine stitches per inch. The back is brought to the front to finish the quilt.

In our own family, our great-grandmother pieced a number of Star quilt tops, which were given to her great-granddaughters when they married, long after her death. The tradition in our family was that a quilting bee took place to "quilt the girl's top" when she became engaged.

Mrs. Bastardo obviously took a great deal of pride in doing a fine job with the materials she had at hand. Her piecing is quite good, and she has made effective use of the fabrics in her scrap basket to create a striking, colorful design. Seven

Tomasita Ferro Bastardo at age ninety, 1970
(Wallace Studios photo)

Sisters is also called Seven Stars or Boutonniere, as noted in Hall and Kretsinger's *The Romance of the Patchwork Quilt in America,* which adds that the pattern "offers many interesting possibilities and makes a very attractive quilt when set together with triangles" (p. 55). In this case, the large red-orange triangles surrounding the groupings of seven six-pointed stars form vivid six-pointed stars themselves.

Mrs. Bastardo's Seven Sisters quilt illustrates how dramatic a scrap-basket quilt can be. "Use it up, wear it out, make it do, or do without" is a well-known maxim among Texas' early quilters, those who quilted during the Depression, and quilters working in the years during World War II and immediately following. The limitations imposed by thrift, however, never precluded good craftsmanship, and many wonderful quilts that are now family treasures, such as Seven Sisters, resulted from inventive forays into the scrap basket.

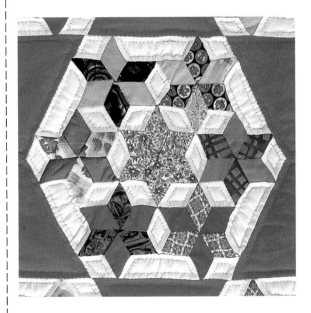

SUNBURST QUILT

66½″ × 88½″
Cotton

1948

Pieced by Annie Mabel Bridges England in Luling,
Caldwell County
Quilted by Rosemary England, native Texan, in Terre
Haute, Vigo County, Indiana
Owned by D. Gene and Rosemary England

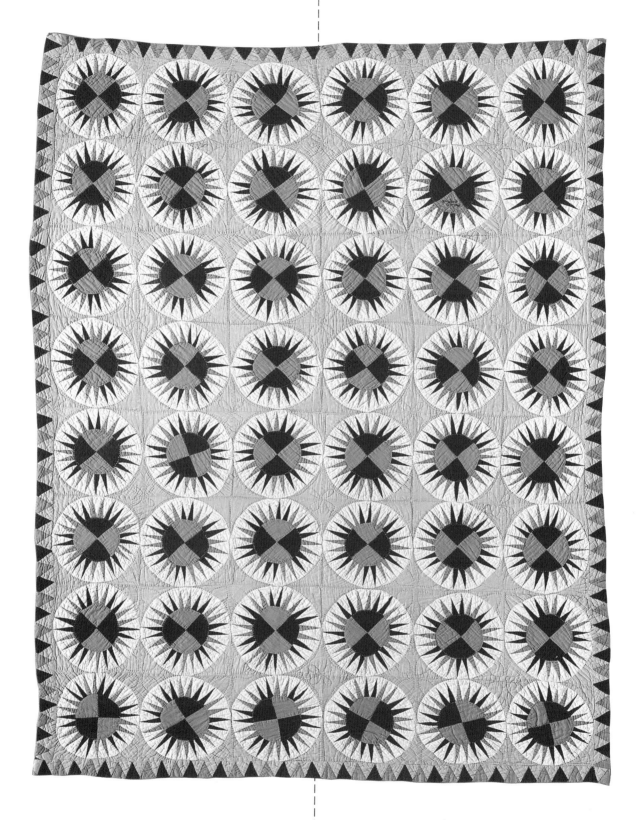

A QUILTMAKER who spent her entire ninety-four years in Texas, Mrs. England lived in Sullivan, Kingsbury, and Bethany, all in Guadalupe County, for her first thirty-eight years. She and her husband, who was a mule-team contractor for Magnolia Oil Company, now Mobil Oil, and whom she married in 1909, moved to Luling in 1924, where she spent the remainder of her life. Her husband died in 1938, when their three children were in their twenties.

"Mama" England, as she was known, was basically a homemaker but clerked in a local clothing store in the 1930s and 1940s. She completed all of the grades of public school that were offered at the time and married in 1909.

Mrs. England raised chickens, grew flowers, and was "an extremely independent woman, at least during the latter part of her life," according to her grandson and his wife, who now own the Sunburst. As a widow from 1938 to her death in 1980, she "had to learn to do for herself with very little income."

Her grandson said that, though her house usually needed paint and repairs, it was clean and the yard was full of flowers of every kind. "She walked every day and visited the 'old ladies.' She was always concerned about 'poor old so-and-so' and it didn't matter that they were twenty years younger." He recalled that one of her sons became convinced in the late 1940s that Mrs. England was "going to kill herself plowing the huge plot of land with her hand plow, so he broke it. She hand spaded the plot from then on."

Mama England loved to piece quilts, and her Sunburst top was machine pieced on a treadle sewing machine. She pieced a number of quilts in the 1940s and early 1950s. After 1963, when her grandson, D. Gene, married, she gave this Sunburst top to the couple, who now live in Indiana. His wife, Rosemary, herself a quilter, finished the top in outline quilting one-half to one inch apart. ("Do I qualify as a Texan?" she asked. "I'll be surprised if I'm not, as I was born and raised in Texas and come from family that arrived in the 1850s." She did qualify, for the reason best expressed by T. R. Fehrenbach in *Seven Keys to Texas*: "A Texan who goes to Washington or New York [or, in this case, Indiana] may make his mark on the nation, but he remains a Texan" [p. ix]). In the mid−1960s, Mama England gave several more tops to them, which they had quilted in Luling by a church quilting group.

Mama England liked to quilt alone or while talking to family or friends or listening to the radio. After she got a television in the 1960s, she worked in front of it. She never sold her quilts; instead she either gave them to family or friends or used them herself. Quilts were made in preparation for marriage in Mrs. England's day and thereafter as cover was needed, so she learned the basics of quilting from her mother as a young girl. She completed the first quilt of her own in her early teenage years on her family's farm in Guadalupe County, but her family is not sure what the pattern was. Mrs. England never entered quilt competitions, quilting instead for her own pleasure and that of her family.

Showy red-and-orange sunbursts, each with twenty-four rays, in white circles on a light gray-blue, almost chambray-colored background make this a striking quilt. All in all, the quiltmaker "was very bold in her choice of colors," as her grandson pointed out. The quilt top originally had a border of alternating red-and-orange diamonds. There are three tiny mended places in the orange fabric, evidence that care was expended in preserving this quilt.

The quilt is quilted on one side of each piece in outline quilting. Rows of quilting are one-half to one inch apart, and there are five stitches per inch. The quilter turned one-half of that original diamond border to the back and backed the quilt with a deeper turquoise. The back of the quilt now is as vivid as the top.

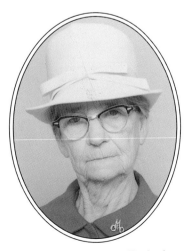

Annie Mabel Bridges England

WHEN I PUT OUT TO SEA QUILT

78″ × 85″
Cotton

1948

Appliquéd, pieced, embroidered, and quilted by
Felma Green Headrick in Georgetown, Williamson
County
Owned by Ray G. Green

THIS UNUSUAL pictorial quilt was made in memory of the quiltmaker's husband who served in the United States Navy in World War II and died in 1946 of service-related injuries. Original pictorial quilts were uncommon during the 1940s, and this example features both significant imagery and symbolism. Perhaps the most remarkable fact about this quilt is that the quiltmaker created and finished it in only eighteen days: April 12 through April 30, 1948. She worked both day and night on the quilt to complete it in time to be included in the Georgetown Centennial celebration, where the patriotic theme made it tremendously popular with visitors to the event. One anonymous visitor was so moved by the quilt, which was on display in one of the town merchant's show windows, that he or she recorded impressions of the quilt and sent a long letter about it back to the *Williamson County Sun.* Included in the letter were these comments:

Both old and modern history [were] combined to show a minute picture of our progress from the Liberty Bell to our modern war planes and battleships of today— the Flag we love and honor and the old Eagle which lifts his head high and proudly stands guard over us all. [The quilt tells] a story of a sailor, of all sailors, who did his bit for the land he loved and has now passed over the Sea of Death to claim the reward he so richly deserves.

The sea gull seems to claim an honored place in this memory quilt—with one small bird stopped in his flight where the sea washes the sandy beach, seeming to miss the sailor friend who has gone away. The anchor wedged into the sand shows a good strong loyalty to our U.S. Navy, of which we are all proud. This quilt honors the memory of all our sailor boys who fought a good fight and gave their lives—and in so doing, perhaps their children will have the great privilege of celebrating another Centennial.

The quilt is quilted in a medium grid of approximately 1½ inches, and each piece is outline-quilted. In addition, clamshell quilting, appropriate for the theme of the quilt, is used in the design, as are clouds and waves. The words "When I put out to sea," "U.S. Navy," and "S 1/C" (seaman first class) also appear on the quilt. Embroidery is used to create the illusion of froth as the waves break on the beach. The seagulls are realistically captured in fabric and stitching. The Texas flag symbolizes both the birthplace of the quiltmaker and the naval base in Corpus Christi where her husband was stationed.

Felma Green Headrick was born in 1905, met and married her husband, and died in 1988, all in Georgetown. She worked briefly as a beautician and lived on her widow's pension after her husband's death. She learned to quilt from her mother. Her brother, now the owner of this quilt, recalled: "She was interested in many things. She painted in oils, she did leathercraft and macramé, she made many quilts, and she attempted to play the accordion. Most of her quilts were made to use and to give away."

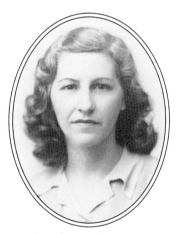

Felma Green Headrick

DOUBLE WEDDING RING QUILT

72″ × 85″
Cotton

ca. 1948

Pieced and quilted by Lelia Mae Smith Mackey in Uvalde, Uvalde County
Owned by Margie Welty Barber and Raynese Welty Woody

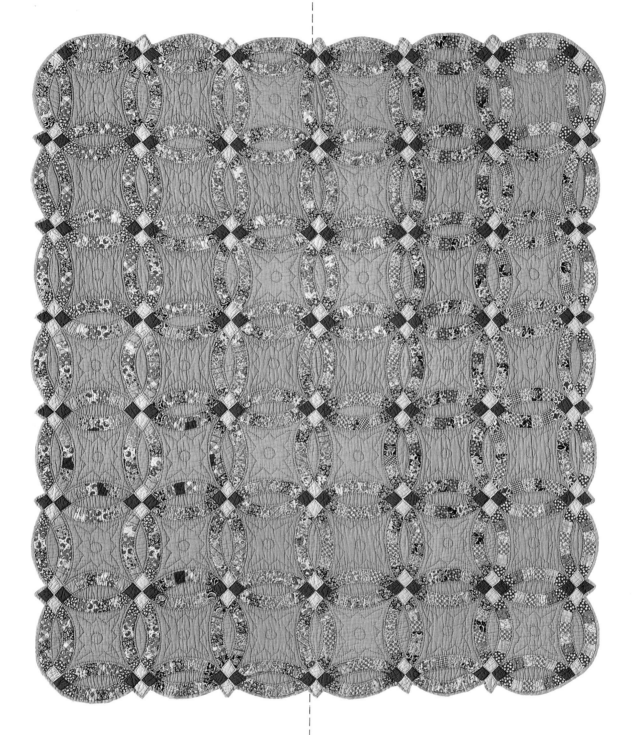

THE DAUGHTER of a trail driver featured in John Marvin Hunter's book, *The Trail Drivers of Texas*, and the first white child born in Fort Inge, whose own father was an army scout and buffalo hunter, this quiltmaker lived through a historic time in the Hill Country and in northern Mexico during the days of Pancho Villa and the revolution.

Lelia Mae Smith Mackey was known as "Momo" to her granddaughters who inherited this quilt and eight others she made. Born on April 10, 1889, in Uvalde, she was one of eleven children and lived on a ranch much of her growing-up years. The family also maintained a home in town where the children attended school, a common custom for ranch families in Texas. Following her school years, she and her sister worked at the telephone company until she married on December 23, 1912. She had taken the train to visit an older married sister who lived in Port Arthur when she met her husband, Charley Leslie Mackey, whose family lived next door to her sister's.

The young couple set up housekeeping in Port Arthur and stayed there until 1914, just before their daughter, Gladys, was born, when they moved to Del Rio. Because of her pregnancy, Mrs. Mackey stayed with an aunt in Del Rio while her husband worked on a ranch some distance from town, able to get into town to see her only every two or three weeks.

"Meantime, Papa and Mama had moved down in Old Mexico, about 200 miles below Piedras Negras, where Papa was running a large ranch for the Washer Brothers of San Antonio," Mrs. Mackey recalled in an interview with a reporter from the *Uvalde Leader-News* in 1972. Her father had to visit Eagle Pass on business and extended his trip to go see his daughter and three-week-old grandbaby in Del Rio. "When he found out I was staying with Aunt Fannie and Charley was off at work without me he just had a fit." Her father, who had gone "up the trail" six times in the 1870s and early 1880s and was a charter or early member of the Old Trail Drivers Association of Texas, probably could have expressed himself rather vigorously. He insisted his daughter pack up her things and those of the baby and return to Mexico with him. In those days, women were likely to comply with such ultimatums, as Mrs. Mackey did.

She had no way of getting word to her husband, and when he returned to town and found his wife and baby gone, he caught the first train to Monclova, Mexico. He rented a horse for all of his smoking tobacco and rode it bareback for several miles before finding a fellow who would trade him an old saddle for a pair of khakis. Because of the unrest in the area due to the revolution, the gates to the family's ranch were kept locked, so when he reached them, Mr. Mackey turned the horse loose to make its way home and walked the distance to

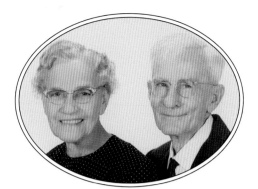

Lelia Mae Smith Mackey with her husband, Charley Leslie
(Hall Studio photo)

the ranch headquarters, surprising his wife and astonishing his father-in-law.

The Mackeys lived in Mexico two years and found it beautiful country, with mountains and wild game. They lived in a large, adobe ranch house with a Chinese cook. Mrs. Mackey's father got along with both the Mexican soldiers and the revolutionaries. Mrs. Mackey recalled: "Pancho Villa's men camped near the ranch house many times and he sometimes had as many as 1,800 men with him . . . Papa caught one of the soldiers with one of his registered bulls once, ready to butcher him, but he raised such a ruckus the soldier let it go . . . The Nationalist soldiers were much worse about killing your beef and stealing your horses than Pancho Villa's men were."

As the war worsened, Mrs. Mackey's father and the ranch owners determined to leave with as much of the stock as possible but were only able to get a small part out in 1917. The Mexican government confiscated the rest. "We couldn't get out by way of Piedras Negras, so had to come out by Boquillas in the Big Bend," Mrs. Mackey said.

Her granddaughters recalled hearing that their great-grandmother, Sarah Andrew Fulgham Smith, who died in 1948, taught Mrs. Mackey to quilt and crochet. Her quilts were quilted on frames set up in her dining room. Mrs. Mackey made this quilt in about 1948, when she was around fifty-eight; she died in 1981.

This particular pattern is one of the most beloved of the 1930s and 1940s. As the authors of *The Romance of the Patchwork Quilt in America*, Carrie A. Hall and Rose G. Kretsinger, point out, "Real quilt enthusiasts delight in this all-over pattern but it is hardly the design for the novice to undertake" (p. 101). Pastels and flowered scraps cut into small pieces, finished scallops formed by the completion of the rings, and a separate bias binding make this a model Double Wedding Ring of the era. It is simply quilted with four to six stitches to the inch.

LITTLE WOMEN QUILT

78″ × 94″
Cotton

1951

Appliquéd, pieced, and quilted by Betty Huegele in
San Antonio, Bexar County
Owned by the quiltmaker

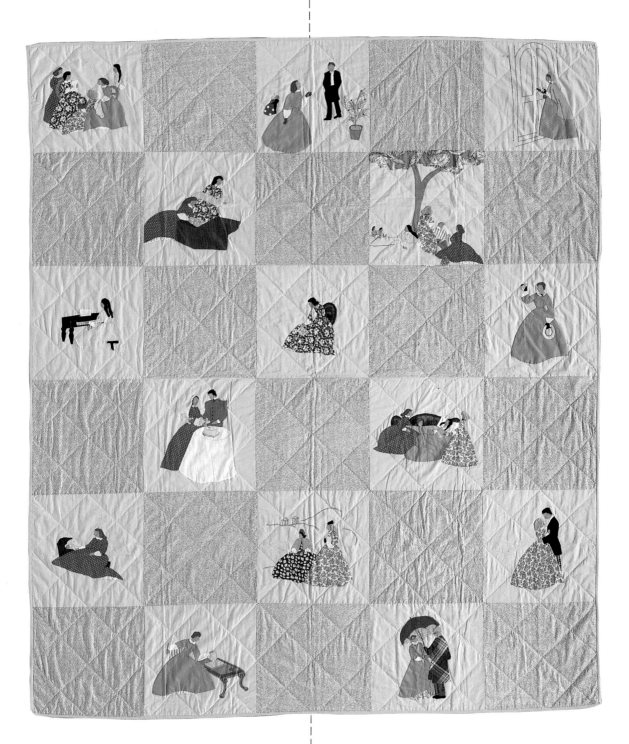

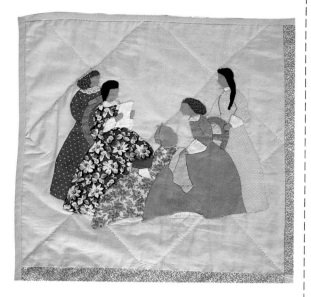

WORKING with patterns ordered through *Ladies' Home Journal* magazine, this quiltmaker visually conveys the story of Louisa May Alcott's well-loved book *Little Women*. The appliqué blocks each depict a scene well known to readers and moviegoers who remember the 1949 version starring June Allyson as Jo, Margaret O'Brien as Beth, Janet Leigh as Meg, and Elizabeth Taylor as Amy.

The 1930s and 1940s saw the development of quilts that mirrored popular culture in a realistic, rather than abstract, manner—in the Texas Quilt Search a significant number of quilts were found in this category. One well-known Texas quilt, made in 1932 by Fannie B. Shaw in Van Alstyne, gained national fame because of its pictorial depiction of one of the most popular catch phrases of the day: "Prosperity is just around the corner." In it, people from all walks of life, including the Democratic donkey and the Republican elephant, are pictured peering around a corner. In Wichita Falls were seen two Crayola-style quilts, one that depicted the Campbell Soup Kids in all their advertisements, another that illustrated Shirley Temple in her many screen roles. Another delightful quilt consisted of original designs taken from the comic strips of the 1930s and 1940s. In San Antonio was found a quilt made entirely of flour sacks printed with Texas memorabilia and the slogan, "Please pass the biscuits, Pappy," referring to a popular Texas governor of the period,

W. Lee "Pappy" O'Daniel. Literary figures, movie stars, popular figures from advertisements, politicians, comic strip characters—all played a role in the development of this minor, but fascinating, category of quilts.

Little Women is completely hand-appliquéd; the blocks are pieced together. It is hand-quilted in a medium grid design with squares larger than two inches. The simple quilting designs are executed with seven to nine stitches per inch, and the appliqué designs are outline-quilted. "Family members helped with the quilting," recalled the quiltmaker who learned to quilt by helping two aunts "whenever they had a quilting bee." She was only twenty-four when she made this quilt "in her spare time" while working full-time as a registered nurse.

Born in 1927 in San Antonio, Betty Huegele graduated from nursing school, married, and had three children. Today she makes baby quilts for gifts and works alone on a hoop while watching television. She chose to make this quilt as her first effort because "I loved the story about the *Little Women*."

Betty Huegele

79

FAN QUILT

58″ × 70″
Cotton

1955

Pieced by Merle Blanche Ellerbe Gallagher in
Kermit, Winkler County
Quilted by Wanda Fae Hanson Gallagher and Linda
Gallagher Joiner in Abilene, Taylor County
Owned by Linda Gallagher Joiner

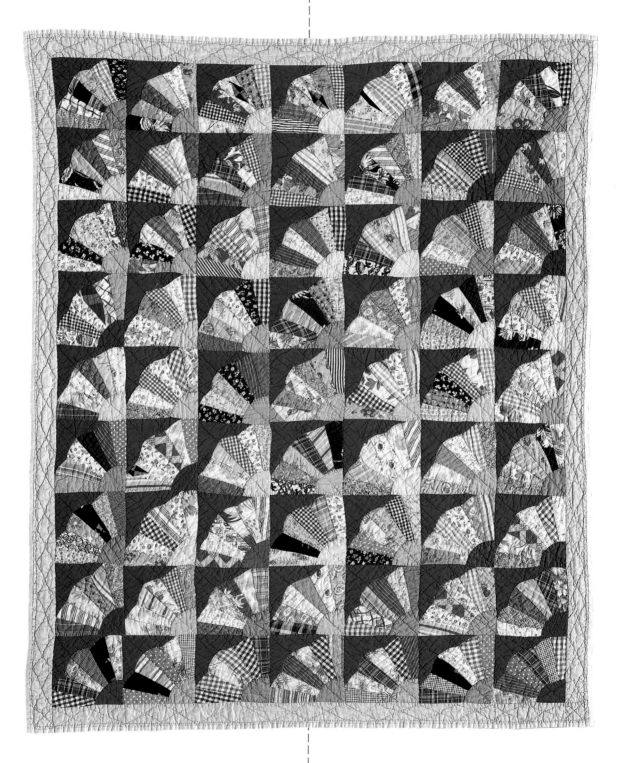

A DUTIFUL grandmother who made quilt tops for each of her ten grandchildren during the 1950s, Merle Gallagher breathed a sigh of relief when the last one was finished. But later, a shoe box of scraps sent by her daughter-in-law announced to Big Mama better than any letter that grandchild number eleven was on the way and her piecing days were not over yet.

Born on April 28, 1904, in Grandview, Johnson County, Mrs. Gallagher eloped at age sixteen by complaining of a headache and being sent, ostensibly, home from school. Actually, she ran away and got married. She had four children and raised them and lived most of her life in Jayton, Kent County. During World War II, she moved to Jal, New Mexico. When her husband worked for El Paso Natural Gas, the couple lived in West Texas, New Mexico, and Arizona. They retired to Kermit, Winkler County, where Mrs. Gallagher died in May of 1989.

Because of his position as a construction foreman for the gas company, the couple traveled in their small mobile home. Her granddaughter, Linda Gallagher Joiner, for whom this Fan quilt was made, recalled: "Merle loved flowers, especially roses. She had a beautiful rose bush in a large barrel that she took with her on the road. It was the first thing off the trailer when they arrived at their new location and the last thing that was put back on when they left. The rose bush made every location 'home'."

Her grandmother sewed for herself, her daughters, and for the public throughout her life and probably acquired a lot of scraps for her quilts from her sewing. She made quilts for each of her four children and tops for the grandchildren. "She was always busy with her hands, most often with crochet," Mrs. Joiner said. "She liked to crochet better than quilting. During the thirties the house in Jayton in which she and her husband were living burned to the ground. Merle was busy crocheting at the time and was able to save only what was on the table beside her chair, but that included a wonderful crocheted tablecloth which she had made."

During the Depression, Mrs. Gallagher raised, picked, shelled, and canned blackeyed peas for five cents a quart. "She was an excellent cook, especially well known for her sourdough bread, for which she used a potato sourdough starter, for her jalapeño pepper jelly, and her wild plum jam. She sold her bread, jams and jellies, plus needlework items, and one year she had enough money from such projects to buy her husband a recliner for Christmas," Mrs. Joiner added.

Mrs. Gallagher played the piano, especially hymns, for she was a dedicated Methodist and very active in the church. She also volunteered for

Merle Blanche Ellerbe Gallagher

many years as a "pink lady" at the hospital. In addition, she was a talented gardener. Her granddaughter remembered: "The Gallagher home was a garden spot in the barren terrain of Kermit in the West Texas Permian Basin. There were fruit trees, pecans, grapes, a year-round vegetable garden, and flowers, lots of flowers—especially roses."

The quilt tops this active quiltmaker machine-pieced were utilitarian ones, but they made effective use of the scraps to which she had access. Her daughter-in-law, Wanda Fae Hanson Gallagher, and her granddaughter, Linda Gallagher Joiner, finished this Fan quilt, which had been pieced for Mrs. Joiner, in 1974. They outline-quilted one side of each piece in seven to nine stitches per inch and finished it by bringing the back to the front. Now the quilt is used on the bed of the quiltmaker's great-grandson, Elijah Scott Joiner, named after Linda's father, Wanda's husband, and Merle's son, who died at the age of fifty-four.

"One of the saddest things I have ever seen was his parents standing with their arms around each other alone over his grave," Mrs. Joiner remembered of her father's death.

CROSSED CANOES
QUILT

82″ × 97″
Cotton

1957

Pieced by Retta Booher Holland in Grand Prairie,
Dallas County
Quilted by Kathleen Holland McCrady in Austin,
Travis County
Owned by Kathleen Holland McCrady

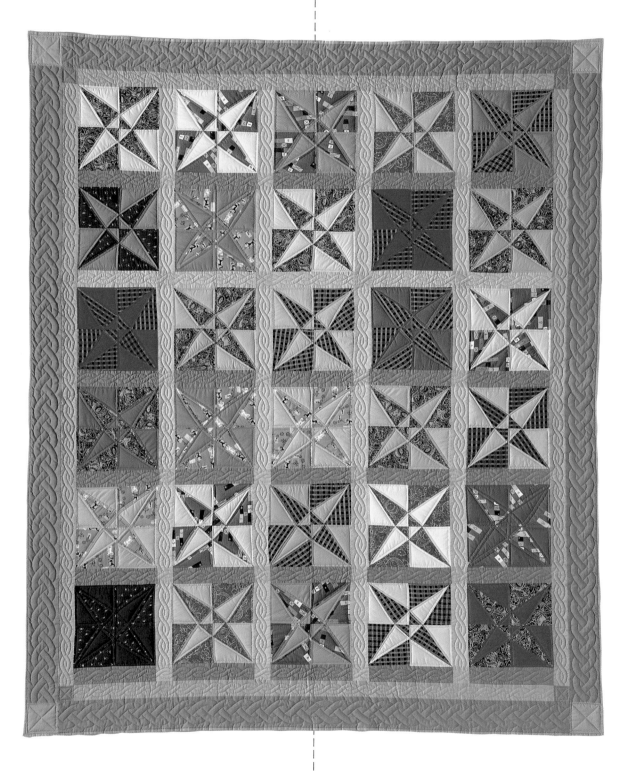

THE 1950s may have been a quiet time politically for the United States, but the fashions of the decade were anything but quiet. From the vestiges of Christian Dior's "New Look" with its boning and tiny waists to the popular chemise, or "sack" dress, that closed the decade, the 1950s was a time of retrospection. Hoop skirts swayed on a daily basis for the first time since the Civil War era, and high school girls, reverting to the days of their great-grandmothers, went to school in layers of petticoats holding out their voluminous skirts, which often contained more than four yards of fabric.

The cotton fabrics available during the 1950s featured bold colors, sometimes garish patterns, little subtlety, and popular abstract designs taken from modern art. This Crossed Canoes quilt could serve as a sample album of 1950s textiles, because it was made entirely of scraps, or "cutaways," from a dress factory in Grand Prairie. "It was such fun to get a sack of scraps, for they were prints and solids coordinated," remembered the quiltmaker's daughter, who later quilted the top. She recalled that the price of a grocery sack of scraps was only one dollar.

The pattern, also known as Indian Canoes, creates the visual illusion of curves in the construction of the canoes although each block is composed entirely of straight-line machine piecing. The quiltmaker's daughter purchased a fifty-cent pattern for this quilt that was copyrighted by McCall's in 1953; the pattern package also contained instructions for five other well-known quilt patterns based on twelve-inch blocks: Peony, Star, Wild Rose, Garland, and Basket. The quiltmaker, who learned to quilt from her own mother, may have borrowed her daughter's pattern to make this quilt, because the daughter remembered that "she did not make quilts after about 1946, so this one was pieced because I was getting scraps and she decided to do one too."

A classic generation quilt, begun by one generation and finished by another, Crossed Canoes shows how the love of quilting is handed down through families just as family heirlooms are carefully bequeathed to family members who will treasure them. The daughter chose to quilt the top by stitching on both sides of each piece as well as quilting "in the ditch" where the quilting stitches are actually in the seam. She added grey borders to contain the vivid colors of the pieced blocks and quilted the borders in a running cable. Her quilting stitches measure seven to nine per inch. The edge of the quilt is finished with a separate straight binding.

Retta Holland was born in 1896 in Grayson County, Texas, married in Cooke County in 1912, reared five children, and died in 1971 at the age of seventy-five in Fort Worth. As remembered by the daughter who quilted Crossed Canoes, "My dad farmed most of his early life, and mother was the housewife and part-time farm hand, making do and making over as many women did during the Depression." Like many other families during World War II, when new opportunities opened up, the couple left the farm and began working for wages; Mrs. Holland worked in a cafeteria in Fort Worth. Toward the end of the war, they moved to California to work on the campus of Fresno State College and returned to Fort Worth in 1946. They built a washateria in a northside neighborhood and ran it for about six years, then moved to Grand Prairie where they ran a small diner. "Mother worked hard all her life, and perhaps enjoyed most the part of her life after they retired from the café business," recalled her daughter. "She sewed for others and worked for her church, keeping babies in the nursery. She was always busy, seemed happy with her lot in life, and made the best of her situation."

Retta Booher Holland
(Olan Mills photo)

THE GREAT EAGLE QUILT

72″ × 78″
Cotton

1957

Pieced, appliquéd, and quilted by Lotta Meeks
Snyder in Oakwood, Leon County
Owned by the quiltmaker

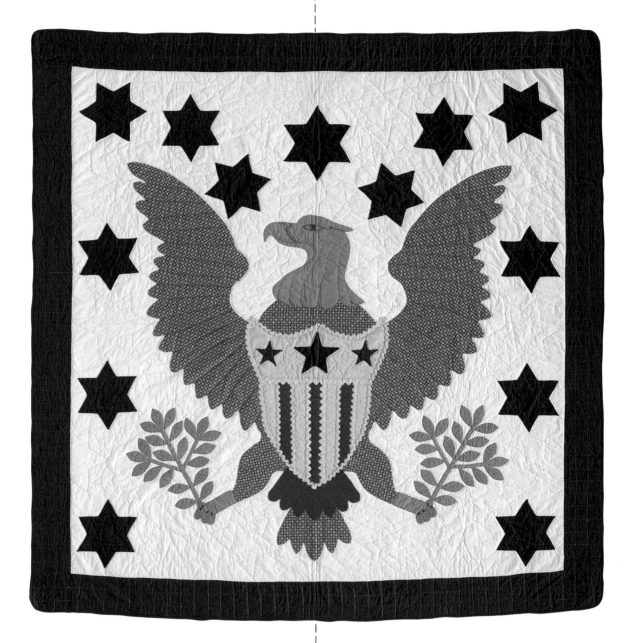

"WELL, of course, when I was young, my mother made quilts. I was born before New Mexico became a state and it was wild country then, and cold. We had to make quilts for cover; we had no electric blankets. As soon as I was old enough, I was taught to quilt. For my first quilt, we had to card the cotton."

That is how Lotta Meeks Snyder remembers learning to quilt. She made her first complete quilt in 1930 from a pattern published in the *Fort Worth Star-Telegram* when she was twenty years old. Before then, "Mama let us help on her quilts."

Born in Logan, New Mexico, in 1910, she taught school two years, married there in 1930, and moved to Texas in 1933, living in Brownwood and then in Oakwood, near Palestine. Mrs. Snyder's husband owned his own business and was also a cattleman before he retired. She is now a widow with a lot of hobbies, including oil painting, which she has studied for two years, crochet, and, of course, quilting. She generally makes three or four quilts a year and is at work now on a Double Irish Chain quilt that she plans to enter in a show in Marshall, where she now lives.

In 1954 or 1955, Mrs. Snyder began making The Great Eagle, from an original pattern designed by her aunt, Nancy De Phillips, who is now in her mid-nineties and living in a rest home. She thought a quilt featuring "our national bird, the Eagle," would be beautiful. She made the entire quilt of cotton—top, batting, and backing—and outline-quilted her pieced and appliquéd design on both sides of the pieces with six stitches to the inch.

Her efforts resulted in a folk-art quilt that is strikingly dramatic and surprisingly sophisticated.

The graceful and dignified eagle bears a colorful, warlike shield but also clasps olive branches in both sets of talons. A very orderly galaxy of thirteen large, navy blue stars surrounds him. It is no wonder that The Great Eagle was a popular entry in the touring exhibition of the Great Texas Quilt RoundUp during the State's Sesquicentennial celebration. Mrs. Snyder regularly receives requests to exhibit this quilt and others in fairs and quilt shows in such locations as Longview and Jefferson, as well as in Marshall. Many of her quilts have won ribbons in various shows.

When she retired as a realtor, Mrs. Snyder decided to make her son and daughter and all her grandchildren quilts. They not only encourage her quiltmaking but also now remind her whose turn it is for one. She quilts alone in the early morning on "old-time frames" in her dining room, the largest room in her house, and works just because she loves to see all the pretty quilts emerge from the frames.

Lotta Meeks Snyder

LONE STAR QUILT

88″ × 88″
Cotton

1961

Pieced and quilted by Marguerite Evelyn Houston
Brock in Dalhart, Dallam County
Owned by the quiltmaker

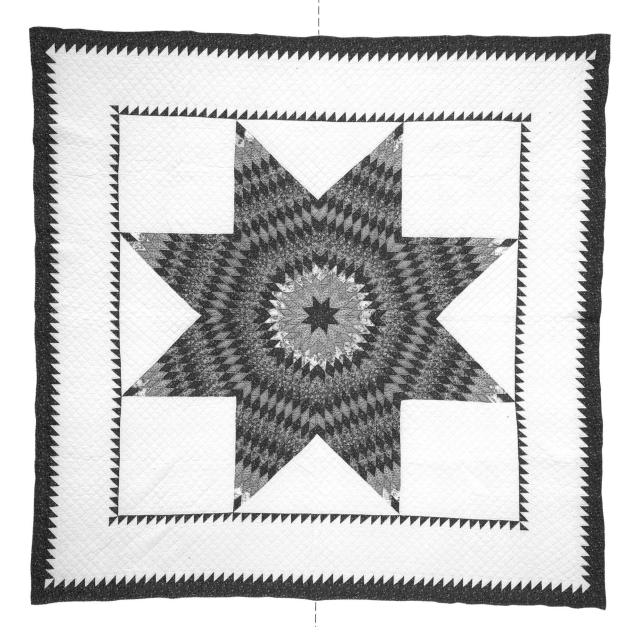

OFTEN called "the national quilt of Texas," the Lone Star quilt had its origins in the biblically named Star of Bethlehem; the "Lone Star" of the quilt title refers not to the five-pointed star seen on the Texas flag but to the fact that the one majestic star reigns alone on the quilt. Whatever the origins of the name, the fact remains that Texas quiltmakers took the Lone Star pattern to their hearts, and thousands have been made in the Lone Star State.

This particularly elegant example, with its combination of printed and solid color fabrics, was pieced in the 1950s and quilted in 1961; that date has been quilted into one corner. The quilt was machine-pieced and set with unbleached domestic, or muslin. One of the early synthetic battings was used when the quilt was finished. "I've been piecing and quilting all of my adult life," recalled the quiltmaker. "I learned to quilt from my grandmother and began making quilts as a means of providing bedding. I made my first quilt when I was sixteen or seventeen years old in Stinnett, Texas. Later I continued to quilt because of a love of the art. I saw this design in a magazine and liked it, so I made it," she added. "I worked on it during the winter months."

The heavy quilting contributes a lush texture to the quilt that emphasizes the striking colors chosen by the quiltmaker. The use of the blue-green shade in this quilt is especially effective in contrast to the dark reds and olive greens. Without the extensive quilting, which measures seven to nine stitches per inch, this Lone Star would have been just another pretty quilt. It is the quilting that makes this quilt a masterpiece. A close crosshatch design, or grid, is used throughout the background of the design, and each diamond in the star has been outline-quilted on both sides of the piece. Two sawtooth borders are used quite effectively: the first frames the Lone Star itself as a central design element, the second repeats the first frame at the outer edge of the quilt. A separate bias binding is used to finish the quilt.

Born in Union County, New Mexico, in 1915, the quiltmaker, like many others of her generation, finished the eighth grade and had no other formal education. Mrs. Brock married in 1934 in Stinnett, Texas, and reared four children in the Texas Panhandle, where she has lived for more than sixty years. She has been custodian of the First Christian Church in Dalhart for almost twenty years. She makes one or two quilts a year as a creative outlet for her energies and works alone on her hobby. She has won several blue ribbons for her quilts, and one of her designs was once named grand champion at the local fair. Mrs. Brock is an outstanding example of the way quilting skills and the love of fine quilts are handed down through the generations. The Diamondback Rattlesnake quilt described in *Lone Stars, Volume I: A Legacy of Texas Quilts, 1836–1936* (pp. 112–113) was made by her great-grandmother, handed down to the grandmother who taught her to quilt, and ultimately given to her "because she also made quilts."

Marguerite Evelyn Houston Brock

DIAMOND FIELD QUILT

72″ × 94″
Cotton

1963

Pieced and quilted by Kathleen Holland McCrady in
Fort Worth, Tarrant County, and Austin, Travis
County
Owned by the quiltmaker

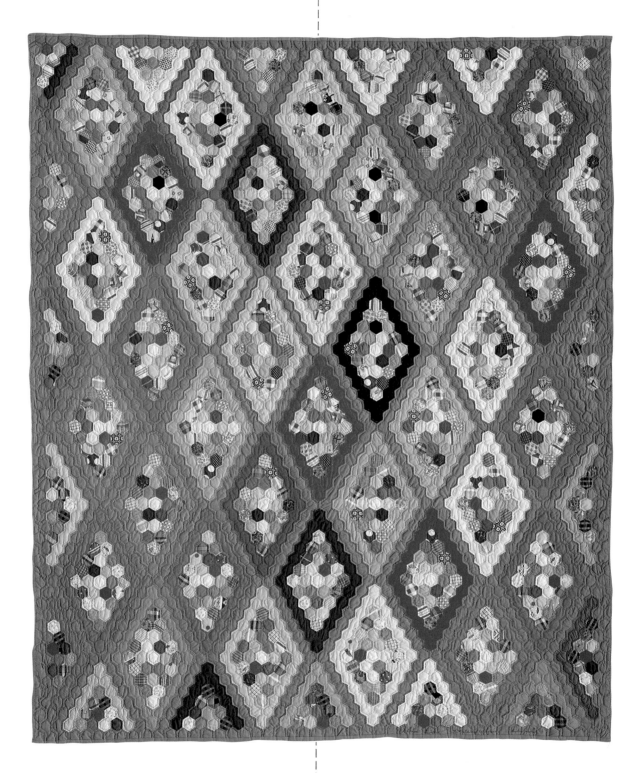

A HOUSEWIFE and mother, at home with a three-year-old during a lonely winter on a farm away from her home state, Kathleen Holland McCrady cut pieces for this Diamond Field quilt and eleven others to while away the time.

Her husband, a major in the Texas National Guard, was on active duty when his unit and others from across the country were activated during the Berlin Crisis and sent to Fort Riley, Kansas. "Housing was at a premium, with no housing on the post, so we lived in a farm house about ten miles away. The winter days were lonely with three children and my husband leaving before sun-up for school and work," Mrs. McCrady said.

Left at home with her youngest child during the days, she recalled, "that winter I cut twelve quilt tops from scraps left in my scrap bag after sewing for my family during the fifties." Piecing was saved for later, in Fort Worth, in 1963. Quilting came later still, in Austin, in 1976.

Well-maintained scrap bags such as Mrs. McCrady's are textile documentaries that may reflect many decades of collecting. Some lucky quilters have even been the recipients of another's scrap bag, usually passed on from a mother or grandmother. Until recently, the great majority of quilt tops were pieced from scraps obtained from worn-out clothing or household textiles. And, while there have always been "planned quilts," now many more quiltmakers are purchasing special fabrics with a very well thought-out color scheme and design in mind. These quilts may or may not be beautiful, but the results are generally predictable. Whether or not that is perceived as desirable, there is little doubt that they lack the excitement that comes from a serendipitous combination of objects discovered in an old-fashioned scrap bag.

They also lack the intimate connections to those persons whose garments or belongings contributed to the scrap bag. Back in 1935 when it was written, Hall and Kretsinger's *The Romance of the Patchwork Quilt in America* quoted Aunt Jane of Kentucky: "'There is a heap of comfort in making quilts, just to sit and sort over the pieces and call to mind that this piece or that is of the dress of a loved friend.' How can the modern quiltmaker know any of that joy if she must go to the store and buy her patches, an eighth of a yard here and another there—or buy a ready-cut quilt?"

Mrs. McCrady saw this hand-pieced, hand-quilted scrap quilt as "a good example of the garish colors that followed the pastels of the twenties and thirties." Its strongly colored, solid borders contain the bright hexagonal printed scraps common to a traditional Grandmother's Flower Garden, but this Diamond Field, or Mosaic, variation has a much different, more dramatic look than the typical Flower Garden quilts of the 1930s. The quiltmaker has retained the green outer border around each block that symbolizes

Kathleen Holland McCrady

the garden path through the flowers. She has used outline quilting on one side of each piece with seven to nine stitches per inch.

Mrs. McCrady was born in Marysville, Cooke County, in 1925 and has lived most of her life in Fort Worth, San Antonio, and Austin, with fifteen years spent in Oklahoma, where she married in 1942. She has four children and is a high school graduate. She worked for a bank as a teller, did retail sales work during World War II, was a full-time homemaker for many years, and was a clerical worker in the public schools, retiring in 1985.

She grew up watching quilts being made and learned to quilt as a teenager from her mother and mother-in-law. She had quilted many years before taking her first quilting class in Austin in 1979 and had quilted many tops given to her before piecing a quilt top herself, a Lone Star, when she was twenty-six years old, married, and living in San Antonio. However, that top was not quilted until later, after she had pieced and quilted several others.

Mrs. McCrady served on the board of directors of the Texas Sesquicentennial Quilt Association and is involved in the ongoing Texas Quilt Search to document the state's quilt heritage. She is also a board member of the American International Quilt Association and has been a very active member and officer in the Austin Area Quilt Guild, of which she is a charter member. She is also a member of several other quilt organizations, including the American Quilt Study Group. Her work has won many awards and been exhibited at many shows, including an exhibit at the Dougherty Arts Center in Austin that focused on fifty years of quiltmaking in her and her husband's families. In March 1988, one of Mrs. McCrady's quilts was named third-place winner out of 2,500 contestants worldwide in the 200th-issue contest conducted by *Quilter's Newsletter Magazine*.

SUNBURST QUILT

74″ × 87″
Cotton

1966

Pieced, appliquéd, and quilted by Lillie Anna Witt
Henderson in Lubbock, Lubbock County
Owned by Kathryn McCabe Shirley

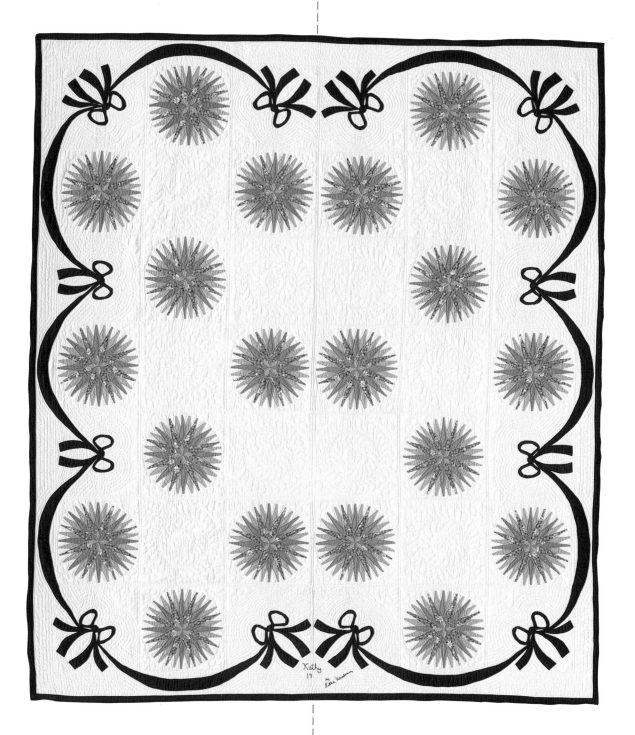

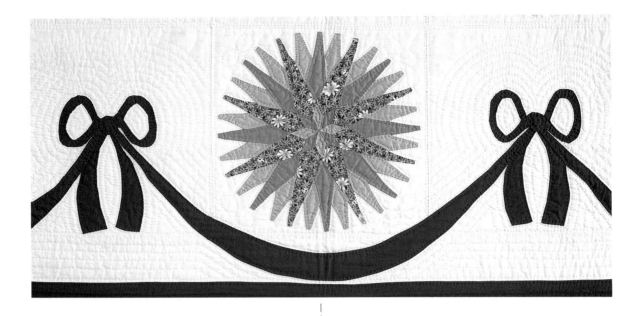

THIS MASTERPIECE of intricate piecing surrounded by beautifully executed appliqué and enhanced with superb quilting reflects a grandmother's love of both her family and her art. Made as a gift for a favorite granddaughter, the Sunburst quilt is a complicated pieced pattern that requires a master's ability; in this case, all of the piecing has been done by hand. The quilt design, which closely resembles the Compass pattern so popular in the nineteenth century, is based on a Stearns and Foster pattern still published in the catalog today. Each of the Sunburst blocks has forty different geometric pieces, which means that eight hundred individual pieces had to be cut and sewn by the quiltmaker to make this quilt.

The elegant swag-and-bow border forms a complementary frame for the pieced blocks; the combination of the sharp points and geometric forms of the blocks and the delicate curves of the border also recall the nineteenth-century practice of juxtaposing curvilinear appliqué borders with pieced central designs. The quiltmaker has used heavy, elaborate quilting on a cotton batting to set off her design, with outline quilting and echo quilting appearing throughout the quilt and feathers and bouquets stitched for accents. The rows of quilting stitches are close together, ranging from one-half inch apart to one inch apart. Each individual piece has been quilted on both sides, with beautiful quilting stitches measuring ten to twelve per inch. A separate bias binding in navy finishes the edges of the quilt and provides one final frame for the design.

Born in 1895 in Puryear, Tennessee, Lillie Witt Henderson has lived in Texas for sixty-three years, forty-eight of them in Lubbock. A graduate of Oklahoma College for Women in 1920, she taught high-school English in Oklahoma and Texas for nine years. She married Albert Lee Henderson in 1926 in Fort Worth and had two children.

Unlike many women of her generation, Mrs. Henderson did not learn quilting at home, even though her mother quilted. Instead, only after her daughter-in-law admired a quilt made by her mother did she decide to try making quilts. Her first, Crown of Thorns, was made in the mid–1950s, not a time when quilting was particularly popular in Texas. Since that beginning, she has made many award-winning quilts, including the Morning Glory, Daisy, Pineapple, Dogwood, Star of the Bluegrass, and a superb Hawaiian-style appliqué quilt. Self-taught, she has developed excellent skills, and her many quilts have earned the ribbons to prove her ability. She has won four best-of-show ribbons and many blue ribbons from the Texas State Fair, was a Texas finalist in the Great Quilts of America contest sponsored by *Good Housekeeping,* the United States Historical Society, and the Museum of American Folk Art in 1978, and has had her work displayed in many invitational exhibits.

Lillie Anna Witt Henderson
(Olan Mills photo)

DRESDEN PLATE QUILT

79″ × 98″
Cotton

ca. 1966

Pieced by Ella Wilhelmina Glaeser Pearce in San
Antonio, Bexar County
Appliquéd by Wilhelmina Henrietta Glaeser in San
Antonio
Quilted by Wilhelmina Henrietta Glaeser and Edith
Nolting Karoline Glaeser Goodrich in San Antonio
Owned by Nancy Helen O'Bryant Puentes

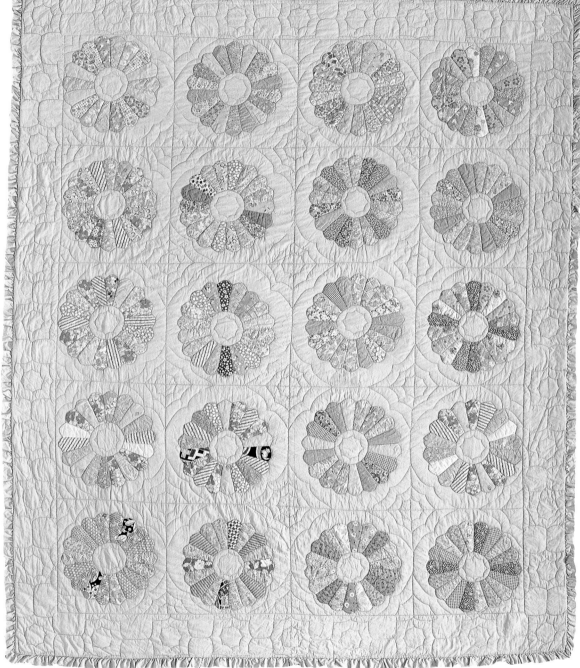

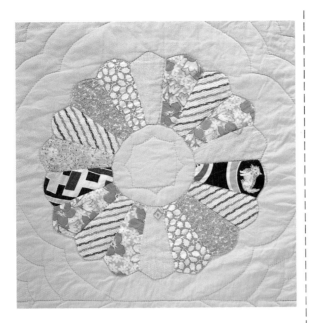

ONE OF THE THREE quilt designs most beloved of quiltmakers who went through the Great Depression in Texas was the Dresden Plate—the other two were Grandmother's Flower Garden and Double Wedding Ring. No doubt this was due at least in part to the fact that all three offer thrifty ways to combine many different printed fabric scraps into aesthetically pleasing quilts.

Another reason is that the look that was popular among Texas quiltmakers of the day was a pretty, pastel one. Scraps from flour sacks and from print housedresses were almost always small floral or abstract designs in pastel or soft colors on pastel backgrounds. When then combined and set on a pastel foundation fabric, they produced quilts that have a distinctive look highly prized by the makers but only now coming to be appreciated again. Most quilts made in the intervening years were far bolder in color, and quilts that have been in favor with most collectors have been either earlier quilts or folk art quilts.

The Dresden Plate pattern is thought to be a replication in fabric of the flowered china from Dresden, Germany, which many women had seen but few could afford. Carrie A. Hall and Rose G. Kretsinger, in *The Romance of the Patchwork Quilt in America,* also note that the pattern is sometimes called Aster or Friendship Ring when signed in the center portion. Virtually no Texas quilter refers to this pattern by any name other than Dresden Plate, however.

This particular Dresden Plate quilt was made as an apology of sorts to the owner by her grandmother, who was unhappy with the wedding quilt top left for her by her great-grandmother. In this family, the great-grandmother had pieced quilt tops for the birth of each great-grandchild but died before piecing a special top for this baby.

So the great-grandchild was to be given a Touching Stars top that had been pieced much earlier, in fabrics from about 1915 to 1920. Her grandmother was never happy with the idea. "Granny always disliked the top, saying, 'It doesn't look like a bride—it's too dark. It looks like men's old shirts.' Of course, the reason is that it was *pieced* from men's old shirts—flannels, work shirts, chambrays—and Great-Granny never intended it to be a wedding quilt for a girl," said the owner.

Her grandmother pieced the plates for this Dresden Plate around 1966, working from an older scrap bag of late 1930s fabrics. She wanted the top to be a replacement for the other, dark top but died the following year. "When I married, the family decided that my wedding quilt should be the Touching Stars top from Great-Granny, so that's what was quilted at my wedding quilting bee," the owner recalled.

But her mother, Helen Pearce O'Bryant, decided to carry out her own mother's wishes and had an aunt appliqué the pastel plates down onto a soft turquoise typical of the 1960s. "Then that aunt and another, my great-aunts, Minnie and Egy, quilted it in a lovely cobweb quilting pattern, about eight stitches to the inch. To make sure that the Dresden Plate quilt Granny had wanted for my wedding quilt was pretty and feminine, my mother had them finish it with a ruffle.

"And Granny was right—my real wedding quilt looks nothing like her idea of a bride's quilt. It is a striking Touching Stars set on a salmon pink background, backed with purple, and finished with purple prairie points. It's typical of Great-Granny, who loved to piece stars. In reality, I came out ahead with wedding quilts, because I actually got two," said the owner.

Ella Wilhelmina Glaeser Pearce

THE HOME PLACE QUILT

44″ × 66″
Cotton

1976

Appliquéd, embroidered, and quilted by Naomi
Stanley Echlin in El Paso, El Paso County
Owned by the quiltmaker

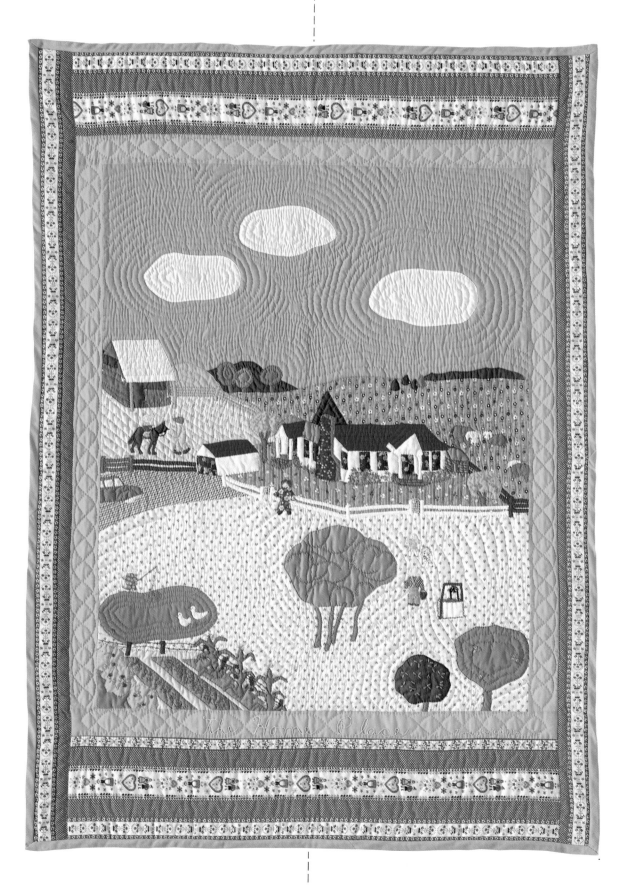

THIS fourth-generation native Texan chose to commemorate her family's centennial reunion and that of her family's church with an original pictorial quilt based on the Stanley homestead in Washington County. She has chosen to depict the farm and ranch, which has been occupied by members of the same family for more than a hundred years, during the decades between 1940 and 1960 when her retired parents, John and Georgia Stanley, lived on the home place. Meticulous detail combined with naïve charm make this quilt reminiscent of the work of America's favorite primitive painter, Grandma Moses.

Although untrained in quiltmaking at the time, the designer was a skilled weaver and spinner and had taught weaving. The Home Place was an ambitious project for a first quilt, successfully achieved because of her familiarity with the subject and her training in other fields of needlework. The use of embroidered details—the barbed-wire fence around the garden, the wire gate of the white rail fence surrounding the house, the faces on the people, the flowers and vegetables—add significantly to the pastoral effect of the quilt. To convey the texture of the house, she has used white pique; her choice of calico for the lawn surrounding the house effectively evokes a yard full of flowers.

Naomi Stanley Echlin

As with naïve or primitive painters, perspective plays a secondary role to concept; the objects of memory are all located accurately according to the mind's eye, but the perspective may change several times throughout the piece. This is particularly evident in the quiltmaker's rendition of the duck pond in this quilt.

Each appliqué piece has been quilted in outline; in addition, echo quilting has been used around the clouds in the sky. Contour quilting has been used to convey the difference in ground levels and the different areas of the farm. The quilting stitches measure approximately four to six per inch.

Born in 1920 in Port Arthur, Naomi Stanley Echlin received a Bachelor of Arts degree from the University of Texas at Austin in 1942. She married Robert Echlin that same year and reared three children. She learned to quilt by taking a class and has continued to make quilts as an expression of "nostalgia for things past." In addition to having her quilt selected for the Great Texas Quilt RoundUp during the Texas Sesquicentennial celebration, she was one of two Texas finalists in the Great Quilts of America contest sponsored by *Good Housekeeping* magazine.

VIRGINIA REEL QUILT

78" × 88"
Cotton

1976

Pieced and quilted by Donna Ray Brown Landers in
San Angelo, Tom Green County
Owned by the quiltmaker

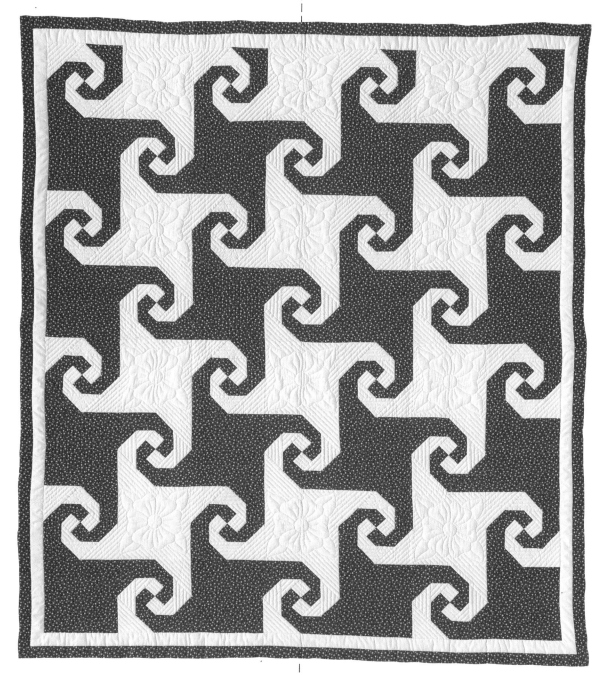

Donna Ray Brown Landers

SINKING into the summer doldrums in 1975, Donna Ray Brown Landers picked up a *Reader's Digest* and thumbed through an article on "How to Cope with Boredom." None of the ideas alleviated her tedium until she read the no-nonsense advice of the chairman of the board of the Scovill Manufacturing Company in Waterbury, Connecticut: "Sit down and list five things you've always wanted to do. Then, pick one, and flat-out go and do it." That galvanized her into action.

What Mrs. Landers wanted to do—and did after reading the article—was to make a quilt from a quilting book she had daydreamed over for ages. The Virginia Reel was made during the United States Bicentennial for Mrs. Landers' husband, Lyndon Claude Landers, to whom she was married for forty years until his death in July 1989. In 1976, the spring after she read the article, the quilt won a blue ribbon and best-of-show award in a quilt exhibition at the San Angelo rodeo.

The advice propelled her into a new phase in her life, one that took her forward into more quilting, teaching quilting classes, holding leadership positions in the Concho Valley Quilter's Guild, and directing the West Texas Quilt Show in Fort Concho for seven years in a row. But not only did it take her forward, it also took her back—back to the female side of her famly that she had never known, back to her "roots, if you please," as she put it.

Born in San Angelo on Christmas Eve, 1931, she was the youngest in a family of ten. Her mother died when she was four years old and her father and two brothers raised her, moving away from Texas when she was five. With her mother dead and her older sisters back in Texas, there was no one to teach her needlework, though she was drawn to it. Even then, she was a can-do sort and taught herself knitting, embroidery, crochet, sewing, and quilting by reading instruction books.

"Ever since I was a small child, I had known that my mother was a fine seamstress, accomplished at needlework, including quilting. I was always interested in quilting, in particular. A lovely old aunt (my mother's sister) told me of my 'lineage.' She said that I came from a long line of quilters," Mrs. Landers recalled.

Her aunt told her that quilting was all the needlework that she ever saw her own mother and grandmother do and that she often wondered who would "carry on the quilting" in the family. She was pleased to learn that Mrs. Landers would continue the tradition. "Quilting is a bond between my great-grandmother, Maria Crosley, my grandmother, Lucy Crosley Haney, my mother, Ethel Haney Brown, and me," said Mrs. Landers. "Though I never knew them, Lord, how I love them."

Mrs. Landers was married on January 4, 1949, just after her seventeenth birthday. She made her first quilt, an appliquéd Butterfly crib quilt, in the spring of 1950 when her first child was born, and that started her quilting endeavors. She makes an average of one quilt a year and occasionally, but not often, sells one, although that is not why she quilts. "I simply enjoy it, for the quietness of spirit that I feel. There is also definitely a sense of heritage involved, for I come from a long line of quilters," she said.

This quiltmaker quilts at all times of the day except the early evening. She tends to continue working at night when a pattern is developing and likes to quilt in the living room with the radio on, usually to an "easy listening" station. Sometimes she quilts with a friend. When quilting alone, she lap quilts without a frame.

Mrs. Landers is a charter member of the Concho Valley Quilter's Guild and served as its first president. She quilts with them and also quilts at a fabric store in San Angelo, one of two where she teaches quilting. She also teaches at Fort Concho and was the originator of the West Texas Quilt Show there. She has won numerous awards for quilting at the San Angelo Stock Show and Rodeo and at the West Texas Quilt Show and also won a ribbon for originality at the Texas State Fair.

This Virginia Reel quilt, also known as Snail Trail, made of red calico and white muslin, has a synthetic batting and is machine-pieced and heavily hand-quilted in a fancy quilting design featuring flowers, leaves, twisted ribbons, geometrics, and close crosshatch. The quiltmaker has taken ten to twelve stitches per inch, and her rows of quilting are three-eighths of an inch apart. She has turned the edges of her top and backing under and blind-stitched them together.

Although Mrs. Landers followed the "go and do it" advice of the business executive quoted in *Reader's Digest* and carried a clipping of the article with her for many years, she did not know who he was. She discovered he was a man who practiced what he preached when she learned of his death while doing what he loved: competing in professional rodeo events. The author was Malcolm Baldrige, President Ronald Reagan's Secretary of Commerce.

In a letter to the editor of the *San Angelo Standard-Times* in which she recounts her indebtedness to Baldrige and his practical wisdom, Mrs. Landers added these words from Ecclesiastes 9:10:

Whatever thy hand finds to do, do it with might; for there is no work, nor device, nor knowledge, nor wisdom in the grave, whither thou goest.

STRAWBERRY QUILT

74″ × 93″
Cotton

1976

Appliquéd, embroidered, and quilted by Betty Peace
Royal in Plainview, Hale County
Owned by the quiltmaker

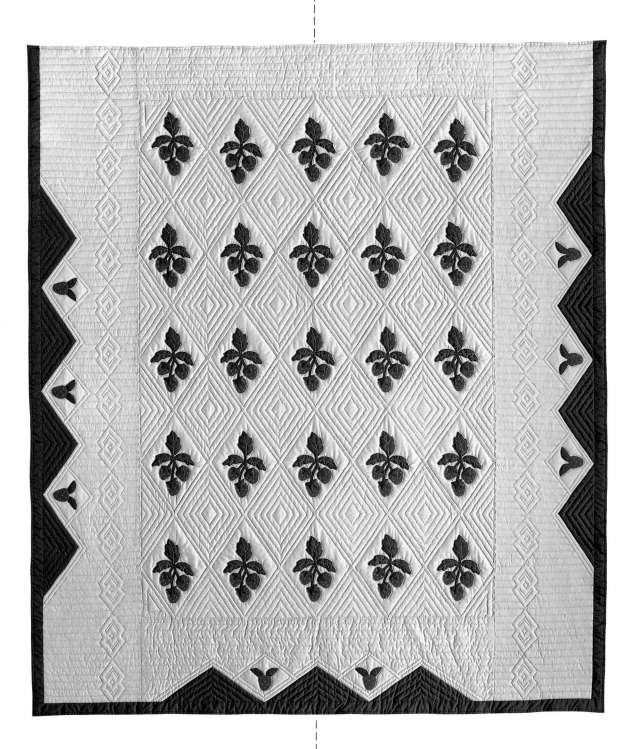

EVENLY SPACED geometric quilting provides the counterpoint needed to emphasize the Strawberry blocks in this quilt. The strawberries are embellished with French knots for realism, and even the veins are embroidered in the leaves of the plant. The sharp lines of the diamonds formed by the quilting stitches in the counterpane blocks contrast handsomely with the delicate appliqué of the fruit. Although the Strawberry design was never one of the most popular patterns in quilt-making history, it shows up repeatedly from the middle of the nineteenth century to the present, usually as one block in an album quilt rather than as the design for an entire quilt. According to Elly Sienkiewicz, author of *Spoken without a Word*, a 1983 book about album or friendship quilts: "a strawberry trefoil means the Christian Trinity, while strawberries in general are symbols for Esteem and Love, their leaves meaning Completion or Perfection" (p. 21).

Betty Peace Royal

This quilt is entirely handmade: the strawberry blocks are hand-appliquéd, the blocks are pieced together by hand, the embroidery is all hand-stitched, and the hand quilting measures approximately six stitches per inch. The quilt is finished with a separate bias binding. The brilliant red and green contrast handsomely with the soft tan background; the use of tan rather than white or cream for the background was an interesting design choice because it softens the effect rather than emphasizing the sharp contrast. Never used, this excellent example of 1970s quilting has been saved for display at quilt shows.

Born in 1924, Betty Peace Royal grew up in Oklahoma but moved to Texas in 1937. She married in 1940 in Littlefield, reared three children, and has lived for more than fifty years in the South Plains areas around Muleshoe and Plainview. She makes two to four quilts a year as a means of artistic expression and "because I like to—I enjoy it." Mrs. Royal quilts alone in a bedroom and finds the early morning hours to be her most productive time. After learning to quilt from her mother, she made her first quilt at fifteen in Muleshoe; it was a Brick quilt made from her dress fabrics.

BRIGHT MORNING STAR QUILT

84″ × 84″
Cotton and cotton blends

1977

Pieced, appliquéd, and quilted by Vickie Lynn Perino
Milton Buttery in El Paso, El Paso County
Owned by the quiltmaker

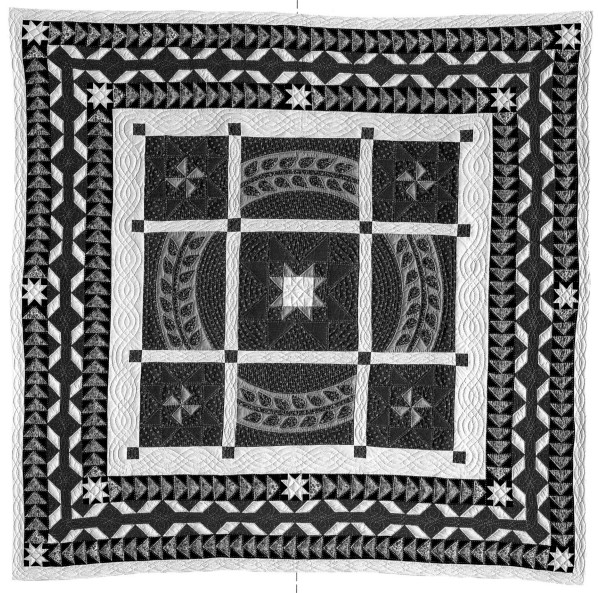

Vickie Lynn Perino Milton Buttery

DURING the 1970s, America's Bicentennial brought together a nation that had been sorely divided over the war in Vietnam and once again made it popular to reestablish connections with one's cultural history instead of rebel against society. Old-fashioned values of patriotism and strong family ties reemerged, and people turned to the traditional arts as a counterpoint to the high-tech society facing them in the computer age. Quilts were pulled out of closets, and a new generation saw them with fresh eyes, not as cover for beds but as art for walls. The fact that the quilts were tangible links to the past heightened their appreciation, and America enjoyed a tremendous renaissance of quilting fever just after the 1976 Bicentennial.

Hearkening to nineteenth-century quilting traditions, this talented quiltmaker has incorporated a deliberate error into her visually engaging work. Quilting lore emphasizes that the concept of the deliberate error had its roots in humility and the lack of pridefulness that were so prized in the ideal nineteenth-century woman. Since only God was perfect, to make a perfect quilt was a sin of pride, and many devout quiltmakers included a deliberate mistake in their quilts. Sometimes the mistake was obvious, such as a blue-and-white quilt with one red block in it. Sometimes it was more subtle, such as a pieced word with one reversed letter. Sometimes it was hidden carefully in the quilting and visible only to the quiltmaker herself. A close observer of this quilt will find that the quiltmaker has hidden her deliberate error in the windmill blades in the center of the corner stars.

Made with the specific purpose of "winning a contest," this quilt succeeded in being selected as the state winner from Texas in the Great Quilts of America competition sponsored by *Good Housekeeping,* the United States Historical Society, and the Museum of American Folk Art. Bright Morning Star is machine-pieced and appliquéd by hand; it is quilted by hand with approximately six stitches per inch. The blocks have been quilted by the piece, with a row of quilting on each side of the individual piece. Interlocking chains are quilted into the solid white borders that frame the central medallion; the chains add dimension and repeat the gentle curves of the medallion. The quilt has a separate bias binding. In the center of the medallion is a double star, the Bright Morning Star of the title, derived from Revelation 22:16, which refers to Christ as "the bright and morning star." This imagery was also used to great effect in a turn-of-the-century Adam and Eve folk-art quilt that is part of the Spencer Art Museum collection at the University of Kansas.

For this piece, the quiltmaker chose the striking contrast of the Southwestern colors typical of the region around El Paso, named for its famous pass, El Paso del Norte, America's lowest pass through the Rocky Mountains. The El Paso region itself presents a dramatic contrast between desert and lush farmland, largely dependent on irrigation. In 1960, in John F. Kennedy's Inaugural Program, Texas historian Walter Prescott Webb described the critical importance of water to the development of the Southwest:

Those who would understand the Southwest must realize—and accept—the power of the desert to reverse values that obtain elsewhere and to turn conventions born in a different clime upside down. Water is more valuable than land; geology is on the surface as well as beneath it; and many rivers sink into the sand and not the sea . . . The blessed rains, when they come to argue with the dryness, touch the emotions of the people as a religious experience. They are the grace coming before the bounty they promise; they call forth the dormant plants which hasten to adorn the land with flaming colors and to fill it with odors more subtle and powerful than incense.

Bright Morning Star was made when Vickie Buttery, then Vickie Milton, was a pre-nursing student of twenty-six. She graduated with a degree in nursing and worked as a registered nurse in pediatric intensive care. She first became interested in quilts when her sister was given one for a wedding present. "It was so beautiful that it made me want one, and at that point in my life, I knew the only way I was going to get one was to make one myself," she commented. Born in Amarillo in 1951, Mrs. Buttery lived throughout the Southwest until she moved to El Paso in 1971. She married and divorced, then married a second time in 1989; she is the mother of one child. She makes quilts primarily for gifts and as a creative outlet, and other than Bright Morning Star, she has focused her abilities on baby quilts for friends and family.

LOG CABIN QUILT

94″ × 110″
Cotton

1978

Pieced and quilted by Etta Speck Tilley in Elm Mott,
McLennan County
Owned by the quiltmaker

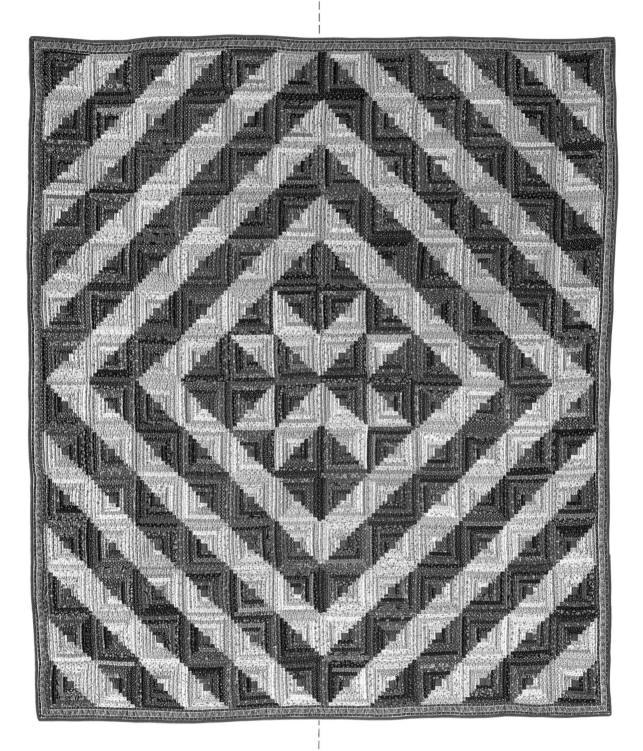

LOG CABIN quilts are among the most easily recognized patterns in the quilt world. The basic design consists of one square block, pieced of strips, or "logs," half of dark fabrics and half of light, and many variations can be created depending on how the blocks are set together. In this quilt, whose rich earth tones of rust and brown are typical of the 1970s, the blocks have been set to form the concentric diamonds of the Barn Raising variation, but the quiltmaker has departed from the traditional set by placing the blocks to form an eight-pointed star in the center.

Because there are so many seams in a Log Cabin quilt, it is not unusual to find quilts of this design finished as tacked comforters or quilted with a minimum amount of stitching. However, this quiltmaker obviously decided to lavish time and effort on her quilt, which was made for a special family occasion. She has quilted each separate log, so that the quilting stitches on the rust fabric of the backing form a series of concentric squares. The quilting stitches, which measure approximately ten to twelve stitches per inch, add both texture and dimension to the quilt. The outer edge of the quilt is enclosed with a separate bias binding that matches the backing fabric.

Etta Speck Tilley

According to Bonnie Leman and Judy Martin in their book *Log Cabin Quilts*: "Probably the first time the design was used to make bed quilts was in England in the early 1800s, but it was the American quiltmaker who developed it, varied it, and made it a quilt classic. Since the first quarter of the nineteenth century, the pattern has come to be so strongly associated with the American patchwork tradition that its 'American-ness' is taken for granted" (p. 1). That sentiment was particularly appropriate for this Log Cabin quilt, which was made for the twenty-seventh birthday of Mrs. Tilley's only grandchild, a grandson living in West Germany. The quilt was his grandmother's way of reminding him of America, of Texas, and of his father's family, from whom he was estranged as a child.

Etta Speck Tilley, a lifelong Texan, was born in McLennan County in 1912 and lived on a farm there until she married in 1934 and moved to Bosque County. Her son was born in 1937. She has worked in nursing, but her true calling was in working with children—she has taken in foster children for thirty-five years. She is a self-taught quilter who first became interested as a girl when she saw a neighbor making a Dutch Doll quilt. She asked for the pattern and made her own Dutch Doll in 1926, when she was only fourteen years old. Mrs. Tilley has continued to quilt all her life and today usually finishes two quilts a year. She gives most of them away, although she has sold a few. Although she quilts primarily for creative rewards, she is proud of the blue ribbons she has won on her pieced quilts, appliquéd quilts, and cross-stitched quilts.

AUTUMN LEAVES QUILT | 1978

80″ × 84″
Cotton

Pieced, appliquéd, and embroidered by Thelma
Francis Vail in North Richland Hills, Tarrant County
Quilted by Thelma Francis Vail and others in North
Richland Hills
Owned by the quiltmaker

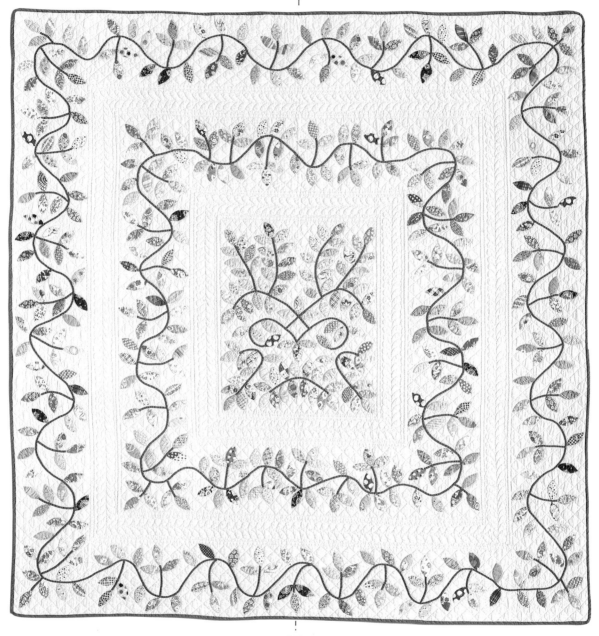

Thelma Francis Vail

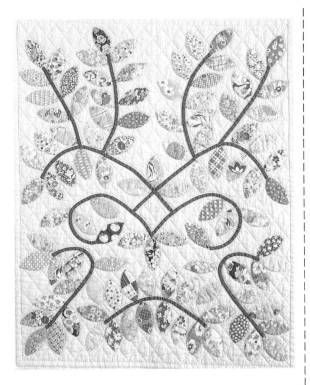

AS A MINISTER'S WIFE for forty-six years, Thelma Francis Vail said she used to quilt sometimes on Sundays, even though it was a day of rest, "to quiet minister's wive's nerves. My husband used to say, 'Oh, sweetheart, you will have to rip out all those stitches with your nose when you get to Heaven.'"

Her Autumn Leaves quilt is made from a pattern popular in the nineteenth century. She cut the leaves in 1937 from thirties print fabrics and basted the edges down years later when she had more time. The woman whom she had wanted to draw off, or mark, her quilt for her died before she could afford the white background fabric for it. Later, in 1944, when she and her husband were living in Sedgwick, Kansas, during his last pastorate of twenty-six years, they were invited to a Sunday dinner, "and where we laid our wraps, an Autumn Leaves quilt was on the bed." The owner gave her permission to draw it off. She appliquéd it in 1978, in Texas, and quilted it with friends. She said: "Some of my church friends wanted to learn to quilt, so all kinds of quilting are on it. I promised them no matter what, I wouldn't rip any of their stitches out."

She was being kind, for it was common practice for stitches to be inspected after a group quilting party concluded. Persnickety quilt owners were quite likely to rip out stitches deemed too large or too crooked and redo them.

Mrs. Vail was born in 1911 on a small farm in Vernon County, Missouri, four miles from Kansas' eastern border. She moved to Kansas and attended public schools and junior college at Fort Scott. She "married a Fort Scott gentleman in 1932 who was ministering at the Christian Church I attended. I was his secretary and right hand our forty-six years of his ministry."

A year and a half after her husband's retirement, they moved to Texas to help care for their only daughter's two sons. "She, a nurse, made us think she needed our help!" When her husband died in 1979, Mrs. Vail began quilting for the public.

She quilts alone in the sunroom of her daughter's home, sometimes eight to fourteen hours a day, while watching sports, "baseball, mainly, and news on TV. TV is the way I travel to all parts of the world." Mrs. Vail makes around eight quilts a year, quilting tops for others.

She learned to quilt from her mother and made her first quilt, a Bow Tie, when she was eleven years old. "Doing this was punishment for being naughty. I had a younger sister who was always pulling my long curls. If my sister and I didn't behave, we were told to sit and quilt. I loved to piece and quilt so much that I was naughty a lot in order to work on the quilts."

Mrs. Vail joined the Trinity Valley Quilters' Guild in September 1983. In 1984 one of her 1950s quilts, the Bluebird of Happiness, won the People's Choice award at the guild show, the first competition she had ever entered, and in 1987 Autumn Leaves also received the same award.

Her Autumn Leaves quilt has a cotton top and backing, and she used a synthetic batting. The variety of multi-hued small 1930s prints used for the leaves is interesting, and the quilt is tied together by the green stems and sinuous vines that form an outer and inner border around a central medallion. The design is quilted in a medium crosshatch and feathers, and each piece is quilted around the edge. Nine stitches per inch are in the quilt, which is finished with a separate bias binding in the same green.

Mrs. Vail found that quilting helped her "as a minister's wife to solve many problems, and to think through others' problems that only a minister and his wife could know about. Quilting gives one time to think and peace of mind." She also feels a sense of kinship with other quilters, adding, "I never saw a quiltmaker I didn't love."

LONGHORNS ON
THE CHISHOLM TRAIL
QUILT

70″ × 92″
Cotton

1979

Pieced, appliquéd, and quilted by Helen Gage
Blackstone in Austin, Travis County
Owned by the quiltmaker

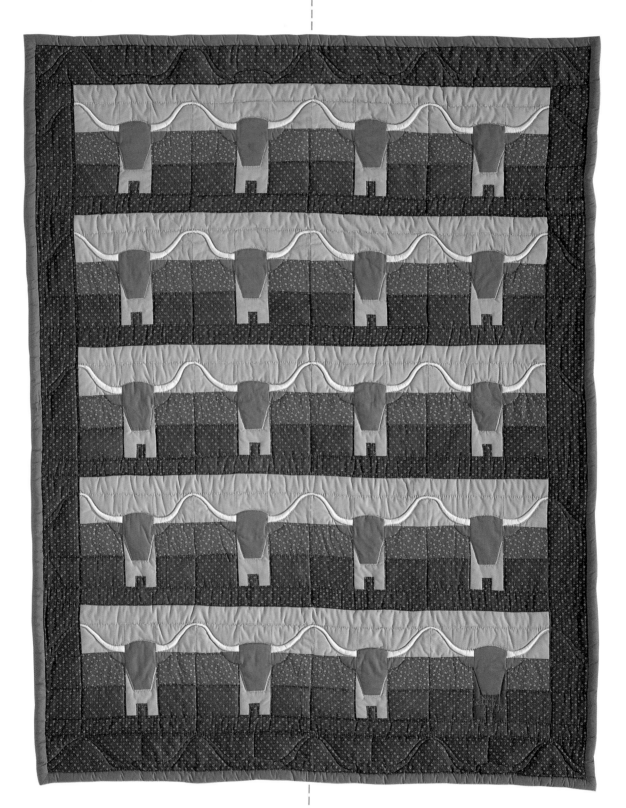

Helen Gage Blackstone

A QUILT CONTEST in honor of the Chisholm Trail roundup and Battle of Plum Creek in Lockhart, Caldwell County, inspired Austin quiltmaker Helen Gage Blackstone to design an entry that spotlights the Texas longhorn. The Chisholm Trail was, of course, one of the most famous of the cattle trails over which cowboys and traildrivers drove cattle to market. The Battle of Plum Creek, or the Plum Creek Fight, was a well-known battle that took place near Lockhart in 1840 in which Texas Rangers and other Texans defeated the Comanches.

So engrossed was Mrs. Blackstone with her quilt project that, during a vacation trip to Montana with her husband, she insisted they circle several blocks to get good looks at signs that showed cattle and other western symbols she might want to use.

While her original design quilt was not finished in time for that contest because "it took half a year to design something that suited me," it has been a consistent winner in many others and has been featured numerous times in various publications, including *Texas Highways, Quilter's Newsletter Magazine,* and *Alcalde.* It has been shown in exhibits from Houston to Marin County, California, to Sydney, Australia, and was in the Great Texas Quilt RoundUp during the Sesquicentennial.

Mrs. Blackstone was born in 1913 in Waco and has four children. A retired teacher, she holds a Master of Science degree in education from the University of Texas at Austin. She has embroidered since she was eight years old, taught by an aunt who was expert in Madeira work, tatting, and crochet. She was inspired to try quilting by articles in *Woman's Day* magazine in 1940 or 1941 and followed the Rose Wilder Lane series called "The Story of American Needlework" in that magazine. She learned to quilt from her mother but has also taken numerous classes. In 1941, at about twenty-seven, she started her first quilt, a Delectable Mountains, which she finished twenty to thirty years later. Mrs. Blackstone belongs to the Austin Area Quilt Guild and to one of its quilting bees, but she works on her quilts by herself.

A widow now, she shared an interest in Texas history with her husband. She quilted this quilt in a frame before a cozy fire during a cold month, with her husband "seated in his big chair reading aloud an exciting mystery story."

Her Longhorns on the Chisholm Trail is a stylized portrayal of the reason Texans embarked on the cattle drives that have become part and parcel of cowboy lore—the abundant Longhorn cattle that existed in greater numbers than there was population in the days of the early Texas settlers.

Cattle, cowboys, and Texas are synonymous worldwide. Over a long period of time, the longhorn as we know it had evolved, and the millions that ranged over Texas freely became the basis for the cattle industry that began prior to the Civil War. Cattle later offered Texas a way out of the financial straits of Reconstruction. New cattle trails were established that led to more accessible westerly terminuses and, ultimately, to transport by rail to northern and northeastern markets. Escorting those cattle to the ends of famous trails such as the Chisholm Trail, the Goodnight-Loving Trail, and the Dodge City Trail was the Texas cowboy on his horse.

T. C. Richardson, in the *Handbook of Texas* noted:

The spectacular quarter of a century beginning in 1866, which saw the northward movement of ten million cattle and one million stock horses, requiring forty thousand men and three hundred thousand saddle horses, may well be called the 'Cavalier Era.'

[These] Texas cattle trails carried more than beef. Whereever they led, went the art of handling cattle, the picturesque vocabulary and the cow-sense indigenous to the Texas cow-country, the supreme self-reliance and independent initiative of the best type of Texan. The trails pioneered new frontiers and colored the social, political, and economic pattern wherever they went. The click of the Longhorns' horns was heard in the countinghouses of Europe; their tough hooves clove new paths into virgin lands; their bedgrounds sprouted cities; and the men who followed them left the indelible imprint of their honesty, courage, and far vision upon every locality that felt their presence. (Vol. 1, p. 316)

QUEEN'S MEDALLION QUILT

81″ × 96″
Cotton

1979

Pieced and quilted by Janet Marie Scrimshire Mullins
in Fort Worth, Tarrant County
Owned by the quiltmaker

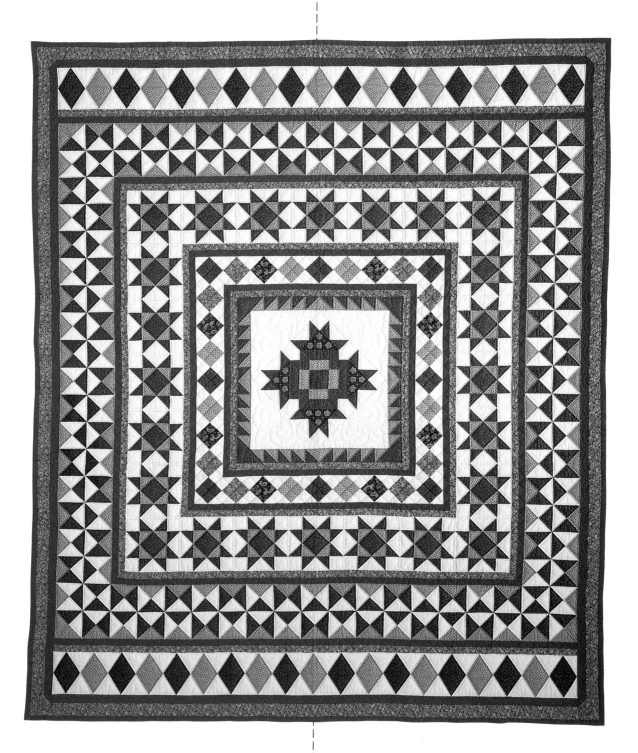

ONE of twelve children, Janet Mullins grew up in Willow, Arkansas, with memories of chilly winter nights spent dreaming under piles of cozy quilts. Her mother, like many quilters who needed to make the best use of limited space, kept her quilt frame suspended from the ceiling in the parlor that doubled as the master bedroom.

After the evening meal had been cleared away, down came the quilt frame, out came the thimble, needle, and thread and slowly, from feed sacks and dress scraps, a Grandmother's Flower Garden quilt bloomed in the wooden farmhouse. Sometimes Janet, who was not ordinarily turned to domestic arts, found herself drawn to the quilt when no one was around and would take a few surreptitious stitches on the quilt herself, enjoying her secret.

Years later, after she had graduated *cum laude* from Texas Christian University and taught first grade for about ten years, Janet Mullins noticed the proliferation of home decorating magazine articles on quilts as the focal points for bedrooms. She also noticed the prices for quilts of the quality she admired and found them quite high. She decided she could make a quilt, too. The quilt pattern she picked for her first quilt? A Grandmother's Flower Garden.

While she remembers her mother quilting, Mrs. Mullins did not actually learn quilting from her but instead was more or less self-taught. After her first quilt, she made many others before signing up for quiltmaking seminars at the International Quilt Festival in Houston.

Mrs. Mullins quilts in her den so she can keep her retired husband company and work at the same time. She generally quilts in the afternoons or early evenings and prefers to make bed quilts, usually double or queen-size. For the most part, she quilts alone. Occasionally, though, she quilts with the Back Room Bee, a group of friends who meet in each other's homes to work on their individual projects and exchange ideas.

She makes from three to five quilts a year and says: "I quilt foremost as a creative and artistic expression. I just love the needlework in hand quilting and love the results when I put a quilt together. I've done many kinds of needlework almost all of my life, but none is as fascinating and enjoyable as quilting." So interested was she in quilting that, for six years, Mrs. Mullins owned a quilt shop, where she estimated she taught three thousand women to quilt.

Janet Marie Scrimshire Mullins

The Queen's Medallion quilt has as its central medallion an original adaptation of a pattern known as Four Queens. It won two blue ribbons at the Texas State Fair in 1979, one for Best of Show and another for Creative Excellence. Mrs. Mullins recalls that when it was hung at the state fair, a number of people sketched the design. Many commented that it reminded them of Native American designs, but Mrs. Mullins herself thinks its appeal stems primarily from the way the fabrics and design complement each other.

She hand-pieced the quilt top and hand-quilted it seven to nine stitches per inch in outline quilting that is one-half to one inch apart. There is also some crosshatch quilting in the borders, zigzag quilting in the outer border with an additional design between, and a modified fleur-de-lis design in the larger triangular pieces.

Mrs. Mullins has won several other state fair awards for her quilting. Her work is very precise, with an emphasis on lots of quilting. She finds it "easier to make a quilt the correct way than to do it just any way." She once told a reporter for the *Fort Worth Star-Telegram* that she "never liked art in school because I wanted to draw houses with my ruler. I wanted them to look straight and perfect and the teacher didn't want that. I'm pretty precise."

Quilting gives her "a wonderful sense of pride and accomplishment" and something she can enjoy over and over again. Mrs. Mullins has never lost her enthusiasm for quilts or her interest in the process of quiltmaking. "I never get tired of looking, planning, and dreaming," she says.

MY BLUE JEAN QUILT

83″ × 103″
Cotton

1980

Pieced, appliquéd, embroidered, and quilted by Pearl
Glover Cox in Fredericksburg, Gillespie County
Owned by the quiltmaker

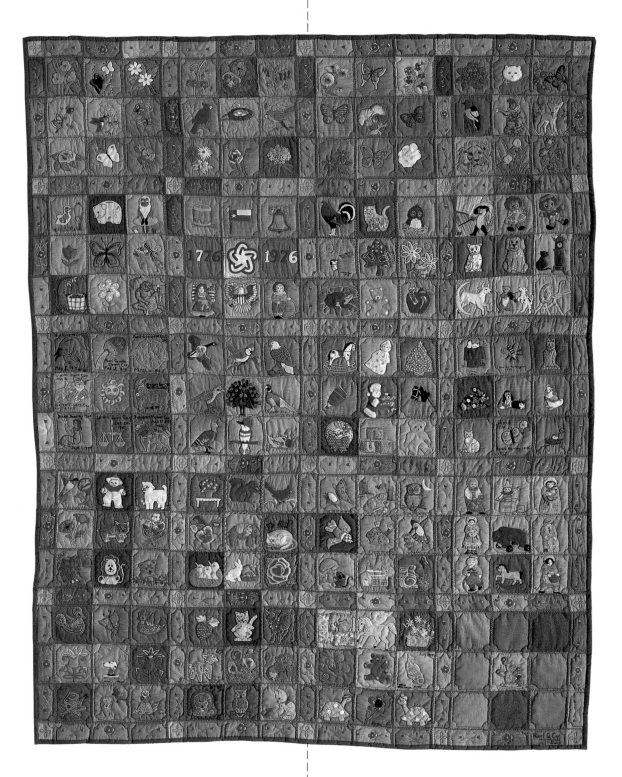

BEGUN in 1975 at the height of the blue jean revolution and finished five years later, My Blue Jean Quilt is a remarkable document of family history that required 1,752 hours to complete, making it a true labor of love. It most closely resembles the nineteenth-century genre known as Crazy quilts, in which each block is heavily embroidered with symbols and designs. This quilt, which is the quiltmaker's first attempt at quiltmaking but which reflects her mastery of embroidery, is made entirely of faded denim from the blue jeans worn by the quiltmaker's three sons. Three generations of family life are depicted in the quilt, and each of the twenty blocks has a distinct theme. One commemorates the United States Bicentennial in 1976 and includes emblems of America, particularly the Liberty Bell with its famous crack. Another is embroidered with family names and zodiac signs; still another features favorite Christmas toys. One block is deliberately left empty—according to the quiltmaker, "it is ready for more family history."

All of the embroidery elements in the twenty Nine Patch blocks are original designs created by the quiltmaker, who drew on her extensive experience with embroidery and crewel work to create the realistic, imaginative patterns. She worked with cotton embroidery floss and used many familiar stitches such as the feather, stem, running, chain, buttonhole, and satin stitches. Some types of stitches not often used today were learned by carefully pulling out embroidery stitches from a worn-out Crazy quilt found in a trunk in Cameron, Texas. Working backwards, the quiltmaker learned how to stitch each one; then she replaced missing patches in the old quilt with materials from the appropriate period and replaced and repaired the stitches to restore the quilt.

Blue jeans quilts were popular in the late 1970s since the quiltmakers of that decade, frugal as their foremothers, could not find it in their hearts to throw away good fabric but instead chose to recycle it into quilts. Usually, the jeans wore out first at the knee and were transformed into the cutoffs beloved of all American teenagers. This left the pants leg from the knee down in good condition but otherwise useless. The blue jeans quilts were almost always made from these leftover pants legs. However, few of them are as heavily quilted as this one, and working on heavy denim, even fewer stitchers could accomplish the ten to twelve stitches per inch that this quilt displays. The quiltmaker found that the traditional running stitch used in quilting was an impossible chore through two layers of denim and one of batting, so she decided to use a stab stitch instead.

The quilt was almost completed when the quiltmaker's husband suggested that she enter it in the Gillespie County Fair. "I felt it was so beautiful—a work of art—that people should see it,"

Pearl Glover Cox

he commented. His wife, who had never even been to a county fair before, "finished sewing on the binding at 2 P.M. to meet the 4 P.M. deadline for entries." At its debut, the quilt won the first prize and the Best of Show award; it then went on to win the same prizes at the Kerr County Fair. With that success behind them, Mr. Cox then insisted that the quilt had to be entered in the Texas State Fair. When the family went to Dallas to bring the quilt home, at first they could not find it among all the other entries, until they saw a large crowd gathered in the center of the room around a glass showcase. There, inside the showcase, featured as the centerpiece of the show, was My Blue Jean Quilt—with a first premium award, Best of Show in the senior section, and the Mountain Mist Outstanding Quilt award. My Blue Jean Quilt was also selected as the prize-winning quilt from Texas to be featured in *First Prize Quilts* in 1984.

Born in 1919 in Houston, Pearl Glover Cox has lived in Texas all of her life; she married Russ Cox in 1939 and had three sons. She and her husband lived in Houston for most of their married life but retired to Kerrville.

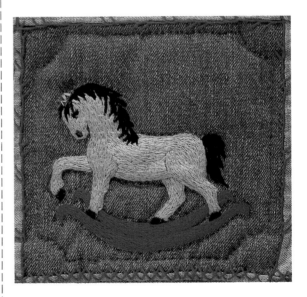

TEXAS BLUEBONNET
QUILT

108″ × 108″
Cotton

1981

Appliquéd, embroidered, and quilted by Grace
Bowman Simpson Caudill in Houston, Harris County,
and Greensboro, North Carolina
Owned by Karoline Patterson Bresenhan

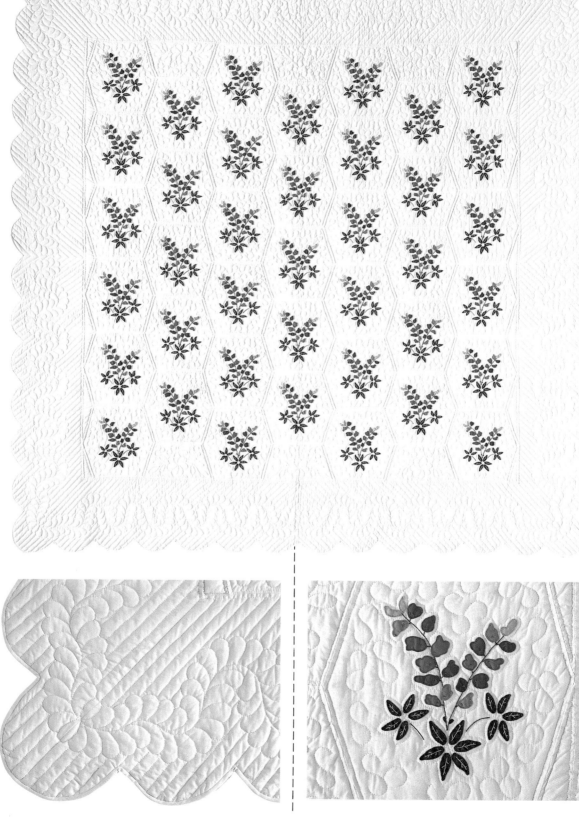

MADE from an original pattern designed by the quiltmaker, this exceptionally beautiful quilt is the work of a master quilter. The hexagon blocks feature meticulously appliquéd bluebonnets, the state flower of Texas, with embroidered stems and details on the flowers. Each bluebonnet block contains thirty-nine tiny pieces that form the petals of the flowers and the realistic leaves. The quiltmaker's appliqué stitches are so perfect that they resemble the eighteenth-century broderie perse technique. Each individual piece has been applied to the muslin background with extremely tiny, close buttonhole stitches rather than blind stitches; the buttonhole work is so close that no raw edges are permitted to show between the stitches. In her 1981 book, *Quilts Beautiful,* the quiltmaker explains that, unlike the blanket stitch, the buttonhole stitch requires that all seam allowances be trimmed off before the pieces are stitched down and that only little stitches are acceptable in this method of appliqué: "And I do mean little . . . like you work a buttonhole—no more than 1/8 inch deep or a little less. When this is done properly, it is exquisite . . . washing after washing doesn't take away from its beauty. If it is improperly done, the only word to use is tacky" (p. 11).

The elaborate, fancy quilting is the perfect complement to the quiltmaker's precise workmanship. The quilting pattern was marked by "laying off" the design—tracing each element with a long sharp needle or a hat pin and then quilting before the indentation left by the needle point could fade. This method is time-consuming, but the end result is that the splendid feathers seem to have been created almost by magic, with no pencil markings to detract from their symmetry and elegance. According to the quiltmaker, "Seeing pencil marks on an otherwise beautiful quilt is like seeing outline marks on a lovely painting!" To fill in the bluebonnet blocks, the quiltmaker used small swirling designs she called "curlicues" along with delicate rosettes and leaves. The feather quilting has been planned to turn the corners of the quilt gracefully, another mark of a master quilter. The quilt was a gift of appreciation to the woman who edited the *Quilts Beautiful* manuscript; it was started in Texas and quilted after Mrs. Caudill moved to North Carolina.

The bluebonnet pattern Grace Simpson (the name she was known by in the quilting world) designed was only one of her many original creations. In her book, she lists eighteen patterns that she designed, including the Yellow Rose of Texas, the Bluest Day (in memory of Pearl Harbor), and Tar Heel Daisy (for her adopted state and new husband). In discussing the bluebonnet pattern, she used the following description:

When Texas was admitted to the Union and the Texas Legislature came to consider the issue of a state flower, the bluebonnet was crowned queen, primarily because of its thriving profusion and beauty throughout the state. Even today, for a few weeks each spring, Texas fields and roadsides turn a deep, vivid blue, covered gaily with bluebonnets. Bluebonnet is the Texas name for Lupinus texensis Hook, of the Lupine family. Since the little petals looked like ladies' bonnets, naturally the Texans Americanized it with that most accurately descriptive name. (P. 139)

Grace Bowman Simpson Caudill was born in Kentucky and spent most of her early life in Booneville, a mountain town in the southeastern part of the state, widely recognized as a center for fine quilting. Her mother and aunt were acknowledged as experts by this superb group of quilters, and it was here as a small child that her love affair with quilting began. "I was fascinated by the beauty flowing from Mama's needle," she once said. "When most of my friends wanted to play with dolls and other toys, I wanted to quilt. And if I had to stand on a chair to see the top of the quilting frame, that was alright too. I still wanted to quilt."

She attended Eastern Kentucky State Teachers College and went on to hold positions as a teacher and mortgage banker, but her true love was always quilting. "Some years ago during a trip to Cincinnati, I met a lady who said, 'All the quilting gals seem to live in their own world.' . . . I finally concluded that she was absolutely right. By no stretch of the imagination could ever a 'livin' soul,' except another quilter, understand the delight, enjoyment, and pleasure that hanging over a quilting frame can bring and how quilting can transform an otherwise loving wife and mother into someone totally oblivious to all mundane and earthly distractions, such as dusty furniture, unmade beds, yelling kids, or hungry husbands!" (p. viii).

Grace Simpson Caudill married, moved to Texas, divorced, reared two daughters, and later in life married an old friend, Ed Caudill, a college professor, and moved from Houston to Greensboro. She considered herself to be a professional quilter and supported herself largely through her quilt-related earnings from teaching, lecturing, pattern sales, custom quilts, and her book. She is perhaps best known for her magnificent Bicentennial Quilt, which was featured on the cover of *Quilter's Newsletter Magazine* in 1976. One statement in her book, which refers to growing up during the Depression, sums up this quilter's way of looking at life: "I'm eternally grateful to have learned early that happiness survives adversity as an attitude and not a condition dependent on circumstance" (p. 43). Grace Simpson Caudill died in May 1989.

ORION QUILT

62″ × 62″
Cotton and cotton blends

Pieced and quilted by Libby Anthony Lehman in
Houston, Harris County
Owned by the quiltmaker

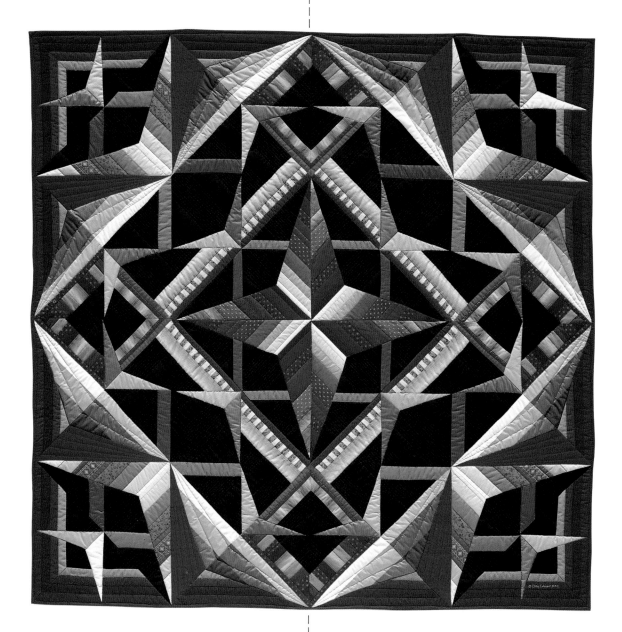

IN 1971, a year after graduating with a Bachelor of Arts degree from Rice University, Libby Lehman hand-pieced a Trip around the World as her first quilt. This was a commitment that many more experienced quiltmakers would not have tackled, since it generally involves sewing together sometimes hundreds of pieces of fabric about the size of a postage stamp.

Twenty-four at the time, this quiltmaker has been busy at what has become both a profession and a passion ever since. After a couple of years as a secretary following graduation, she discovered her real interest lay in quiltmaking, teaching, and lecturing. In addition, she is also a calligrapher.

Her start in quilting came from a class she took in Santa Fe under Mary Woodard Davis, somewhat surprising because Mrs. Lehman's mother, Catherine Henry Anthony, is a well-known quiltmaker, teacher, and lecturer also. This, however, is actually how many young women learn to quilt today—either in intensive workshops or through classes taught at a quilt specialty shop or in adult education courses, rather than directly from a family member.

Mrs. Lehman has since studied with Michael James, Jinny Beyer, Nancy Crow, Nancy Halpern, and other internationally known teachers. Her work has won many first-place awards, and Orion, one of her first strip-pieced quilts, has been exhibited in five states, featured in a Japanese craft magazine, and awarded Best of Show in the Fibers for Architectural Spaces competition in Houston in May 1983.

Currently remodeling her home studio to double the space she has for quiltmaking, Mrs. Lehman quilts alone in the early morning and during the midday. She is married, has two children, and has been a lifelong resident of Houston, with the exception of one year spent in Sweden. As a professional quiltmaker, she does sell her quilts but says quiltmaking gives her "a sense of fulfillment, as well as monetary rewards."

While her first quilt was a very traditional one, Mrs. Lehman has become associated in recent years with contemporary quiltmaking, and most of her current quilts are in that genre. She makes between two and five quilts a year, depending on their complexity. Orion, for example, is machine-pieced, hand-quilted in outline and geometric quilting designs around each piece in ten to twelve stitches per inch, and finished with a separate bias binding.

Libby Anthony Lehman

CELEBRATION—NINA QUILT

56″ in diameter
Cotton and blends

1983

Pieced, appliquéd, and quilted by Catherine Henry
Anthony in Houston, Harris County
Owned by the quiltmaker

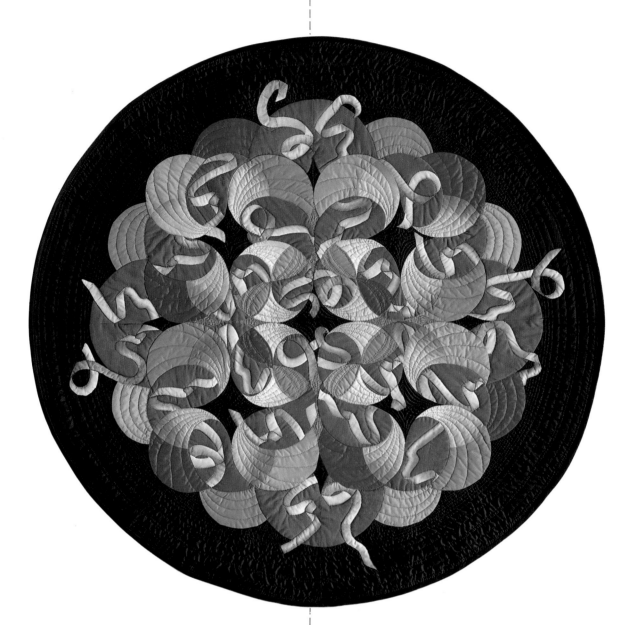

A QUILT-IN-THE-ROUND in honor of the woman who brought theater-in-the-round to Houston, Celebration—Nina is one of a series of quilts saluting women that quiltmaker Catherine Henry Anthony admired.

Nina Vance, who made Houston's Alley Theater (now the Nina Vance Alley Theatre) into a regional theater powerhouse and who established a permanent professional theatrical troupe in Houston, is the subject of this work.

Mrs. Anthony, who grew up in Taft, San Patricio County, and Edna, Jackson County, has lived all her life in Texas, with the exception of one year in Boulder, Colorado. She holds a Bachelor of Arts degree from Rice University and has taught quiltmaking in Houston, throughout the country, and abroad for eighteen years. She owned a quilt shop in Houston for eleven years and has a collection of antique Amish quilts.

Essentially self-taught as a quiltmaker, with no formal art training, Mrs. Anthony has furthered her skills through seminars and workshops taught by other quiltmaking professionals. Her work at first was in the traditional quiltmaking style but later moved into more contemporary approaches. Well-known quilt artists Nancy Crow and Michael James have been important influences on her work.

Catherine Henry Anthony

In *The Art Quilt,* authors Penny McMorris and Michael Kile note:

It was not until the feminist movement began in the early 1970s, and more and more women challenged the male-dominated art establishment, that quiltmaking caught the interest of women (and men) who possessed professional art backgrounds. Today, there are many quilt artists . . . who are working in the medium. They bring to it a broad repertoire of artistic talents. As a result, they have, through the use of these talents, expanded the format, scale and subject matter of quilts. Before them, quiltmaking was, for the most part, dependent upon a catalogue of established geometric and appliqué patterns. Now, however, trained artists are making one original design after another and, as is the case with several of them, they are manipulating the traditional geometric plane with a new vivacity. In turn, their work has challenged tens of thousands of contemporary and traditional quiltmakers, the overwhelming majority without academic art backgrounds, to experiment with color and pattern, to innovate. As thousands of quiltmakers who might otherwise consider themselves traditionalists have studied with quilt artists like Burbidge, Crow, James, Myers, and Porcella, they have translated what they have learned to their own quilts . . . Thus, the influence of these quilt artists goes far beyond their own artistic output; it includes their powerful influence on the whole of modern quiltmaking. (Pp. 61–62)

Certainly Celebration—Nina is nontraditional in its concept as a round quilt. It is a mostly pieced quilt with a small amount of appliqué and is made of cotton and a mix of fabrics, with a cotton-blend backing and a wool batting. The quilting follows the general design of the quilt, which is very contemporary, and it has seven to nine stitches per inch. A separate bias binding completes it. The drama of the quilt's vivid blacks, reds, blues, golds, lavenders, and purples echo the drama of Alley Theatre productions themselves.

SHIRAZ QUILT

69″ × 96″
Cotton

1983

Pieced and quilted by Judy Parrish Cloninger in
Taylor Lake Village, Harris County
Owned by the quiltmaker

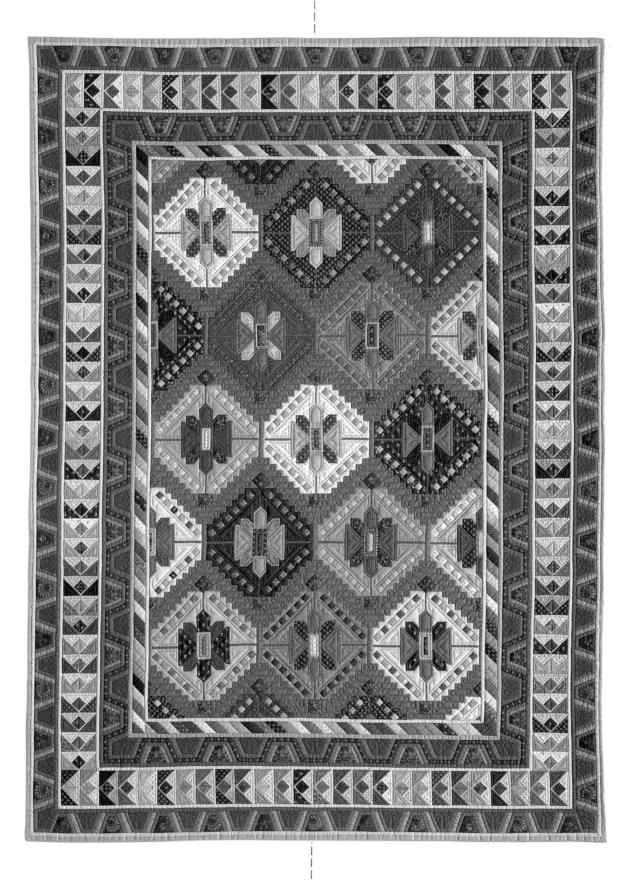

A FORMER urban planner who graduated *magna cum laude* with a degree in economics and a Phi Beta Kappa key and now teaches and lectures about quilting, Judy Parrish Cloninger is one of the new breed of quiltmaker.

She was born in Nashville, Tennessee, in 1941, married at twenty, and worked seven years before having two children. She has lived all her life in the South: Tennessee, Georgia, Florida, and Texas.

Although she remembered her grandmother quilting when she was a child, Mrs. Cloninger taught herself to quilt in 1969, when she was living in Clearwater, Florida, and at home with her children. Her first quilt was a traditional crib quilt.

Moving to Texas in the early 1970s provided her with an opportunity to learn in depth about quilts. The mid–1970s was a time of renewed interest in handicrafts as our nation celebrated its 200th birthday. "The revival of interest furnished me with fabrics, information, and shared enthusiasm," she said. Her first full-size quilt was made in Houston for the Bicentennial in 1976 and was a blue-and-white Courthouse Square.

She quickly discovered a talent for making prize-winning quilts, receiving awards for Best Color and Design and first place in the Adaptation category at the 1978 quilt show sponsored by the Quilt Guild of Greater Houston for her quilt Lilies of the Field. Shiraz was her next full-size quilt to win prizes, taking Best of Show, Founders' Award, first place in the Pieced Division, and second place Viewers' Choice in the 1983 South/Southwest Quilt Association judged show in Houston.

Her family is supportive of her quiltmaking; however, Mrs. Cloninger said, "for the first year, my husband sang 'Aunt Dinah's Quilting Party' every time he saw me quilting, but over time he has encouraged all my efforts, especially helping with publications and editing."

She averages one quilt per year, because her quilts are complex, heavily quilted designs. An intricate quilt, such as Shiraz, may take as many as two thousand hours of work.

Shiraz has cotton fabrics in its top and backing, but the quiltmaker has chosen a synthetic batting. It is completely hand-pieced and hand-quilted in outline quilting around each individual piece, with seven to nine stitches per inch and many rows of quilting less than one-half inch apart. The

Judy Parrish Cloninger
(Ball Photographers photo)

heavy and elaborate quilting is in designs that repeat Oriental motifs, including the S or serpent shapes, latch hooks, and running vines.

According to the quiltmaker:

Shiraz is a blending of two textile art forms—the Oriental carpet and quilts. The challenge was in manipulating colors and fabrics to create intricate geometric shapes. The central design is based on the eight-pointed star, although it has evolved and changed through many centuries. The blocks are set on point, with stepped sides. The stars are surrounded by twenty-four small [¾ inch] squares, which give the illusion of lace or lightness to the blocks. The borders include a barber-pole stripe, running vines, and a main border of stylized floral motifs. Rugs from the villages around the Persian city of Shiraz provided the inspiration for this quilt.

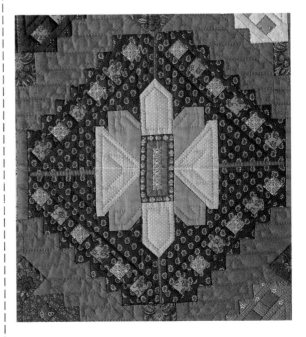

FOLK LIFE FESTIVAL POSTER QUILT

90″ × 90″
Cotton and cotton blends

1983

Pieced and quilted by members of the Greater San Antonio Quilt Guild in San Antonio, Bexar County
Owned by the University of Texas Institute of Texan Cultures at San Antonio

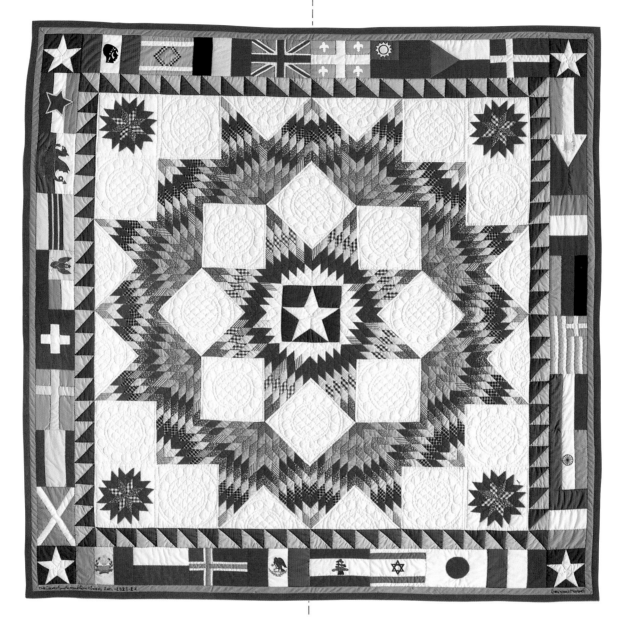

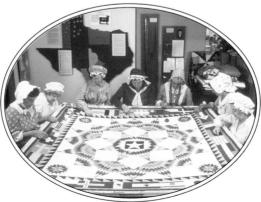

Members of the Greater San Antonio Quilt Guild

POSTERS of quilts usually come after the quilts are made, but in this case, not only did the poster come first but also it was based on a painting of a quilt rather than the real thing. In fact, members of the Greater San Antonio Quilt Guild had to hurry with their quilting so the quilt could even debut at the Folk Life Festival that it commemorated.

This topsy-turvy turn of events came about because Beverly Orbelo, a member of the guild's board of directors at the time, met a young artist and illustrator at an arts fair at the Institute of Texan Cultures in April 1983. Christopher Moroney mentioned to her that he was submitting a painting of a quilt in the poster contest for San Antonio's Folk Life Festival, an annual celebration of Texas and her people sponsored by the Institute. Mrs. Orbelo told him that she would try to make a quilt from his painting if it won the contest.

Just a few weeks before the Festival opened, the young man called to tell her the good news. The bad news, of course, is that a few weeks is not very much time to make a quilt from start to finish. Fortunately, there were willing and highly motivated quilt guild members who wanted to help.

The first step was to obtain funding to purchase the fabrics and supplies needed for the quilt. The Institute of Texan Cultures agreed to pay those expenses in return for the Greater San Antonio Quilt Guild's donation of its members' time and quiltmaking abilities.

With that partnership arranged, plans for the quilt proceeded. Under the direction of Mrs. Orbelo, who did the piecing of the central Star of Bethlehem surrounded by a Broken Star and four Starry Heavens or Blazing Star variations in the corners, work on the quilt progressed rapidly. Mrs. Orbelo said that the very short time available to complete the quilt made it imperative that the piecing be done quickly on a sewing machine and that it fit together properly the very first time, things that are easier to achieve if only one person is involved.

Obtaining the right fabrics for the quilt was a joint effort, for the need to match the painting required a wide variety of material. Some of it was purchased, some antique fabrics from quilt guild members' collections were used, and still other fabrics came from friends who joined in the effort. Some of the old prints the artist had turned up in his research and duplicated in his painting were especially difficult to match, and similar prints had to be dyed to make them work.

The guild's goal was to have the quilt in the frame, ready for attendees at the Folk Life Festival to help with the quilting, and they made it. Everyone who came by was invited to sit and quilt, with the promise that no one's stitches would be removed. This public invitation to quilt is often made by guild members all over the state

Beverly Orbelo
(Parish Photography photo)

when they demonstrate quilting in a frame at various events. It is considered by all guilds to be a good opportunity to teach people about quilting, to show them that it is easy and fun, and to recruit new members for their organizations.

Beverly Orbelo recalled that both the quilt and the quilting were a great success. People waited in line for their turn to quilt, and one family purchased the Institute's post card of the poster and marked where each member had quilted, planning to view their stitches on succeeding visits. The project seemed to capture the public's fancy and was featured in several newspaper and magazine articles.

Following the Folk Life Festival, the quilt was finished by guild members. The thirty two flags in the border, showing the many countries whose emigrants make up the Texas population, were rather daunting, and no one really wanted to begin them. Eventually, however, some of the hardiest guild members tackled the project. The flags were pieced, small details on them were painted, and they were sewn onto the quilt, forming a colorful and culturally significant border. The quilt is finished with a straight-grain binding with mitered corners in red.

Because so many people worked on this quilt, there is a great variety in the number of stitches per inch and in the straightness of those stitches. But what the quilt lost in quilting expertise by the public's being invited to quilt, it more than made up for in a shared experience, which is in the true spirit of quilting and of the Lone Star State.

As guild member Charla Viehe said in an article on the quilt for *Lady's Circle Patchwork Quilts*, "it is an outstanding tribute to the Lone Star State and the many settlers who came, fought for, and shaped Texas. It is also a tribute to a young man who had a vision of Texas history, and his appreciation of quilts and quilting—one of the significant symbols of our development as a state, nation, and as women."

DANCING STARS QUILT

1983

88" × 90"
Cotton

Pieced by Connie Saggert Hufnagel in Austin, Travis County
Quilted by Billie Norman, Jewel Patterson, and Catherine Thompson in Houston, Harris County
Owned by Mary Harrison

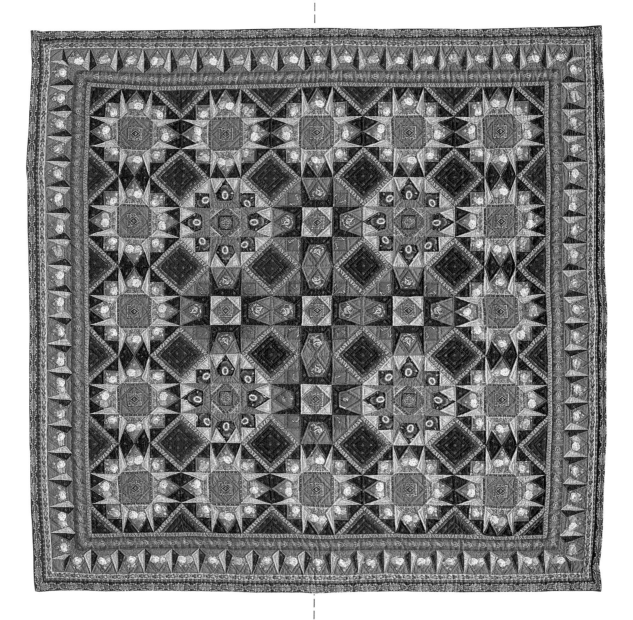

AN ORIGINAL block design created for the sixtieth birthday of the quiltmaker's mother, this pieced star is both graphic and complex. The subtle colorations of teal, pomegranate, and warm brown emphasize the painterly quality of this quilt, which features the unbeatable combination of masterful workmanship and originality. Made to be given to the American International Quilt Association as its fund-raising quilt for 1983, Dancing Stars is entirely hand-pieced; devoting the time required to hand-piece a full-size quilt that is ultimately destined to be given away reflects the quiltmaker's dedication to achieving the highest quality in her work.

Like many fund-raising quilts, Dancing Stars was quilted by someone other than the quilt's designer. The quilting stitches measure approximately nine per inch; each piece in the intricate design is individually outline-quilted around the edge. The quilting adds depth to the design and emphasizes the complicated piecing. The original block of this design was created in 1982 and named A Rose for Grace.

Connie Saggert Hufnagel was born in 1944 in Seguin, married and divorced, and has three children. She studied for two years at Texas Lutheran College, works as a bookbinder at the University of Texas, and serves as business manager for the Genetics Society of America. A lifelong fabric collector, Ms. Hufnagel taught herself to quilt because she found quilts "the perfect way" to use her fabrics. She subsequently took several advanced seminars taught by nationally recognized authorities. She works on her quilting in her studio and also with quilting groups. She was a member of the Sunday Friends (see the Rose of Sharon quilt on page 128) until it disbanded and now quilts with another group in Austin.

She made her first quilt, a prestamped Carousel crib quilt, in 1968 at the age of twenty-four while

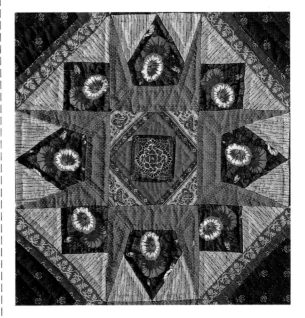

she was expecting her first baby; it was hand-quilted in time for the birth of her son. "In 1975, after a lapse of seven years, I caught quilt fever and made my first full-size quilt, a scrap Churn Dash, for my daughter and three crib quilts for the birth of my second son. I've been at quilting as much as possible ever since," remarked the quiltmaker. "I get creative fulfillment out of my quilting . . . and sometimes frustration, too," she added. Her family is supportive of her quilt-making, "but not always of my fabric purchases."

The quiltmaker's work has achieved recognition by winning ribbons at the American International Quilt Association judged show in 1980 and 1985 and being featured on the cover of *Quilter's Newsletter Magazine*. In addition, she was commissioned by two batting companies to make special quilts for their collections.

CHERRY RIPE QUILT

73″ × 89″
Cotton

1983

Pieced, appliquéd, and quilted by Laverne Noble
Mathews in Orange, Orange County
Owned by Linda Roberts Mathews

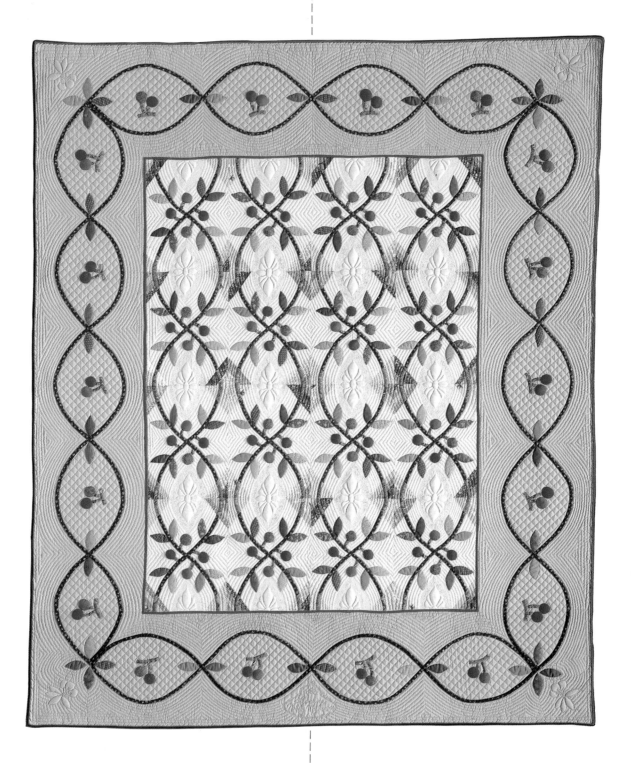

THIS QUILTMAKER, with an exceptional sense of design and color, has created a family tradition of giving her quilts away and has made special quilts for every member of her extended family—sons, daughters-in-law, grandchildren, sister, brothers, mother, mother-in-law, nieces, and nephews. For years, the recipients of her quilts were decided in a Christmas drawing. The lucky person whose name was drawn would get to select a quilt pattern and fabrics, and that special quilt would be their Christmas present the next year. "I've made all of them so many quilts now that we don't even hold the drawing any more!" explained the quiltmaker. "Some of them have two and three quilts each," she added.

Cherry Ripe was made for a daughter-in-law who loved the finished quilt so much that she based the colors for her new home on the colors the quiltmaker selected for the quilt: greige, gray, black, green, and four shades of red. The quilt is appliquéd by hand but machine-pieced. The arrangement of the vining cherries creates a negative space that the quiltmaker has emphasized with stuffed trapunto designs. This lovely design is taken from a published Mountain Mist pattern.

Heavy, elaborate quilting is used on this elegant quilt, with a close grid of less than one inch used for the background and outline quilting used around the pieced and appliquéd designs, trapunto, and stippling. The stippling was used for the specific purpose of flattening the area in and around the trapunto design so that the stuffed work appears in sharper contrast to the background. In the border, the quiltmaker has quilted her signature and the date the quilt was made. She has placed as much emphasis on the quilting as on the appliqué and piecing, which is one of the characteristics of a masterpiece quilt, and her quilting stitches measure ten to twelve per inch. In many parts of the quilt, the rows of quilting stitches are closer than one-half inch apart. The quilt is finished in a classic mid-nineteenth-century method often used on intricate appliqué

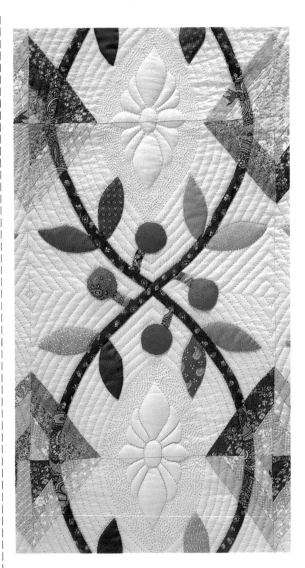

Laverne Noble Mathews

quilts—a row of red piping is inserted between the outside edge of the quilt and the black binding.

Laverne Noble Mathews was born in Wichita Falls and has lived in Texas all of her life, primarily in the Orange area. She holds a master's degree in education from Lamar University and taught sixth and seventh grades for twenty-five years. She married J. L. Mathews in 1945 and had two sons. She quilts as a form of artistic expression and makes three or four quilts every year. Although she has a separate quilt room on the second floor of her home, she quilts throughout the house. She actively participates in the Golden Triangle Quilt Guild and the Blockheads, a quilting bee, and she and her two daughters-in-law quilt often together. Her first quilt was a Lone Star made in 1971; her work is often based on traditional patterns that she adapts creatively. Because of their beauty and fine workmanship, Mrs. Mathews' quilts are often selected for viewer's choice awards in quilt shows. She has won many ribbons for her workmanship and artistry, and two of her quilts are in the collection of a planned museum in Kentucky.

STAINED GLASS QUILT

83″ × 84″
Cotton and cotton blends

1983

Pieced, appliquéd, and quilted by Vivian Osie Hobbs
Parker in Fort Worth, Tarrant County
Owned by the quiltmaker

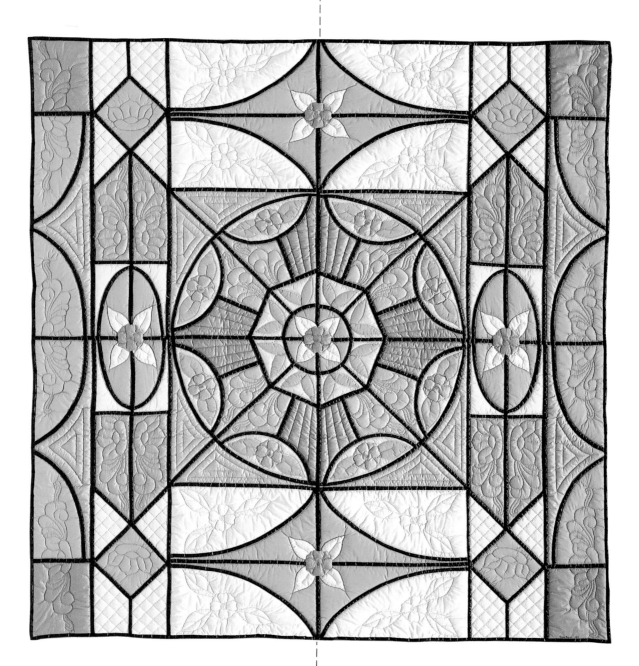

DURING her thirty years as a military wife, Brady native Vivian Osie Hobbs Parker lived all over the United States and the world—California, Washington, D.C., England, Colorado, Florida, Alabama, France, Maine, and Illinois.

When her husband, an air force colonel, retired in 1970, they made their home in Fort Worth, where Mrs. Parker set up quilting frames in a spare bedroom. She says that there is almost always a quilt in them and that her current project is quilting a top she thinks is ninety to ninety-five years old for a friend.

She has quilted since age five or six, or since she was "just big enough to stand at a frame." Both her mother and grandmother were avid quilters, so "we always had a quilt in the frame." She speculates that her first quilting stitches were pulled out but says that she never knew it for sure. "No one ever discouraged me. I was always allowed to quilt on their quilts, and they never said a word about my big stitches."

Mrs. Parker, who was born in 1922, pieced her first quilt at age nine or ten when she was living in Clyde. It was a Nine Patch, and she describes it as "a true disaster."

She did little quilting as she raised her family and moved around the country and the globe, and when she did, she made mostly crib quilts. Since her husband's retirement, Mrs. Parker has quilted a great deal and usually finishes two quilts a year. While she does many other types of needlework, including crochet, knitting, counted cross-stitch, and some embroidery, she would much rather quilt. Her two daughters both are also interested in handcrafts.

A member of the Trinity Valley Quilters' Guild, Mrs. Parker helps with guild projects and quilting demonstrations but usually does not quilt with a group. She quilts in the early mornings and afternoons and "any time I find time!" Since 1979, she has taken quilting classes in Houston, Kentucky, and Georgia, as well as in Fort Worth at guild-sponsored workshops.

Her Stained Glass quilt was a blue-ribbon winner at the state fair and hung in an invitational show, Stained Glass Connection, in Lexington, Kentucky. She has received awards for other quilts also, some of which have been published in various quilt magazines.

Vivian Osie Hobbs Parker
(Hollis photo)

In making Stained Glass, she used cotton and polyester chintz and synthetic batting. Her pastel colors are set off by the dark brown "leading" that produces the stained glass effect in this type of quilt, which became very popular in the late 1970s, following on the heels of the heightened interest in the making of stained glass. Mrs. Parker has sewn her "leading" in between each piece of the top rather than taking the easier route of appliquéing it onto the top. She used a combination of hand and machine piecing and hand appliqué, with outline quilting, quilted flowers and leaves, and a one-to-two-inch crosshatch in her quilting design.

Each individual piece in the quilt is quilted on both sides of its edge. Mrs. Parker quilted about seven to nine stitches per inch, and her designs are one-half to one inch apart. She explains that the high loft quilt batting that she used, as well as her choice of chintz fabrics, made it difficult to take tiny stitches. She used a separate bias binding to finish her quilt.

"I inherited my love of quilts from Mother and Grandmother. I love the creativity of quilting; it gives me great peace of mind, a sense of heritage, and a feeling of accomplishment. One of my daughters is very interested in quilting, and my second granddaughter, who is five, already sits beside me and quilts," Mrs. Parker said.

ROSE OF SHARON SAMPLER QUILT

98″ × 104″
Cotton

1983

Pieced by Sunday Friends in Austin, Travis County
Quilted by Kathleen Holland McCrady in Austin
Owned by the quilter

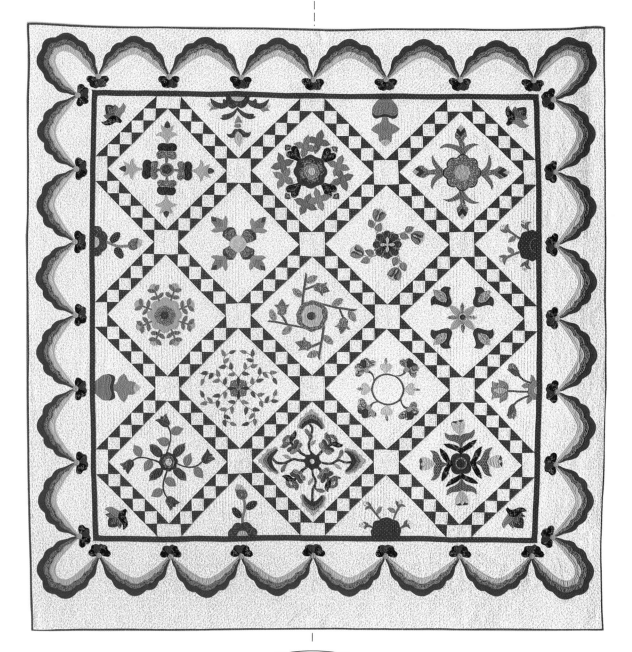

Members of Sunday Friends: *left to right,*
Flo Cochran, Connie Hufnagel, Modena Lyons,
Lorre Weidlich, Kathleen McCrady, and Nancy Ryerson

FOLLOWING the United States Bicentennial celebration in 1976 and the general nostalgia it created for what were perceived as old-fashioned, home-based arts and crafts, there was a renewed interest in quilting. While some women have always quilted with no thought for whether it was in or out of style, others began to be aware of the rich heritage that quilts embodied.

This waxing and waning of interest in quilts and quilting has been going on for centuries, a fact that comes as quite a surprise to recent converts. In Austin, as in other parts of the country, interest in quilting once again was waxing in the late 1970s. Women who had previously quilted alone and believed themselves to be stepping to a different drummer found to their surprise and delight that others were falling into formation all around them.

"Quilting for me during the fifties and sixties was a lonely time, and when I found others who I could share quilting with, I was like a child with a new toy. It opened up a whole new world for me. No longer was I 'different'—there were others out there who liked the same things I did! What a wonderful discovery!" said Kathleen Holland McCrady, the owner of the Rose of Sharon Sampler.

Sunday Friends was a group of Austin Stitchery Guild members who were primarily interested in quiltmaking and started meeting on Sunday afternoons in 1978 to quilt together. The group remained in existence from 1978 to 1984, sharing ideas, fabrics, patterns, and other quiltmaking tools as well as piecing, appliqué, and quilting skills with one another. It disbanded only when members found a larger support group within the Austin Area Quilt Guild, which had also begun in 1978.

The group worked on a point system under which a quiltmaker kept a record of quilting activity done for another member, such as helping to quilt a quilt or piecing a block. When, for example, a quiltmaker had quilted eight times on a quilt, she earned a token. When a project was completed, one token was drawn from the pot, and the winner could choose to have her quilt top go into the frame next, or she could have a top pieced. If the winner decided to have a top pieced, she furnished the fabric and usually the design, and a system was worked out for that project to determine how many points would be awarded for piecing a block.

When Kathleen McCrady won a Sunday Friends drawing, she decided to have an appliqué top made that would combine several traditional Rose of Sharon blocks of her selection, some of which were personalized by the Sunday Friends making them in 1982–1983. After the blocks were completed and sashed, Mrs. McCrady added the swag borders and more appliqué and then quilted the top in 1987–1988. The finished quilt combines hand piecing, appliqué, and embroidery. Each piece in the design is quilted around the edge, in the ditch. Feathers and a close crosshatch of one inch or less, with quilting less than one-half inch apart, form an overall elaborate and fancy quilting design.

Many Sunday Friends quilts, including the Rose of Sharon Sampler, have won prizes in various competitions. One judge, in giving a special merit award for appliqué to the Rose of Sharon Sampler, noted the evenness in the workmanship and commented that she "couldn't believe it was a group quilt."

Members of Sunday Friends included Ruth Aulds, Flo Cochran, Donna Fickie, Mary Holt (deceased), Connie Hufnagel, Marge Kelly, Beth Kennedy, Nancy Loayza, Modena Lyons, Kathleen McCrady, Nancy Ryerson, Katherine Smith, and Lorre Weidlich.

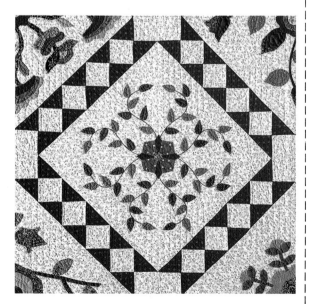

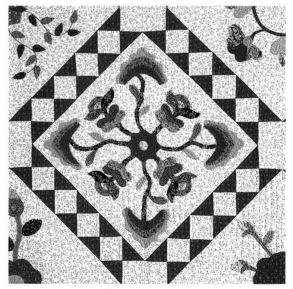

HOUSES, BARNS, AND CHURCHES QUILT

96″ × 104″
Cotton

1984

Pieced, appliquéd, and quilted by Shirley Ann Godbold Fowlkes in Dallas, Dallas County
Owned by the quiltmaker

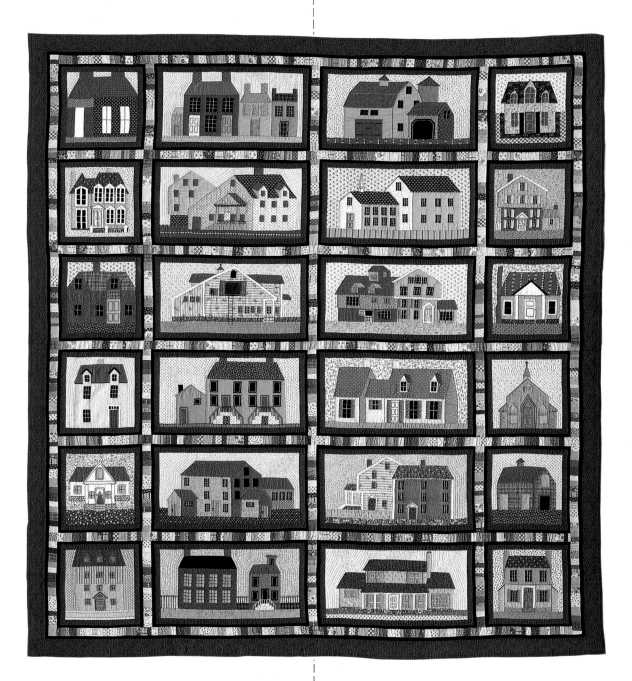

MANY PEOPLE depend on photographs of special places to capture memories; this quiltmaker chose the medium of quilting to bring her memories to life. Many of the buildings in this completely original quilt are personal to the quiltmaker and her family—"homes we have lived in, the church we were married in, and my parent's home and barns," as she recalled.

The buildings were all designed to fit within two basic block sizes, which gave the quiltmaker more freedom in the type and complexity of structures she depicted in the quilt. Each block is framed in a double mat, and the sashing between the blocks was string-pieced from leftover fabrics first used in the buildings themselves.

The quiltmaker used a mixture of techniques to create this personal memory quilt: machine piecing, hand appliqué, hand embroidery, and hand quilting are all used in this piece. Each piece of each building has been quilted in the ditch; the stitching is less than a half inch apart and contains approximately six to eight quilting stitches per inch. Shadow quilting is used in the background. A separate binding is used to finish the edge of the quilt.

"I chose to make a quilt on buildings because they have played a big part in my husband's and my life—he is an architect and I am a realtor, and both of us specialize in residential work," commented the quiltmaker. "Many good times were experienced in these buildings." She specified that the quilt, because of its graphic qualities, should be displayed on a wall rather than used on a bed. After having spent approximately a thousand hours on this design, her efforts have been

Shirley Ann Godbold Fowlkes

well rewarded with the honors garnered by this quilt—at the 1984 International Quilt Festival in Houston, known as the largest quilt show in the world, where the judged show of the American International Quilt Association is on display each year, this quilt won third place Judge's Choice, honorable mention for the Founders' Award, and second place Viewer's Choice.

A trained artist with a degree in art education from the University of Texas, Shirley Godbold Fowlkes grew up on a ranch in the Hill Country north of Leakey. There she learned needlework skills from her mother and from the ranch foreman's wife. This fifth-generation Texan began designing and sewing on her own at the age of eight when she stitched her first original design on an old treadle machine using fabric from a bathrobe she found in the rag bag. Married in 1955 in Leakey, Mrs. Fowlkes was inspired to take up quilting after seeing her sister at work on a quilt; she started with a Sampler quilt made in 1981, and she is now a consistent blue-ribbon winner in local, state, national, and international shows. She has received more than a dozen blue ribbons and several best-of-show awards, and her work has been featured in magazines, books, and museum exhibitions.

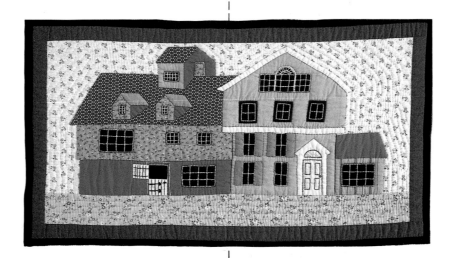

HONEYMOON ALBUM QUILT

104″ × 90″
Cotton

1985

Appliquéd and quilted by Lorraine Austin Boehme in Sugar Land, Fort Bend County
Owned by the quiltmaker

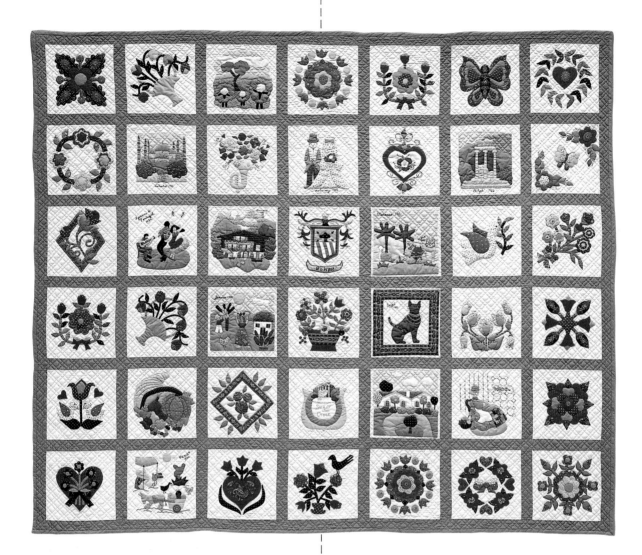

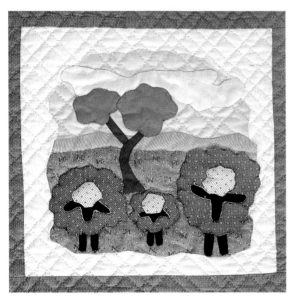

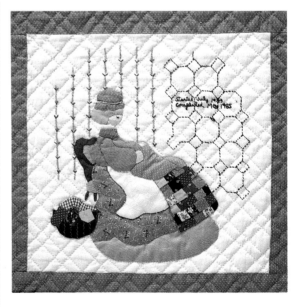

REMARRYING at age sixty-two to a retiree like herself, Lorraine Boehme and her new husband embarked on new travels and experiences. A few years later, when they needed a new bedcover, Mrs. Boehme decided to make an album quilt depicting shared personal recollections. She thought a block design showing countries they had visited, their wedding date, the house they shared, and other personal memories would constitute a unifying theme for the quilt.

The only thing standing between her and the realization of the quilt she pictured was the fact that she had never made a quilt before. However, Mrs. Boehme did not let her lack of experience keep her from her goal.

After a quilting lesson at the local community center she bought a book on appliquéd album quilts and began her quilt with the sixteen designs shown by the authors. "When you finish all sixteen, I guarantee that you can create any appliqué design with confidence," she said. "I hate to do the same thing twice, and, since I needed fifty blocks to complete a king-size quilt, I began to draw pictures—patterns of my own. I also looked for appliqué designs in magazines and other sources."

Since she had embroidered and sewed clothes and other items for years, she decided to stick with her project even though she was a beginning quilter and appliquéd album quilts frequently are a challenge for even an experienced quiltmaker. Before the project was finished, she realized that her lack of expertise was something of a drawback for fulfilling her ideas for the quilt. "I would recommend beginning quilters join a [quilting] bee or get some expert supervision. I failed to do this, and subsequently the quilting and appliqué stitching leave much to be desired. A quilt book is good for learning, but you still need some expert criticism along the way," she cautioned.

Mrs. Boehme's skills were honed as she "learned by doing" the complicated project she chose. Her charming design and original ideas give her quilt great appeal, and it has appeared in several quilt publications. The quiltmaker has received many requests for patterns for her unique blocks, although she did not save the designs after she completed the blocks.

"I have painted and designed as a hobby," she said. "Nothing especially great came out of my artistic endeavors, but the urge to create has always been part of me . . . I became interested in quilting in the appliquéd album style because it offers a great outlet for artistic expression. You have such great freedom to move. As you can detect, I find pieced quilting very limiting except for color use," Mrs. Boehme said. "I love to draw and to paint and, to me, quilting is art—using fabric and thread instead of paint to create a work of art."

She quilts with a quilting bee, with a long-time friend at least once a week, and also alone, in a room with other family activities going on. Generally, she works in the afternoon and at night. Mrs. Boehme finds quilting a creative outlet, "and it keeps my hands occupied so that I do not smoke cigarettes. I have been called a compulsive quilter because family visits do not interfere with my work, and I always have a project beside me when the television is turned on."

On her first quilt, she used hand appliqué, hand quilting in a one inch or less crosshatch for the background, and outline quilting around each individual piece of the appliquéd design, with seven to nine stitches per inch. After her very difficult first quilt, Mrs. Boehme worked on other types of projects but began another quilt in 1989.

Mrs. Boehme was born in Mobile, Alabama, lived most of her life in Lake Charles, Louisiana, and Houston since 1957, and has a daughter by her first marriage. She holds a master's degree in nursing education from the University of Texas and taught nursing at various colleges and universities, including Texas Woman's University, before she retired in 1972.

The quiltmaker's Honeymoon quilt was begun in 1983 and finished in 1985, when it was entered in the American International Quilt Association's judged show. Mrs. Boehme had not thought of a title for the quilt until the contest entry form forced her to name it. "The best I could come up with was Honeymoon—and it has been a long honeymoon," she added.

TRIBUTE TO THE COWHAND QUILT

53″ × 53″
Cotton and polyester blends

1985

Pieced, appliquéd, embroidered, and quilted by Jil
Garrett Branan in Pampa, Gray County
Owned by the quiltmaker

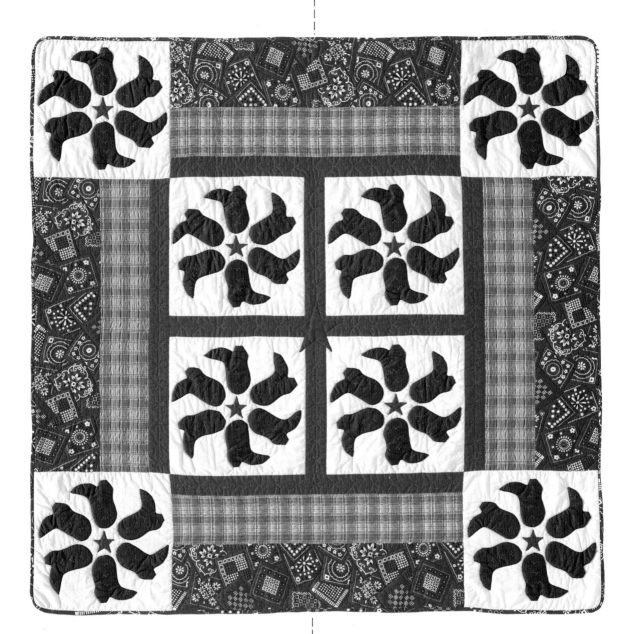

AS A LITTLE GIRL growing up in Valdosta, Georgia, Jil Garrett Branan equated Texas with cowboys. After she married and moved to the Panhandle in 1984, one of the first Texas images that imprinted itself in her mind was of cowboys driving up in a horse trailer, pulling off the side of the road, and unloading cow ponies to begin working cattle.

"So, when I heard about Texas' Sesquicentennial, I decided to design and make a quilt that portrayed the ranching industry, especially the cowhands," she said.

Her efforts resulted in an original design that incorporates boots, stars, bandannas, and plaids into a colorful quilt intended for the wall rather than the bed. Tribute to the Cowhand was selected to tour with the Great Texas Quilt RoundUp during the Texas Sesquicentennial.

The quiltmaker spent about two hundred hours designing and making her quilt, with the embroidery on the boots taking the most time. It is quilted on one side of each piece in outline quilting. Quilting follows the plaids and goes around the designs in the bandanna fabric, with seven to nine stitches per inch. There is a separate bias binding of bandanna fabric finishing the quilt.

Everything in this quilt is symbolic of some aspect of the cowboy's life. The bandanna is used to filter out dust and to protect against the sun and the cold. The boots are synonymous with a cowboy's gear, and embroidery suggests the elaborate stitchery often seen on them. The star is for the Lone Star State, the country's leader in cattle production. The plaid is a traditional fabric used in Western shirts. Quilting in the red borders and latticework depicts barbed wire, the key factor in the closing of the open range.

It is difficult to summarize how important the cowboy was, and is, in Texas. Suffice it to say that Texas changed the former cowherd into the cowboy, and the cowboy changed Texas.

According to T. R. Fehrenbach in *Seven Keys to Texas*:

Texans who owned livestock had previously herded them on foot in the time-honored British fashion. But on the frontier, they seized upon the entire Mexican cattle culture, even its jargon, from lariat (la reata) *to buckaroo* (vaquero). *They took up Mexican longhorn cattle, the open range, the ranch, the brand, the male-bonding of the* vaquero *and the values of the* charro, *or Mexican mounted gentleman: courage, skill with horse and rope, semifeudal loyalty to owner and brand. They took a way of life and infused it with the cold, hard pragmatism of capitalistic enterprise—for the frontier* was *a business, even in its wildest, most 'romantic' Indian-fighting years.*

The true Cattle Kingdom in most ways was as ephemeral as the true frontier. It was gone when Texas turned from open range into the land of big pastures in the 1880s. But meanwhile, Texas and Texans exploded it north and west across the remaining continent: to Kansas, Colorado, and Wyoming, to Montana and distant Calgary, and from the Pecos to the California mountains. And meanwhile, there was time enough for Texans to stamp forever the image of the Cattle Kingdom into the American consciousness, just as the frontier had impressed itself on them. (P. 25)

Though the freewheeling days of the cattle culture are over, cattle and the men who care for them remain a part of the state's culture and economy. In 1968, for instance, the state reached the all-time high cattle count of 10,972,000 cows. The population of Texas at the time was 10,819,000. And though the work of the cowboy has changed greatly, he is still basically a "cow servant," as the ranch hands from the Rocking Chair Ranch were humorously termed. "Obviously, these people weren't originally from these parts," said Kirk Dooley in *The Book of Texas Bests,* in citing the term as the best name for a ranch hand (p. 174).

Mrs. Branan's background in handwork gave her considerable ability to conceive and execute her Tribute to the Cowhand. Her grandmother, Mrs. Louie Wetherington, first taught her to hand sew, so she could make clothes and quilt tops for her dolls. For three summers between the fifth and eighth grades, her parents sent her to sewing school. After Mrs. Branan moved to Pampa, she took quilting lessons. When she made the quilt in 1985, she had an arts studio. She is now a sales representative for United Notions and Fabrics, a large national sewing notions and fabric distributor.

Historian Joe B. Frantz, in *Texas: A History,* said: "The cowboy has his chroniclers and poets. Without doubt he has been heroized until he would have been almost unrecognizable to his contemporaries, and yet in today's complex world he appeals to the poetry in today's urban soul as he appealed to the professional poet in previous ages. Sometimes those poets caught him, perpetuated him, and tied him particularly to Texas, so that the Texas myth is wrapped around his saddle and chaps" (p. 135).

That is how Mrs. Branan thinks of this Texas icon, and that is the essence of the cowboy that she wanted to portray in her quilt.

LIVE OAK IN SPRING
QUILT

86″ × 86″
Cotton

1985
Pieced and quilted by Constance Turner Hester in Bryan, Brazos County
Owned by the quiltmaker

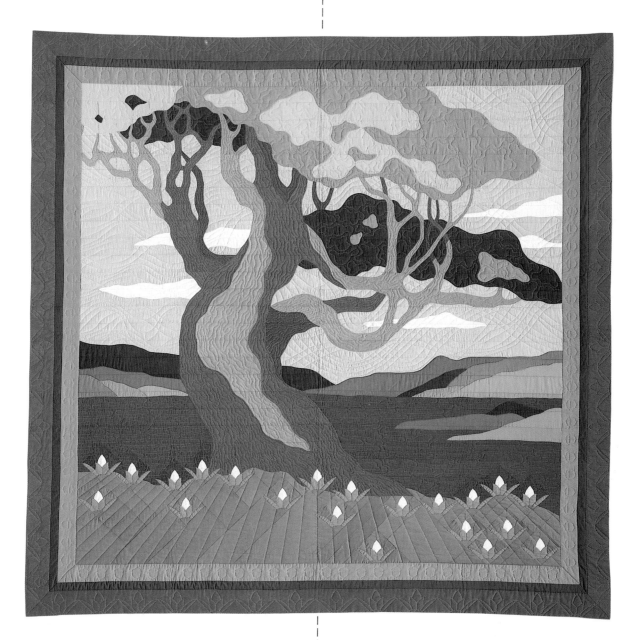

A REMARKABLE EXAMPLE of piecing skill, Live Oak in Spring represented an enormous challenge for this quiltmaker. An avowed "tree person, who stands in awe of beautiful trees," she wanted to capture the strength and spirit of one of the majestic live oak trees that shade Texas—but she was determined to capture this complex image entirely in piecing, rather than appliqué.

The entire design is strip-pieced, with the upper three-quarters of the pictorial panel based on 2½-inch strips. To accomplish this feat, she drew her design life-size onto two huge sheets of vellum, using a heavy black line for the outline and the grid. She laid the vellum pattern face down on a glass-topped table, then laid the fabrics face down over the pattern. The next step was to trace the pattern lines directly onto the reverse side of the fabrics. She then proceeded to create her strips and piece the quilt. "This was an ambitious idea, and I'd never do it again," recalled the quiltmaker. The lower quarter of the quilt is based on a traditional pieced flower, with blocks set on the diagonal as delicate accents for the massive tree. The entire design was first drawn as a very small sketch—approximately 2½ inches—then a grid was placed over it to allow the sketch to be enlarged to the large square of the finished quilt.

Completely hand-quilted with cotton batting and seven to nine stitches per inch, Live Oak in Spring offers visual proof that the quilting is fully as important as the concept or piecing. Each piece is outline-quilted, and in addition, clouds, tree bark, wind, water ripples, acorns, flowers, and leaves are carefully quilted into this piece to create both texture and dimension and add immeasurably to the final visual effect. The quilt is finished by turning the front edge to the back and stitching it down.

The quiltmaker's color and fabric choices are equally important to the success of this design. Anyone familiar with the Texas landscape in spring, before the summer heat sears the earth and coats the countryside with dust, has seen innumerable versions of this quilt created in nature: the stately oak tree with its gnarled limbs, the wildflowers below, the still water barely moving in the light breeze, the verdant hills, and white clouds drifting across the light-drenched blue sky. Each hue and fabric was chosen to create the specific effect needed.

Constance Turner Hester

Connie Hester was born in Indiana and moved to Texas in 1978. She married in 1980 at Washington-on-the-Brazos State Park, site of the first Texas capital during the days of the Republic. She holds a master's degree in special education and taught in a psychiatric hospital in Indiana for six years; after moving to Texas, she taught art at a private school. Having taught herself several needle arts as a child, she knitted her first sweater at the age of six, sewed most of her own clothes from the time she was eleven, and made her first quilt—a Cottage Tulips pattern—in 1973 at the age of twenty-three. "Making quilts was a natural progression through a lifetime heavily involved in the needle arts," she commented. "With two small children, I've discovered that quilting in sections is more portable and consequently more productive. It's easy to quilt, even on an airplane." Working as a professional in the quilting field, she designs and sells quilt patterns, creates commissioned quilts, and has designed a special tool for speed-piecing blocks based on triangles. Her work brings her "a sense of pride and joy from making quiltmaking easier, and all the more rewarding, to myself and others."

Live Oak in Spring has garnered two significant honors: a first-place award in the Great Texas Quilt RoundUp for the Sesquicentennial in 1986 and a first-place award in the judged exhibit Contemporary Texas Quilts at the Museum of the Southwest in Midland.

PRICKLY PEAR QUILT

78″ × 78″
Cotton

1985

Appliquéd and quilted by Minnie Dyson Perryman in
Purmela, Coryell County
Owned by the quiltmaker

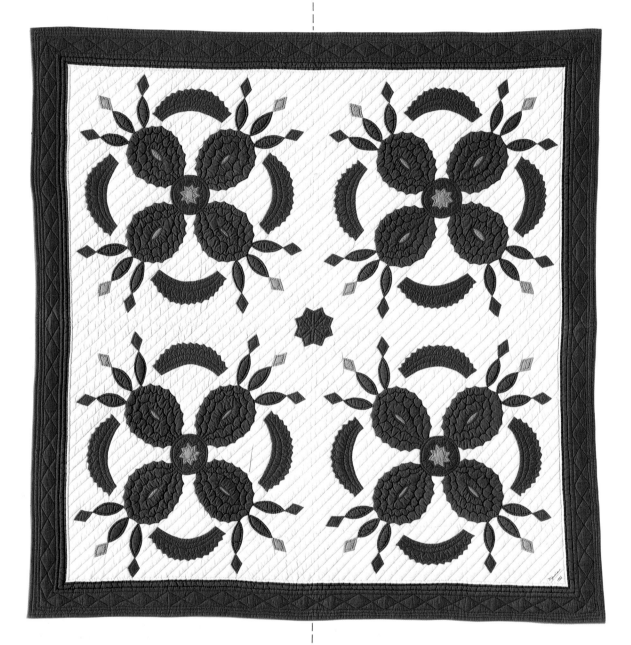

SINCE THE EARLY DAYS of the Texas Republic, when massive herds of Longhorn cattle grazed among the stands of prickly-pear cactus, Texas ranchers have carried on a love-hate relationship with this plant. When the spines are seared off with blowtorches, the cactus pads can provide a substantial food for cattle, while the tunas, or seed pods, are often used for making jelly; yet the pervasive growth habit of the cactus can threaten ranch land.

The utility of the prickly pear in desperate times is clearly stated in a letter reprinted in Ada Morehead Holland's *Brush Country Woman*: "The year 1951 was dry . . . The mesquite and catclaw are putting out, but it is just pitiful to see how dry and drear the prairies are. The cows try to find something to eat. The wind and sand have blown so today. No doubt we'll get all that sand back from the north tomorrow . . . The drought continued until finally Pell [her husband] was forced to take a torch and burn the spines from the prickly pear plants in the pasture so the cows would have something to eat."

This quiltmaker, the wife of a Texas rancher whose cattle ranch has been in his family since before the turn of the century, is well acquainted with the prickly pear and has planned her quilt to reflect the cactus: "green for the plant, gold for the flower, and red for the pear-shaped edible fruit. These colors make it a joy to use especially at Christmas time," she added.

She first saw this design in 1983, while visiting her niece in Arkansas. "The original quilt from which my pattern came was a wedding gift to my niece's father-in-law's grandparents around 1840." The intricate appliqué design with its jagged edges representing the spines of the cactus is not a pattern for a beginner. The abstract conceptualization of this widespread plant is also sometimes depicted as a pieced pattern, according to Hall and Kretsinger's *The Romance of the Patchwork Quilt in America*.

The quiltmaker has appliquéd the four large blocks entirely by hand and has quilted the piece by hand using outline quilting of the appliqué design, accent quilting on the appliqué pieces, and diagonal quilting to fill in the background. The quilting stitches measure approximately seven to nine stitches per inch. The quilt edge is finished with a separate binding cut on the straight of the grain rather than a bias binding.

Minnie Dyson Perryman

Born in 1928 in Gatesville, also in Coryell County, Minnie Dyson Perryman married and reared four children; she now has three grandchildren. She received an associate degree with a major in business and lacks only a few hours to obtain her bachelor's degree. She has worked in accounting for years and presently serves as Coryell County Auditor. As a small child, she worked on quilts alongside her mother, but she "never really completed one until after I married and made an appliqué quilt for my first child." She was twenty-one at the time and living on a ranch west of Purmela. Most of her creative work is now focused on quilted clothing such as skirts, jackets, and coats, but "all of my beds and windows have quilted spreads and curtains, and I use quilted tablecloths."

Although Mrs. Perryman usually works alone, she is active in area guilds. A nationally certified quilting teacher, she has taught quilting at a shop and at Central Texas College in Killeen, and she has had workshops and trunk shows of her quilted clothing for guilds and quilting groups. The quiltmaker's abilities have been recognized with several honors, including a first place in the Coryell County Fair and honorable mention at the state fair in Dallas. In addition, Prickly Pear was selected as one of the Texas theme quilts chosen to tour the state's shopping centers during the Sesquicentennial year.

A TEXAS
SESQUICENTENNIAL
QUILT

100″ × 114″
Cotton

1985

Pieced, appliquéd, and quilted by the Quilter's Guild
of Dallas in Dallas, Dallas County
Owned by Mr. and Mrs. Thomas S. Miller

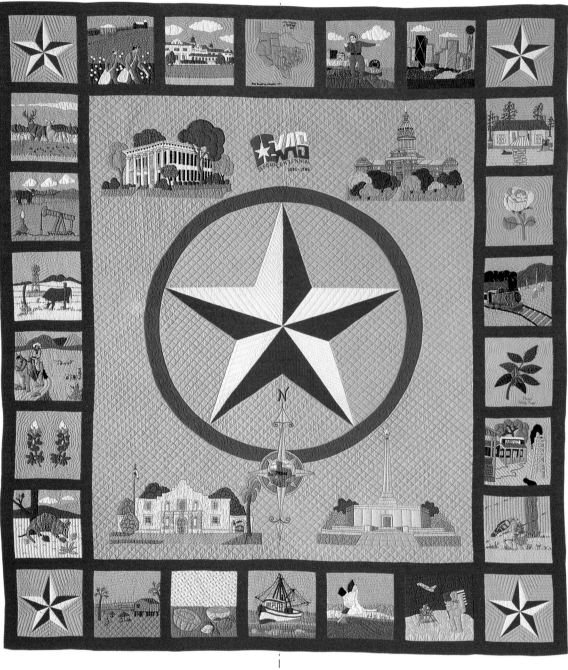

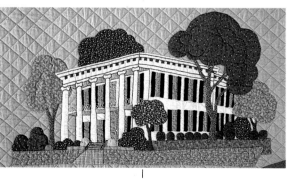

QUILTS have been used for fund-raising purposes for good causes since the middle of the nineteenth century. Signature quilts, auction quilts, raffle quilts, donation quilts, all have been used to support the organizations and causes favored by quilters. The Quilter's Guild of Dallas, a non-profit organization wishing to raise funds for the further development of quilt art through such methods as college scholarships, grants, and museum endowments, created this masterpiece quilt in honor of the Texas Sesquicentennial and offered it for sale to the highest bidder.

The quilt was designed by Shirley Ann Fowlkes, a member of the guild who also served as appliqué coordinator for the group project. A fifth generation Texan who grew up on a Hill Country ranch, the designer is also featured in this book; her Houses, Barns, and Churches quilt may be seen on page 130. After researching her own ancestors for the Daughters of the Republic of Texas and discovering that two of them fought in the struggle for Texas' independence, she was inspired to design this quilt for the guild. Lynn Wright was the member who served as quilting coordinator. Fifty guild members worked on the project over a two-year period; they are listed at the end of this entry.

Made to celebrate the Texas Sesquicentennial in 1986, the center portion of the quilt features four of the most famous Texas historical landmarks—the Capitol, the Governor's Mansion, the Alamo, and the San Jacinto Monument—arranged around the central five-pointed Lone Star. Under the Lone Star is a mariner's compass, adapted from one that appeared on a 1955 Texas highway map; this compass orients the twenty-two pictorial blocks that frame the quilt on all four sides.

The row of blocks at the top are all taken from the history of North Texas, from cotton plantations to Big Tex at the state fair. The block that depicts picking cotton is particularly noteworthy since King Cotton played such an enormous role in the economic history of the state. In 1923, Dorothy Scarborough captured the romance and significance of cotton to Texas in *In the Land of Cotton* (as quoted in Graham's *Texas: A Literary Portrait*):

In autumn the fields are like other flower gardens, each opened boll a great white chrysanthemum upheld on a five-pointed star. Level the fields stretch, vast, illimitable against the sky where rides the golden sun across his field of blue, where clouds hang fleecy as the cotton-wool. This is the time toward which the whole year turns, toward which the ardors of the wind, the cool assuagement of the dew and rain, the burgeoning beams of sun have gone. The cotton now is ready to be picked, for nature has done her part and perfect stands the yield. Man must do the rest . . . In such a white field one may [see] the hopes and dreams and toil of myriad men. The heart of the south is visioned here. (P. 83)

South Texas blocks, seen at the bottom of the quilt, feature a shrimp boat, melons from the Rio Grande Valley, and a space scene in honor of NASA. West Texas blocks, ranging from Hill Country animals to cattle and oil wells, are seen on the left of the quilt. On the right are six blocks depicting scenes familiar to East Texans including early pioneer houses and the Yellow Rose of Texas, famous not only in legend but also because Tyler, located in East Texas, is known as the Rose Capital of the World. Tyler's unquestioned success at growing roses belies nineteenth-century descriptions of Texas as "a country where there are no roses, but where everything that grows has a thorn" (*Texas: A Literary Portrait*, p. 128).

The quilt features many different techniques: hand piecing, machine piecing, hand appliqué, and embroidery. A crosshatch grid of approximately one inch has been used for quilting the background of the quilt, with outline quilting employed around the pieces of the individual blocks and historic buildings. In addition, chain quilting with miniature Texas Stars has been used in the sashing of the quilt, and shadow quilting has also been used in portions of the design. The quilting stitches measure seven to nine to the inch. A separate bias binding has been used to finish the edge of the quilt.

Winner of Best of Show at the Texas State Fair in 1986, this quilt also won a blue ribbon in the judged show of the American International Quilt Association in 1985.

Guild members who worked on the quilt include Sally Redman Ashbacher, Betty Baker, Julie Barnes, Dorothy Burchfield, Katie Copeland, Paula Corbett, Margaret Cothrum, Eleanor Eubanks, Ruth Field, Shirley Fowlkes, Susan Fuqua, Virginia Garver, Jean Hanz, Lynn Harkins, Laura Hobby, Betty Howell, Peggy Huddleston, Margaret Kalmus, Dana Klein, Nona Lee, Libby Legett, Evelyn Leonard, Kaye Lotman, Marcia Meehan, Jan Mitchell, Joanne Morris, Margaret Noullet, Margaret O'Bannon, Darla Pearson, Phyllis Read, Camille Reagan, Sandy Rex, Virginia Reynolds, Dorothy Richards, Karen Roossien, Polly Schafer, Susie Skelton, Jean Smith, Linda Smith, Mary Smith, La Trelle Sommers, Sara Steel, Liz Tyler, Jo Valenti, Tricia Van Buskirk, Nancy Vencevich, Mary White, Marilou Wimmer, Ginny Wright, and Lynn Wright.

TULIPS FOR TIFFANY
QUILT

82″ × 88″
Cotton

1985

Pieced and quilted by Cherry Faulkner Crain
Schorfheide in Texarkana, Bowie County
Owned by the quiltmaker

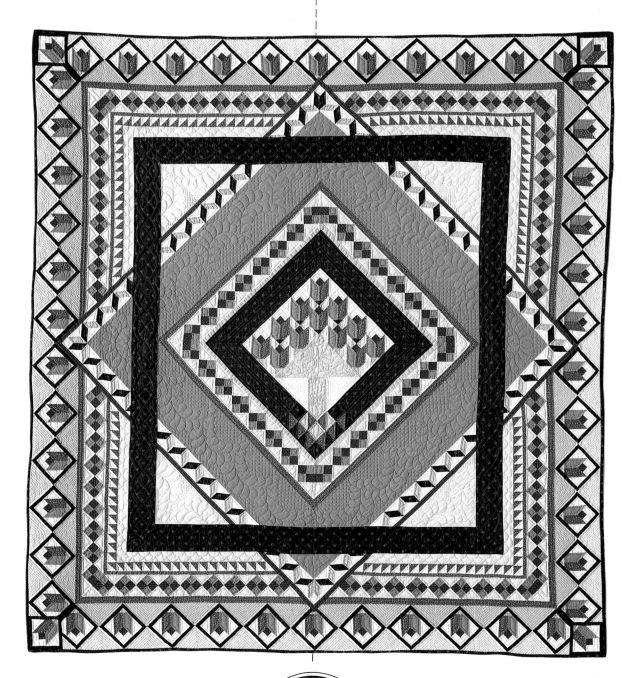

Cherry Faulkner Crain Schorfheide
(Pat's Studio photo)

BASED on the symmetrical medallion-style quilts that have intrigued and challenged quiltmakers since the late eighteenth century, Tulips for Tiffany is not only artistically planned in its design and shading but also unusual for a 1980s quilt in that it is entirely hand-pieced in a time when piecing on the sewing machine reigns supreme. Commented the quiltmaker, "It's fun to hear people say when they see my quilt, 'You *made* this? All by *hand*? How did you do it?'"

The formally designed quilt consists of a series of borders surrounding the central block, a Tulip Tree freely adapted from a classic Pine Tree design. The quiltmaker's decision to set some of the borders on the diagonal adds a different dimension to this quilt, as do the multiple pieced designs used in the borders. The dark green border that repeats the deep border around the central block acts as a frame for the quilt, focusing the eye of the viewer on the central design and providing a sense of visual illusion. The shaded tulips are achieved with two gradations of the same color; the quiltmaker's choice of the rich bottle green, almost a black, provides necessary contrast to the subtle mid-tones of the quilt's predominant colors.

The heavy, elaborate quilting used on this piece adds both texture and tactile appeal. The background of the quilt has been closely quilted in a half-inch grid that is reduced still further to a quarter-inch grid in places. The pieced designs are each outline-quilted around the edge. In addition, clamshells, geometric designs, flowers, and feathers have been quilted into the quilt with stitches that measure ten to twelve per inch. In the bottom of the right-hand corner are quilted the name of the quilt, the date it was completed, and the first name and last initial of the quiltmaker. A separate bias binding in a contrasting color has been used to enclose the edges of the quilt.

The quiltmaker's expertise in quilting may have been inspired by the use of heirloom quilting frames. She explained: "This quilt was quilted on my husband's great-great-grandmother's quilting frame which dates back to 1855. It has been handed down from generation to generation and my husband presented it to me as a wedding present when we were married in 1983."

Born in 1950 in Wynne, Arkansas, Cherry Schorfheide attended three years of college, majoring in art, and went on to graduate from nursing school in Hope, Arkansas, and work professionally in home health care. She married for the first time in 1970 in Arkansas and had two children by that marriage; she married for the second time in 1983 in Texas. During the two-year period when she was divorced and rearing her family as a single parent, she supplemented her nursing salary by selling quilts and wall quilts. "I lost my parents when I was young and lived with an aunt who was an old maid," the quiltmaker explained. "She was a home demonstration agent and always did a great deal of crafts. Because of her, I grew up knowing how to 'eat it up, wear it out, make it do, or do without.' In other words, you make something out of nothing, using what you have on hand."

People quilt for many different reasons—for thrift, for artistry, for money, for the joy of giving of themselves, for creative expression. Mrs. Schorfheide quilts because "I love it!" She commented further, "To have the patience to cut up different fabrics and put them together to create a work of art that will be here long after I'm dead and gone is a challenge that I love." Her first quilt, a Sampler quilt, was made in 1980. She quilts under some conditions other quilters would find enviable: "When this quilt was made, I lived in a very large house and had a quilt room for my work. We have since moved, and my husband has built me a quilt house!"

Her quilting abilities have earned widespread recognition. Tulips for Tiffany was the second-place winner at a quilt show at a Midland museum, won best of category in the Great Texas Quilt RoundUp, and was pictured in the *Quilt Art '89* engagement calendar. Other quilts of hers have won awards in the Arkansas Quilt Guild show and the National Quilting Association show.

44 QUILT

64″ × 54″
Cotton

1985
Pieced and painted by Pamela Studstill in Pipe Creek,
Bandera County
Quilted by Bettie Studstill in Pipe Creek
From the collection of Pat and Martha Connell,
courtesy of Great American Gallery, Atlanta, Georgia

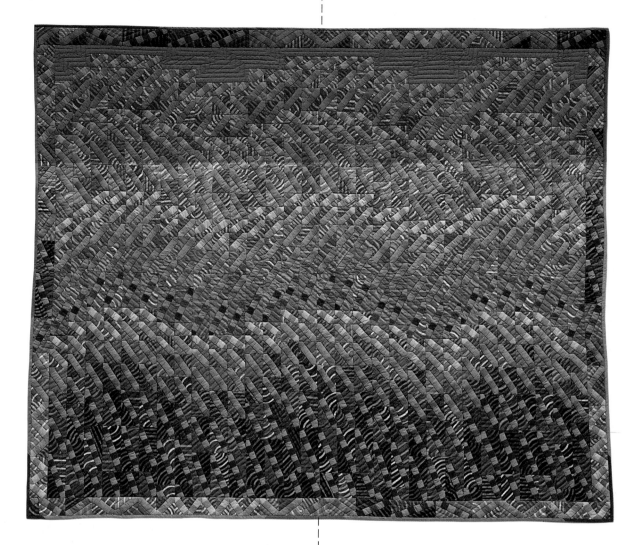

TWICE a recipient of a National Endowment for the Arts Visual Arts Fellowship in 1983 and 1988, Pamela Studstill is an important contemporary artist who happens to be a quiltmaker.

She was born in 1954, the middle of three daughters, and learned to sew so early that she can hardly recall not knowing how. She and a sister always made their dolls' clothes, and her mother made most of hers. She learned to quilt at age seven, taught by her grandmother. Her first quilt, begun then, was a Nine Patch that she completed later, at age sixteen.

After high school, Ms. Studstill, who made clothing and embroidered, moved to Austin, where her work was sold in a specialty clothing store. "It was one of those loose, early 1970s Austin situations," she said of her association with the shop. Then she attended San Antonio College and the University of Texas at San Antonio, where she completed a Bachelor of Fine Arts degree. While taking a surface-painting workshop one summer, she rented a huge, light, airy studio space on Houston Street for thirty-five dollars for the top two floors. "My roommate and I both met our husbands that summer," she recalled. She married in 1978.

Later, when Ms. Studstill began working on her distinctive quilts, an interior-designer friend thought Jack Lenor Larsen needed to see her work. Her friend called the famous designer and sent him photographs of some Studstill quilts. In 1982, Ms. Studstill and her husband flew to New York City. "I made two big canvas bags and managed to get ten quilts into them," she said. Larsen bought one, his receptionist bought another, and he sent her to see the head of the American Craft Museum. "I was lucky; it was my first trip to New York, and I got a real New York cab driver who showed me the sights of the city on the way," she remembered.

It was a lucky trip, indeed, for her work was featured in the museum's show Pattern—An Exhibition of the Decorated Surface the following year, 1983. That year was a major turning point in Ms. Studstill's life for two other reasons also. She won Best of Show in Quilt National, a major biennial contemporary quilt show. And 1983 was the year she received her first National Endowment for the Arts Visual Arts Fellowship.

Pam Studstill's quilts have a complex, luminous quality that draws the viewer into the work.

Pamela Studstill
(Hal Lott photo)

All her quilts are numbered, not named. "People see different things in them. I don't want to label them so they think their ideas are wrong," she explained.

She starts on a quilt by working on a plan, a drawing, or a graph that shows exactly how the finished quilt will look. Then she paints expanses of cotton fabric with acrylic paints, cuts the fabric into squares and begins her strip piecing. Generally, she works on her designs during the day and pieces at night. She sometimes goes on "night binges" and thinks she is getting to bed early if she is there at eleven o'clock.

"There are two ways I think about a quilt: either I see the whole quilt or I see a block design and want to know what it will look like as a whole quilt. Ideally, pattern equals 50 percent of the whole; color 50. Now, to me, though, it's the patterning that is becoming more important than the color. Color has a finite range; I can see the end of color. I can't see the end of patterns."

This is a departure for an artist and quiltmaker who until now has perhaps been best known as a colorist. She is represented by a craft gallery in Atlanta, and the manager there explained that to date Ms. Studstill's work has evidenced her "love of color and her desire to use color in ways that excite the eye, color that the eye mixes as it does in Impressionist paintings."

It is possible that Pam Studstill's work may take a somewhat different turn in the future because she is mulling over words these days. "I've been thinking about the significance of language a lot. I have a hard time with the concept of language and words as symbols. I've drawn out a whole pattern language, a pieced alphabet. I'm not sure where it will all lead."

COUNTRY COUSINS QUILT

62″ × 84″
Mixed fabrics

1985

Appliquéd and quilted by Peggy Stieler Wahrmund in Fredericksburg, Gillespie County
Owned by Tyson E. Wahrmund

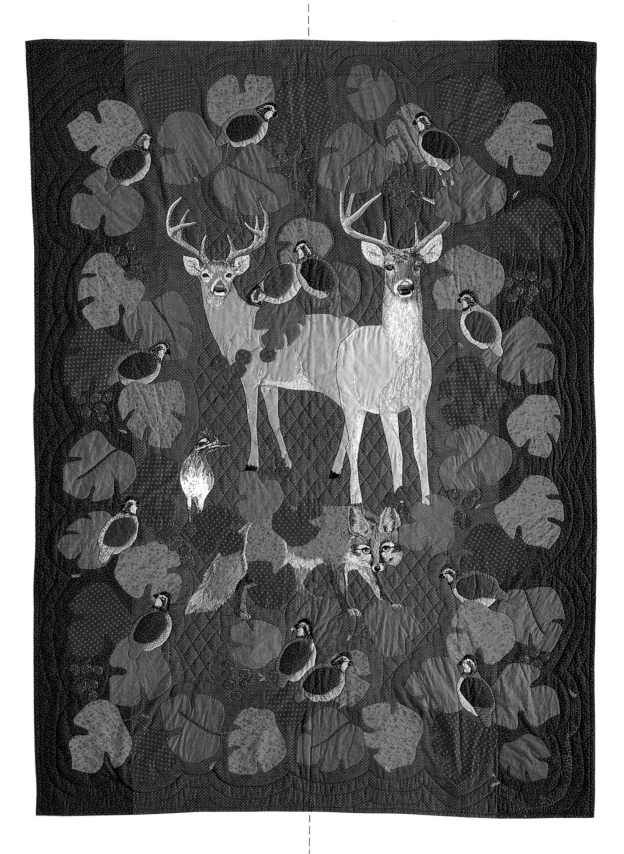

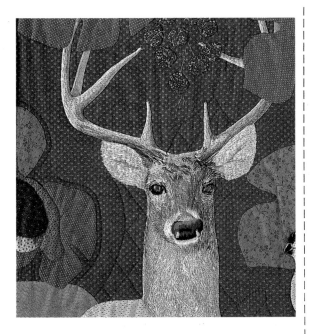 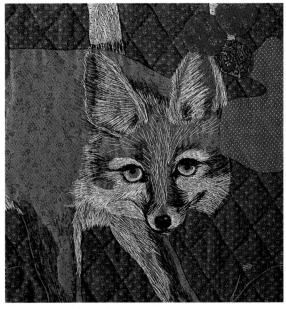

TEXAS is famous for its ranches, and this quilt-maker's work clearly reflects a lifetime spent on Texas Hill Country ranches. She was born and married on a ranch in Kerr County, lives on the Circle Ranch in Gillespie County, and has spent her entire lifetime within the boundaries of those two counties. "I try to make people aware of our Texas Hill Country heritage," commented the quiltmaker. She created this spectacular quilt for her grandson who was learning to talk. "Some of his first words were the names of the animals on the quilt," she said. The quilt was later given to this grandson.

After years of pursuing an interest in weaving and other fiber art, the designer developed a method of creating extraordinarily realistic flora and fauna that she termed "enhanced appliqué." Using this method, it was possible to create elaborately detailed animals that seem ready to step off the quilt in front of the viewer. Her mastery of the pictorial quilt is most evident in the extraordinary eyes of the animals—they convey intelligence, curiosity, and caution as accurately as any nature photographer could capture on film.

Describing the enhanced appliqué method, the quiltmaker explained: "all of the pieces are cut freehand, the entire quilt is arranged in layers and then quilted on a table in one process." The multi-layered appliqué is based initially on photographs taken on the Circle Ranch, which are creatively interpreted to produce the final arrangement. Country Cousins is quilted by hand in a cross-hatch design with a grid smaller than one inch; in addition, all of the appliqué designs are outline-quilted, and freely arranged flora and fauna designs are stitched throughout. There are seven to nine stitches per inch in the quilting. The quilt is finished by turning in the edges and blind-stitching them together.

Peggy Stieler Wahrmund, a secondary-school art teacher for fifteen years, holds a bachelor's degree from Texas Woman's University and a master's degree from New Mexico Highlands University. Married in 1950, she and her husband have one child. She specializes in creating wall hangings and usually produces up to four per year in her home studio. She works alone, rather than with a group, and loves to quilt "all night when I can't sleep!" A professional quilt artist, Ms. Wahrmund creates commissioned pieces. Formerly a dedicated weaver, she started quilting in 1971 when she developed an allergy to wool—a catastrophe for someone working in the medium of weaving. Turning to quilts as a creative outlet to express inventiveness, she decided to focus on the environment and lifestyle of a Texas ranch for inspiration.

Country Cousins was awarded third place in the Great Texas Quilt RoundUp for the Texas Sesquicentennial in 1986. Other work by Ms. Wahrmund has been featured in national exhibits, publications, and magazines, and one of her pieces is permanently installed in a bank in Fredericksburg. She is now working on a new series, even more highly enhanced than the Hill Country Cousins series.

TEXAS WILDFLOWERS #1: BONNETS AND BRUSHES QUILT

51″ × 61″
Cotton

1985

Pieced, appliquéd, and quilted by Janet Hartnell-Williams in McAllen, Hidalgo County
Owned by the quiltmaker

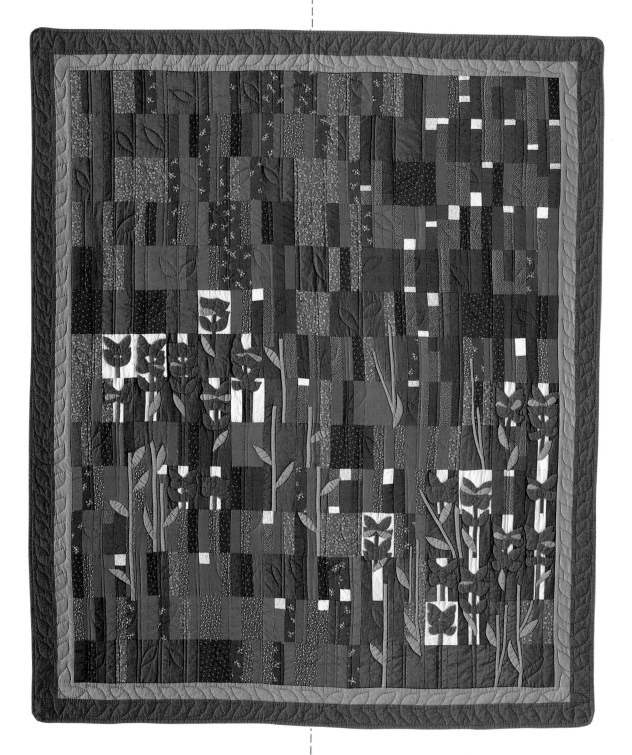

A TEACHER with a bachelor's degree in psychology and a master's in education, who taught in Iran and Guatemala as well as Texas, decided her life needed a change. Janet Hartnell-Williams' interest in color, textiles, and graphic display thus led her into quiltmaking, and that in turn led her, along with her mother Virginia Hartnell, into opening a quilt store in the Rio Grande Valley. Mrs. Hartnell-Williams learned to quilt from her mother.

For five years their shop was one of the few sources of quilting supplies, fabrics, and classes for the region. When it closed in 1985, Mrs. Hartnell-Williams moved to New Braunfels and continued her interest in quiltmaking.

She was born in 1947 in Illinois but was raised mostly in South Texas, with stints in the Valley, Houston, and San Antonio. In this quilt, which was selected to tour in the Great Texas Quilt RoundUp during the state's Sesquicentennial celebration, Mrs. Hartnell-Williams wanted to capture "the wonderful displays of wildflowers seen in Texas," home of the National Wildflower Research Center, an organization founded by Lady Bird Johnson in 1982. Mrs. Hartnell-Williams pursued her goal of portraying the natural beauty of Texas wildflowers in a series of three quilts, of which this is the first.

Janet Hartnell-Williams

This particular quilt relies on a manipulation of solid colors and prints to suggest the bluebonnet, State Flower of Texas, and the Indian paintbrush, the two wildflowers that almost always come to mind when one thinks of spring in Texas. Mrs. Hartnell-Williams executed the quilt in machine piecing and hand appliqué and quilted it in simple outline quilting with four to six stitches per inch. There are two borders of rose and red, and the quilt is finished with a separate bias binding. Like many contemporary quiltmakers, Mrs. Hartnell-Williams' primary concern is with exploring an idea graphically. The actual quilting of a quilt is only one aspect of realizing that idea.

Her first quilt, a Nine Patch, was made in 1981, when she was thirty-four and living in San Antonio. She has progressed from that simple first quilt to quilts that have been prize winners in the state fair, the Comal County Fair, and the Greater San Antonio Quilt Guild show. Mrs. Hartnell-Williams sells her work and considers herself a professional quiltmaker, taking classes at quilt stores, seminars, and festivals to master new techniques she wants to incorporate into her work.

Where she quilts depends on the phase of the quilt she is in, with machine piecing taking place in her studio and hand quilting being done in her family room. Likewise, certain aspects of quiltmaking take place at certain times of the day: she spends mornings on "book work and P.R." related to her quilt sales, afternoons and evenings on machine work, and evenings on handwork.

The mother-daughter duo of Virginia Hartnell and Janet Hartnell-Williams was instrumental in the flowering of quiltmaking among both native Texans and "snowbirds" in the Rio Grande Valley.

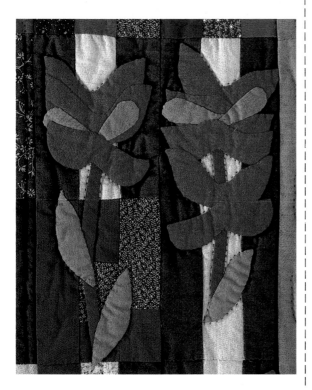

AN AMERICAN SAMPLER QUILT

78″ × 78″
Cotton

1985

Pieced, appliquéd, embroidered, and quilted by Lynn Lewis Young in Houston, Harris County
Owned by the quiltmaker

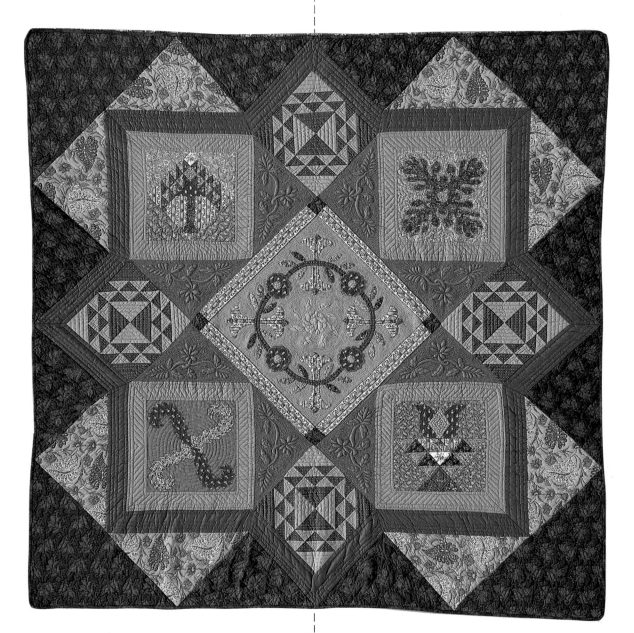

Lynn Lewis Young

TO CREATE a once-in-a-lifetime heirloom quilt was the quiltmaker's goal when she conceived of this project, and the elaborate design with exquisite workmanship that resulted has more than achieved that ambition. In addition to complex patterns from quilts of the past, An American Sampler incorporates trapunto work, stipple quilting, an imaginative blend of printed fabrics, and heavy quilting.

The quiltmaker, a quilting teacher in Houston, first had the idea for this quilt when she was searching for a new class project. "There was an antique quilt exhibit at the Museum of Fine Arts in Houston, an exhibit from the Bybee collection of American decorative arts. Quilts were a big part of that exhibit, although there have been no quilt exhibits in the museum since then, and there was my source of new patterns," she recalled. She sketched blocks from the antique quilts, diagrammed them, and drew quilting designs for this Sampler of those quilts. Included in her quilt are six nineteenth-century patterns she saw that day: President's Wreath, Lady of the Lake, Pennsylvania Basket, Snowflake, Tree of Life, and Princess Feather. The design for the elegant trapunto work of twining stems and leaves was taken from an 1840s counterpane.

This quilt was a six-year project: first Ms. Young made the individual blocks for samples to use in teaching her classes; later she set them into the basic Star design of the quilt, then she spent two years quilting it. The quilting required such a long period of time not only because the piece is very heavily quilted but also because the quiltmaker was working and going to school and had to fit the quilting in around an already busy schedule. The designs are quilted with ten to twelve stitches per inch. In some places, the quilting is extremely close, less than a half inch apart. The stipple quilting in the center is used to flatten the background so that the trapunto designs are clearly raised in sharp relief. Stipple quilting is rarely seen today because of the inordinate amount of time that it requires to execute; it reached its height of popularity in the nineteenth century, particularly in mid-century when elaborate whitework, or counterpane, quilts were popular. All of the designs are outline-quilted with additional quilting on each piece; extensive geometric quilting has been used to set off the complexity of the pieced and appliquéd blocks.

A teal floral fabric was selected for the triangles that finish out the square quilt; quilting stitches outline the floral pattern to create additional dimension. The color combination of teal, tans, and rust is sophisticated yet reminiscent of the soft, old colors of the 1840s. The quiltmaker has pieced, appliquéd, embroidered, and quilted by hand; however, machine piecing was used to set the blocks together into the square. A separate bias binding was used to finish the edge of the quilt.

Lynn Lewis Young was born in Huntsville, Texas, in 1950 and lived in Tyler and Marshall in East Texas until 1963, at which time her family moved to Houston. She completed her bachelor's degree at the University of Texas in 1972 and also married that year. In 1976 she received her master's degree from the University of Texas Graduate School of Biomedical Sciences and from 1972 to 1983 she participated in advanced studies at the school. She turned to quilting after the American Bicentennial, when she signed up for classes at Great Expectations Quilts in Houston. "At the time I was doing medical research in the cancer field, and the quilting was a great relief and source of relaxation," she remembered. Her first project was completed when she was twenty-seven; it was a king-sized counterpane Sampler with each block a different quilting design. Referring to An American Sampler, Ms. Young stated: "I was aiming for workmanship of the highest heirloom quality and a setting for the blocks which showed the design ideas and traditional approach of quiltmaking today. I feel it is one of my finest traditional efforts, and I enjoy sharing it. I will probably never make another like it, as I am now interested in other aspects of quilting."

The quiltmaker quilts alone, working mostly at night, but she is active in quilting organizations. She is past president of the Quilt Guild of Greater Houston, the founder of that city's Contemporary Quilt Group, and former president of the American International Quilt Association. In addition, she has worked with Houston's International Quilt Festival and with Quilt Market.

Her first quilt designs were traditional. "Quilts had been in my past. I remember my Grandmother Lewis making tops and a few quilting parties in her living room at which I got to thread needles and sit under the frame," she recalled. Today, she has turned to abstract contemporary design and wearable art, including sophisticated garments featuring hand-dyed fabrics and surface design. She has also continued her art training at the art museum's Glassell School of Art and at Arrowmont School of Arts and Crafts. In addition to her work with quilts, she likes to work in mixed media and jewelry. Ms. Young sells her work and considers herself to be a professional quilt artist. Her quilts have been accepted in many shows, including invitational quilt exhibits, and she has won awards in the American International Quilt Association's annual judged shows. An American Sampler was selected first runner-up for the Founders' Award at the International Quilt Festival in 1985.

TEXAS STARS QUILT

78″ × 82″
Cotton

1985–1986

Pieced, appliquéd, and quilted by Diane Carson Lott
in Austin, Travis County
Owned by Mr. and Mrs. Dan Gillean

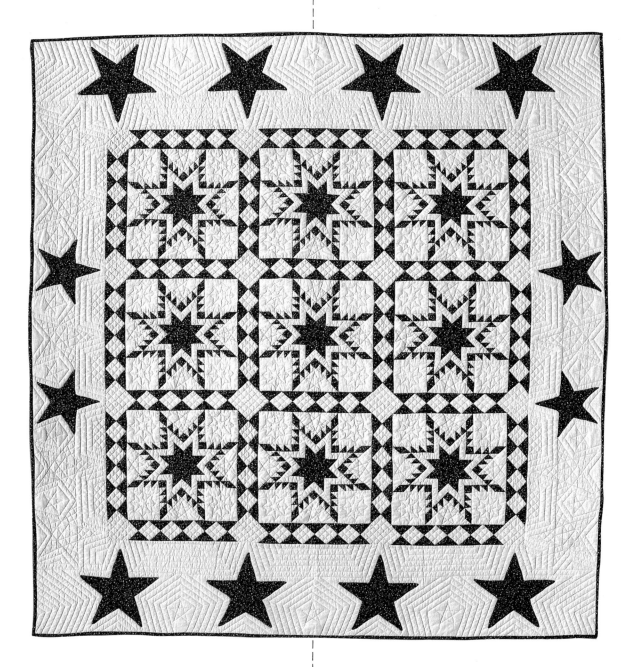

BASED on the traditional Feather Edged Star pattern, this dark red-and-white quilt with its unusual sashing and five-pointed Texas Stars appliquéd on the border is a graphic expression of the quiltmaker's ability. A classic bed quilt, beautifully quilted, the Texas Stars was made to commemorate 150 years of Texas independence and because "I had always wanted to make a Feathered Star," as the quiltmaker recalled.

The sashing design forming an eight-pointed star in the intersections proved an excellent choice to set off the intricate Feathered Stars, and the Texas Stars in the border have been properly placed according to an old Texas tradition that claims that the stars reflect the people: Texans stand with their two feet firmly planted on the ground and their head in the stars. The quiltmaker commented that "this Feathered Star was made during my 'star' period which was followed by another 'blues' period. My grandmother pieced many, many quilts, and I had always had an interest in quilting, but I did not take up this hobby until 1978, when I took a quilting class from my friend, Judy Murrah. I completed a Sampler quilt as a class project, then in 1984 I made my first quilt without help: a machine-pieced, quick-method Trip Around the World. Since then I have pieced and quilted many quilts."

The Texas Stars quilt has been both hand-pieced and machine-pieced, and the quilting has been planned to emphasize the geometrics of the pieced design. Each piece has been quilted on both sides of the seam, and the quilting stitches measure seven to nine per inch. The edge was finished with a separate bias binding in red, to form the final frame of the quilt.

Diane Carter Lott was born in 1942 in Decatur, Texas, attended McNeese State College for two years, married in 1966, and has two children. She lived for more than twenty years in Houston and moved to Austin in 1983. An accomplished seamstress, she has taken five advanced sewing courses and makes "about everything that I wear." Each year in January Mrs. Lott begins "a new, special quilt." "I make from five to ten quilts a year as a creative outlet and for gifts," she added. The Texas Stars quilt was given to her friends, the current owners of the quilt, for Christmas in 1986. The quiltmaker won a white ribbon in the First Quilt category at the judged show of the American International Quilt Association in 1985.

Diane Carson Lott

DAISY TWISTS AROUND THE HOMETOWN SQUARE QUILT

80″ × 80″
Cotton

1986

Pieced, appliquéd, and quilted by Sally Redman Ashbacher in Rowlett, Rockwall County
Owned by the quiltmaker

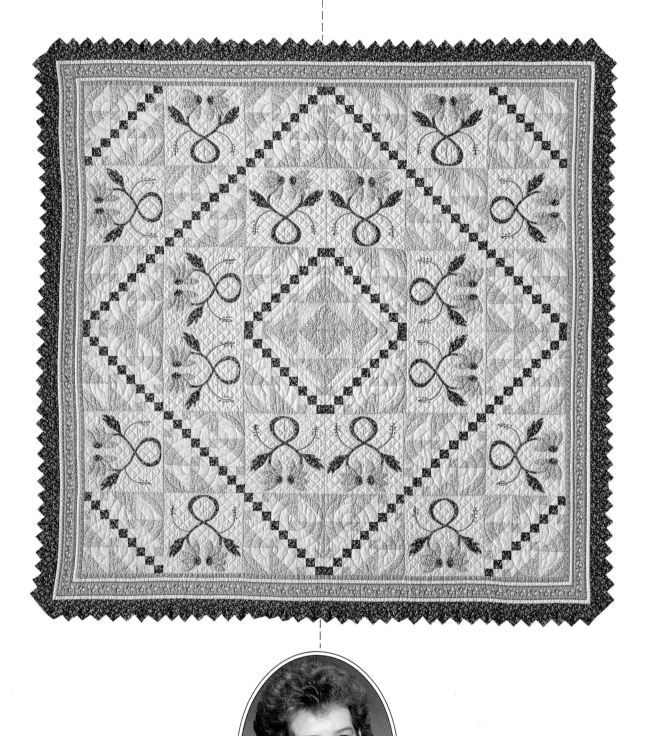

Sally Redman Ashbacher

A SUMMER spent in bed convalescing from rheumatic fever under a Grandmother's Flower Garden quilt made by her own paternal grandmother left a powerful impression upon six-year-old Sally Redman Ashbacher.

"I remember tracing my finger over each of the patches in that quilt, daydreaming about the pastel scraps from old dresses of mine and other family members. At that point, I decided that when I grew up I wanted to quilt and to make a quilt just like that one. I loved the feeling I got from that summer and always knew that one day I too would make a quilt."

Mrs. Ashbacher's mother died in 1978, and "when Father broke up housekeeping this quilt disappeared. Like a lost child, I always thought about it and longed for it, as it was my favorite one of those I knew Grandmother Redman had made." Her father remarried, and about a year later, on her birthday, Mrs. Ashbacher's stepmother sent her a big box with a note saying "I think this belongs to you." Inside was Grandmother Redman's Flower Garden quilt, "the best birthday present I could have gotten," she recalled.

"As far back as I can remember, I held a needle in my hand doing some kind of needlework, mostly embroidery. I was taught at my mother's knee until I learned it perfectly. I then progressed to sewing clothes, needlepoint, crewel, and then quilting. My mother never did quilt; however, I feel if she were alive today, she would be quilting and we would be doing it together."

Mrs. Ashbacher was born in 1937 in Chicago. She married in 1957, three years after completing high school, had two children, and divorced in 1968. Two years later, she married her present husband, and they moved to Dallas in 1982 and to Rowlett a year later. She works full time with her husband in their own freight transportation business and says that "working with one's husband is not for the faint of heart!"

This quiltmaker works mostly in her bedroom, "sitting cross-legged in the middle of the bed with my cat nestled under the hoop in the folds of the quilt, where he is usually purring and drooling on my quilt." She quilts alone and tries to quilt every night after dinner, until at least midnight. Her first quilt, a "typical Sampler," was made when she was forty-two and living in Downers Grove, Illinois, where she took quilting lessons at a local quilt shop.

She says she quilts for many reasons: "I love winning ribbons and knowing that I am creating a legacy for hundreds of years for my family and family to come. I want to leave a piece of me on earth forever." Occasionally she may sell a quilt, although she does not make them to sell. Her family thinks her quilting is "wonderful—that my quilts are the best in the whole world!" In fact, she said, "the kids are already fighting over Daisy Twists. Soon it will hang in the reception area of my daughter's new office."

This quilt was made from two of twenty-four original blocks, Hometown Square and Daisy Twist, from a quilt block contest sponsored by the *Indianapolis Star,* thus the name Daisy Twists around the Hometown Square. "My daughter and son-in-law live in Indiana. She doesn't care for quilts, whereas he really likes them. So each Monday morning he would put the winning block that appeared in the Sunday paper in the mail to me in hopes I would make a quilt."

The quilt Mrs. Ashbacher did make is her original setting of the two patterns. It has a cotton top and backing and synthetic batting and is a combination of machine piecing and hand appliqué. Her unusual combination of the two blocks has produced a light, airy quilt that she has quilted heavily on both sides of the individual pieces, using ten to twelve stitches per inch. Her quilting design features circles that are close together, with crosshatch in one inch squares or less. As many modern-day quilters do, she has completely planned her quilt and purchased fabrics specifically for it rather than using pieces from a scrap basket. Today's quilters also almost always coordinate the backing of a quilt to its top, as Mrs. Ashbacher has done by using the same fabric as that in the daisies. She has also employed prairie points, a decorative and surprisingly simple edging that is an old but sometimes overlooked means of finishing a quilt distinctively.

Daisy Twists around the Hometown Square has won an award in almost every quilt show in which it has been entered. Mrs. Ashbacher regularly receives recognition for her work, winning ribbons at the state fair, the American International Quilt Association's judged show, the show sponsored by her local guild, the Quilter's Guild of Dallas, and others. Her work has appeared in *Quilter's Newsletter Magazine, Quilt,* and *Stitch & Sew Quilts.*

Even though she is now an accomplished, award-winning quiltmaker, there is one time-consuming quilt design Mrs. Ashbacher has never attempted. "Although as a child I really wanted to make a Grandmother's Flower Garden, I must say I am truly glad that I have Grandmother Redman's and don't ever have to make one!"

MY TWO LOVES QUILT

77″ × 97″
Cotton

1986

Pieced and quilted by Joy Ann Rose Baaklini in
Austin, Travis County
Owned by the quiltmaker

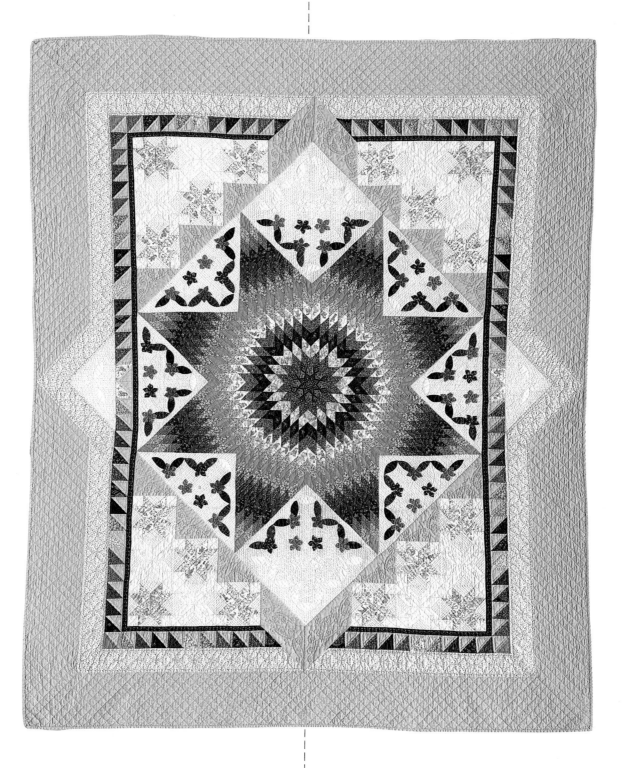

"I HAVE BEEN a weaver, painter, photographer, potter, but none of that 'took.' I can never imagine my life now without quilting."

In those words, Joy Baaklini described her discovery of and conversion to quilting, which this quilt, her first full-size one, represents. The quiltmaker began picking fabric for it on the day her second baby was due in 1985. She wanted to complete the quilt for the Texas Sesquicentennial and the Austin Area Quilt Guild show in 1986. Her effort was worth it because My Two Loves won Best of Show.

"This quilt has brought more than just a cover for my bed; it has changed my whole life. I now consider myself a full-time quilter, making and exhibiting quilts as a quilt artist," Mrs. Baaklini said. When she began making quilts, she just wanted to make a quilt for her bed but, in the process, "discovered the most satisfying means of expressing my art."

Born in Fort Worth in 1947, Mrs. Baaklini has lived all her life in Texas, except for one year in Pennsylvania. She holds a Bachelor of Fine Arts degree from the University of Texas at Austin. The studio at home where she works "is not the family room, but at times the whole family is in it. It has become an alternate living area, and it's more fun for the kids, with the typewriter, the drafting table, templates, and other things." Mrs. Baaklini likes to work there in the early morning and at night. She works alone but discusses her design, color, and fabric choices with fellow members of the Nite Owls, one of a number of quilting bees affiliated with the Austin Area Quilt Guild, or those in the Austin Fiber Artists. While self-taught, Mrs. Baaklini refines her skills in classes offered by her guild and at International Quilt Festival in Houston.

My Two Loves is Mrs. Baaklini's personal name for this beautiful Star of Bethlehem, or Lone Star, because it was made in honor of her two daughters. She has hand-pieced, hand-appliquéd, and hand-quilted it. The blocks surrounding the central star medallion have an original appliqué design of flowers and leaves. Four smaller eight-pointed stars anchor each corner of the quilt before the series of four borders, which form a square within a square, begin.

Within the center star medallion, the use of prints is especially intricate. The fabrics are well chosen to suggest an older quilt, and the piecing is skillfully handled in the center of the star,

Joy Ann Rose Baaklini

where less proficient quiltmakers sometimes have difficulty. Mrs. Baaklini has cut each of her pieces to center single red and blue flowers in the diamonds of her darkest print and to position individual figures in the diamonds of her light print.

The quilting designs she chose are many and complex, including stars, geometrics, and interlocking chains. A wineglass provided a circular pattern for quilting in a border, and Mrs. Baaklini has quilted her daughters' hand prints into the top corners of the outside border. Her initials and the date the quilt was completed are also quilted into a border, an important touch that will aid future generations who will want to know the maker and the age of such a fine quilt. The heavy and intricate quilting has seven to nine stitches per inch, and quilting stitches and designs are less than one-half inch apart in most places, just one-fourth inch apart going into the center star.

A narrow inner border in a dark print sets off the central medallion. Next is a sawtooth border that employs many antique-looking prints against a pink fabric. Another border in a small beige print follows, than a wide pink border and separate pink bias binding finish the quilt. The border treatment creates the "square within a square" look of the central medallion.

Old-fashioned—looking prints combined with the heavy quilting that virtually fills the quilt create the look of an antique quilt, although the design and setting of the elements are quite contemporary. Thus, Mrs. Baaklini's quilt looks both to the past and to the future, and she has this comment about her work: "I know the quilts I make will have something to say about me, about creativity, about women for a long time to come. I think quilts are from the mind, heart, and spirit." My Two Loves certainly speaks volumes about this quiltmaker and her abilities.

TEXAS STAR OF INDEPENDENCE QUILT

98″ × 98″
Cotton

1986

Pieced, appliquéd, and stenciled by volunteers from Chi Omega Alumnae, Chi Omega Mothers' Club, and the Cullen Residence Hall, Center for the Retarded, Inc. in Houston, Harris County
Quilted by Marge Weisheit in West Columbia, Brazoria County
Owned by Thelma McClung

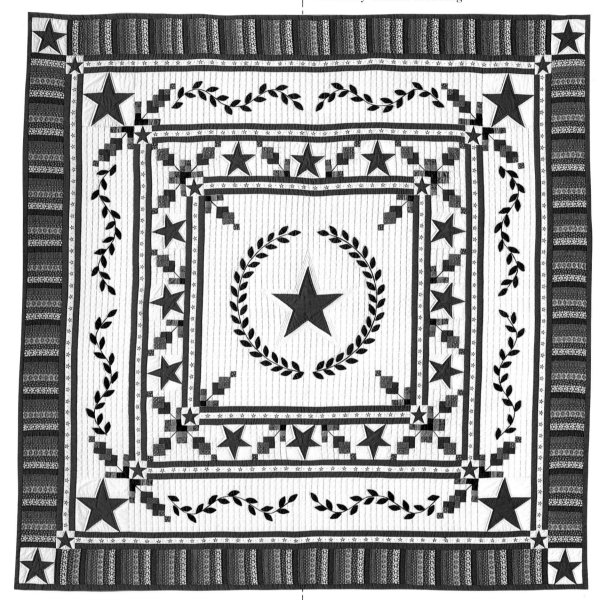

THE GRAND PRIZE winner in the Great Texas Quilt RoundUp for the Texas Sesquicentennial in 1986, this spectacular quilt features not only excellent workmanship, a remarkable feat for a project that involved so many volunteers, but also historic and patriotic symbolism. Continuing the old tradition of using quilts to raise funds for worthy causes, the Houston chapter of the Chi Omega Alumnae, the Chi Omega Mothers' Club, and their friends at Cullen Residence Hall created this quilt to honor Texas in a special year, to draw attention to the quest for independence carried on by the mentally handicapped in everyday life, and to raise funds to assist Houston's Center for the Retarded.

The central block of the medallion-style quilt is a five-pointed star, honored by Texans as the Lone Star on the Texas flag. The original of this lone blue star on a white field was designed and stitched in 1836 by Joanna Troutman of Georgia to be used as a banner to lead the Georgia recruits joining General Sam Houston and Stephen F. Austin in the Texas Revolution. Embroidered on the silk flag were the words "Liberty or Death." Joanna's flag flew at Goliad only a short time before the Texas command was defeated in one of the early battles of the revolution; the Texans were marched out of the old fort they had rebuilt and named Fort Defiance and were massacred without mercy. The flag then became a symbol for the fledgling republic, just as "Remember the Alamo" and "Remember Goliad" became rallying cries for the Texas army. At the first convention of the Texas Congress the Lone Star was adopted as the emblem of the new republic, and Joanna Troutman is today remembered as the Betsy Ross of Texas.

The laurel wreath, a symbol of both victory and peace, encircles the lone star as a symbol of the hard-won independence Mexico finally granted to the Republic of Texas, and the four pieced bluebonnets in the corners signify the four major events of the Texas Revolution—the signing of the Declaration of Independence, the heroic stand at the Alamo, the tragic massacre at Goliad, and the victory at San Jacinto. Surrounding the Lone Star are three pieced borders, one of which is a strip of a historical fabric reproduction, "Tiny Texas Stars," designed by Texas artist and Chi Omega Ann Eppright. The outside border of fenceposts represents the settlers whose spirit and resolve led to Texas' independence; they formed an army of farmers and landowners who were fighting not for an abstract idea of freedom but for the reality of their land, their homes, their families, and their friends. The eight trails of laurel leaves that form one of the borders pay tribute to the eight hundred who died in the Texas War for Independence. The thirty-two other pieced five-pointed stars that form one of the borders and are used in the corners of successive borders represent the Immortal Thirty-two, the Texans who gathered at Gonzales and bravely marched off to certain death at the Alamo. The quilt is hand-quilted with stitches measuring approximately ten per inch. Outline quilting is used on both the pieced and appliquéd designs.

The Texas Star of Independence quilt was designed by Loine Kauachi. Thirty-five volunteer stitchers, many of whom had never worked on a quilt before, executed her design in piecing, appliqué, and stenciling. Advice and encouragement were provided by Jewel Patterson of Houston, a professional quilting teacher. The quilt was won by the current owner, the mother of a Houston Chi Omega alumna.

FLYING X
(As in TeXas) QUILT

96″ × 100″
Cotton

1986

Pieced and quilted by Karen Louise Sikes Collins in
Midland, Midland County
Owned by the quiltmaker

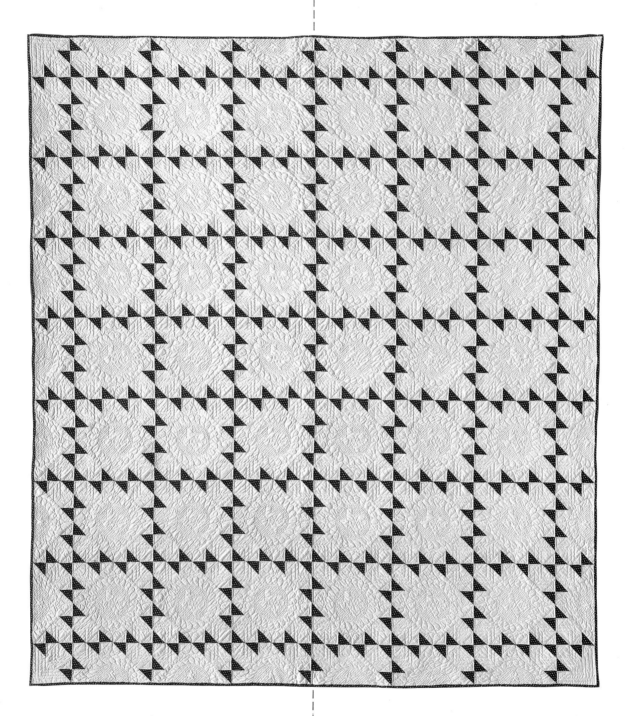

TURNING to her roots for the Texas Sesquicentennial, Karen Collins selected a Flying X pattern that was popular when her great-great-grandmother, Judith Damron Duncan, also a quilter, arrived in Texas.

Her fine handwork in this old pattern, which Mrs. Collins has called Flying X (As in TeXas) in her version, so impressed the judge in the Great Texas Quilt RoundUp that she won the Judge's Choice award. On her entry form, Mrs. Collins said that the Flying X "symbolizes the flight to Texas of so many of our ancestors. Following earlier Spanish settlers to Texas, migration from the north in the 1820s filled colonies founded by Stephen F. Austin and others. The maker of this quilt is the fifth generation descendant of a quilter who came to Texas in 1829."

The quiltmaker's intense interest in the traditional aspects of quilting is apparent in her inclusion of a deliberate error in her quilt. She says the intentional mistake in her piecing "symbolizes the one old sorehead who also came to Texas along with the millions of wonderful people."

Quilting is a tradition on both sides of her family, and she treasures the quilt heritage she learned from her mother, Bertha Mitchel Sikes, and from both grandmothers, Judia Chapman Mitchel and Louisa Haise Sikes. When she quilts, Mrs. Collins is usually sitting on a small couch that belonged to her great-grandmother, Belle Haise, another quilter.

Not only does quilting run in this family, it starts early, too. Mrs. Collins' mother says her daughter worked on a quilt for a doll as a child, although she does not remember it. The first quilt she does remember making entirely on her own was done in 1969, after she was married and after her children were enrolled in school and playschool.

This quiltmaker holds a master's degree in history from the University of Texas at Austin and was born in 1941 in Brenham. She has lived all her life in various Texas towns, except for, in her words, "a ten-year exile in Lexington, Kentucky."

She has worked as a librarian, an editor, and a historical researcher but feels most passionate about her quiltmaking. As a quiltmaker, she regards herself as an artist-hobbyist, although she says quilting has really become "more than a hobby—it's close to an obsession." She makes three or four quilts a year and rarely quilts with a group, preferring to work alone or with her mother. She likes to quilt in the early morning or early evening.

Her interest in both Texas and history is evident, not only in the old pattern she chose for her quilt, the Flying X, but in the materials and quilting designs she selected. Her quilt is all cotton—top, batting, and backing—an appropriate choice for a Texas Sesquicentennial quilt contest since Texas is the largest producer of cotton in the

Karen Louise Sikes Collins
(Olan Mills photo)

United States. She hand-pieced and hand-quilted it, in accordance with the oldest quilting traditions, in outline quilting by the piece. And she alternated her pieced blocks with counterpane, or whitework, blocks with feather quilting in circles and half-circles to complement her Flying X pattern choice. Within them appear in tiny quilting stitches the outline of the state, the word "Texas," and five-pointed Lone Stars. Close crosshatch is used to fill in the remainder of the circles.

Mrs. Collins is known for her fine quilting, and Flying X (As in TeXas) shows it off, featuring nine to eleven stitches per inch. The red calico and ivory quilt is set off with a simple bias binding in red, a classic finishing method that is completely in keeping with the overall feel of this very traditional quilt.

This historian and her archeologist husband gained hands-on experience to go along with their "book learning" when they helped restore an early Texas log house belonging to his parents in Williamson County. This is standing them in good stead, as they have become deeply involved in restoring three early structures found by Mrs. Collins as she drove around central Austin looking for a house they might want to buy. When she saw the outline of one of the condemned buildings, she immediately suspected it was an old log dogrun and they made arrangements to buy the small compound.

Now they live in one of the buildings—a rock former dairy—as they work on the oldest of the three. His professional training and her painstaking research guarantee that the project will be a long one but one that will be historically accurate. On the wall of their temporary home is one of Mrs. Collins' Log Cabin quilts, a reminder of their immediate goal of completing and moving into the early log cabin on the site and a reminder of a larger goal as well: of living in harmony with Texas' history and, through their children and grandchildren, its future.

TRIBUTE TO THE HEROES OF THE ALAMO QUILT

102″ × 102″
Cotton

1986

Pieced and quilted by Annick Thorr Harris in Harker Heights, Bell County
Owned by the quiltmaker

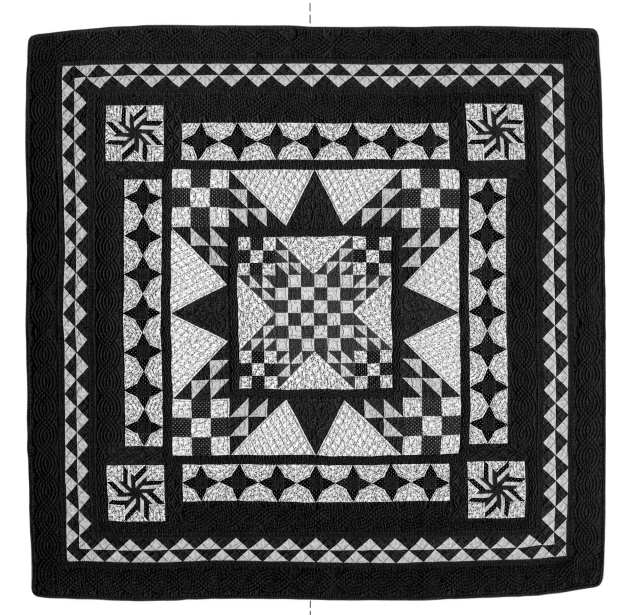

Annick Thorr Harris

MADE as a tribute to her adopted state and new country by a Frenchwoman just after she was sworn in as a United States citizen, this quilt is not only technically excellent but also imaginative and symbolic. The quilt was first drafted on paper from three traditional patchwork patterns—Battle of the Alamo, Star of the Alamo, and Star of Liberty. The central medallion is composed of four squares of the Battle of the Alamo pattern with the colors arranged to form a six-pointed star; the next row of the center design includes four partial squares of the Battle of the Alamo set in each corner, also forming a star. The two stars appear to be lying against a huge Star of the Alamo, and this same design is repeated twenty-eight times in the border around the central medallion. Each of them represents a state of the Union or a foreign country that lost gallant men during the Battle of the Alamo. In each of the four corners of the quilt is a Star of Liberty, because the Alamo is also called the Cradle of Texas Liberty. The outer border of triangles repeats part of the pieced design from the central medallion.

According to the quiltmaker, "The colors are red for the courage shown by the Heroes of the Alamo and white and blue for the loyalty of the Alamo's fighters to the vision of a free and independent Texas more than to the value of their own lives. These colors are, of course, also the colors of today's Texas flag. The quilting design resembles a Fleur de Lys. This choice is my own apology to my new state for the only man who decided not to stay for the final stand on that March day of 1836 at the Alamo, the Frenchman Louis Rose, one of my countrymen."

France and Texas have long cooperated—for example, France was the only European country to open an embassy in Texas during the Republic period, and colonies of French immigrants settled in Texas, most notably around the Castroville area. Summing up the relationship between France and Texas, one of France's most famous citizens, the actress Sarah Bernhardt, was quoted in the *New Orleans Picayune* in 1892 as saying, "After Paree, I would like to be a Texan best of all."

This quilt was the quiltmaker's first; it was made while her husband, a major in the United States Army, was stationed at Fort Hood.

I had never quilted before 1985, when I started on this quilt. In 1977, while still in France, I had taken my students to a traveling exhibit of American quilts in our local museum in Nancy, France. We enjoyed the show, but I didn't really get interested in quilts until I moved to Texas and went to a meeting of the local quilt guild with a friend who was an avid quilter. I joined, and the rest, as they say, is history. I thought it would be fantastic to celebrate Texas' birthday with a special quilt at the same time that I became an American (as well as Texas) citizen. The day I was sworn in as an American citizen in San Antonio, my husband took me to the Alamo. I was very moved as I listened to the guides. I purchased some books about that part of Texas history as well as a book of Texas patchwork patterns, A Texas Quilt Primer. I had an excellent background in geometry, if none in quilting, and decided it could not be so difficult to draft a quilt. I did so and did quite well on paper. I had more trouble with the actual piecing and quilting, but I watched the ladies at the guild and read a lot of quilting books.

The quilt is machine-pieced and quilted in a medium crosshatch design with additional outline quilting of the pieced designs plus geometric designs and interlocking chains. The quilting stitches measure seven to nine per inch. A separate bias binding in a contrasting color has been used to finish the raw edges of the quilt. "Creating a quilt is a great way to unleash my creativity," stated the quiltmaker. "I discovered colors and how they work together. I am also very competitive and strive for excellence from start to finish. My husband is very supportive of my quilting and even brings me fabrics and books from his trips."

Annick Harris was born in 1951 in Laxou, France, and was educated in France as an elementary-school teacher; in addition, she studied needlework in mandatory classes. She taught school in France and Germany for seven years before marrying an American and moving to the United States in 1978, and she has taught French and adult education classes in the United States.

This quilt was selected for the Great Texas Quilt RoundUp traveling exhibit during the Sesquicentennial year. In addition, the quiltmaker has won several awards at regional shows.

TEXAS WILDFLOWER
ABCs QUILT

80″ × 80″
Cotton

1986

Pieced, appliquéd, embroidered, and quilted by Mary Ann Jackson Herndon in Houston, Harris County
Owned by the quiltmaker

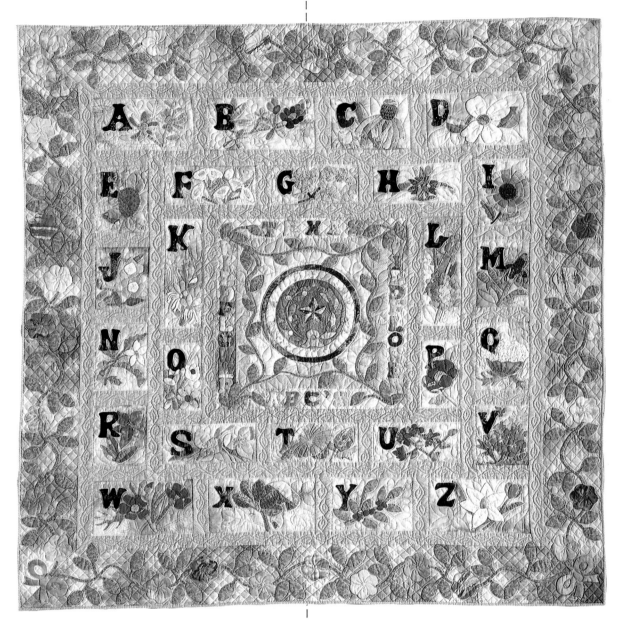

Mary Ann Jackson Herndon

THIS elegant, delicate design was inspired by two books—*The ABCs of Texas Wildflowers* and *Roadside Flowers of Texas*—particularly appropriate resources for the designer, who holds a master's degree in library science. After the quilt was finished and the quiltmaker had painstakingly achieved the beautiful shaded color combinations, the ABCs book, previously available only in black and white, was re-issued in color. To achieve the soft, antique hues most suitable for this design, the quiltmaker hand-dyed fabrics in muted pastels.

The twenty-six blocks containing flowers for each letter of the alphabet are irregularly shaped to suit the style of each letter; the blocks are arranged around a central medallion containing the Texas state seal and the name of the quilt. All of the diverse elements in the central medallion are tied together by the use of a vine that twines around the center seal. A more elaborate version of the vine is used in the lush borders, where wildflowers have been repeated in appliqué. Embroidery stitches have been added to the flowers to emphasize both their designs and specific botanical details.

The quilt is hand-appliquéd and uses a combination of hand and machine piecing. The quiltmaker's workmanship is as outstanding as her sense of design, and the quilting designs were carefully planned to enhance the appliquéd blocks. In addition to close crosshatch background quilting, the designer has used outline quilting on both sides of each individual piece and has quilted leaves into the background. The heavy quilting seen on this piece is an integral part of the overall effect, creating the look of stuffed work without the use of trapunto techniques. The quilting stitches measure ten to twelve per inch. According to the quiltmaker, "Some details in the flower blocks are quilted designs rather than appliquéd." A separate bias binding in a contrasting color has been used to finish the edges of the quilt.

Mary Ann Herndon was born in Galveston and later earned degrees from the University of Texas in Austin and from Sam Houston State University in Huntsville; in addition, she has completed postgraduate work at the University of Houston. She married in 1955 and reared three children; she is the director of libraries for the Spring Branch Independent School District in the Houston area.

"I attended a meeting of the Houston Quilt Guild where Yvonne Porcella was the speaker, and that's how I got started making quilts," recalled the quiltmaker, who later took classes at two Houston quilt shops. She made her first quilt about 1979, an Amish design she has yet to finish, and now averages completing about one quilt per year. "I quilt everywhere—with the family, in front of the television, in bed, and even in the car," she commented. "I enjoy quiltmaking because it is a form of creative expression that provides a way of offering a permanent record of artistic endeavor." Her talent has been recognized in several ways—this quilt was selected for a judge's award in the Great Texas Quilt RoundUp for the Texas Sesquicentennial; another quilt won a first-place ribbon at the judged show of the American International Quilt Association.

HUNTSVILLE'S BIRTHDAY QUILT

52″ × 86″
Cotton

1986

Appliquéd, embroidered, and quilted by participants at the Huntsville Grandpersons Center in Huntsville, Walker County
Owned by the City of Huntsville

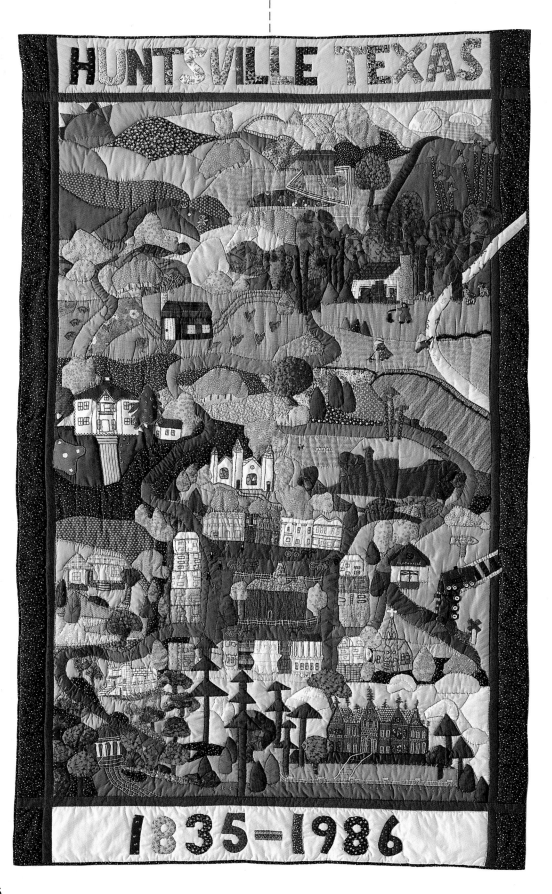

FOURTEEN women from the Huntsville Grandpersons Center celebrated the Texas Sesquicentennial and Huntsville's 151st birthday by telling the story of the city in quilting. The results of their effort is a folk art quilt that was a source of pride for them, and for the city, when it was hung in the Sam Houston Museum for July 12 birthday festivities in 1986.

The quilt project, which received a grant from the Texas Commission on the Arts and the National Endowment for the Arts as well as a matching grant from the Huntsville Arts Commission, began in March with Roberta Norris as project director. Working with her were Annie Adamson, Lois Alexander, Iona Andrea, Fannie Mae Bass, Ruth Cass, Lillie Crockett, Hester Frazier, Mable Goodin, Joyce Hilliard, Robbye Martin, Evelyn Mosley, Bennie Sue Murray, Eleanor Russell, and Bessie Schultz.

To begin the design of the quilt, the Grandpersons told Roberta Norris stories of their years growing up in Huntsville—what they remembered, what happened to them, what was going on in the city. They included such things as a railroad accident that happened about 1918 but could not be further documented since the town newspaper burned down in 1920 and only three people could be found who remembered it. Luckily, Mable Goodin, one of the Grandpersons, was one of the few that recalled the accident, and she made the train tumbling down an embankment onto the street below just as she remembered it.

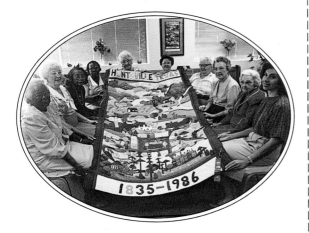

Quilters at the Huntsville Grandpersons Center: *left to right,* Bennie Sue Murray, Eleanor Russell, Evelyn Mosley, Fannie Mae Bass, Mable Goodin, Joyce Hilliard, Ruth Cass, Iona Andrea, Lillie Crockett, and Roberta Norris

Iona Andrea, the center's arts and crafts director, found the pattern for the road that runs through the wall hanging and provides a unifying motif for the twelve blocks that comprise the quilt. Eventually, the design included such things as Sam Houston's house, Old Main, the Sam Houston Museum, Steamboat House, the courthouse, the schoolhouse, a farm scene with log cabin and animals, the First Methodist Church, the railroad accident, a family home, the town square, and a scene at Huntsville Prison, with a mounted guard overseeing prisoners working in a field.

Individuals were assigned a block to complete once the design had been agreed upon, but there was much interchange of effort. "People contributed according to their interest and ability. Perfection was not so important as was a genuine effort," Roberta Norris said. Some people worked hard in spite of physical handicaps. Hester Frazier, the only Grandperson who worked on the quilt who has since died, put in hundreds of hours of intricate embroidery on Old Main, the museum, Steamboat House, and the courthouse, in spite of failing eyesight and arthritic fingers.

Quilting of the quilt began just before the Fourth of July weekend and proceeded over the holiday. By the following Tuesday, the quilting was completed; by Wednesday, the quilt had been bound. On Thursday, finishing touches were added and the quilt was photographed. Friday found the Huntsville's Birthday quilt hung in the Sam Houston Museum just in time for the weekend birthday celebration. The quilt was also selected for the Great Texas Quilt RoundUp in honor of the State Sesquicentennial.

The quilt combines hand appliqué and embroidery with outline quilting in ten to twelve stitches per inch and is finished with a separate bias binding.

"The project allowed these seniors to show their true pride in the community they pioneered by making the folk art quilt a gift to the City of Huntsville to commemorate its 151st birthday," said Roberta Norris. She added that she had heard a lot of "I don't think I can," while the quilt was underway. But when the project was finished one of the Grandpersons summarized the feelings of many when she said, "I'm glad that you made me do things that I never thought that I could do."

YELLOW ROSE OF TEXAS QUILT

66″ × 80″
Cotton and cotton blends

1986

Pieced and quilted by Donoene McKay in Gilmer, Upshur County
Owned by the quiltmaker

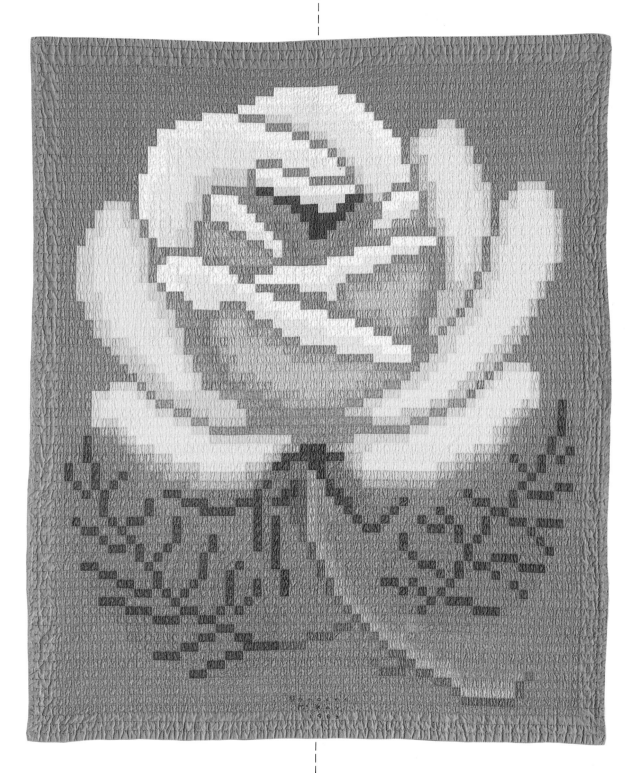

FORTY YEARS of hairstyling for motion pictures and television in New York City could not erase Texas from Donoene McKay's mind. She was born in 1917 in West Mountain, married in 1936 in Port Arthur, and retired in 1983 to Gilmer, after spending her working years in the Big Apple.

When she retired, she had a quilt in mind that she wanted to make.

I had always wanted to do something in mosaic and did not know how. I had always done my own needle-point designs and realized one day that each stitch could be used as a square. I worked out a needlepoint rose from a catalog, then painted it in oils, and marked a grid. The rotary cutter was new and gave me trouble learning to use it, but what a godsend for cutting five thousand plus little squares. I sewed on four sewing machines, each with a different color thread, after filing the presser feet to one-eighth inch in width. Then I made a mock-up with a muslin background and began again with the green background. Both quilts were finished in one year.

While Mrs. McKay had learned quiltmaking "at her grandmother's knee," she did not make a quilt until 1980, when she was sixty-two and living in New York. It was a Clamshell, and she made it "between working times and on the subway number nine—there was much waiting time in my work."

After she made the Yellow Rose quilt, she entered it in the American International Quilt Association's judged show, held each fall in Houston at the International Quilt Festival. Because she had quilted the rose design and tacked the background, the quilt hung unevenly, a fact pointed out by the judge in her critique. With the benefit of this helpful criticism, Mrs. McKay decided to pick out all the tacking and then quilt the background as she had the rose design, keeping only a tacked border for a difference in texture. The quilting is done on both sides of the piece in a medium crosshatch of one inch or less, and the quilt is finished by taking the front to the back.

Donoene McKay
(Johnny Welsh photo)

When she finished the reworking of her quilt, Mrs. McKay entered it in the Great Texas Quilt RoundUp in 1986, where it was selected as the best in the category of Texas Myths and Heroes as a tribute to the Yellow Rose of Texas—Emily Morgan. According to popular tradition, Emily Morgan was a mulatto servant captured by Santa Anna on his way to the Battle of San Jacinto. The Mexican general took a fancy to her and their dalliance in his tent so preoccupied him that the Texan forces under Sam Houston were able to rout his army, thus leading to Texas' independence. Folk belief is that Emily intentionally distracted Santa Anna due to her loyalty to the Texan cause. The clever and patriotic slave was freed by her owner as a reward for her action.

Mrs. McKay attended college for a year and has taken many art workshops. She is currently learning more about painting on silk in order to make a quilt employing that technique. She quilts an hour or two throughout the day. When she made the Yellow Rose, she basted the quilt on a frame suspended from the ceiling and quilted it on a fourteen-inch hoop in front of the television.

FREEDOM TO DREAM QUILT

$72'' \times 72''$
Cotton

1986

Pieced, appliquéd, and quilted by Marie Anita
Wingate Murphy in Kountze, Hardin County
Owned by the quiltmaker

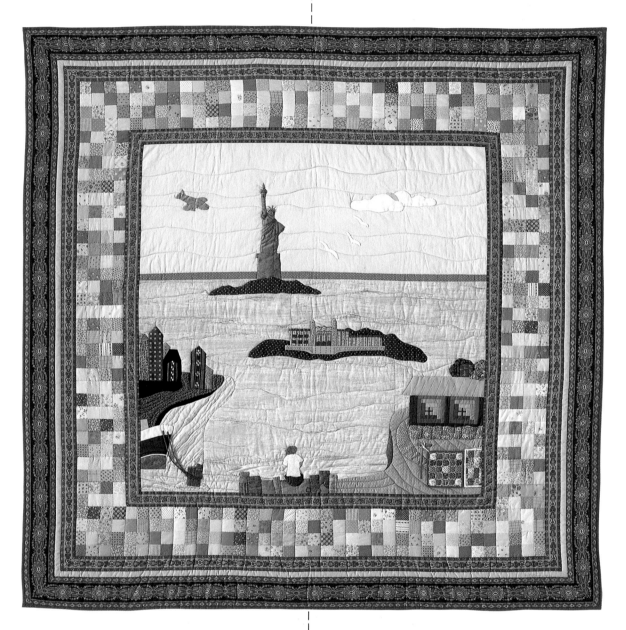

FROM A BLUE-AND-WHITE Ohio Star doll quilt made when she was seven to her pictorial quilt Freedom to Dream, selected as the Texas state winner in the Statue of Liberty Centennial quilt contest, Anita Murphy's life has been filled with quilts and quilting.

Born in Kansas City, Kansas, she and her parents moved to Omaha and then to Tulsa, when she was nine. She attended the Ursuline Sisters School from the fourth to the eighth grade, then graduated from Marquette High School in 1945. Mrs. Murphy recalled, "I have to smile, thinking about when in the sixth grade the sisters hired a lay teacher to teach sewing. Due to an ear infection, I had to miss two classes, and when my father took me back to school after treatment, the lady said I would never learn to sew!"

What the visiting teacher did not know was that an aunt, Helen Burt, who held a degree in home economics from the University of Texas, had already taught the child to quilt during a nine-month visit to her grandfather and two aunts in Brownwood when she was seven years old.

After her high school graduation, Mrs. Murphy worked for the government, was an airline hostess for Continental, then took a job with Stanoland Oil & Gas, and was transferred to Houston. A co-worker's husband introduced her to his best friend at a Mardi Gras party at Saint Thomas University and three days later the young man proposed. Less than three months later in 1951 the Murphys were married. By 1955 they had three daughters and a son, and in 1968 they adopted a son. In 1956 the Murphys opened their own business in Beaumont and ran it for twenty-five years.

Mrs. Murphy quilts with the Golden Triangle Quilt Guild in Beaumont, which she founded, as well as by herself in the early morning and at night. She said she has "many operettas and musicals of yesteryear and [I] often quilt until 2 and 3 A.M. listening to them."

"When the children were young, we lived in a two-story, elegant older home. I turned the maid's pantry off the kitchen into a sewing room. In the house I now live in, on twelve acres six miles outside the city limits of Kountze, I seem to have different projects in each room."

Mrs. Murphy considers herself a professional quiltmaker, accepting commissions for pictorial wall quilts; she also teaches and lectures about quilting. She limits the number of quilts she makes each year so there are "not too many," preferring instead to teach and do volunteer quilt teaching "to help others learn and enjoy this remarkable art form . . . I love to share, encourage, and confirm in each student her ability to grow and to learn to be proud of her accomplishments. Then I know that I have passed on the gift God so lovingly gave me."

Marie Anita Wingate Murphy

Freedom to Dream was made as an entry in the Great American Quilt contest planned to celebrate the one-hundredth birthday of the Statue of Liberty in 1986. It shows a boy gazing out over the harbor at the statue. Mrs. Murphy said:

The airplane is a reminder of the first time I saw the Lady. I had earned free travel miles as an airline hostess for Continental and flew to New York City. The pilot tipped the wing so I could see her out the window. The ship at the dock is to commemorate my husband's mother, who was born on board ship waiting to dock. Several days were spent deciding if she would have U.S. citizenship or Irish; she was given U.S. The log cabin depicts humble beginnings. The quilts show what a warmth and comfort they are in our lives. The little boy is not fishing . . . he is dreaming of what he can grow up to become with our right to be free.

She used both hand and machine piecing, hand appliqué, and embroidery in her quilt. Each piece is outline-quilted, with some special quilting designed to evoke waves, sky, and roads used in portions of the quilt. In her inner border, she used "580 one-and-one-half-inch squares depicting the earth, from the white plains to the red earth of Oklahoma, and the wildflowers found in every state of the union." A printed paisley outer border frames the picture, and a separate bias binding in a contrasting color completes the quilt.

After Mrs. Murphy's quilt was selected to represent Texas in the contest, she was invited to Austin to meet then-Governor Mark White, and she later met Vice President George Bush and Mrs. Bush. Along with other state winners, she was invited to New York City to attend the premiere exhibit of the quilts, before they left on tour across the United States and four cities in Japan.

Her quilt holds some poignant memories for Mrs. Murphy, for she completed it in thirty-six days while her husband was in the hospital with an illness that later claimed his life. "James' encouragement and pride in what I made and the designs I have created were as good or better than most art classes," she said. In his memory she has set up a nursing scholarship at Lamar University.

FOUNDERS' STAR QUILT

96″ × 96″
Cotton

1986

Pieced by Jewel Pearce Patterson in Houston, Harris
County
Quilted by Marge Weisheit in West Columbia,
Brazoria County
Owned by Jewel Pearce Patterson, Karoline Patterson
Bresenhan, Helen Pearce O'Bryant, and Nancy
O'Bryant Puentes

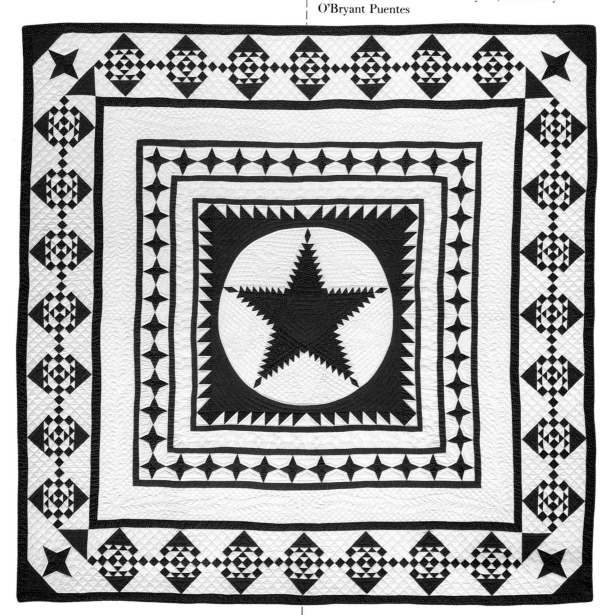

Left to right,
Karey Patterson Bresenhan,
Nancy O'Bryant Puentes,
Jewel Pearce Patterson,
and Helen Pearce O'Bryant
(Chisholm Rich Associates photo)

CREATED in honor of the 150th birthday of the Republic of Texas, this extraordinary piece was made as a fund-raising quilt for the American International Quilt Association (AIQA) during the Texas Sesquicentennial. The quilt was designed and pieced by one of the founders of AIQA, a fourth-generation Texas quilter and professional quilting teacher; her sister, Helen Pearce O'Bryant, also a fourth-generation Texas quilter and AIQA founder, helped her select the designs, plan the quilt, and cut the pieces. Their daughters, the other two founders of the organization, also assisted in this family project, a reflection of their quilting heritage and their love of Texas.

The center medallion is a Feathered Texas Star, an original pattern created by the quiltmaker and based on the traditional five-pointed Lone Star on the Texas flag. Feathered Stars have always been a test of a quiltmaker's ability because of their complex piecing; designing the Feathered Texas Star was a distinct challenge. The star medallion is surrounded by a sawtooth border; the next border is a row of pieced four-pointed stars known as Texas Tears, so named because of the hardships faced by the settlers who tamed the frontier. The outer border is a row of Battle of the Alamo blocks in honor of that shrine of Texas liberty. The colors of deep red, navy blue, and cream were chosen to symbolize the colors of the Texas flag.

Quilting designs for the Founders' Star were chosen and placed by the quiltmaker. Around the Feathered Texas Star are quilted Texas wildflowers, including the state flower, the bluebonnet. In addition to feather quilting and other elaborate designs, a row of five-pointed stars has been included. The quilting stitches measure approximately nine per inch. The quilt is finished with a separate bias binding.

Offered as the Grand Prize of the International Quilt Festival in Houston in 1986, the quilt was won by AIQA member Kathleen McCrady of Austin. (See page 88 for a quilt made by this talented quiltmaker and page 128 for a quilt she designed.) In 1988, in an act of remarkable generosity, Mrs. McCrady donated the Founders' Star back to the AIQA founders because she felt that "the quilt should stay in this family in appreciation for all that they have given to quilting."

Jewel Estelle Pearce, a native Texan, was born in Sabinal, Uvalde County, in 1910 and moved to San Antonio as a child. Married to C. C. (Pat) Patterson in 1934, she moved to Gilmer in Upshur County four years later. Her daughter was born in Gilmer in 1942, and six weeks later the Pattersons moved to Houston where in fewer than fifty years the quiltmaker has witnessed the drastic change of Houston from a sleepy Southern town to the nation's fourth largest city. She was valedictorian of her graduating class in San Antonio and studied for a two-year degree from Westmoreland College there. After her husband was killed in an accident when she was only forty-four, she went back to school to earn her bachelor's degree "because teaching was the only way I had to support my family, and without a degree, I couldn't be hired full-time." She later earned a master's degree in library science. She taught kindergarten in the Houston public schools for many years and then made a midlife career change to work as a school librarian until she retired in 1975.

"I retired to go to work," Mrs. Patterson has often said, since after retiring, she took on the challenge of commuting to another city to serve as part-time librarian, working as a librarian for several private schools, and beginning to teach quilting classes and work in her daughter's quilt shop, Great Expectations, in Houston. In 1979, the quiltmaker and her family founded the South/Southwest Quilt Association, which changed its name to the American International Quilt Association a few years ago. She has planned and coordinated four fund-raising quilts for the association, most recently a stunning Fairytale quilt featuring in appliqué the silhouette designs of Hans Christian Andersen, which was created for the association's second European conference in Odense, Denmark, Andersen's hometown. In addition, she has also helped to plan and coordinate special fund-raising quilts for the Quilt Guild of Greater Houston, which she helped found in 1976.

Mrs. Patterson learned to quilt as a child, piecing her first quilt, a Four Patch, at age six. She comes from a quilting family (see pages 58 and 92 for other quilts from this family) and, like her mother, was a professional seamstress for many years before beginning to teach. Her daughter remembers being married for two years before buying her first store-bought dress: "My mother made every dress I owned—school dresses, church dresses, even prom dresses—and they were all wonderful. I never started the first day of school without a new dress, but sometimes Mama was finishing the hem five minutes before I had to walk out the door!" The quiltmaker carried on the tradition of marrying with thirteen quilts, and she married a man whose mother had made him a hope chest full of quilts (see page 53). Quilts and quilting have always played an important role in her life, and that love has been handed down to her daughter, one of the authors of this book.

WILD, WILD WEST QUILT

62″ × 82½″
Cotton

1986

Appliquéd and quilted by Willoa Stockton Shults in Boerne, Kendall County
Owned by the quiltmaker

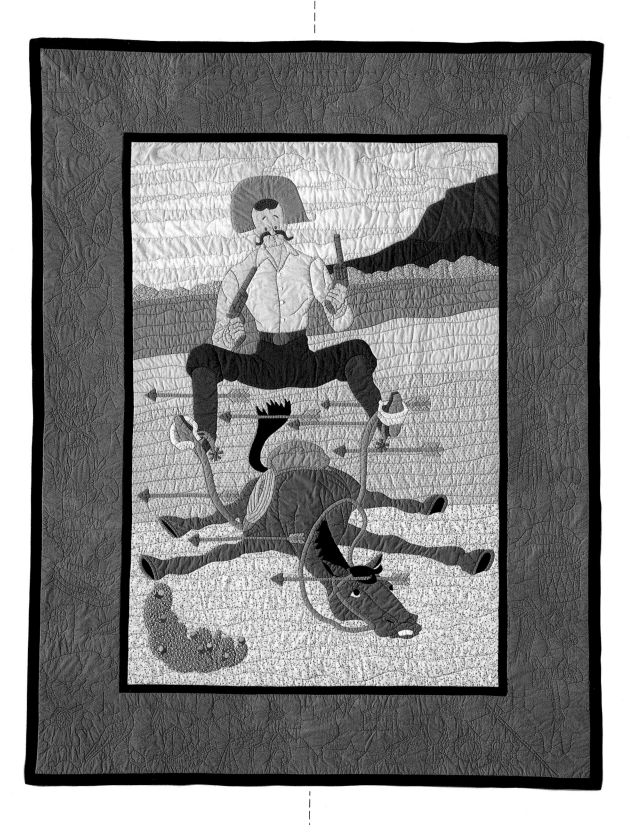

ALTHOUGH the role of the cowboy and the Indian in Texas history has been romanticized by film and books to an idealized state that is a far cry from reality—the strong, silent cowboy vs. the noble savage—in truth the two groups were natural adversaries. The cowboy existed to tend the vast herds of cattle that ranged over the Indian's traditional hunting grounds. The cowboy ran the miles of barbed wire that cut the Indian off from the campsites of his forefathers. The cowboy was the forerunner of the mass migration west, and with that migration came the towns and schools and churches and railroads—in short, civilization—and it was civilization that spelled the end of the Indian's nomadic way of life.

This charming, humorous pictorial quilt depicts the perhaps unavoidable confrontation between the cowboy and his faithful companion, his horse, and the Indian, represented by the flying arrows. The background is a textile painting of the terrain of West Texas, with the Guadalupe Mountains in the distance. The entire composition is executed in hand appliqué.

The frame around the picture is composed of symbols from Texas of the cowboy era: the armadillo, windmill, longhorn, bow and arrow, sunbonnet, Alamo, yellow rose of Texas, moccasins, tomahawk, cowboy boots, mockingbird, roadrunner, calumet, cowboy hat, tom-tom, saddle, hangman's noose, one-room jail, six-gun, and authentic cattle brands. Buttons on the cowboy's regalia were taken from the button box belonging to the mother of the quiltmaker, so, as she recalls, "they could easily have been authentic to the period depicted in the quilt." The quiltmaker chose fabric that resembles leather for the frame and quilted the symbols in off-white thread to look like saddle stitching. Simple outline quilting is used in the central picture with more elaborate quilting in the borders, including stars and flowers. The quilting stitches average seven to nine to the inch. A separate bias binding finishes the edge of the quilt.

Wild, Wild West was a crowd-pleaser during the Texas Sesquicentennial year when the Great Texas Quilt RoundUp finalists toured the state. According to the quiltmaker, she developed her humorous style in quiltmaking because "my mother's storytelling of family history from the funny side definitely affected my view of things." She believes that quiltmaking should be fun and enjoyable for both the quilter and the viewer, and her quilts reflect that belief.

Willoa Stockton Shults

Born in 1931 in California, Willoa Stockton Shults earned her bachelor's degree from Chico State College, then did a year of postgraduate work. She joined the United States Women's Air Force (USWAF) in 1954 and played bassoon in the WAF Band at Lackland Air Force Base. She married in 1955, had one daughter and twin sons, and spent six years on Okinawa while her husband was involved in military duty. The family returned to San Antonio in 1968 when her husband was medically discharged; at that time, she opened a bookstore. After her first husband's death in 1975, the quiltmaker remarried three years later and moved to Boerne in the Texas Hill Country.

She began making quilts that same year when she saw a quilt her sister had made and decided to try quilting. First she made the appliqué blocks for a reversible Sampler quilt but never finished setting the blocks together; later she took classes at Hill Country Quilts "to learn it right." Ms. Shults has subsequently won several ribbons for her quilts, including first place in appliqué at the American International Quilt Association judged show at the International Quilt Festival in 1981. She is active in the Greater San Antonio Quilt Guild, the Hill Country Quilt Guild, the Hoop 'n Frame Quilt Bee, AIQA, the National Quilting Association, and the American Quilters Society. She taught quilting in a Boerne store from 1982 to 1987, then purchased the quilt store, renamed Sew Special, in 1987. She makes eight to ten quilts per year, "now mostly by machine." About Wild, Wild West, Ms. Shults commented that her original design was planned "to tweak the noses of historical buffs hung up on our grand and glorious heritage yet depict some of the problems of the day. Who says quilts can't be fun?"

175

SESQUICENTENNIAL MEDALLION QUILT

75″ × 84″
Cotton

1986

Pieced and appliquéd by Marilyn McAdams Sibley in Houston, Harris County
Owned by the quiltmaker

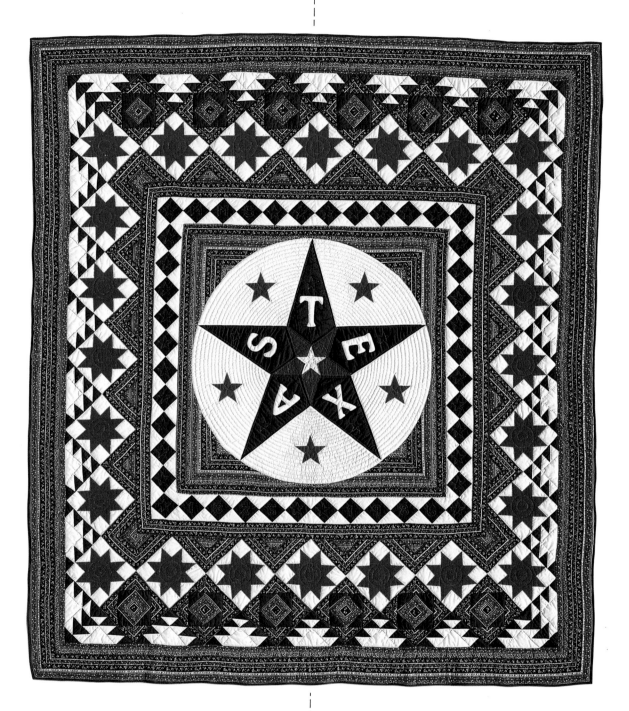

A DESCENDANT of a Texas revolutionary soldier, now restoring a dogtrot house that soldier built on land received for his service in Walker County, won a Sesquicentennial award for this quilt commemorating the cause for which her ancestor fought.

Quiltmaker, chairman of a university history department, and author, Professor Marilyn McAdams Sibley, a descendant of John McAdams, Jr., who came to Texas in 1832 with his parents, said: "My husband and I began restoring a family ranch house built by my great-grandfather in the 1840s. In casting about for items suitable for it, I hit upon quilts—but could not afford those gorgeous, expensive beauties in quilt shops. Thus, of necessity, I began making my own."

This quilt is a natural outgrowth of that restoration of the McAdams Homeplace, which Sam Houston used as a stopping point when traveling from his home in Huntsville, and of a lifelong interest in Texas history on the part of Professor Sibley, who served as president of the Texas State Historical Association in 1981.

Born in Walker County, Mrs. Sibley holds a Ph.D in history from Rice University and chaired the Department of History at Houston Baptist University for seventeen years. She is the author or editor of seven books related to Texas history (including three published by the University of Texas Press: *Travelers in Texas, 1761–1860*; *The Port of Houston: A History*; and *George W. Brackenridge: Maverick Philanthropist*). The design for the medallion in Mrs. Sibley's quilt came from an advertisement in an 1840 newspaper, which she found while researching a book on Texas newspapers before the Civil War.

Mrs. Sibley purchased striped fabric quite some time before making her Sesquicentennial Medallion but at that point in her quiltmaking was not aware how much fabric it takes to match and miter stripes to turn corners in quilts. By the time she realized it, the striped fabric was sold out. "Thus, after the center medallion of this quilt was made, the pattern was determined more by the leftover scraps than by a master plan," Mrs. Sibley said.

Marilyn McAdams Sibley

The red, white, and blue fabric for the top and backing of the quilt is cotton, and the batting is synthetic. The quilt is both pieced and appliquéd and is quilted in outline quilting seven to nine stitches per inch. Stars are also quilted into it, along with the maker's initials and the dates 1836–1986, the years from Texas' independence from Mexico through the Sesquicentennial. The quilt is finished with a separate bias binding.

This self-taught quiltmaker, whose first quilt was an Ocean Waves made about 1972, does not take classes in quiltmaking. She usually quilts alone in the early evening in her family room, other times with three friends in their homes. She has no other needlework interests.

She quilts for relaxation and for the pleasure of the product. That interest has resulted in two awards for her Sesquicentennial Medallion quilt, a blue ribbon in the history and symbols category of the Great Texas Quilt RoundUp and another in the American International Quilt Association judged show.

INDIAN QUILT

58″ × 66″
Silks and cotton blends

1986

Pieced and quilted by Ruby Greer Wolfe in Lampasas,
Lampasas County
Owned by the quiltmaker

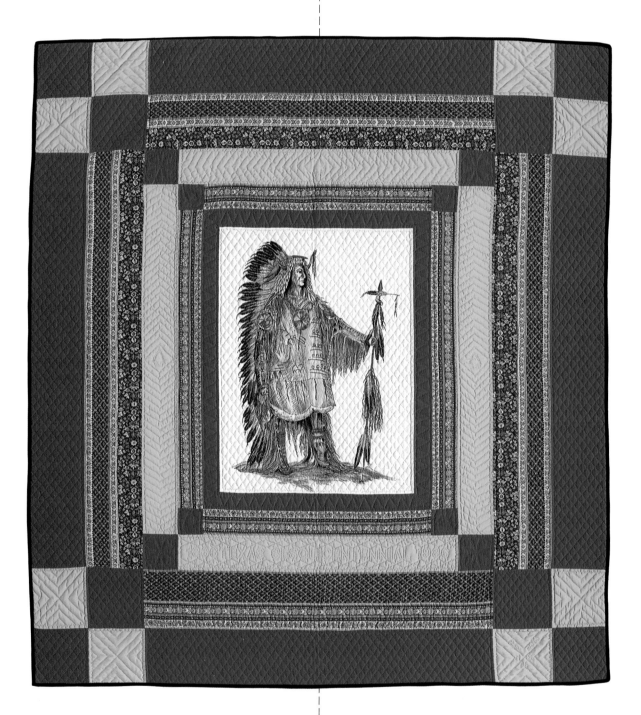

THIS QUILTMAKER made her first quilt top—a small Nine Patch, the traditional beginner's pattern—when she was only five years old, living on a farm near Rockdale. "I had seen my mother quilt and helped her, so I knew how it was done. I quilted for cover when I was on the farm. I grew up with my mother making quilts for cover. Some were made from old clothes, but we always had plenty of cover to crawl into on cold winter nights," she recalled. Married at the age of fifteen, she raised her family of four children on another Texas farm, where she continued to quilt to produce bedcovers to keep her family warm.

The quiltmaker's mother, Viola Greer, gave her a Broken Star top, which she quilted while she was living on the farm. "It made one of the most beautiful quilts I had ever seen," she commented.

After I had moved to Lampasas, around 1976, I entered it in a quilt show. I just knew I would get some kind of ribbon. Well, I didn't. That made me start looking at the quilts that had won ribbons and at their stitches and sets. I made up my mind that if they could, I could, too. I thought for a while on what I wanted to make as a special quilt. In the meantime I was quilting, trying to improve my stitches. The first quilt I made as a show quilt was one of the Lampasas courthouse. I won the grand overall prize with it at the Lampasas show and won a white ribbon at the state fair. So from then on I was hooked on doing something special with quilts.

When plans for the Texas Sesquicentennial were announced, Mrs. Wolfe decided to attempt another very special quilt for the Great Texas Quilt RoundUp competition. Like nineteenth-century women who used commemorative printed handkerchiefs as the basis for a special quilt, particularly around the time of the nation's Centennial celebrations in 1876, she found the Indian print at a local dime store and used it as the center medallion of this quilt. She machine-pieced complementary borders to complete the medallion effect and then "quilted it to death" on a small frame, while listening to Bible tapes.

She used close crosshatch quilting to enhance the details of the Indian chief and quilted each line of the Indian design. On the reverse side of the

Ruby Greer Wolfe

quilt, every fringe and feather of the Indian's buckskin garments is clearly delineated with quilting stitches. The extensive quilting adds depth and visual complexity to the printed design. More heavy quilting is used on the concentric borders that frame the central medallion, arrowheads are created with quilting stitches, and the words and dates, "1836—Texas Sesquicentennial—1936," are backstitched for emphasis. The quilting stitches measure seven to nine stitches per inch through a synthetic batting. The raw edges of the quilt are enclosed with a separate bias binding in a contrasting color.

When Mrs. Wolfe originally created the quilt, which was one of the finalists in the Texas competition, and entered it into the Lampasas Quilt Show, the judges disliked one of her borders, which was white. They strongly recommended that she change the border to a darker color. After she changed the border to a mixture of black prints, the quilt won Best of Show at the state fair as well as the Mountain Mist Best of Show ribbon.

Born in Lometa in 1921, Ruby Greer Wolfe moved to Lampasas in 1937 after her marriage, and opened a sewing machine and antique shop where she worked for approximately twenty years. She has "been working with quilts ever since" and makes two per year by hand and another twenty-five by machine.

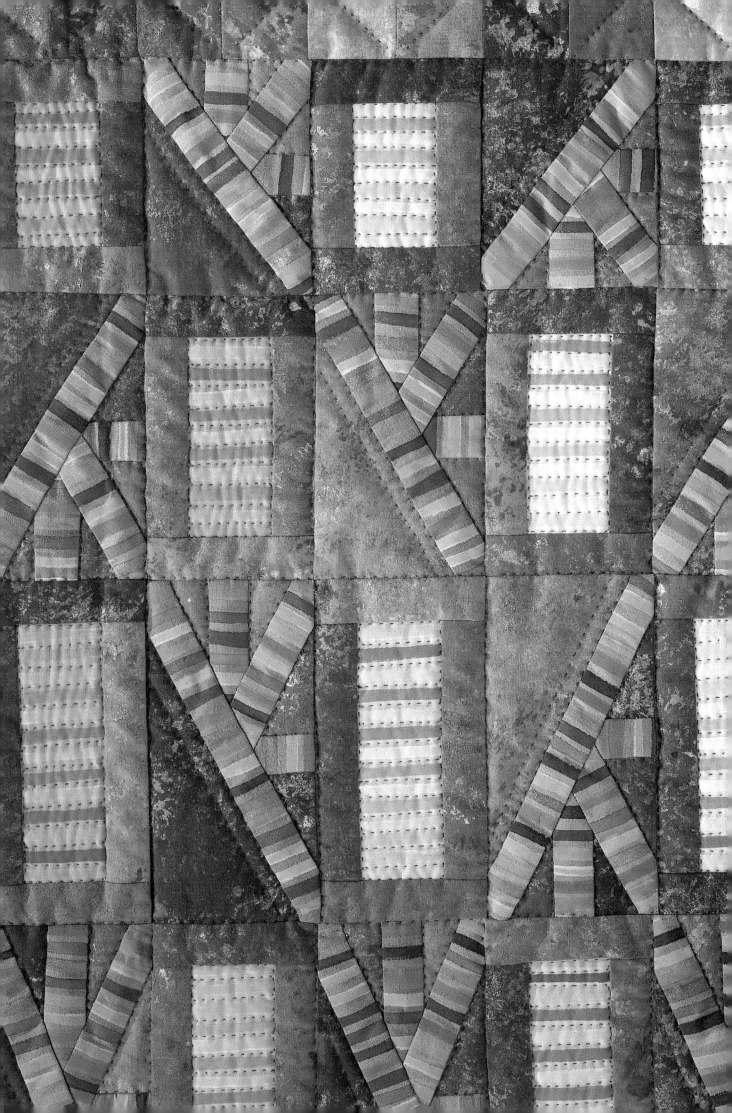

CONTEMPORARY
QUILTMAKING
IN TEXAS

A METAMORPHOSIS took place in the work of a significant, though still small, number of Texas quilters around 1986. They may have been working in a traditional method previously, or at least learned their technique on traditional quilt designs, but for many reasons they began experimenting with their quiltmaking. An even smaller segment of that group had begun nontraditional quiltmaking years earlier. Several things combined to create a climate favorable to this trend, which became identifiable around the Texas Sesquicentennial.

Quilting had reached another peak. In the thirties, activity was at a high point, then began to taper off during the forties. It reached a low point in the late fifties and sixties, then began a resurgence in the early seventies. The American Bicentennial sparked an acceleration in this trend, which has yet to slow down. And this time it may not, for quilting has possibly reached a critical mass.

The women's movement of the sixties, seventies, and eighties, whether or not it touched individual women's lives, provided a catalyst for the examination and evaluation—in some cases, the reexamination and reevaluation—of women's contributions as a group and as individuals in various fields. It also sparked an interest in certain areas of achievement that were uniquely "female." Quilting was, and is, such an area.

Quilt specialty shops opened. Prior to the establishment of quilt specialty shops, there was no one source for all of a quiltmaker's needs. She had to buy batting and fabric in one place, possibly order patterns from a newspaper or get them from a friend, and learn new techniques and solve construction problems by herself or with help from family members, friends, or members of a traditional quilting club. The quilt specialty shop gave her one-stop shopping and an important focus for quilting activities. Moreover, it offered classes in all phases of quiltmaking. For members of the nuclear families from the 1950s onward, who were frequently cut off from regular contact with relatives and who therefore had no opportunity to be a part of a generational chain of learning quilting from and teaching quilting to their extended families, this was of incalculable importance. Once women learned to quilt and once they were exposed on a regular basis to all of the necessities of quiltmaking gathered in one spot, with new inventory regularly coming in, they did not stop at one quilt. They made many, each generally more advanced, challenging—often even experimental—than the preceding one.

Furthermore, as quilting blossomed once again and retail quilt specialty shops opened to serve that market, wholesalers, distributors, and manufacturers greatly expanded their quilting product lines. New product designers became active, and many innovative or improved items for quilters were developed and brought into the marketplace. New types of batting, for instance, were developed for different groups of quilters, such as quilted clothing designers. The rotary cutter provided a new, fast way to cut many pieces of fabric needed for certain kinds of quilts. Different types of sewing notions, such as leather thimbles, were marketed. Hundreds of new patterns were offered. The introduction of these and many, many other new products to make quilting easier often attracted the casual quilter, who frequently became a more dedicated one.

Of particular note in this explosion of new products was the proliferation of books on every conceivable aspect of quiltmaking. Among them, quilting technique books frequently straddled a middle ground between instruction and education, helping to fill the void previously occupied by transmission within the family of the methods and lore of quilting.

Another development was the establishment of overarching quilt organizations. Yabsley, in *Texas Quilts, Texas Women*, says:

The growing trend toward participation in a formally organized quilt guild is the most important influence on present-day quiltmaking in Texas. Throughout the state and all across North America, guilds are providing the focus and continuity necessary to ensure that the quilt revival of the 1970s will be more than a passing wave of nostalgia. Through education, special activities, and the stimulation provided by a grass-roots communications network, guilds are fostering a large group of people who are particularly knowledgeable about quilts. This trend is a new approach to quiltmaking in Texas, and it marks a distinct departure from the ordinarily isolated, rural-based quilting clubs still common in the state . . . Perhaps the most significant point that can be made in distinguishing clubs from guilds is that the former has its roots in the past while the latter is contemporary in every respect. (Pp. 63–64)

While these new quilt guilds can be considered super-clubs, there is another category of organization that must then be termed a supra-club. It is the regional, national, or international organization with a larger purpose. The East Coast–based National Quilting Association has been instrumental in arriving at a set of standards for quilters, teachers, and judges. Another, located on the West Coast, is the American Quilt Study Group, which aims to establish a body of research on quilts, quilters, and quiltmaking. Texas is home to the American International Quilt Association, the only international quilt organization, which is dedicated to preserving and developing the art of quilting and attaining recognition of quilting as an art form.

Such organizations, along with the scrutiny given the female aesthetic sensibility and feminine creative undertakings fostered by the women's movement, have provided a philosophical underpinning for the quilts-as-art movement discussed in an earlier section of the book.

Modern quilt shows, unlike their predecessors that were primarily extensions of quilting-club activities or county-fair type competitions, offer a sophisticated range of activities. Nationally and internationally known lecturers and quilting instructors provide new and thought-provoking theories on all aspects of quiltmaking and quilt history and an ever-expanding number of technique classes; commercial exhibitors display a proliferation of new fabric lines and tools to make quiltmaking easier and ever more appealing; book and pattern publishers bring out new products continuously; demonstrations show novices quilting in action; special events and features such as films on quilters and quilting and quilted-fashion shows are offered; and, above all, a brilliant panoply of quilts of every kind, antique and contemporary, is available for viewing in judged competitions and in specially curated exhibits. The intense atmosphere, the mind-boggling display of color and pattern, the sheer amount of activity at some large quilt exhibitions can be stupefying.

The epitome of such shows is held in Houston each fall. International Quilt Festival, which celebrated its fifteenth anniversary in 1989, is the largest annual quilt show and sale in the world. That year, over a four-day span, 25 special quilt exhibits, 125 quilting classes, 35 lectures, and 215 exhibitors attracted 30,000 plus attendees.

One quilter who had attended the 1984 International Quilt Festival in Houston with her mother said both of them were left "overwhelmed, speechless, brain-dead." It is safe to say they would have exhausted their superlatives in 1989.

International Quilt Festival has expanded to include a midyear Festival that travels to various parts of the country. Each of these shows is held in conjunction with the world's only wholesale trade show for the quilting industry, Quilt Market, also headquartered in Houston. Quilt Market is where products reach the retailers who maintain quilt specialty shops around the world. In addition to the semiannual United States–based Quilt Market, there is an annual European Quilt Market, now in its third year, which serves an expanding base of quilt retailers who are supplying the rapidly growing number of European and Pacific Rim quilters.

All of these major developments have combined to produce an interlocking, overlapping, and underlying network for quilters that provides an extremely supportive atmosphere, a sense of belonging to a larger whole and of being a link in the continuous chain of this female art form, a fertile environment for experimentation, growth, and change, and a sizeable audience that is, if not always appreciative, at least accepting of new directions and innovations in quiltmaking. In addition, a reexamination of the folk arts and crafts traditions of this country has produced outside the quilt world a growing cadre of increasingly sophisticated collectors and admirers who respect both the established and familiar conventions of the traditional quilt and the spontaneous and imaginative originality of the contemporary.

While the scope of our book is the fifty-year span of Texas quiltmaking beginning with the Texas Centennial in 1936 and ending at the Texas Sesquicentennial in 1986, we would be remiss if we did not indicate the general direction of some of these emerging trends in quiltmaking. A feel for this new dimension of quilting that we consider an important development can be obtained by looking at five quiltmakers working in a contemporary vein. It is worth noting that all five of these quiltmakers consider themselves artists and four of them are professional quiltmakers.

AMISH PAINT QUILT

72″ × 72″
Cotton

1986

Pieced and quilted by Mary Ann Jackson Herndon in
Houston, Harris County
Owned by the quiltmaker

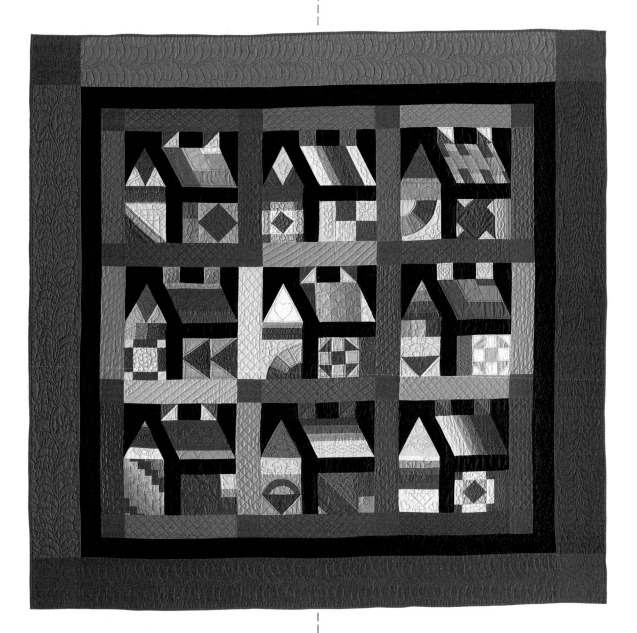

THE FAMILIAR School House block has been
transformed by the use of vibrant solid colors
found in classic Amish quilts, with traditional pat-
terns found in Amish quilts being used in minia-
ture to construct each School House. Rich hues
set off by black brought this original adaptation
a first place in the interpretive pieced division of
the 1986 American International Quilt Associa-
tion judged show and attention from several
publications.

For more information on quiltmaker Mary Ann
Jackson Herndon, please see page 165.

JUXTAPOSITION: RED QUILT

48″ × 64″
Cotton and cotton blends

1987

Pieced, appliquéd, and quilted by Elizabeth J. Axford
in Houston, Harris County
Owned by the quiltmaker

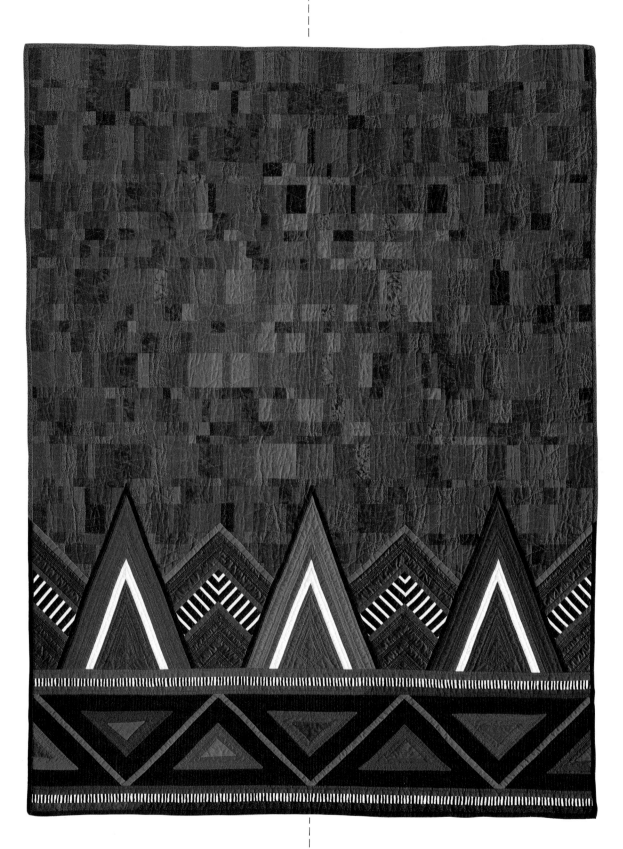

SHE BEGAN her first quilt, a Nine Patch, at age nineteen at her parents' home in Bowie, Maryland, on summer vacation from college. "I began making this first quilt, although I never finished it, after seeing a Nine Patch Texas Depression-era utility quilt. I loved it and had to create one," quiltmaker and architect Liz Axford said. She is a self-taught quilter but has taken classes at quilt specialty shops, at the International Quilt Festival in Houston, and at an arts and crafts school.

Ms. Axford has a Bachelor of Arts degree in architecture and fine arts, as well as a 1978 Bachelor of Architecture degree from Rice University. She was born in Vancouver, British Columbia, Canada, on April 28, 1953, and was enrolled in the Winnipeg School of Art children's program from age seven to age ten in Winnipeg, Manitoba, Canada.

At ten, she moved to Texas, living first in Irving, then in Houston. "I've always drawn, painted, created. I began sewing in a required home ec class at age fourteen, quickly becoming obsessed and staying up all night to sew," Ms. Axford said.

She married in 1980 and says her attorney husband is "extremely supportive" of her quiltmaking. "I do machine work in a small studio in our home. Handwork is done in the den. The television or stereo is always on." Her most productive times for quilting are early morning, afternoon, and early evening.

Juxtaposition: Red Quilt has won a blue ribbon in the American International Quilt Association judged show, was a winner in a 1988 show, and has been accepted into several juried fiber or all-crafts shows.

For this dramatic quilt, Ms. Axford has used strip piecing and hand appliqué; in an unusual effort, she has also pieced the back of her quilt. The quilt is outline-quilted, channel-quilted, and freeform machine-quilted with metallic thread. Seven to nine stitches per inch were taken, and the quilt is bound with a separate straight-grain binding.

About her quilting, Ms. Axford said: "It's something I seem to have to do. I feel I'm free of the outside world. It's a totally indulgent activity. I love to manipulate color and forms; I hope to find myself through this creation."

Elizabeth J. Axford

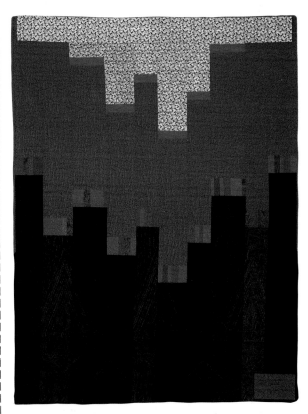

Reverse side of quilt

#70 QUILT

89″ × 61″
Cotton

1988

Pieced and painted by Pamela Studstill and quilted by
Bettie Studstill in Pipe Creek, Bandera County
From the collection of Linda and Paul Neely, courtesy
of Great American Gallery

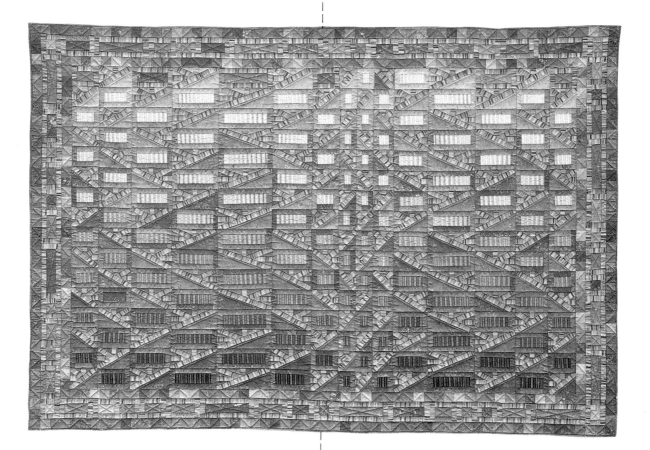

GENTLY COMPELLING rhythms of pattern and color glow with light in the quilts of Pam Studstill. Working alone in a small town, apart from the ferment of change taking place in the quilt world and also insulated from the influence of movements within both the crafts and arts communities, this quiltmaker keeps her own counsel and charts her own course. She describes herself as "obsessed" with her work. She has strong opinions, for instance, on appliqué: "I don't like all that hand work"; on intricate machine work: "I don't like machine stitching to show on top [of the quilt]"; on wild and opulently embellished art quilts: "I love them, love the beads, but in my own work, it's not right for me"; on how she defines herself and her work: "I am a quiltmaker."

Once Ms. Studstill has hand-painted her designs and machine-pieced her quilt, it is ready for her mother, Bettie Studstill, to quilt. The two women have an easy rapport in their collaboration and work on each quilt in a certain manner. "I give her specific directions for quilting each quilt. I used to draw her pictures, because she likes to quilt but doesn't want to make decisions about how to quilt a piece," Ms. Studstill said. "She quilts in the ditch a lot, especially on my last quilts. In the past, we used scallops or diamonds all over. Sometimes I can't think of anything I want until she gets it in the frame."

For this quiltmaker whose works are in many corporate collections, such as IBM's and several banks', inspiration is everywhere, in everything. She is attracted to weaving but has not had the time to pursue it, and she also has an urge to do tile mosaics. Since she makes seven to eight quilts a year, "There's no time to paint any more, although I stretched some canvas recently and tried. It didn't come as naturally as before. It seemed funny without construction, incomplete somehow. I wanted to put stuff on it."

When she's not busy with her quilts, Ms. Studstill and her husband, John Hannah, like to go canoeing on the upper reaches of the Medina River for relaxation. Her husband is a photographer and graphic artist who has taken some time off to build their new home in Bandera, a dream he has had for some time. She has "gardening ambitions" for their new home and is looking forward to a large, new studio. Right now, "my work area is the pits," she laughed. "At first I looked for studio space in Bandera, but there wasn't any. Now I'm using the living room and dining room of our little five-room house."

She looks forward to moving the short distance away to Bandera when their house is completed but enjoys living in Pipe Creek. "My mother's family settled here in the 1880s, and my grandmother lived here until her death this year. My parents retired here and built a house, after my father's career in the air force. We live in an old house behind theirs. I like to stay close to my folks. I like the hills around here, and Bandera is really interesting. It doesn't have that Fredericksburg flavor, where things have been fixed up. People here leave things—and each other—alone."

For more information on quiltmaker Pamela Studstill, please see page 145.

TO PELE, GODDESS OF VOLCANOES, QUILT

64″ × 81″
Cotton, synthetics, and metallics

1989

Appliquéd, pieced, and quilted by Beth Thomas
Kennedy in Austin, Travis County
Owned by the quiltmaker

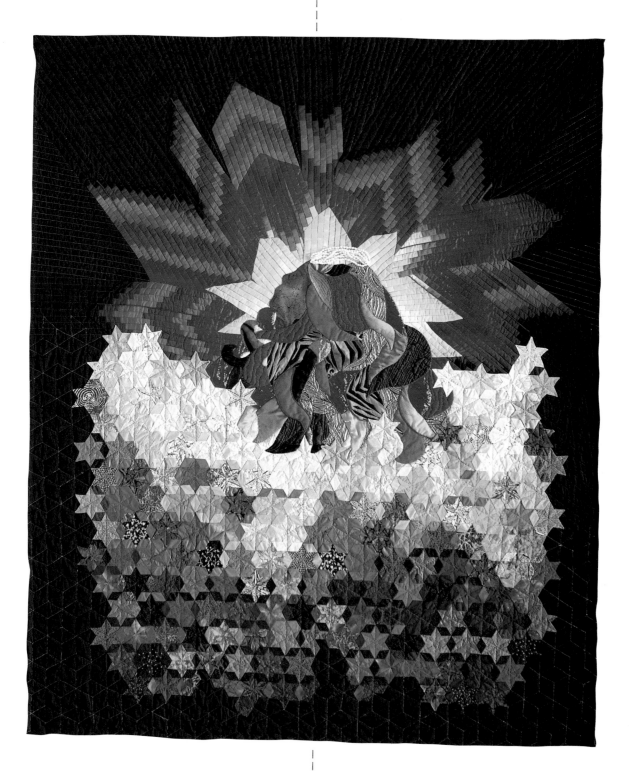

FOURTH in a series of quilts honoring matriarchal rituals, To Pele pays homage to the fire goddess of Hawaii.

"On a trip to Hawaii, I collected some small pieces of lava found on a Kaui beach to bring back as a memory of a dream trip to Paradise," said the quiltmaker. "A short time later, while on Oahu, I learned about Pele and her fury with those who take lava from its resting place. Not wanting to offend Pele, I returned the small lava rocks to the sea with an apology, asking her to return them to their proper place. After deciding to make a series of quilts on matriarchal rituals, I knew Pele would forgive me if I made her a quilt. It is also a vivid reminder of a beautiful place and time."

The quilt combines several techniques: hand appliqué of the free-form lava designs, hand piecing of hexagonal stars and machine strip piecing, machine quilting with metallic threads, and embellishment with beads and shells. Quilting rows are one-half inch apart. The quilt is finished with a separate straight-grain binding that is taken to the back of the quilt.

Mrs. Kennedy was born in 1941 in Dallas where she lived until arriving in Austin to attend the University of Texas. She holds a master's degree in linguistics, is married, and has one son. She worked for twelve years as a linguist and in test development and training for an educational development laboratory before deciding to open a natural fiber and quilt shop for two years. She is now a professional quiltmaker, lecturer, and teacher.

She belongs to a quilting guild and two quilting bees within it, as well as to a new group of nontraditional quiltmakers and fiber artists. Her first quilt, made in 1979, was a traditional one: "pieced and appliquéd—the works," she said. Current quilts are more contemporary. She also has other needlework interests such as counted thread and machine fancywork.

Beth Thomas Kennedy

This quiltmaker uses every room in her house for quilting. "My studio is my house; every room has supplies, books, fabric, or equipment. I piece and quilt around my family, but I love the solitude of being alone during the day."

"Quiltmaking gives me a very fulfilling sense of sisterhood with women, a sense of carrying on the tradition and furthering the art. I get personal gratification from creating a lasting contribution to our heritage, as well as occasionally contributing to the financial well-being of my family," Mrs. Kennedy said.

MARDI GRAS QUILT

54″ × 54″
Cotton and cotton blends

1988

Pieced, painted, and quilted by Libby Anthony
Lehman in Houston, Harris County
Owned by the quiltmaker

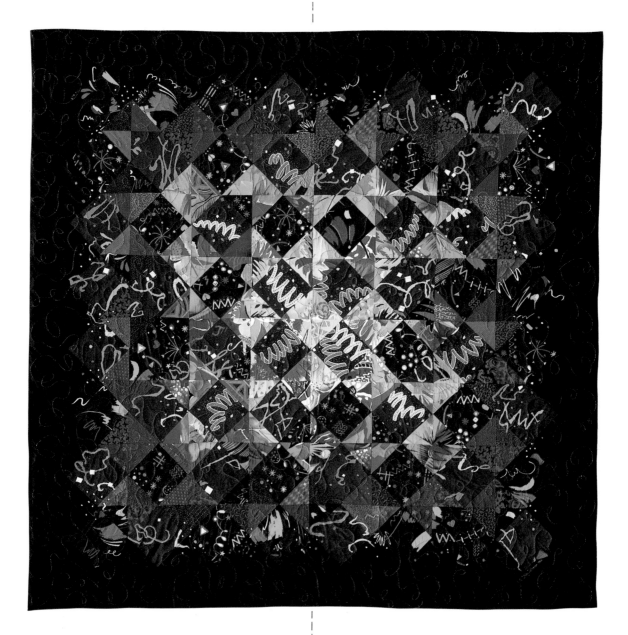

PART of this quiltmaker's series of quilts on various celebrations, Mardi Gras is pieced and painted with acrylic and metallic paints. It is an exuberant reflection of the high-spirited carnivals held on Shrove Tuesday, the day before Ash Wednesday, with their parades of costumed merrymakers. Resembling handfuls of confetti and streamers tossed into a New Orleans night sky, it explodes like a festive firecracker.

For more information on quiltmaker Libby Lehman and her work, please see page 115.

DEFINITION OF TERMS

Appliqué: Derived from French verb *appliquer,* meaning to apply or lay one thing on another; cutout shapes of fabric are "applied" to a larger background fabric and held down with a blind stitch, whip stitch, buttonhole stitch, or embroidery.

Batting: The filling of a quilt, originally cotton or wool; also called wadding or inner lining; the middle layer of the quilt "sandwich."

Binding: Finishing the raw edges of an otherwise completed quilt, or the finished edge itself.

Broderie perse: French term meaning Persian embroidery; nineteenth-century appliqué method in which design elements, such as trees or flowers, are cut from printed fabrics and sewn to a background fabric using blind stitch, whip stitch, or decorative stitches.

By the piece: Quilting around each edge of each piece.

Carding cotton: Method of working raw cotton by hand into quilt batting by placing the cotton between a pair of boards with metal "teeth" and combing the cotton through the "teeth" to produce a flat batting of uniform thickness.

Corners, to turn: Planning the borders and quilting designs to curve around the corners without having a broken line; stems from old superstition that a broken line in the border foretells a broken life.

Counterpane: Derived from French *contre-point,* meaning backstitch or quilting stitch; refers to plain blocks that alternate with pieced or appliquéd blocks in a quilt and are often quilted with a fancy design; sometimes refers to a spread used on top of a bed; counterpane, or whitework, quilts contain no piecing or appliqué, the design formed entirely from the elaborate quilting stitches.

Draw off: To apply the quilting patterns to the finished top; sometimes elaborate patterns are used, sometimes quilters would simply trace around a household object such as a plate, cup, or bowl.

Fabrics:
Calico: Cotton cloth with small, stylized patterns printed in one or more colors.
Chintz: Glazed cotton cloth; in the eighteenth century, always printed; first manufactured in India but then imitated elsewhere; printed designs usually have at least five colors and are frequently large-scale floral patterns; solid color chintz available today.
Muslin: A fine cotton cloth with a downy nap on its surface; today considered a basic of quilting; also called unbleached domestic in common usage.

In the ditch: Quilting stitches just beside or actually in the seam.

Laying off: Drawing a quilting design on fabric with the point of a needle so that the impression of the design remains long enough to quilt but leaves no lasting mark on the quilt.

On the halves: A common practice wherein one quilter would make a top or finished quilt for another person and, in return for her work, would receive enough of the same fabric to make herself an identical top or quilt.

Piecing: To sew small patches of fabric together with narrow seams to form a quilt block, top, or backing.

Prairie points: A method of finishing the edge of a quilt involving folded squares of fabric to form points.

Quilt: A fabric "sandwich" consisting of three layers—top, batting, or filling, and back; derived from French *cuilte,* which was derived from Latin *culcita,* a stuffed mattress or cushion.

Quilting: Simple running stitches, preferably small and even, holding all three layers of a quilt together; stitches often follow fancy designs.

Quilt top: The top side of the fabric "sandwich" that shows on the bed; usually used to refer to the completed pieced or appliqué design before it is quilted.

Reverse appliqué: Method of appliqué whereby part of background fabric is removed in a desired shape and another fabric added from underneath to fill the area; known also as inlaid appliqué.

Sashing: Strips that are used to separate blocks in a quilt; also called stripping.

Set: To sew the finished blocks together to form the top; refers also to the arrangement of the blocks; often secondary designs are produced by the set of the blocks.

Stipple: Stipple quilting utilizes very tiny, very close quilting stitches that form no discernible pattern but are used to flatten the background of the quilt; often used in combination with trapunto or padded appliqué so that the stuffed areas rise in relief.

String piecing: Sewing tiny scraps of fabric to a foundation, often newspapers, letters, or old catalog pages; the foundation is cut to form a pattern piece; once the scraps are sewn down, the foundation can be torn away, and the finished piece is ready to be used in piecing the quilt top.

Strip piecing: The creation of new fabric by sewing together narrow strips of other fabrics; once the new fabric is created, designs are cut out and pieced into the finished quilt.

Stuffed work: Produced when a quilter stitches the design outlines in a fine running stitch and then from the back carefully eases cotton or wool through small holes to pad the outlined areas.

Trapunto: A term applied in the nineteenth century to American and English stuffed and corded work.

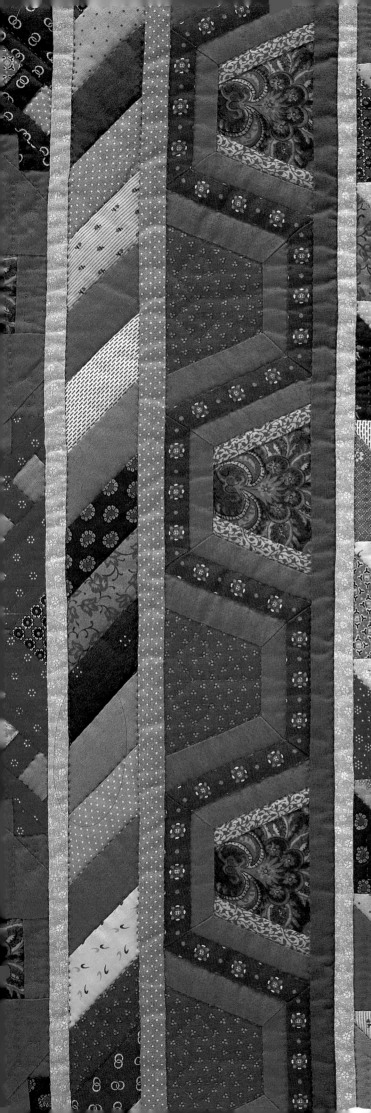
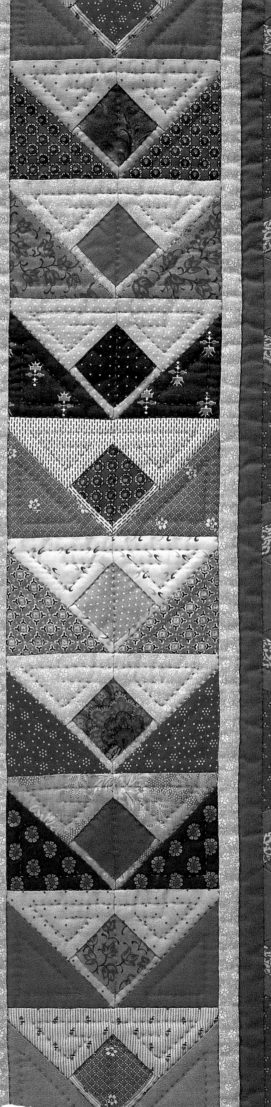

SELECTED
READING LIST

FROM the many good books on quilts and quilting we have selected a few for individuals who want to learn more. If we had to choose a single reference book, however, there is no question that it would be *Quilts in America* by Patsy and Myron Orlofsky. This book is truly encyclopedic in the depth and breadth of its coverage of American quilts. It is, unfortunately, out of print, but it can be found in libraries and, sometimes, through out-of-print and rare book dealers. It is well worth seeking.

History of Quilts and Quilting

Binney, Edwin, 3d, and Gail Binney-Winslow. *Homage to Amanda: Two Hundred Years of American Quilts.* San Francisco: RK Press, 1984.

Bishop, Robert, Karey P. Bresenhan, and Bonnie Leman. *Hands All Around: Quilts from Many Nations.* New York: E. P. Dutton, 1987.

Bishop, Robert, and Carter Houck. *All Flags Flying: American Patriotic Quilts as Expressions of Liberty.* New York: E. P. Dutton, 1986.

Bresenhan, Karoline Patterson, and Nancy O'Bryant Puentes. *Lone Stars, Volume I: A Legacy of Texas Quilts, 1836–1936.* Austin: University of Texas Press, 1986.

Carlisle, Lilian Baker. *Pieced Work & Appliqué Quilts at Shelburne Museum.* Shelburne, Vt.: Shelburne Museum, 1957.

Colby, Averil. *Patchwork.* New York: Charles Scribner's Sons, 1958.

———. *Quilting.* New York: Charles Scribner's Sons, 1971.

Cooper, Patricia, and Norma Bradley Buferd. *The Quilters: Women and Domestic Art.* Garden City, N.Y.: Doubleday and Co., 1977.

Denver Art Museum Textile Department. *American Patchwork Quilts.* Denver, 1986.

Finley, Ruth E. *Old Patchwork Quilts and the Women Who Made Them.* Philadelphia: Lippincott, 1929.

Hall, Carrie A., and Rose G. Kretsinger. *The Romance of the Patchwork Quilt in America.* New York: Bonanza Books, 1935.

Holstein, Jonathan. *The Pieced Quilt: An American Design Tradition.* New York: Galahad Books, 1973.

Ickis, Marguerite. *The Standard Book of Quilt Making and Collecting.* New York: Dover Publications, 1949.

Kolter, Jane Bentley. *Forget Me Not: A Gallery of Friendship and Album Quilts.* Pittstown, N.J.: Main Street Press, 1985.

Lasanky, Jeannette. *In the Heart of Pennsylvania: Nineteenth & Twentieth Century Quiltmaking Traditions.* Lewisburg, Penn.: Oral Traditions Project of the Union County Historical Society, 1985.

———. *Pieced by Mother: Over 100 Years of Quiltmaking Traditions.* Lewisburg: Oral Traditions Project of the Union County Historical Society, 1987.

Lipsett, Linda Otto. *Remember Me: Women & Their Friendship Quilts.* San Francisco: Quilt Digest Press, 1985.

Martin, Nancy J. *Pieces of the Past.* Bothell, Wash.: That Patchwork Place, 1986.

Orlofsky, Patsy and Myron. *Quilts in America.* New York: McGraw-Hill Book Co., 1974.

Peto, Florence. *American Quilts and Coverlets.* New York: Chanticleer Press, 1949.

———. *Historic Quilts.* New York: American Historical Co., 1939.

Ramsey, Bets, and Merikay Waldvogel. *Quilts of Tennessee: Images of Domestic Life Prior to 1930.* Nashville: Rutledge Hill Press, 1986.

Safford, Carleton L., and Robert Bishop. *America's Quilts and Coverlets.* New York: E. P. Dutton, 1980.

Sienkiewicz, Elly. *Spoken without a Word.* Washington, D.C.: Turtle Hill Press, 1983.

Swan, Susan Burrows. *Plain & Fancy: American Women and Their Needlework, 1700–1850.* New York: Holt, Rinehart, 1977.

Woodard, Thomas K., and Blanche Greenstein. *Twentieth Century Quilts, 1900–1950.* New York: E. P. Dutton, 1988.

Yakima Valley Museum & Historical Association. *Quilt Masterpieces in Full Color.* New York: Dover Publications, 1986.

Quilts and Art

Abernethy, Francis Edward. *Folk Art in Texas.* Dallas: Southern Methodist University Press, 1985.

Bishop, Robert. *New Discoveries in American Quilts.* New York: E. P. Dutton, 1975.

Holstein, Jonathan. *The Pieced Quilt: An American Design Tradition.* See History.

Kallir, Otto. *Grandma Moses.* New York: Harry N. Abrams, 1973.

McMorris, Penny, and Michael Kile. *The Art Quilt.* San Francisco: Quilt Digest Press, 1986.

Mainardi, Patricia. *Quilts: The Great American Art.* San Pedro, Calif.: Miles & Weir, 1978.

Robinson, Charlotte, ed. *The Artist & the Quilt.* New York: Alfred A. Knopf, 1983.

Rumford, Beatrix R. *The Abby Aldrich Rockefeller Folk Art Collection.* Williamsburg, Va.: Colonial Williamsburg Foundation, 1975.

Safford, Carleton L., and Robert Bishop. *America's Quilts and Coverlets.* See History.

Steinfeldt, Cecilia. *Texas Folk Art: 150 Years of the Southwestern Tradition.* Austin: Texas Monthly Press, 1981.

Opposite: detail from
Shiraz Quilt, page 118

Quilt Pattern Identification

Hall, Carrie A., and Rose G. Kretsinger. *The Romance of the Patchwork Quilt in America.* See History.

Khin, Yvonne M. *The Collector's Dictionary of Quilt Names & Patterns.* Washington, D.C.: Acropolis Books Ltd., 1980.

Rehmel, Judy. *The Quilt I.D. Book: 1000 Illustrated and Indexed Patterns.* New York: Prentice Hall Press, 1986.

Smith, Wilene. *Quilt Patterns: An Index to the Kansas City Star Patterns, 1928–1961.* Wichita: Wilene Smith, 1985.

How to Quilt and Quilt Patterns

Beyer, Jinny. *Medallion Quilts: The Art and Technique of Creating Medallion Quilts.* McLean, Va.: EPM Publications, 1982.

———. *Patchwork Patterns.* McLean, Va.: EPM Publications, 1979.

———. *The Quilter's Album of Blocks and Borders.* McLean, Va.: EPM Publications, 1980.

———. *The Scrap Look: Designs, Fabrics, Colors, and Piecing Techniques for Creating Multi-Fabric Quilts.* McLean, Va.: EPM Publications, 1985.

Bonesteel, Georgia. *Lap Quilting with Georgia Bonesteel.* Birmingham: Oxmoor House, 1982.

———. *More Lap Quilting with Georgia Bonesteel.* Birmingham: Southern Living Books, 1985.

Elwin, Janet B. *Hexagon Magic.* McLean, Va.: EPM Publications, 1986.

Hassel, Carla. *You Can Be a Super Quilter! A Teach-Yourself Manual for Beginners.* Des Moines: Wallace-Homestead Book Co., 1980.

———. *Super Quilter II: Challenges for the Advanced Quilter.* Des Moines: Wallace-Homestead Book Co., 1982.

Horton, Roberta. *Calico and Beyond: The Use of Patterned Fabric in Quilts.* Lafayette, Calif.: C&T Publishing, 1986.

Houck, Carter. *American Quilts and How to Make Them.* New York: Charles Scribner's Sons, 1975.

Hughes, Trudie. *Template-Free Quiltmaking.* Bothell, Wash.: That Patchwork Place, 1986.

Ickis, Marguerite. *The Standard Book of Quilt Making and Collecting.* See History.

LaBranche, Carol. *A Constellation for Quilters: Star Patterns for Piecing.* Pittstown, N.J.: Main Street Press, 1986.

Leman, Bonnie. *How to Make a Quilt.* Rev. ed. Wheatridge, Colo.: Leman Publications, 1979.

———. *Quick and Easy Quilting.* Great Neck, N.Y.: Hearthside Press, 1972.

———, and Judy Martin. *Log Cabin Quilts.* Wheatridge, Colo.: Moon Over the Mountain Publishing, 1980.

———. *Taking the Math Out of Making Patchwork Quilts.* Wheatridge, Colo.: Moon Over the Mountain Publishing, 1981.

McClun, Diana, and Laura Nownes. *Quilts! Quilts!! Quilts!!! The Complete Guide to Quiltmaking.* San Francisco: Quilt Digest Press, 1989.

McKim, Ruby. *One Hundred and One Patchwork Patterns.* Rev. ed. New York: Dover Publications, 1962.

Martin, Judy. *Scrap Quilts.* Wheatridge, Colo.: Moon Over the Mountain Publishing, 1986.

———. *The Ultimate Book of Quilt Block Patterns.* Denver: Crosley-Griffith Publishing Co., 1988.

Millard, Debra. *A Quilter's Guide to Fabric Dyeing.* Englewood, Colo.: Debra Millard, 1984.

Penders, Mary Coyne. *Color and Cloth: The Quiltmaker's Ultimate Workbook.* San Francisco: Quilt Digest Press, 1989.

Puckett, Marjorie. *Patchwork Possibilities.* Orange, Calif.: Orange Patchwork Publishers, 1981.

Schaefer, Becky. *Working in Miniature: A Machine Piecing Approach to Miniature Quilts.* Lafayette, Calif.: C&T Publishing, 1987.

Shirer, Marie, and Barbara Brackman. *Creature Comforts: A Quilter's Animal Alphabet Book.* Chicago: Wallace-Homestead Book Co., 1986.

Simpson, Grace. *Quilts Beautiful: Their Stories and How to Make Them.* Winston-Salem, N.C.: Hunter Publishing Co., 1981.

Young, Blanche, and Helen Young. *The Irish Chain Quilt.* Oak View, Calif.: Young Publications, 1986.

Texas Quilts and Needlework

Bresenhan, Karoline Patterson, and Nancy O'Bryant Puentes. *Lone Stars, Volume I: A Legacy of Texas Quilts, 1836–1936.* See History.

Orbelo, Beverly Ann. *A Texas Quilting Primer.* San Antonio: Corona Publishing Co., 1980.

Yabsley, Suzanne. *Texas Quilts, Texas Women.* College Station: Texas A&M University Press, 1984.

Quilt Care

Bachmann, Konstanze, ed. *Bulletin No. 12: Textile Conservation.* New York: Cooper-Hewitt Museum and the New York State Conservancy Consultancy, 1984.

———. *Bulletin No. 13: Warning Signs—When Textiles Need Conservation.* New York: Cooper-Hewitt Museum and the New York State Conservancy Consultancy, 1984.

Green, Sara Wolf. "A Guide to Home Care of Quilts." In *From Our Hands.* Austin: Texas Memorial Museum, 1986.

Gunn, Virginia. "The Display, Care, and Conservation of Old Quilts." In *In the Heart of Pennsylvania Symposium Papers.* Lewisburg: Oral Traditions Project of the Union County Historical Society, 1986.

Mailand, Harold F. *Considerations for the Care of Textiles and Costumes: A Handbook for the Non-Specialist.* Indianapolis: Indianapolis Museum of Art, 1980.

Orlofsky, Patsy. "The Collector's Guide for the Care of Quilts in the Home." In *Quilt Digest 2.* San Francisco: Kiracofe & Kile, 1984.

Puentes, Nancy O'Bryant. *First Aid for Family Quilts.* Wheatridge, Colo.: Moon Over the Mountain Publishing, 1986.

Quilt Magazines

The following magazines are published periodically and cover a wide range of information regarding antique quilts and contemporary quiltmaking. This is a representative list of publications available by subscription or through local quilt specialty shops. Some are available on newsstands.

COUNTRY QUILTS

LADY'S CIRCLE PATCHWORK QUILTS

QUILTER'S NEWSLETTER MAGAZINE

QUILT MAGAZINE

QUILTMAKER

QUILT WORLD

QUILTING TODAY

Quilt Videos

Beyer, Jinny. *Mastering Patchwork.* McLean, Va.: EPM-Con, 1988.

———. *Palettes for Patchwork.* McLean, Va.: EPM-Con, 1987.

Martin, Nancy J. *Shortcuts to America's Best-Loved Quilts.* Bothell, Wash.: That Patchwork Place, 1989.

Michell, Marti. *Patchwork Quilting.* Peoria, Il.: PJS Publications, 1987.

Texas History

Dooley, Kirk. *The Book of Texas Bests.* Dallas: Taylor Publishing Co., 1988.

Exley, Jo Ella Powell, ed. *Texas Tears and Texas Sunshine: Voices of Frontier Women.* College Station: Texas A&M University Press, 1985.

Fehrenbach, T. R. *Seven Keys to Texas.* El Paso: Texas Western Press, 1983.

Frantz, Joe B. *Texas: A History.* New York: W. W. Norton & Co., 1984.

Graham, Don, ed. *Texas: A Literary Portrait.* San Antonio: Corona Publishing Co., 1985.

Hunter, John Marvin, comp. and ed. *The Trail Drivers of Texas.* Austin: University of Texas Press, 1985.

Kelton, Elmer. *The Time It Never Rained.* Fort Worth: Texas Christian University Press, 1984.

O'Connor, Robert F. *Texas Myths.* College Station: Texas A&M University Press, 1986.

Olien, Diana Davids, and Roger M. *Life in the Oil Fields.* Austin: Texas Monthly Press, 1986

Ragsdale, Kenneth B. *The Year America Discovered Texas: Centennial '36.* College Station: Texas A&M University Press, 1987.

Webb, Walter Prescott, ed. *The Handbook of Texas.* Vols. 1 and 2. Austin: Texas State Historical Association, 1952.

Welch, June Rayfield. *People and Places in the Texas Past.* Dallas: Yellow Rose Press, 1974.

Women's History

Bank, Mirra, comp. *Anonymous Was a Woman.* New York: St. Martin's Press, 1979.

Evans, Sara M. *Born for Liberty: A History of Women in America.* New York: Free Press, 1989.

Friedan, Betty. *The Feminine Mystique.* New York: W. W. Norton & Co., 1963.

Holland, Ada Morehead. *Brush Country Woman.* College Station: Texas A&M University Press, 1988.

Moore-Lanning, Linda. *Breaking the Myth: The Truth about Texas Women.* Austin: Eakin Press, 1986.

Winegarten, Ruthe. *Texas Women: A Pictorial History, From Indians to Astronauts.* Austin: Eakin Press, 1986.